ELVIS AFTER ELV

"For a dead man, Elvis Presley is awfully noisy. His body may have failed him in 1977, but today his spirit, his image, and his myths do more than live on: they flourish, they thrive, they multiply."

Why is Elvis Presley so ubiquitous a presence in US culture? Why does he continue to enjoy a cultural prominence that would be the envy of the most heavily publicized living celebrities?

In *Elvis after Elvis*, Gilbert Rodman traces Elvis Presley's myriad manifestations in contemporary popular and not-so-popular culture. He asks why Elvis continues to defy our expectations of how dead stars are supposed to behave: Elvis not only refuses to go away, he keeps showing up in places where he seemingly does not belong.

Rodman draws upon an extensive and eclectic body of Elvis "sightings," from Elvis's appearances at the heart of the 1992 presidential campaign to the debate over his worthiness as a subject for a postage stamp, and from Elvis's central role in furious debates about racism and the appropriation of African-American music to the world of Elvis impersonators and the importance of Graceland as a place of pilgrimage for Elvis fans and followers.

Rodman shows how Elvis has become inseparable from many of the defining myths of US culture, enmeshed with the American Dream and the very idea of the "United States," caught up in debates about race, gender, and sexuality, and in the wars over what constitutes a national culture.

Gilbert B. Rodman is Assistant Professor of Communication at the University of South Florida.

ELVIS AFTER ELVIS

The posthumous career of a living legend

Gilbert B. Rodman

London and New York

First published 1996
by Routledge
11 New Fetter Lane, London EC4P 4EE

Simultaneously published in the USA and Canada
by Routledge
29 West 35th Street, New York, NY 10001

Typset in Perpetua by
Keystroke, Jacaranda Lodge, Wolverhampton
Printed and bound in Great Britain by
Butler and Tanner, Frome, Somerset

British Library Cataloguing in Publication Data
A catalogue record for this book is available from the British Library

Library of Congress Cataloging in Publication Data
Rodman, Gilbert B.,
Elvis after Elvis : the posthumous career of a living legend /
Gilbert B. Rodman.
p. cm.
Includes bibliographical references and index.
1. Presley, Elvis, 1935–1977. 2. Popular culture—United States—
History—20th century. I. Title.
ML420.P96R58 1996
782.42166′092-dc20 96-8157
CIP
MN

ISBN 0–415–11002–5 (hbk)
ISBN 0–415–11003–3 (pbk)

You've established a wonderful thing here with Hitler. You created it, nurtured it, you made it your own. Nobody on the faculty of any college or university in this part of the country can so much as utter the word Hitler without a nod in your direction, literally or metaphorically. This is the center, the unquestioned source. He is now your Hitler, Gladney's Hitler. It must be deeply satisfying for you. The college is internationally known as a result of Hitler studies. It has an identity, a sense of achievement. You've evolved an entire system around this figure, a structure with countless substructures and inter-related fields of study, a history within history. I marvel at the effort. It was masterful, shrewd and stunningly preemptive. It's what I want to do with Elvis.

Murray Jay Siskind, in Don DeLillo's *White Noise* (1985: 11–12)

CONTENTS

CONTENTS

PLATES

While every effort has been made to contact owners of copyright of material which is reproduced in this book, we have not always been successful. In the event of a copyright query, please contact the publishers.

ACKNOWLEDGMENTS

One of the more interesting side effects of writing a scholarly book on Elvis is that seemingly everyone you know – regardless of who they are or what they do for a living – has something to contribute to your project. Had I been studying post-modern architecture, nineteenth-century US poets, or even a phenomenon as widely familiar as music videos, it's likely that only a handful of people – most of whom would have been fellow academics working on similar topics – would have come forth with information directing me to additional texts and resources related to my project. Because I was studying Elvis, however, my problem was never one of finding other people to share their theories, opinions, anecdotes, or citations with me; on the contrary, from day one of this project, the problem on my hands was that of keeping up with the flood of Elvis texts that came my way from a veritable army of helpful friends, colleagues, and family members.

In the space available to me here, then, it would simply be impossible to name everyone who provided me with advice, editorial comments, support (moral and otherwise), and – most crucially – a file cabinet's worth of assorted "Elviscera" during the course of researching and writing this book. Recognizing that I'm inevitably doomed to overlooking someone who deserves mention here, I'd like to make up for such oversights by giving my first thanks to the many people not named below who nevertheless contributed to this project.

In part, the research behind *Elvis after Elvis* was underwritten by a grant from the Graduate College at the University of Illinois at Urbana-Champaign (UIUC). A previous incarnation of sections I and II of chapter 3 (and a smidgen of intro-ductory prose from chapter 1) appeared as "A Hero to Most?: Elvis, Myth, and the Politics of Race" in *Cultural Studies*, 8(3), pp. 457–83.

I owe a sizable debt to Larry Grossberg, Michael Bérubé, Norm Denzin, James Hay, and Tom Turino, who guided me through seven years of life and learning on the prairie and helped steer this project through its various dissertational stages. Extra special thanks and a waggle of the elbow go to Diane Tipps, the backbone – and the heart – of the Institute of Communications Research at UIUC, for her

kind help, support, and friendship over the years. For helping to make life in Champaign not merely bearable but actually happy over the years, many warm thanks (and cold beverages) go to Jack Bratich, Anne Eckman, Cheryl Elsbury, Lee Furey, Ivy Glennon, Julian Halliday, Natasha Levinson, Carine Melkom, John Nerone, Carrie Rentschler, David Schulman, Jackie Seigworth, Jonathan Sterne, Mary Vavrus, Cat Warren, and Greg Wise.

I am especially grateful to Rebecca Barden for her unflagging faith in this project and for being as kind, supportive, and patient an editor as any author could ever hope for. Greil Marcus and Simon Frith provided invaluable support, criticism, and correspondence – far above and beyond the call of duty – at several key points during this project. Many thanks also to Lindsay Waters for the thrill of the chase.

Melanie Amin, Karen DeMars, and Mark Mauer deserve special mention for bringing particularly twisted and delightful Elvis sightings to my attention. Joan Bernstein, Joel Cohn, Pam Inglesby, Rob Kirsch, Jake and Joe Marini, Eddi McKay, Bill Mikulak, and Beth Shillin have been constant sources of love and friendship since my early years as a scholar-wannabe at the University of Pennsylvania. Johanne Blank and Beth Kolko entered the picture much further down the road, but their support and friendship have been no less valuable – and no less appreciated – for being (relatively) new.

I owe an Elvis-sized debt to Aaron Caplan, Jon Crane, and Greg Seigworth, who are not merely good friends, but also served as an *ad hoc* outside committee of readers through several early drafts of this manuscript. This book is better for their careful attention and insightful criticisms. A similarly large dollop of gratitude belongs to Carol Stabile, queen of the nesters, for her steadfast friendship and for keeping me intellectually honest. My fondest hope is to be just like her when I grow up. And unless (until?) she sends me a plane ticket to Sydney and offers me my old job as her research assistant again, it's probably not possible for me to repay the debt I owe Meaghan Morris, who has been a pillar of support and inspiration from the very earliest stages of this project.

To say that this book would never have been seen through to completion without the love, support, and understanding of my parents – Jacquie Rodman and O.G. Rodman – would be an understatement of the highest degree. Between them, they provided me with countless newspaper clippings, magazine articles, books, video tapes, and other assorted Elvis knick-knacks that were of immeasurable value to this project – not to mention their assistance (financial and otherwise) in keeping the other aspects of my life in order over the years.

If the debts listed above can't be expressed adequately in the handful of words provided here (and they can't), then what I owe Linda Detman would be impossible to do justice to without devoting the rest of this book to the task. She helped to keep me sane (or relatively so) and focused at those moments when

ACKNOWLEDGMENTS

I might otherwise have been tempted to throw in the towel, and has enriched my
life in more ways than I could ever have dreamed of. I don't fully understand
where the depth of her faith in me comes from, but I'm eternally grateful for it.
It's with the deepest love that I dedicate this book to her.

ELVIS STUDIES

This is the nature of modern death. . . . It has a life independent of us. It is growing in prestige and dimension. It has a sweep it never had before. . . . It continues to grow, to acquire breadth and scope, new outlets, new passages and means. . . . I sense that the dead are closer to us than ever. I sense that we inhabit the same air as the dead. Remember Lao Tse. "There is no difference between the quick and the dead. They are one channel of vitality." He said this six hundred years before Christ. It is true once again, perhaps more true than ever.

(DeLillo, 1985: 150)

WHEN IT RAINS, IT REALLY POURS

For a dead man, Elvis Presley is awfully noisy.

His body may have failed him in 1977, but today his spirit, his image, and his myths do more than live on: they flourish, they thrive, they multiply. As the musical duo of Mojo Nixon and Skid Roper (1987) has observed, "Elvis is everywhere," sneaking out of songs, movies, television shows, advertisements, newspapers, magazines, comic strips, comic books, greeting cards, trading cards, T-shirts, poems, plays, short stories, novels, children's books, academic journals, university courses, art exhibits, home computer software, cookbooks, political campaigns, postage stamps, and innumerable other corners of the cultural terrain in ways that defy common-sense notions of how dead stars are supposed to behave. Elvis's current ubiquity is particularly noteworthy, not just because he refuses to go away, but because he keeps showing up in places where he seemingly doesn't belong.

Take, for example, Elvis's appearance in a *New York Times* story on the 1991 National Hardware Show in Chicago. Given that this is a straight news story on a trade convention and the products on display there, one wouldn't expect Elvis to receive even a passing mention. Heated birdbaths, electronic pet feeders,

dehydrated potting soil: all these items belong here, insofar as their appearance in such a context seems perfectly in keeping with the subject of the story; Elvis, on the other hand, is not a figure with any obvious connection to hardware or home improvement goods. Nevertheless, the article concludes with a discussion of Vegiforms,

> plastic molds that are placed over growing vegetables. The vegetables then grow into the shape of celebrities and cartoon characters. . . . [Vegiforms company president Richard] Tweddell's favorite mold was a bust of Elvis Presley, which he had to stop making after being pressured by the Presley estate. "They indicated that they have had bad experiences with licensed Elvis food," said Mr. Tweddell, holding up summer squash bearing a striking resemblance to the king of rock-and-roll.
>
> <div align="right">(Shulruff, 1991: 4)[1]</div>

As is the case with so many of his recent manifestations, Elvis's presence here seems unnatural, but there he is anyway: a particularly boorish and persistent gate-crasher, one who not only shows up where he doesn't belong, but who does so in a loud and unsubtle fashion.

The most notorious of Elvis's recent newspaper appearances, of course, take place not in mainstream papers such as the *New York Times* but in the less well-respected realm of the supermarket tabloids, where hardly a month goes by without at least one banner headline announcing newsflashes such as "WOMAN CURED OF THROAT CANCER – BY LICKING ELVIS' STAMP" (Fontaine, 1993) or the not-yet-dead Elvis's advice to his daughter ("DIVORCE MICHAEL!" (Dexter, 1994))[2] to millions of shoppers waiting to pay for their groceries. While these stories are often sufficiently outrageous to merit attention themselves,[3] perhaps more surprising is the fact that they have inspired a sizable number of Elvis sightings[4] *outside* the pages of the tabloids. For example, in 1990, a San Jose software firm capitalized on the tabloid-fueled "Elvis is alive" rumors by introducing *Search for the King*, a graphic adventure computer game in which the goal was to discover the true whereabouts of the supposedly dead "King," a singing star partial to white jumpsuits and performing in Las Vegas showrooms.[5] Underscoring the supermarket papers' inspirational role here, the original release of the game came with a copy of a fictional tabloid containing appropriate "King"-related headlines (Himowitz, 1990).

Response to the tabloids' tales of Elvis, however, hasn't been limited to good-natured parody. For example, both the *New York Times* (Schmidt, 1988) and the *Washington Post* (Harrington, 1991) have taken Elvis items first reported in the tabloids and followed up on them without any hint that they might have been doing so satirically. Other major dailies have even gone so far as to run their own outrageous Elvis stories *before* the tabloids' reports could make it to press: the

Scripps Howard News Service (Saavedra, 1991a, 1991b), for instance, beat the *Sun* (Shaw, 1991) into print on the story of an Arizona conference investigating the possibility that Elvis might still be alive.

In fact, recent years have found a surprising number of people responding to the tales of Elvis's continued good health by explicitly stating that "Elvis is dead" (e.g., Barth, 1991: vii; Carlson, 1992; Dominick, 1990: 116; Guterman and O'Donnell, 1991: 13; Olson and Crase, 1990: 277; Quain, 1992: xx; Sammon, 1994; Wombacher, 1991). These days, when Joe Esposito and other former members of Elvis's Memphis Mafia are interviewed (as they not infrequently are) on radio and television talk shows, their hosts almost always ask them to verify that Elvis is, in fact, dead. Taken as a collective statement, these affirmations of Elvis's demise come across less as simple expressions of fact than as urgent proclamations intended to put an ongoing debate to rest once and for all, as if the question of Elvis's current health (or lack thereof) were still in serious doubt.

Perhaps the oddest example of the moves to reaffirm Elvis's status as a corpse is *The Elvis Conspiracy*: a 1992 television special, hosted by Bill Bixby and broadcast live from a Las Vegas hotel showroom, that took two hours in the midst of prime time to demonstrate that Elvis Presley did indeed die in 1977. What makes this program particularly odd is not just the fact that it didn't present evidence supporting the official account of Elvis's demise (statements from eyewitnesses, hospital records, the coroner's report, etc.) – instead, it focused on debunking a series of tales of post-1977 encounters with a living, breathing, perfectly healthy Elvis – but that it was actually a sequel to *The Elvis Files*, an almost identical live broadcast from 1991 created by virtually the same team of writers and producers.[6] The only major difference between the two shows was that the August 1991 broadcast (*Files*) preempted two hours of prime time programming around the anniversary of Elvis's death in order to convince its audience that he was still alive, while the January 1992 broadcast (*Conspiracy*) preempted two hours of prime time programming around the anniversary of Elvis's birth in order to convince its audience that he was still dead. In other words, the makers of *Conspiracy* not only took the trouble, fifteen years after the fact, to prove that Elvis was no longer living, but they did so as a rebuttal to their own barely five-month-old claims to the contrary.

What makes these "Elvis is dead" sightings especially noteworthy is the surprising amount of respect they have for both the tabloids' reports of Elvis's non-death and the wave of rumors concerning Elvis's current whereabouts that have circulated in the wake of the tabloids' claims. Under the best of conditions, after all, the tabloids' reputation as reliable sources for believable (much less accurate) news is sufficiently poor that even their most conventional news stories are regularly ignored.[7] That the tabloid-fueled tales of Elvis encounters have been taken seriously enough to generate *any* response – even when that response takes

the form of derisive parody and disbelief – is highly unusual. Tellingly enough, when the tabloids finally managed to attract "mainstream" media attention[8] for one of their stories – the January 1992 *Star* feature on Bill Clinton's alleged affair with Gennifer Flowers – many commentators found that Elvis provided the best point of reference by which to judge the *Star*'s scoop. As one anonymous *Star* staffer aptly described it, the Flowers/Clinton story "is *bigger than Elvis* because for the first time, the rest of the press has to come to us. They think we're trash, but they do the same things we do all the time. They just hate to admit it" (Savan, 1992, emphasis added).

Not all of the press attention given to Elvis recently, however, has been tabloidesque in nature . . . though even the straight news items that play the Elvis card don't always do so in predictable ways. Take, for example, a *Washington Post* article (Pressley, 1991) about a Charlottesville, Virginia, woman who legally changed her name to Elvis Aron Presley. At first glance, this appears to be a fairly conventional tale of the unconventional and obsessive fandom that Elvis inspired. But closer examination reveals that the former Lilly May Painter made her unusual name change back in 1981 (so the *Post* wasn't exactly jumping on a fresh piece of news), that she had no intentions of changing her name anytime soon (so there's no change in the old news to report), and that the story ran in late May (well outside the usual time frame for the waves of Elvis stories that regularly crop up around the anniversary of his birth (8 January) and his death (16 August)). Ms Presley is no longer even an obsessive fan of her namesake, as a 1983 car accident convinced her that God was a more important figure than Elvis. What makes this article particularly unusual, however, is not only its placement in the news-oriented "Metro" (as opposed to the features-oriented "Style") section of the *Post*, but that it dominated the front page of the section, featuring two *photos* above the fold that (combined) took up more space than any other single *story* on the page. On this day, all the section's "hard news" articles (including stories on a local university's hunt for a new president, growing tensions between Hispanics and suburban police, and Memorial Day ceremonies involving then Vice President Dan Quayle and former Joint Chiefs of Staff chair Colin Powell) took a back seat to the quirky feature on Ms Presley. While the notion of a "slow news day" might explain the appearance of Elvis-related stories in the dark recesses of a paper (e.g., buried somewhere in a corner between the obituaries and the classifieds), it's a wholly inadequate explanation for the way that Elvis effectively hijacks the *Post*'s "Metro" section here. (Further discussion of this sighting can be found in chapter 2.)

Yet another example of Elvis's ability to intrude upon the mainstream press in abnormal ways comes from a *Wall Street Journal* story on an alleged "voodoo plot" to murder a Mississippi judge (McCoy, 1989). The story ran as front page news, it dealt with a very real and very serious felony case, it took up over thirty column

inches of text, and the alleged crime had nothing whatsoever to do with Elvis. Yet since the events in question took place in Tupelo – Presley's birthplace – Elvis was accorded a place of prominence not only in the article's title ("Mississippi Town *All Shook up* over Voodoo Plot" (emphasis added)) but within the body of the story as well, where Elvis allusions in the opening and closing paragraphs framed the piece. The article's conclusion makes the gratuitous nature of Elvis's appearance here especially clear:

> The case isn't likely to come to trial before May. In Tupelo, some people remain curious about the whole affair. "I'm glad the judge didn't come to harm, but I'd like to see someone get cursed, just to find out if it works," muses Laverne Clayton, sitting next to the actual bed in which Elvis supposedly was born at the cramped two-room Presley family home, where Mrs. Clayton works as a guide. "That's a mystery I'd like to see cleared up." Incidentally, as to that other mystery with which Tupelo is connected, Mrs. Clayton's expert opinion is that "Elvis is dead as a doornail."
>
> <div align="right">(McCoy, 1989: 4)</div>

Not only is Elvis not directly relevant to the impending trial that prompted the *Journal* to send McCoy to Tupelo in the first place, but Laverne Clayton has nothing to do with the case either: her only connection to the story is that she holds a job relevant to Elvis's unusual presence here.

Elvis's ability to take over the news, however, is not limited to the odd story here and there (which could conceivably be explained by the playful self-indulgence of a few editors and journalists who also happen to be Elvis fans): taken as a whole, the US media seem more than willing to give prominent play to Elvis-related stories, even at the cost of neglecting more serious hard news items. For example, the trade journal *Advertising Age* runs a monthly column called "Cover Story," a ranking of celebrities' popularity as determined by their appearances on the covers of major national magazines; for June 1989 the "Cover Story" champ was Danielle Riley Keough (Donaton, 1989). Who is this Keough person? And how did she manage to beat out such luminaries as Oprah Winfrey, Rob Lowe, Roseanne Barr, Madonna, and even the then newly deceased Gilda Radner by comfortable margins for this honor? The answer is simple: on 29 May 1989, Keough was born, becoming Elvis's first grandchild. Two things make the "Cover Story" coronation of "the newest Presley" (as the infant was often incorrectly referred to) so remarkable: (1) the fact that she was probably the youngest person ever to be accorded this honor, and (2) the only "accomplishment" that allowed her to command such overwhelming media attention was her kinship with Elvis. In other words, twelve years after his death and across two generations, Elvis is still important enough in the eyes of a majority of editors and journalists to make headlines and cover photos simply by having a grandchild.

Perhaps a more clear-cut indicator of Elvis's unusual posthumous newsworthiness, however, is the massive media attention given to the Elvis postage stamp. After months of news stories, feature articles, public opinion polls, op/ed columns, letters to the editor, and political cartoons on the subject, on 4 June 1992 the US Postal Service announced the results of the public election (the first of its kind) to determine the stamp's design. All four of the major broadcast television networks (including Fox) provided live coverage of the early morning press conference in which "the young Elvis" design was declared the winner. That very same evening, however, when President Bush scheduled a rare press conference of his own, only CNN carried it live: the broadcast networks refused to disrupt their prime time schedules to do the same. Even during an election year, a dead Elvis managed to attract more press attention than an incumbent president running for office, lending an unexpected credence to a favorite punchline of cartoonists and columnists (political and otherwise) that the *real* election in the US in 1992 was not the one to choose a president, but the one to choose a stamp. (The Elvis stamp is discussed further in chapter 2.)

Another prominent site where Elvis lives on today is in the thriving phenomenon of Elvis impersonators: by some estimates, there are 3,000 such performers working in the US alone (Hinerman, 1992: 119). And, like Elvis, impersonators are showing up more and more in places where neither they nor Elvis would seem to belong. For instance, recent years have found ersatz Elvises cropping up in a variety of advertisements,[9] on network television news stories,[10] as part of successful recording acts that *don't* record Elvis songs,[11] and even on the presidential campaign trail.[12] Moreover, the "will to imitate" that characterizes Elvis impersonators is no longer limited to attempts to duplicate his look and sound: one can find a scale replica of Graceland in Roanoke, Virginia (Clauson-Wicker, 1994; DeNight *et al.*, 1991: 309; Rosenfeld, 1992) and a full-sized re-creation of the mansion in Australia ("Long Live the King," 1991). There are even women who have found work (at least fleetingly) as Priscilla impersonators ("Elvis Is Everywhere," 1992; "Long Live the King," 1991), one of whom has even gone so far as to marry an Elvis impersonator (Joe Berger, 1995), though it's not yet clear whether the couple will make their re-creation of the original Presley marriage complete by divorcing after five years.

Recent years have also seen the publication of a vast number of books devoted to Elvis, ranging from efforts to (re)tell the story of Elvis's life (e.g., Greenwood and Tracy, 1990; Guralnick, 1994) and death (e.g., Goldman, 1991; Thompson and Cole, 1991) to collections of Elvis-centered fiction and poetry (e.g., Peabody and Ebersole, 1994; Sammon, 1994; Sloan and Pierce, 1993); from cookbooks filled with his favorite recipes (e.g., Adler, 1993; Butler, 1992) to collections of quotes by and about him (e.g., Choron and Oskam, 1991; Rovin, 1992); from thinly veiled fictionalized accounts of his career (e.g., Charters, 1992; Childress,

1990) to semi-scholarly collections of writings on his art and his cultural significance (e.g., DePaoli, 1994; Marcus, 1991; Quain, 1992). Some of the most unusual of Elvis's recent book appearances, however, have occurred in the unlikely realms of science fiction stories and children's books. In 1992 alone, for instance, three different Elvis-based parodies of the popular "Where's Waldo?" series of children's picture books were published: *Where's Elvis?* (Holladay, 1992), *In Search of Elvis* (Sales *et al.*, 1992), and *In Search of the King* (Gelfand *et al.*, 1992). A slightly (but only slightly) more traditional children's book is *Elvis Hornbill: International Business Bird* (Shepherd, 1991), a beautifully illustrated, if decidedly off-beat, tale about a couple who adopt an orphaned hornbill and name it Elvis because of its lovely singing voice (see plates 2a–b). Echoing the real-life conflicts between many liberal baby-boomers and their increasingly conservative children, the book's plot revolves around the tension between the hopes of the proud "parents" that Elvis will pursue a career in the glamorous world of rock 'n' roll and the bird's fervent desire to enter the world of high finance and corporate economics. Ultimately, Elvis successfully resists parental pressure to follow in his namesake's footsteps and becomes the financial manager of an international hotel.

Meanwhile, in the realm of science fiction, the image of Elvis as a religious figure has become a familiar motif in tales of the near future. For instance, Allen Steele's novel *Clarke County, Space* (1990) revolves, in part, around the Church of Elvis, a mid-twenty-first-century religion organized entirely around the life and teachings of Elvis. In Neal Stephenson's cyberpunk novel *Snow Crash* (1992), where everything (from suburban communities to highway systems, from police forces to criminal courts) has been privatized and franchised, Elvis appears as the second figure in the holy trinity of Reverend Wayne's Pearly Gates, a franchised religion.[13] Elvis also crops up in a quasi-religious fashion in Bradley Denton's *Buddy Holly Is Alive and Well on Ganymede* (1991), which (among other things) makes a strong case for rock 'n' roll as a religious force more powerful than that emanating from any formally organized religion. And while Holly, as the book's title implies, may be the principal deity in Denton's fictitious world, rock 'n' roll is described here as a decidedly polytheistic form of worship and Elvis is invoked – on numerous occasions – as one of its most important gods.

While these stories all invoke the image of Elvis-as-god in service of some other plot line, Jack Womack's novel *Elvissey* (1993) is built entirely around the premise that, in the just-distant-enough future, a living Elvis/God is the only hope to bring a divided world together again. The book tells the tale of a couple who, on orders from the corporate/religious state (Dryco) for whom they work, go back in time and across alternate universes to kidnap another universe's Elvis at the very start of his career. In their own space and time, Dryco hopes to use the abducted Elvis as a pawn/godhead with which to manipulate and convert the countless "Elvii" who exist outside of Dryco's otherwise totalizing sphere of

influence. As the story describes them, the Elvii are more than simply a homogenous, Elvis-worshipping cult; rather, they consist of a wide range of sects and factions – not unlike the countless and often subtle variations on Christianity – who may all agree that Elvis is a holy figure, but disagree violently about how to worship Him properly:

> The C of E was one church become many; its mitosis ensued at conception, and seemed prime to split, divide and resplit into perpetuity. . . . The Prearmyite denomination was but one: amongst the Elvii were the Hosts of Memphis, the Shaken, Rattled and Rolled, the River Jordanaires, the Gracelandians, the Vegassenes, the Gladyseans, the C of E Now or Never, the Redeemed Believers in Our Master's Voice, the Church of the True Assumption of His Burning Love, and a hundred dozen more. Each schismatrix knew their King true, and saw their road as sole and only; their only given was that, for whatever reason, and – they supposed – at no one's command, the King would return.
>
> (Womack, 1993: 43)

Of course, in the end, when the real Elvis is presented to a mass gathering of His faithful followers, they reject him as an impostor.

Perhaps foreshadowing Elvis's role in the 1992 presidential campaign, science fiction authors have also explored the question of how the world might have been different if Elvis had gone into politics instead of music. *Alternate Kennedys* (Resnick, 1992), for example, an anthology of short stories about what our world might have been like if various key events in the saga of the Kennedy clan had gone differently, features several Elvis appearances, including that in Judith Tarr's "Them Old Hyannis Blues" (1992). Tarr's story is based on the premise that the young Elvis never aspired to be a musician, becoming a politician instead, while Joe Kennedy's sons eschewed politics and went on to become the world's greatest rock 'n' roll band. It is in this capacity that the Kennedy Brothers find themselves performing at President Presley's inaugural ball, where they manage not only to rock the house but also to save the newly elected Elvis from an assassin's bullet. (The would-be Elvis-killer? The head of one of Britain's most radical bands of dissidents, a man named Jagger. . . .) A similar tale of traded fates is Howard Waldrop's "Ike at the Mike" (1982), in which Dwight Eisenhower is the hottest clarinet player in jazz and "Wild" George Patton is a drummer, while Boris Karloff is an ambassador and Elvis a US senator – and a huge Ike fan. Sitting up alone at night at tale's end, Senator Presley puts on an Ike record, pours himself a drink, and muses, "I'd give it all away to be like him . . . "

The most twisted of the recent science fiction appearances by Elvis, however, has to be that in Robert Rankin's wry novel *Armageddon: The Musical* (1990). Briefly, *Armageddon* is a tale of two planets: Phnaargos, the world with the fiercest

television ratings wars in the universe, and Earth, which (unbeknownst to those who live there) is the principal soundstage for Phnaargos's most popular television series, *The Earthers*. The story takes place early in the twenty-first century, sometime after what is euphemistically referred to as the "Nuclear Holocaust Event." Contrary to most people's expectations, nuclear war has *not* left Earth an uninhabitable wasteland, but (to the chagrin of the Phnaargs) it *has* transformed it into very bad television. The book's plot thus revolves around the efforts of *The Earthers'* producers to resurrect the show's sagging ratings . . . with the method of choice to achieving this end being to send one of their number back in time to convince Elvis not to join the army. According to the Phnaargs' peculiar logic, Elvis's induction in 1958 implicitly legitimated military service in the eyes of the US youth who idolized him. This, in turn, ultimately blunted the edge of the resistance to the Vietnam War enough so that the US became inextricably bogged down in the conflict: a situation that sent the US into a long downward spiral, in terms of both military power and international prestige, that culminated in the Nuclear Holocaust Event and the dramatic decline in *The Earthers'* viewing audience . . . all of which (allegedly) could have been averted if only Elvis had ducked the draft. The Phnaargs' plan, however, fails to come off as designed (the Rube-Goldbergesque logic justifying their plan is actually the least of the Phnaargs' problems), and much of the book is spent following Elvis and a handful of other characters (among them, Jesus' twin sister Christine) as they try to extricate themselves from the resulting complications.

A somewhat more prominent (and definitely more numerous) variety of contemporary Elvis sightings involves the appropriation of Elvis's name, image, and/or aura for a wide range of promotional and advertising campaigns. Above and beyond the various advertisements involving Elvis impersonators described above (see note 9), these include the use of Elvis to sell Volvos,[14] Golden Grahams crackers,[15] Domino's pizza,[16] Bud Dry beer,[17] DeKuyper schnapps,[18] a biography of Bob Dylan,[19] an Illinois Dodge dealership,[20] a national chain of waterbed stores,[21] a touring performance of an Andrew Lloyd Webber musical,[22] a Chicago miniature golf course,[23] a Philadelphia photocopy shop,[24] a Washington, DC adult education center (see plate 3),[25] and a prominent Catholic university.[26] As odd as these sightings may be, they are actually *not* the most unusual of the many efforts to use Elvis as part of sales pitches. Seemingly much more gratuitous – and definitely much more surreal – are such items as Elvis's name being dropped to push a CD-ROM database to libraries;[27] the 1994 battle between several major airlines to offer Elvis-related discounts to flyers;[28] the use of "the benevolent gaze of Elvis" to sell small wooden bookshelves;[29] Elvis's image (or a facsimile thereof) being used as an eye-grabbing cover for such unlikely publications as *American Libraries*,[30] *Angel Times*,[31] *Chile Pepper*,[32] and *The Humanist*;[33] a loose reinterpretation of the 1970s version of the Elvis stamp as a means of promoting an annual community sausage

festival in Seattle;[34] a drawing of Elvis gracing the cover of a special advertising supplement on heat pumps;[35] and Yamaha's appropriation of the images of Elvis and Nikita Khrushchev to hawk a mixing board (see plates 4–11).[36]

It would be possible to continue this list of unusual Elvis sightings for many more pages, as even the wide range of examples described above barely begins to scratch the surface of the phenomenon. As yet unmentioned, for instance, are the odder musical "tributes" to him that have surfaced in the past few years,[37] his recent use as a synecdoche for all of popular culture by a major academic journal,[38] his appearance as a potential role model (or perhaps a muse) for child and adolescent psychiatrists in one of that field's major journals,[39] Joni Mabe's Traveling Panoramic Encyclopedia of Everything Elvis,[40] the 24-Hour Coin-Operated Church of Elvis in Portland, Oregon (see plates 12a–b),[41] no less than three different alternative comic books (see plates 13–15),[42] and at least two different Elvis-themed porn videos.[43] A complete catalogue of recent Elvis sightings, however, would be an impossible task, if for no other reason than that their number – already prohibitively large – continues to swell at a staggering rate. Today Elvis is more than just ubiquitous: he's ridiculously prolific.[44]

Though I haven't provided (and could not hope to do so) an exhaustive description of the entire range of Elvis's contemporary manifestations, I have hopefully demonstrated that there is in fact something very odd going on with Elvis today, something that deserves closer inspection. Given that Elvis is virtually everywhere on the current cultural terrain, the most pressing question to be addressed here is not "what's going on?" as much as it is "why?" Before I can present my own explanation (or, more accurately, explanations) for Elvis's strange posthumous career, however, I first need to outline – and refute – some of the most common (and supposedly commonsensical) explanations that have been offered for the phenomenon that is Elvis today.

DON'T

One answer to the riddle of Elvis's current ubiquity is that it's the result of the relentless machinations of contemporary capitalism. As Richard Dyer has pointed out, one of the most common (and seemingly commonsensical) ways that media stardom has been interpreted is as "a phenomenon of production": stars, the argument goes, are created and used by media corporations to attract audiences, sell goods (both media texts and various star-endorsed products), and add an element of predictability to the otherwise highly volatile entertainment market (Dyer, 1979b: 9–19). And certainly, since the very earliest days of his stardom, Elvis has been used – sometimes with his knowledge and consent, but just as often without – to make vast sums of money for a number of enterprising individuals (e.g., Colonel Tom Parker), small businesses (e.g., Sun Records), and

multi-national corporations (e.g., RCA Victor). More important here is the fact that the various efforts to transform Elvis's name, image, and music into profits didn't stop with his death in 1977 and that the posthumous continuation (acceleration?) of these practices has contributed in a number of ways to maintaining Elvis's prominence across the cultural terrain. RCA, for instance, continues to release profitable "new" albums of Elvis material (some of it previously unreleased, most of it simply remastered and repackaged) and shows no signs of stopping this practice anytime soon. New books about Elvis – written by fans, critics, and seemingly everyone who ever knew him – show up on bookstore shelves with surprising regularity.[45] And then, of course, there's the merchandising empire: a multi-million dollar industry based on the notion that almost anything – including summer squash – can have Elvis's name and face slapped on it and sell like hotcakes.[46]

Elvis, the ubiquitous phenomenon, however, is more than a mere commodity, and thus the fact that he's been marketed extensively only goes so far to explain his surprising cultural presence today. For one thing, many of the most unusual (and thus most noteworthy) appearances Elvis has made recently are decidedly non-profitable. Recent years have found Elvis appearing out of nowhere (and then disappearing almost as quickly) in hundreds – if not thousands – of novels, movies, television shows, and nationally syndicated comic strips: sightings far too insignificant (in terms of both placement and advertising) to be plausibly interpreted as profit-motivated, but far too widespread and visible simply to be written off as incidental trivia. Nicole Hollander and Garry Trudeau, for instance, don't stand to see any extra money roll in when Elvis appears in their daily comic strips, nor is it easy to see how Elvis's brief and unadvertised intrusions into television shows such as *Twin Peaks* or *The Simpsons* work to increase either the audience size or the profit margin for such ventures.

Perhaps most crucial, however, is the fact that Elvis *is* dead and should thus have ceased to be valuable as a merchandisable figure long ago. Given that the shelf-life for most products connected to *living* celebrities can be measured in months (e.g., the number of celebrity-inspired designer fragrances that have appeared – and almost immediately disappeared – in the past few years), why does a *dead* Elvis still sell so well after twenty years? Even the most successful efforts to market other dead stars (e.g., James Dean, Marilyn Monroe) are largely limited to T-shirts, posters, and home video releases of their movies; the merchandising empire built up around Elvis only *begins* with such pedestrian items. If Elvis's current ubiquity is merely the result of crafty market manipulation, then why aren't other stars – living or dead – promoted with similarly aggressive diversity? [47]

Capitalism, however, is more than just commodification, and the fact that Elvis-related marketing fails to account for his current ubiquity does not in itself

invalidate the notion that Elvis's lingering presence is a byproduct of capitalism. As McKenzie Wark puts it, "Elvis persists in the system because – besides his good looks, tall tales and real-gone sound – he embodies more than just an archetypal piece of product. He embodies certain discoveries about the process itself" (1989: 25). Following a similar train of thought, sociologist Peter Stromberg (1990) argues that Elvis serves an important ideological function within a capitalist social order: as a star who rose to unheard-of success from the depths of rural poverty, he helps to mediate between the "real" world of daily life and the "ideal" world depicted by the popular media,[48] thus reinforcing the myth that US society is a negotiable one. Stromberg's basic premise here is a sound one: media stars *do* serve an important ideological function in the maintenance of a stable capitalist social order,[49] and Elvis is no exception to this rule. Stromberg's ultimate conclusion, however – namely, that Elvis's status as a mediator between the "real" and the "ideal" world is what keeps him alive today – doesn't work quite as well. Given the fact that most media stars fulfill a "mediator" role akin to that described by Stromberg, it would follow – if Stromberg's causal argument here were valid – that any star who served such a function could be expected to roam the cultural terrain in much the same way that Elvis does.

What I would like to suggest, then, is that while the specific facets of capitalism described above are undoubtedly *necessary* to the creation and maintenance of Elvis's contemporary cultural presence, they are by no means *sufficient* to explain that phenomenon, either in part or as a whole. While the extensive and diverse marketing of Elvis plays an important role in keeping his name and face in the public eye, at the most, these efforts merely establish a baseline from which the truly unusual Elvis sightings (i.e., those that make this project possible in the first place) deviate and branch out. To be sure, Elvis *is* still big business and he *does* serve certain ideological functions within a capitalist society, but this isn't the answer to the riddle of his current ubiquity as much as it is part of the question.

The most obvious alternative to a capitalism-based explanation for Elvis sightings is rooted in the traditional counterpart to capitalism-based models of stardom: namely, the idea that stardom is not a purely mercantile phenomenon imposed "from above" by profit-hungry media conglomerates as much as it is a socially based phenomenon generated "from below" at the level of the real people who make affective investments in particular media figures (Dyer, 1979b: 19–22). Applied to the question at hand, a fan-centered model of stardom would imply that Elvis's current ubiquity is less the result of the Presley estate and RCA (among others) flooding the market with a vast supply of Elvis product than it is the manifestation of an overwhelming demand for Elvis by the millions of people around the world who are his fans. According to this school of thought, the cultural circulation of Elvis as an icon has moved beyond the power of big business to control it: today, the people who wield the most power over Elvis's public

image are the millions of individuals across the globe who are his fans. As Lynn Spigel argues,

> Elvis's preservation isn't simply another example of the absurd ingenuity of consumer capitalism and its ability to make even death into a compelling three-ring circus. Though partly that, it also speaks to the need among a community of fans – probably the largest fandom in the world – to keep the memory of Elvis alive.

(1990: 178)

Spigel even goes so far as to suggest that Elvis's untimely demise was responsible for the shift in his status from being a capitalist-controlled commodity to being a fan-controlled icon: "Whereas in life Elvis was the epitome of the mass-market celebrity – packaged and repackaged by the Colonel – in his death he is truly a popular medium – a vehicle through which people tell stories about their past and present day lives" (1990: 180).

The unswerving loyalty of the Elvis faithful goes a long way to explaining a number of prominent aspects of his current ubiquity: the popularity (and sheer number) of Elvis impersonators, Graceland's status as one of the most visited tourist sites in the country, and the surprisingly widespread belief that Elvis is still alive.[50] Nevertheless, the singularity of Elvis's contemporary cultural presence can't be explained any more fully by the tenacity of his fans than it can by the tenacity of multi-national capitalism. Elvis's current ubiquity, after all, is not something common to other stars – no matter how loyal and dedicated their fans might be – and thus it's impossible to explain the phenomenon as if it were merely some "natural" side effect of stardom.

One possible response to this objection is that Elvis fans are somehow fundamentally different from those who've hitched their wagons to other stars: that their admiration for their idol is more obsessive, more fanatical, and more tenacious than that of other fans. And, to be sure, Elvis fans are often exception-ally fanatic in their devotion to their hero. Take, for example, Tom Corboy's video documentary *Mondo Elvis* (1984), which presents the single-minded obsession of half a dozen or so Elvis fans, the most memorable of whom is Frankie Horrocks, a woman who fell helplessly and hopelessly in love with Elvis upon first seeing *Blue Hawaii* in 1966.[51] Her passion for Elvis went far beyond what most people would describe as the "normal" love a fan might feel for his or her idol, to the point where, in her words, "he was someone who took up 99 percent of my time – and my money." For example, when Horrocks's husband eventually filed for divorce, "excessive devotion to Elvis Presley" was the second charge listed on his petition. When her youngest daughter was murdered, Horrocks had her buried in the dress she (her daughter) had worn to an Elvis concert and with a copy of "Burning Love" in her hands. Upon learning of Elvis's death, Horrocks immediately packed up and

moved to Memphis in order to be near him, leaving her teenage son behind in New Jersey to finish high school on his own. And so on. Admittedly, Corboy deliberately chooses to focus on the most fanatical examples of Elvis fandom he could find, and not all – or even most – fans invest themselves quite this heavily in their hero. Nevertheless, the extreme forms of star worship depicted in *Mondo Elvis* provide strong evidence for the argument that there are in fact Elvis fans who are obsessed enough to be responsible for at least some of the more unusual ways in which Elvis currently haunts the terrain of US culture.

The problem here, however, is not that there is no potential connection between Elvis fanatics and his current ubiquity, but that Elvis isn't the only star to attract such obsessive (and perverse) loyalty, and – most crucially – that the fanatical behavior exhibited by other fans hasn't translated into a similarly over-whelming cultural presence for the other stars in question. For example, *Starlust*, Fred and Judy Vermorel's (1985) collection of fan confessions and fantasies associated with a variety of pop music idols (Adam Ant, David Bowie, Boy George, Deborah Harry, Barry Manilow, Siouxsie Sioux, etc.) contains numerous expressions of fanatical devotion that would have been ideal material for Corboy's video had their inspiration been Elvis instead of some other star. For instance:

> You are the most important thing in my life, the only human being for who [*sic*] I would be able to do sacrifice. You are always in my thoughts and in my soul.
>
> (from a fan letter to David Bowie, quoted in Vermorel and Vermorel, 1985: 27)

> There was a programme on TV about what would happen if there was a nuclear war. And I think if a nuclear war did happen I'd be thinking: Is Boy George safe?
>
> (Boy George fan, quoted in Vermorel and Vermorel, 1985: 59)

> Me and my husband only live together now as brother and sister. Because – and this may seem rather silly and stupid – but I just feel unclean with any other man apart from Barry. If I can't have sexual intercourse with Barry, I'll go without. I'll never be unfaithful to Barry I think he's the second coming.
>
> (Barry Manilow fan, quoted in Vermorel and Vermorel, 1985: 80, 85)

From these and other testimonials of obsessive fandom, the Vermorels conclude that "it is not any particular fan who is extreme, so much as the condition of fanhood itself" (1985: 247), a finding that is regularly reaffirmed these days on the Internet. Among other things, the Net is used as a space (or, more precisely, as a

set of spaces) where one's private thoughts can be aired publicly with little (if any) intervening mediation: a type of forum ideally suited for the expression of one's fanatical devotion to any number of stars. For instance, the following 1994 post to the Usenet news group alt.rock-n-roll reveals an obsession with ex-Fleetwood Mac songwriter/vocalist Stevie Nicks that is deeper and darker than anything recorded by either Corboy or the Vermorels. Referring to an appearance by Nicks on David Letterman's *Late Night* program earlier that year, the author writes:

> As I was viewing the show I was slightly taken back on how this beautiful woman could look so worn. I toyed with the idea in my mind that it (I hoped) was not her I remembered that on PBS last year there was a show on Hess and Mengele . . . and photographic proof on whether the later life pictures of the two actually matched Nazi photographic archives. They used a rather simple method of measuring certain anatomic landmarks to establish a ratio that could be compared from picture to picture regardless of photo size. What I did was measure the distance between the left and right anterior temporal bone and then divide that by the distance from the right anterior temporal bone and the tip of the gap in the two upper maxilla teeth. I then performed the measurements on some older Stevie Nicks videos The measurements from the Letterman show DID NOT match the earlier videos I also noticed a discrepancy with her left #5 proximal phalanx joint. The Letterman Stevie had no swelling at this joint but the other two videos showed her with swelling at this joint consistent with either injury or arthritis. There were several differences in mannerisms and physical performance with the microphone that suggested a different Stevie but this was not scientific evidence. Based on the fact that the adult skull changes little in size or form I conclude that the individual on Letterman was not Stevie Nicks.[52]

Similarly, tales of celebrities being hounded and stalked by over-zealous fans have become increasingly common (the best known of these being the case of Mark David Chapman, whose obsession with John Lennon ultimately led him to shoot the ex-Beatle in 1980), giving additional weight to the argument that, in the final analysis, Elvis fans aren't all that different from those associated with other stars.

Perhaps most damaging to the "fandom-gone-wild" theory of Elvis's cultural ubiquity, however, is the fact that a sizable percentage (perhaps even a majority) of Elvis's current manifestations fails to have the "proper" aura of fan-like reverence for him. For many people today, Elvis is little more than the butt of an ongoing national joke, and it is difficult – if not impossible – to argue that the disrespectful ways in which he has frequently been invoked of late are somehow examples of fans unwilling to let go of their hero. While one can find a certain respect for Elvis in even the campiest of his current manifestations (see, for instance, Marcus's

interpretation of KFOG-FM's "Breakfast with Elvis" (1985: 66–7)) or the most pointed jibes at his image (e.g., Mr Bonus, "Elvis What Happened?" (1986)), it strains credibility to argue that *all* such appropriations of Elvis's name and image are the work of good-natured fans. It is possible (though I think it unlikely) that such items as an "Elvis Gobbling Amphetamines" T-shirt advertised in *Rolling Stone* (16 May 1991: 126) are labors of love, but no such interpretation seems plausible for the recent public attacks on Elvis by such figures as Spike Lee (1990: 34), Living Colour ("Elvis Is Dead," 1990), and Public Enemy ("Fight the Power," 1989). It is moments such as these, where, as Marcus puts it, "even people who insisted they could care less felt it necessary to bring him up" (1990b: 117), that perhaps most strongly demonstrate that what's going on with Elvis today is too complex and too diverse to be explained as simply a side effect of the undying devotion of his fans.

The third and final potential solution to the riddle that is Elvis today is the notion that his current ubiquity is somehow another symptom of the postmodern condition. One could argue, for example, that Elvis's current status as a non sequitur "on the trick[y] terrain of art" (Marcus, 1990b: 118) is reminiscent of Fredric Jameson's discussion of the postmodern "cultural logic" of pastiche and nostalgia,[53] while the absence of Elvis's own art from his contemporary appearances across the cultural terrain can be seen as a textbook example of Jean Baudrillard's (1983) notion of simulacra: superficial images, disconnected from the substance that once made them meaningful and divorced from the historical contexts that gave rise to them – the semiotic ghosts of a culture nostalgic for a past it never actually experienced.

For example, in her review of Marcus's *Dead Elvis*, Linda Ray Pratt states quite directly that "the dead Elvis is a Postmodern Elvis, a hermeneutic object in whose emptiness even fictions becomes [*sic*] simulacra" (1992: n.p.). Similarly, McKenzie Wark's attempt to explain Elvis's lingering presence contains fairly obvious echoes of Jameson's vision of our postmodern culture:

> The image refuses to go away – and how could it? Elvis was once the second most reproduced image in the world, next to Mickey Mouse. Yet compared to Mickey, Elvis is much less pure, much more of a pastiche, a collage of bits and pieces, all of which can be pulled out and recombined with other bits and pieces in a great open-ended combinatory of style. Bits of him keep cropping up everywhere The flesh of old images never dies, it just gets carved up, redigested and sacrificed afresh.
>
> (1989: 24–5)

Meanwhile, the *Panic Encyclopedia*, a quasi-apocalyptic, Baudrillard-flavored volume based on the premise that "panic is the key psychological mood of postmodern culture" (Kroker *et al.*, 1989: 13), argues that

Elvis can still attract such necrophiliac fascination because he was always a promotional simulacra which could be wrapped around any passing mood. Thus, in the '70s, it was Elvis' death as a tragedy, and now in the '80s as a nostalgia feast for our own time passing.

(1989: 96)

"Panic Elvis," they tell us, "is invited to come on down for one last retro-appearance as a memory residue, made all the more nostalgic because Elvis' disappearing body is like a flashing event-horizon at the edge of the black hole that is America today" (1989: 13–14).[54]

Such are the images of Elvis's posthumous career conjured up by postmodern cultural criticism. And while they're certainly evocative, as an answer to the riddle of Elvis's current ubiquity they're ultimately no more compelling than either of the other two "explanations" (i.e., capitalism or fandom) discussed above. For one thing, it isn't obvious why or how Elvis manages to embody the basic precepts of postmodernism to a greater extent than any other media figure, and thus it isn't exactly clear why "the cultural logic of late capitalism" (or "the precession of simulacra," or any other version of postmodernism one might care to put forth) has successfully transformed Elvis into a ubiquitous cultural presence, but left Buddy Holly or James Dean (or any number of other celebrities) more firmly rooted in their own cultural niches.

Even more problematic, however, is the fact that attempts to construct postmodern narratives of Elvis's current ubiquity casually elide the question of the phenomenon's historical specificity. Postmodern cultural critics are vague on precisely when US culture moved into the postmodern age, but it seems safe to say that, at the very latest, postmodernism was upon us long before Elvis died in 1977 – perhaps even before he rose to fame and stardom in 1956. All of which raises a particularly troublesome question for efforts to explain Elvis's lingering presence as a result of postmodernism: if he became a star *after* (or, at worst, not long before) the postmodern era began, then how does postmodernism account for the very real differences between Elvis as he wanders the cultural terrain now and the ways in which he did so in 1956, or 1968, or 1977, or whenever? How, for instance, do we make sense of Wark's claim that Elvis's current ubiquity arises from his status as "King of the passage into the better world of recording" (1989: 28)? Wark argues that

> from the beginning Elvis was lost to this other space of recording totally. His "live" performances are merely a dissimulation of the real Elvis, the recorded Elvis In recording the body proliferates, disperses over the country. The star looks into the ether and sees tiny shards of broken mirror, dark chips off the shoulder of his own image spinning out there in space A massive legacy of cliché quotation & anecdote & moral fable, soaring up high and

solid as a rock – but also spinning outward, proliferating out of control. Till the time came when Elvis himself became a mere corporeal appendage to a great body of recording. A corpus so monstrous and obscene as to make his actual body seem sane and straight by comparison.

(1989: 26–7)

At one level, the claims Wark makes here are certainly true enough: the general public certainly knew the recorded Elvis better than they ever knew the flesh-and-blood man, and one way that he lives on today is in the various recorded texts (i.e., his music, television appearances, movies, etc.) that he left behind. The problem with this argument as an explanation for Elvis's posthumous career, however, is that these same conditions held true long before Elvis died without giving rise to the sort of unusual cultural manifestations that comprise the contemporary phenomenon of Elvis sightings. Given the fact that Elvis (the cultural icon) and postmodernism (the cultural logic) have coexisted since 1956 (give or take a few years), the question remains as to why roughly thirty years had to pass before this combination could lead to Elvis's status as a ubiquitous cultural presence. In the final analysis, postmodernism may describe the phenomenon of Elvis's posthumous career very well, but it does very little actually to explain how or why that career came about.

MY WAY

In the end, then, none of the "explanations" discussed above – capitalism, fandom, or postmodernism – whether taken separately or in combination, manages to provide a compelling or convincing account of why Elvis enjoys the current cultural ubiquity he does. This is not to say that there is no value whatsoever in a political economy approach to stardom, ethnographic studies of fandom, or the theoretical questions raised by postmodern theory. On the contrary, these are all schools of thought that have made – and continue to make – important contributions to the study of stardom, media, and culture. The problem here is that, as explanatory meta-narratives, such approaches only work well when it comes to describing the proverbial "big picture"; at the more localized level of individual stars, texts, and practices, things begin slipping through the cracks. These would-be answers to the riddle of Elvis's posthumous career may explain the pedestrian examples of his current ubiquity (the merchandising of Elvis-related memorabilia, the continued presence of his hits on oldies radio station playlists, the existence of hundreds of Elvis fan clubs worldwide, etc.) quite well, but these are only a small part of the phenomenon – and not even the most interesting part, at that. What the approaches discussed above ultimately do is explain how Elvis is just like any (and every) other star and how his story can be stitched back into the

larger fabric of media, culture, and society. The problem here, however, is not that there are no similarities between Elvis and other stars, but that the phenomenon at hand is only interesting because it *exceeds* the normal expectations of capitalism, fandom, and postmodernism. In the end, then, these potential solutions to the puzzle of Elvis's contemporary ubiquity don't explain the phenomenon so much as they explain it away; transforming a unique and unusual range of texts and practices into just another example of a supposedly already understood cultural phenomenon.

The first step towards explaining what's going on with Elvis today, then, is to recognize two things: first, that the phenomenon in question is a *unique* one, insofar as other stars (dead or alive) are not appearing across the cultural terrain in a manner at all similar to Elvis's current ubiquity; and second, that Elvis is not behaving like other stars because he isn't – and never was – like other stars. Thus, understanding Elvis's posthumous career requires us to begin by examining what makes him different from other media icons (not how he's "just like them") and how he exceeds the limits of traditional models of stardom (not how he can be (mis)read as yet another example reaffirming such models' validity). To accomplish this goal, then, I want to turn to cultural studies, an approach to intellectual work that is particularly well suited to addressing the singularity of Elvis's current ubiquity. Cultural studies, it needs to be emphasized, is many different things to different people, and this is not the appropriate time or place to undertake a full-scale definition of the field. I would, however, like to take a brief moment to describe a partial list of those constitutive features of cultural studies that render it especially pertinent to the project at hand: its radical contextualism, its explicitly political nature, its commitment to theory, and its self-reflexivity.

To begin with, cultural studies (as Larry Grossberg (1993a, 1995) has argued) necessarily entails a *radically contextual* approach to scholarship. There is no fixed theoretical or methodological paradigm that defines in advance either cultural studies or the projects undertaken in its name; rather, the field constantly redefines itself to fit the demands of the particular contexts (e.g., different historical moments, geo-political locations, research projects) in which it is operating. This implies not only that the shape and place of cultural studies varies over time and across space (e.g., cultural studies in the US in the 1990s is not identical to what cultural studies was in the UK in the 1970s), but that the objects of cultural studies' critical gaze always need to be examined and understood within their own contexts: that even within the same general place and time, any two given cultural studies projects may have no obvious similarities in terms of their objects of study, their methodologies, or their theoretical underpinnings.

By itself, such a claim does little (if anything) to distinguish cultural studies from any other field of intellectual or political inquiry: all good scholarship, after all, recognizes that its object of study exists in a particular space and time, and that any

adequate understanding of that object of study needs to take those contextual factors into account somehow. Where cultural studies differs from most other fields, however (and this is why cultural studies' contextualism is, to use Grossberg's term, "radical"), is in its recognition that its objects of study and their contexts are mutually constitutive of one another. Contexts are not static and otherwise empty vessels into which completely unrelated phenomena are placed; rather a phenomenon and its context are organically related: the former grows out of the latter and, in turn, transforms the latter (sometimes subtly, sometimes radically) into something different from what it had previously been. Thus, context is more than just an afterthought (or, similarly, a preface) to the "real" analysis; it lies at the very heart of cultural studies, sharing equal billing (as it were) with the phenomenon under scrutiny.

The second aspect of cultural studies that requires discussion here is the field's *explicitly political* nature: that it doesn't pretend to be an "objective," politically neutral project motivated only by some idealistic goal of "advancing human knowledge." Cultural studies has fought a fairly diverse range of political battles over the years on a number of different fronts: enough so that it would be a mistake to assume that its politics are somehow fixed or guaranteed in advance. More importantly for my purposes here, though, cultural studies refuses to assume that politics is somehow limited to the machinations of the state or the field of class struggle; while cultural studies doesn't hold that everything is political, it also argues that politics exists (in one form or another) almost everywhere. For instance, Stuart Hall argues that popular culture

> is one of the sites where [the] struggle for and against a culture of the powerful is engaged It is the arena of consent and resistance. It is partly where hegemony arises, and where it is secured. It is not a sphere where socialism, a socialist culture – already fully formed – might be simply "expressed." But it is one of the places where socialism might be constituted. That is why "popular culture" matters. Otherwise, to tell you the truth, I don't give a damn about it.
>
> (1981: 239)

Thus, cultural studies insists that any serious discussion of popular culture – in part or as a whole – can't simply exclude questions of politics as if these were somehow irrelevant to the subject at hand. Nor is it safe to assume, once we accept that "the popular" is a site where "the political" lives and breathes, that the precise nature of those politics can be fully known in advance, regardless of whether one assumes those politics to be oppressive, progressive, or neutral. While the popular is typically not the terrain on which public policy is either formulated or enacted, it frequently *is* the terrain where public support for such policy is won or lost, and where the political loyalties of the public are struggled over.

Admittedly, the question that drives this particular project forward is not in and of itself an inherently political one: explaining why Elvis is everywhere and what his ubiquity means is not quite the same thing as explaining what the political significance of Elvis (dead or alive) might be. Nevertheless, this project neither shies away from questions of cultural politics nor does it assume that Elvis and politics simply "don't mix." After all, the past few years have seen Elvis playing a significant role in a number of explicitly political debates (cf. chapter 2), and the politics of culture (or, more precisely, the politics of what *counts* as culture) plays a crucial role in helping to keep Elvis alive and well on the cultural terrain today (cf. chapter 4).

The third characteristic of cultural studies relevant to the project at hand is its *commitment to theory*. Cultural studies is not simply synonymous with "critical theory" or "theoretically dense scholarship," nor is there is a fixed body of theory that somehow belongs exclusively (or even primarily) to cultural studies. Cultural studies' commitment to theory is primarily a pragmatic one, where theory is *not* the ultimate destination we're trying to reach as much as it is a territory that we must pass through in order to solve the concrete, real-life problems that motivate our work in the first place. To paraphrase Stuart Hall (1986: 60), cultural studies is not interested in theory for its own sake (i.e., Theory-with-a-capital-T): it's interested in going on theorizing.

In and of itself, cultural studies' commitment to theory is not a distinctive quality: most academic disciplines, after all, devote at least a portion of their energies to one form of theoretical work or another. Where cultural studies differs from other fields, however, is in its insistence that theory is a necessary component of any project done in its name. This is particularly true (and it is here that this facet of cultural studies is most directly relevant to this project) when it comes to studying the arena of popular culture. For many non-cultural-studies critics – including (sadly enough) many scholars who otherwise recognize the need for scholarly work on popular culture – the social, cultural, and political significance of the popular is presumed to be plainly evident on its surface. One doesn't need theoretical tools, the argument goes, to understand the cultural work done by a pop song or a Hollywood movie. In fact, in many critics' eyes precisely the opposite is true: i.e., the act of bringing the full weight of critical theory to bear on "shallow" and "superficial" pop culture phenomena is the worst form of intellectual overkill.

Such arguments, however, carry little weight within cultural studies, which recognizes that the terrain of popular culture is no less difficult to navigate and understand than that occupied by other, supposedly more weighty subject matter, and that, consequently, if one wishes to make sense of that terrain, one needs to draw on the various maps provided by cultural theory to do so. Thus, while the project at hand isn't devoted to lengthy exegeses of theoretical nuances for their

own sake, it is informed throughout by a wide range of critical theory and, in places, it takes "the detour through theory" that is necessary to a thorough understanding of what's going on with Elvis today.

At the same time, however, this project also resists the notion that the maps provided by theory are necessarily accurate and complete. This, after all, is part of the problem with the "answers" to the question of Elvis's posthumous career discussed above: they attempt to locate the phenomenon in its (predetermined) place on a fully mapped-out terrain. In reality, however, the cultural terrain is constantly shifting and changing to such an extent that even those corners of it that are (supposedly) already fully explained by our theoretical maps often prove to contain the biggest surprises. Cultural studies thus recognizes that the terrain often "speaks back" to the theories that lead one onto it: a form of feedback that necessitates a re-theorizing of the shape and nature of that terrain. As a result, while I am interested in using critical theory as a means by which we might make better sense of Elvis's contemporary cultural ubiquity, the reverse is also true: the example of Elvis's posthumous career exposes gaps and weaknesses in our theoretical maps of culture, stardom, and the media, and, consequently, part of the goal of this project is to suggest ways in which we might usefully revise and refine those maps.

Finally, cultural studies is a *self-reflective* approach to intellectual and political work. This is not to say that cultural studies is inherently solipsistic, but that it refuses to take either itself or its position in the world for granted. With respect to the current project, this characteristic manifests itself most plainly around the question of my personal relationship to my object of study. Not only do I consider myself an Elvis fan, but I would argue that my position as a fan is an *en*abling (rather than a *dis*abling) one: that, as someone with a personal (and not just an intellectual) knowledge of and interest in my object of study, I'm able to provide a more insightful and accurate reading of Elvis's current ubiquity than would be possible for a non-fan. Of course, in many people's eyes such a blurring of the boundaries between fandom and research results in scholarship that "fails" to be objective, insofar as the critical and intellectual authority that any good scholar should possess is undermined if he or she has a personal (read: emotional) stake in his or her object of study.[55] Because I care about Elvis, the argument goes, my intellectual faculties will be so blunted by the affective investment I have in my research that anything I have to say on the subject will be of little (if any) critical value.

Perhaps surprisingly, the basic assumption underlying this argument is *not* one that runs contrary to a cultural studies approach to scholarship: after all, one of the primary reasons that cultural studies is a self-reflective form of intellectual work lies in its recognition that the relationship between a critic and his or her object of study invariably shapes that study in significant ways. Where cultural

studies parts with the argument outlined above, however, is that it doesn't believe that scholars can *ever* occupy a position from which completely objective interpretation would be possible. As Michael Bérubé (1995) has argued, "It's not as if there are 'intellectuals' over here and 'fans' over there": the two categories overlap and blur together too much to be treated as clearly distinct subject positions. Intellectuals regularly make fan-like investments in their objects of study, while fans regularly make nuanced critical judgments about the objects of their devotion.

More to the point, though, the notion that one can and should approach one's research dispassionately is ultimately a critically debilitating fiction. By this logic, the only scholars who are objective enough to produce meaningful criticism about something – be it Elvis Presley or Ezra Pound – are those who don't know enough about the subject to have developed any strong feelings about it. But while ignorance may breed objectivity, it doesn't make for a credible foundation upon which to build critical insights of any real value. With this idea in mind, then, I've attempted to wear the hats of both "fan" and "critic" simultaneously here, not only because trying to separate these two subject positions from one another is all but impossible, but because each inevitably informs the other to the ultimate benefit of both.

The question still remains, however, as to how to turn this still somewhat abstract vision of a cultural studies approach to Elvis's posthumous career into a more concrete practice: in other words, given the above, how exactly do I intend to go about the process of examining and explaining what's going on with Elvis today? The most obvious methodological hurdle to be cleared is that of trying to rein the phenomenon in enough to make it into a manageable research project. The number of Elvis sightings, after all, is not only staggeringly large: it's growing far too fast for any one person to keep pace with it, which makes it impossible to strive for any semblance of real closure or completeness when it comes to collecting the texts necessary to the study at hand. No less daunting is the far-reaching scope of the phenomenon, and the fact that Elvis has shown a talent for cropping up virtually anywhere on the cultural terrain. In fact, the instances of the phenomenon that demand the most critical attention are frequently those that are impossible to locate using conventional research methods: looking up "Presley, Elvis" in a periodicals index or library database, for instance, may turn up a handful of unusual and noteworthy items, but most of the sightings uncovered by such a search will be mundane and predictable (reviews of newly (re)released Elvis albums, fan-oriented features around the major anniversary dates in January and August, etc.). The instances of the phenomenon that most need to be included in a study such as this one (i.e., those that are unique, surprising, and/or warped enough to make the phenomenon worth studying in the first place) are precisely those that won't produce cross-references to Elvis in

a database entry – or, more likely, that won't be catalogued at all. Perversely enough, when it comes to studying contemporary Elvis sightings the best examples of the phenomenon are, almost by definition, those that can't be found if you're specifically looking for them.

One of the more troubling methodological quandaries with a project such as this one is that it's all but impossible to take the processes of data collection, analysis of that data, and writing up those interpretations and bracket them off from each other neatly. Given a phenomenon that resists even an illusory or temporary sense of closure, the idea that some sort of meta-narrative might emerge from the data that completely explains the phenomenon is highly unlikely. How, after all, does one purport to explain in full a phenomenon that one can't even describe in its entirety?

The answer that I'd like to suggest to this question is a deceptively simple one: that since I can't realistically hope to wrap the entire range of contemporary Elvis sightings up in one neat and tidy package, I won't attempt to do so. Because Elvis's posthumous career is too large, too scattered, and too diverse to be easily circumscribed or explained by any one meta-narrative, it makes little sense to attempt to organize this study so as to produce a single explanation of the phenomenon, no matter how non-reductionistic or contextually specific that explanation might be. Instead, I intend to approach – and subsequently reapproach – the phenomenon at hand from a number of its multiple entryways. Each of the three chapters that follow represents a separate journey across the cultural terrain occupied by Elvis today: each starts from a different premise as to what makes Elvis and his stardom sufficiently unique to generate the phenomenon of his pervasive cultural presence, and follows its own path across that terrain. While there are places where these journeys overlap with one another (e.g., some sightings are examined more than once, certain themes surface on multiple occasions), there are also numerous points of rupture and contradiction between them; enough so that each chapter can be read as a (partial) explanation unto itself.

What each of these explanations has in common (besides their obvious concern with the subject of Elvis) is that they all revolve around the theoretical concept of a *point of articulation*, an abstraction that, in turn, draws on the work of Stuart Hall (1986) and Lawrence Grossberg (1992b: 52–61ff.) on articulation. As both Hall and Grossberg describe it, "articulation" is not simply a synonym for "utterance" or "statement" (though it does retain important connotations of "language-ing" and "meaning making"); rather it is the process by which otherwise unrelated cultural phenomena – practices, beliefs, texts, social groups, etc. – come to be linked together in a meaningful (i.e., significant, but not necessarily signifying) and seemingly natural way. The analogy that Hall uses to describe this process is that of a tractor-trailer truck, which the British refer to as

an "articulated" lorry (truck): a lorry where the front (cab) and back (trailer) can, but need not necessarily, be connected to one another. The two parts are connected to each other, but through a specific linkage, that can be broken. An articulation is thus the form of the connection that *can* make a unity of two different elements, under certain conditions. It is a linkage which is not necessary, determined, absolute and essential for all time.

(1986: 53)

A more concrete example of articulation in action can be found in the commonly recognized link between "rock 'n' roll" on the one hand and "youth" on the other. No matter how natural the connection between these two categories might seem to be, ultimately there is no *necessary* reason why this particular style of music should be associated in the public eye (or ear) with musicians and audiences of a certain age group. In fact, many of the most prominent figures from the early days of rock 'n' roll (e.g., Alan Freed, Bill Haley, Johnny Otis, Sam Phillips, Big Joe Turner) were in their thirties or forties (i.e., while they may have been "young at heart," they were not actually youths themselves) when they first became rock 'n' roll heroes. Even those figures from rock 'n' roll's formative years who were still in their twenties when they first wandered onto center stage in US culture (e.g., Chuck Berry, Bo Diddley, Fats Domino) were nevertheless a decade (or more) older than most of the teenage fans who helped give them their first big hits. Similarly, the major musical genres (i.e., rhythm 'n' blues, country 'n' western) that came together to form rock 'n' roll were typically concerned with "adult" themes (adultery, bar-hopping, gambling, unemployment, paying the rent, etc.), and many early rock 'n' roll hits ("Get a Job" (Silhouettes, 1958), "Money Honey" (Clyde McPhatter and the Drifters, 1953), "Stagger Lee" (Lloyd Price, 1959), etc.) reflected such concerns in terms that were not at all directly relevant to the day-to-day experiences of most US teens. Far from being natural, the articulation between "rock 'n' roll" and "youth" that came about in the mid-1950s (e.g., the link that made it reasonable to describe someone as "too old" for rock 'n' roll)[56] was forged by a variety of historical agents and social forces: teenagers trying to mark off a portion of the cultural terrain as their own, parents (and other "concerned" adults) in the midst of a moral panic over a number of perceived threats to traditional middle-class values,[57] shrewd (or perhaps merely cynical) musicians and industry executives who recognized that catering to the emerging youth culture was profitable,[58] and so on.

But while articulation works to establish seemingly natural (and thus supposedly timeless) connections between cultural phenomena, it does not fix such meanings and linkages permanently; rather, it is an ongoing process where the connections it establishes are subject to constant adjustment, negotiation, and fine tuning. As Grossberg describes it:

Articulation is the construction of one set of relations out of another; it often involves delinking or disarticulating connections in order to link or rearticulate others. Articulation is a continuous struggle to reposition practices within a shifting field of forces, to redefine the possibilities of life by redefining the field of relations – the context – within which a practice is located.

(1992b: 54)

Again, a useful example here is the connection between rock 'n' roll and youth, as this particular articulation has undergone a variety of changes (some more subtle than others) since the 1950s. One of the more obvious examples of these is the shift in the (perceived) age of the audience for rock 'n' roll that occurred between the mid-1950s and the late 1960s. During the former period, the youth who were seen to be this music's core audience were teenagers, the authority figures against whom those teens rebelled were typically parents (or *in loco parentis* figures such as teachers, principals, guidance counselors, etc.), and the sites where this budding cultural formation most obviously manifested itself were those places where middle-class adolescents could find a temporary (albeit often illusory) escape from parental supervision (sock hops, pajama parties, soda fountains, drive-ins, etc.). Barely a decade later, however, the entire cultural formation around rock 'n' roll (and its newborn cousin, rock) was centered around a population who were a few years older than their immediate predecessors. These youth – the ones associated with "the same" cultural formation as it existed at the end of the 1960s – were predominantly young adults of college-going age, the primary targets of their rebellion were more directly linked to "adult" institutions (e.g., universities, the military-industrial complex, big business, "the establishment"), and the primary sites where this formation operated were generally populated by young adults who no longer lived with their parents (e.g., communes, college and university campuses, political demonstrations, rock festivals, rock-oriented nightclubs and concert venues). Rock 'n' roll was still "youth music," but what "youth" meant in this equation was not at all what it had meant a few years before.

More recently, the link between "rock 'n' roll" and "youth" has undergone another series of transformations, as now-middle-aged baby-boomers have attempted to hold on to rock 'n' roll as "their" music and, in the process of doing so, helped to redefine the notion of "youth" associated with that music. Such efforts have served, on the one hand, to destabilize the connection between the music and the chronologically young and, on the other, to rearticulate rock 'n' roll to a semi-nostalgic spirit of youthfulness; consequently, rock 'n' roll in the 1990s is increasingly not so much the music made by and for those who *are* young as it is the music that helps forty- and fifty-somethings *feel* young.[59]

A point of articulation, then, is a particular site on the cultural terrain (a practice, an event, an individual, etc.) that serves as the major conduit by which two or more *other* phenomena come to be articulated to one another (i.e., the link forged between phenomena A and B only comes about as the result of their respective links, articulative or otherwise, to point of articulation P). While the precise logic behind this process will vary from one example to the next – in one case, for instance, the connection might be primarily metonymic (e.g., practice A is associated with artist P, who works within genre B, thus forging a link between A and B); in another, it might be more associative in nature (e.g., otherwise unrelated practices A and B come to be linked together because both are associated with phenomenon P) – the articulations forged via this process differ from "simple" articulations in that they always come about *in*directly, typically as part of a larger chain of articulative links.

For example, Elvis can reasonably be said to have functioned as the point of articulation by which the guitar came to be *the* definitive musical instrument of rock 'n' roll. By today's standards, the link between the guitar and rock 'n' roll is so firmly established as to be virtually self-evident: it's hard to imagine a musical style that doesn't prominently feature guitar (in one way or another) being accepted and recognized today as an example of rock 'n' roll. When Elvis first came along, however, such was not the case at all; rock 'n' roll in the mid-1950s was characterized by a fairly broad spectrum of sounds and styles, many of which made little (if any) use of the guitar as a prominent instrument. For instance, the music made by artists such as Fats Domino, Jerry Lee Lewis, and Little Richard was based almost entirely around their proficiency on the piano; much of the New Orleans style of rhythm 'n' blues (as exemplified by Frankie Ford, Clarence "Frogman" Henry, Shirley and Lee, Huey "Piano" Smith and the Clowns, etc.) that "crossed over" to score with rock 'n' roll audiences was centered around a combination of saxophone and piano over a "second line" beat; vocal groups such as the Coasters, the Dominoes, the Drifters, Frankie Lymon and the Teenagers, and the Platters built their respective sounds primarily around the harmonic interplay of four or five singers, with the occasional saxophone solo thrown in for good measure; and so on. While these various brands of rock 'n' roll weren't necessarily "guitar-free," they typically relegated whatever guitar may have been present to a supporting role in their overall sound. At the time, however, the relative absence of guitar in these musical styles did *not* automatically mark them as something other than rock 'n' roll. Instead, these were merely different subvarieties within the larger genre: subgenres that stood as equals alongside the more guitar-heavy rockabilly and blues-derived sounds of Elvis, Chuck Berry, Buddy Holly, and the like. By the end of the 1950s, however, the guitar had more or less taken center stage as the instrument most necessary to making rock 'n' roll music, and other, less guitar-centered musical styles found themselves increasingly on the margins of the genre.[60]

Of course, there were many guitarists besides Elvis (e.g., Eddie Cochran, Chuck Berry, Bo Diddley, Buddy Holly) whose music helped to establish and strengthen the guitar's position at the center of the rock 'n' roll map. In fact, from a strictly musicological perspective most (if not all) of these other artists contributed far more than Elvis ever did to (re)defining the sound of rock 'n' roll guitar.[61] The point here, however, is not that Elvis was some sort of virtuoso guitar wizard who forever changed the way that musicians approached their craft (i.e., he was not the Jimi Hendrix of the 1950s); rather, the mere fact that the guitar was his instrument of choice (coupled with his status as the most prominent rock 'n' roll artist of his era) was in itself influential. The popularity of his records created (or at least bolstered) a demand for more guitar-driven rock 'n' roll, and Elvis himself inspired a large number of would-be rock 'n' rollers (not all of whom wound up making music that reflected its Elvis-derived influence in any obvious way) to take up the guitar in the first place.[62] Put simply, the widespread image – both figurative and literal (e.g., the now-famous photo that graces the cover of Elvis's debut album) – of Elvis having the time of his life on stage *with a guitar in his hands* played a crucial role in positioning the guitar (rather than some other instrument, such as the piano, the saxophone, or the stand-up bass) as the instrument that best captured the style and spirit of this new music. It seems fair to suggest that if someone such as Jerry Lee Lewis (i.e., a non-guitarist) had wound up in Elvis's position as *the* charismatic central figure of this music, rock 'n' roll as we know it (i.e., as a guitar-dominated music) wouldn't exist (or, at best, it would constitute a marginal subgenre of some sort): the music industry would have attempted to cash in on the new sound with a spate of piano-pounding Jerry Lee Lewis clones, the thousands (millions?) of fans inspired by Elvis's example to take up the guitar would have chosen instead to invest in piano lessons, and the "standard" instrument configuration of a rock 'n' roll band would have been markedly different from the three guitars (i.e., lead, rhythm, bass) and a drum-kit line-up that is so common today.

In this book, then, I will offer three different explanations for Elvis's posthumous career, each of which is based on different Elvis-related points of articulation. Chapter 2 ("Elvis Myths") explores Elvis's past and present status as an iconic point of articulation around which a wide range of broader cultural mythologies have been built and rebuilt. Chapter 3 ("Elvis Space") focuses on Graceland (in Memphis) and the Elvis Presley Birthplace (in Tupelo) as points of articulation where a tangible and publicly visible community of Elvis fans could congregate and actually make tangible the otherwise ethereal nature of Elvis's stardom. Chapter 4 ("Elvis Culture") maps out the ways in which, during the mid- to late 1950s, Elvis served as a point of articulation around which a new cultural formation (1) came into existence and (2) went on to transform the broader terrain of US culture to such an extent as to spread traces of Elvis's aura throughout that terrain.

This three-pronged approach to the phenomenon should not be seen, however, as a form of triangulation that will somehow reveal "the real Elvis" or explain "the whole story" behind his posthumous career. The real Elvis — whoever (or whatever) he might have been — is ultimately unknowable to us, if for no other reason than that the Elvis we knew when he was alive was never directly available in some unmediated fashion: like any other star, his public persona was always only visible through a maze of mass media filters. Because we have no direct access to an unmediated reality, we can never actually uncover the "true" nature of a person (Denzin, 1989). Whatever previously unseen versions of Elvis this project may reveal, I have no illusions that any of them will — or could — be sufficiently authentic as to be "the real thing." As for attempting to cover "the whole story" of Elvis's current ubiquity, this too is ultimately an impossible task. As I've argued above, the phenomenon in question is already too big (and growing too fast) to be described in its entirety, much less analyzed and explained exhaustively. Since my goal here, however, is not one of producing totalizing meta-narratives, the fact that certain instances of the phenomenon will slip through the cracks and/or contradict the specific arguments I'm trying to make is not, in itself, a problem, if for no other reason than that Elvis's posthumous career is too diverse and too far-reaching not to be riddled with internal contradictions of its own. To demand that an exhaustive and uncontradictory argument (or set of arguments) be made about a phenomenon that is itself neither complete nor self-consistent is to expect far too much of this project. While I believe that the answers I offer here to the contemporary riddle of Elvis are more satisfactory than those that have been offered to date, I make no claims to have explained the phenomenon in its entirety. As Marcus writes, "Real mysteries cannot be solved, but they can be turned into better mysteries" (1989: 24). My hope for this project is not that it finally lays the mystery of Elvis's unusual posthumous career to rest, but that it manages to make that mystery just a little bit better.

2

ELVIS MYTHS

People spun tales, others listened spellbound. There was a growing respect for the vivid rumor, the most chilling tale. We were no closer to believing or disbelieving a given story than we had been earlier. But there was a greater appreciation now. We began to marvel at our own ability to manufacture awe.

(DeLillo, 1985: 153)

WHAT'D I SAY?

The late rock critic Lester Bangs once said, "I have always believed that rock 'n' roll comes down to myth. There are no 'facts'" (quoted in Frith, 1983: 271). In terms of historical accuracy, Bangs's statement is patently untrue. There *are* facts: that Elvis Presley scored his first national hit with "Heartbreak Hotel" (1956) is not a myth, it's a matter of record. In terms of cultural impact, however, Bangs's seemingly illogical claim is actually quite accurate, as what people *believe* the facts to be – no matter how much such beliefs may conflict with the "real" story – matters more than the "true" facts of the situation. And while most (if not all) myths can fairly be said to be rooted in facts, the effectivity of any given myth cannot simply be reduced to a question of the veracity of the facts upon which it is based. Whatever the facts connected to a specific event may be, it is ultimately their articulation to particular myths – and the subsequent organization of those myths into mythological formations – that renders them culturally significant.

Before I get too deep into my main argument, I should say a few words here about what I mean by "myth" and "mythological formation." One of the more commonly used senses of the word "myth" is in reference to a widely accepted falsehood: something we know that just isn't so. And while this sense of the term is certainly a prominent facet of "myth" as I use it here, I want to give the word a somewhat broader inflection than this: what I mean by "myth" in this chapter is a narrative (or, perhaps, a cluster of related ideas) that people collectively believe

(or believe in) independently of its "truth" or "falsity." The difference here is subtle, but important, insofar as a myth can in fact be partially – or even entirely – true. One of the things that distinguishes "myth" from "fact," then, isn't that the latter is true and the former isn't, but that the truth value of facts can be readily verified, while the truth value of myths isn't necessarily subject to straightforward proof or disproof. For example, the idea that Elvis's early music represented racial integration is a myth (and not a fact), not because such a claim is necessarily false, but because its veracity isn't subject to simple confirmation in the same way that the facts of the situation (e.g., that Elvis recorded for Sun Records) are.

A mythological formation, then, is a set of related myths that revolve around a particular point (or points) of articulation. Often, the myths that comprise such a formation won't be mutually compatible; in fact, they may even contradict one another point for point down the line. For example, to broach the subject of race is not to invoke a monolithic myth: instead, it's a discursive act that, for different audiences and in different contexts, calls up a diverse and heterogeneous range of myths about blacks and whites (and Latino/as, and Native Americans, and Asians, and so on), racism, privilege, oppression, discrimination, militancy, and the like. There's no single myth of race in active circulation in the US today; rather, there's a complex formation of multiple myths centered on the point of articulation that is "race."

To return to – and flesh out – Bangs's claim about the importance of myth, then, I want to examine three factual accounts of the same legend . . . or, perhaps more accurately, three legendary versions of the same facts:

> Over and over I remember Sam [Phillips] saying, "If I could find a white man who had the Negro sound and the Negro feel, I could make a billion dollars."
> (Sun Records co-manager Marion Keisker, quoted in Hopkins, 1971: 56)

> Marion Keisker . . . recalled Sam Phillips saying repeatedly, "If I could find a white boy who could sing like a nigger, I could make a million dollars."
> (Goldman, 1981: 129)

> If I could find a white man who had the Negro sound and the Negro feel, I could make a million dollars.
> (Sam Phillips, quoted in Choron and Oskam, 1991: 7)

These are the three principal variations of what is probably the most often repeated "quotation" in the history of rock 'n' roll. The most obvious of the permutations manifests itself in the difference between having "the Negro sound and the Negro feel" and singing "like a nigger," though variations on the age and/or maturity of the hypothetical singer (is he a man or a boy?), his potential value to Sun Records owner Sam Phillips (is he worth a billion dollars? or merely a cool million?), and

the source of the quote (the subtle, yet significant, difference between whether Phillips said it or whether Keisker said Phillips said it) are common as well. The singer who fulfilled Phillips's dreams, of course, was the young Elvis Presley, and while Phillips may never have made that billion (or even a million) dollars off of Elvis, his formula for success – marrying the largely white sounds of country music to the predominantly black sounds of rhythm 'n' blues – ultimately brought him the fame and fortune he'd been seeking. Whether viewed from an aesthetic or a financial perspective, Phillips's success is a matter of verifiable fact; whether he ever uttered any version of the now (in)famous words attributed to him, however, is a matter heavily shrouded in layers of myth.

When the "if I could" quote is cited, it usually appears, as it does in the third example above, without any reference whatsoever to Keisker; in such instances, the statement is attributed directly to Phillips and Keisker's role as an intermediary is completely erased from the tale. Such an omission would be insignificant if Phillips's comments had been publicly recorded or if his version of the story supported Keisker's. On more than one occasion, however, Phillips has denied making any such statement (Marcus, 1981: 16n; Worth and Tamerius, 1988: 153n) and Keisker is the only source of direct evidence to the contrary. While there's no good reason to dispute Keisker's credibility as a witness to the events that transpired at Sun Studios in the 1950s, it's important to remember that all versions of the "if I could" statement are ultimately based on her recollection of conversations with Phillips from at least fifteen years prior to her interview with Elvis biographer Jerry Hopkins. However accurately Hopkins may have quoted Keisker, it's still fair to question how faithful her memory was to whatever Phillips may have once said, either about merging black and white musics or about making a fortune in the music business.

Ten years after Hopkins's *Elvis* (1971) first appeared, Albert Goldman published his "tell-all" biography, also called *Elvis* (1981). That same year, Greil Marcus wrote a scathing review of Goldman's book insisting that the version of the "if I could" quote included therein (the second of the three examples above) was wildly inaccurate – perhaps even willfully so:

> I picked up the phone and called Marion Keisker in Memphis (though Goldman claims to have based his book on more than 600 interviews, he never interviewed either Keisker or Phillips). I read her Goldman's version of Phillips's statement. This is what she said: "UNDER NO CIRCUMSTANCES! What? I *never* heard Sam use the word 'nigger' – *nothing* could be more out of character." She paused, and came back. "Never. Never – *never*. I don't believe Sam ever used that word in his life, and he certainly never used it to me."
>
> (1981: 16)

The goal of Goldman's book, according to Marcus, is to "altogether dismiss and condemn . . . not just Elvis Presley, but the white working-class South from which Presley came, and the pop world which emerged in Presley's wake," and Marcus's primary fear is that Goldman's version of the "if I could" statement, coupled with his attempt to commit "cultural genocide," will do immeasurable and unwarranted harm:

> First, because his book will be the most widely read and widely consulted on Elvis Presley, his perversion of Sam Phillips's statement will replace the statement itself: it will be quoted in articles, reviews, among fans, and in other books, and it will defame the reputation of Sam Phillips. Second, because Goldman has placed a racist slur at the very founding point of rock & roll, and because (here and elsewhere) he makes racism seem ordinary, matter-of-fact, and obvious, he will contribute to the acceptance of racism among rock fans, who might otherwise learn a different lesson from an honest version of their history, and he will contribute to the growing fashionableness of racism among Americans of all sorts.
>
> (1981: 16)

Significantly, the strength of Marcus's argument against Goldman does *not* rest on unimpeachable factual evidence that Hopkins's account of the legend represents Phillips's true words (i.e., that Phillips said "Negro" rather than "nigger"); in fact, Marcus's rebuttal relies almost entirely on his conversation, not with Phillips (the quote's reputed source), but with Keisker (the quote's reputed witness). Marcus even goes so far as to acknowledge (although he relegates it to a footnote) that Hopkins's version of the story is subject to question as well, pointing out that "Keisker recalls saying 'a million' [and that] Phillips denies making the statement" (1981: 16n.).

This is not to claim that Marcus's argument has no factual basis whatsoever. As lawyer and Elvis fan Aaron Caplan argues, according to legal standards of what would constitute proof of the "if I could" legend's truth in a hypothetical court case, Marcus's case is firmly grounded in facts:

> If Marion Keisker takes the stand and says, "I heard Sam Phillips say X," it would be hearsay if used to prove that X was true or that we should believe X. But it is not hearsay if used to prove that Sam said it. On the contrary, it's considered the best evidence there is: a living, breathing eyewitness to the event. (Sam is also a living, breathing eyewitness to the event, one who recalls it differently. The jury has to decide who to believe. It could believe Sam, but it wouldn't have to.)
>
> (personal communication, 8 June 1992)

While I don't wish to dispute Caplan's argument that Keisker's statements (both to Marcus and to Hopkins) constitute factual evidence to support Marcus's case, the question still remains as to why Marcus chooses to give more credence to Keisker's "testimony" than to Phillips's.[1] Given that both Keisker and Phillips are "living, breathing eyewitness[es] to the event" and that their accounts of that event are mutually incompatible, Marcus's argument, while persuasive, is hardly an airtight confirmation of either Hopkins's or Keisker's stories. Judged by the standards Caplan outlines here, Marcus convincingly undermines Goldman's credibility but, because he leaves Phillips's denials uncontested, he fails to demonstrate that either Keisker's or Hopkins's version of the story (e.g., that Phillips said anything resembling the "if I could" statement whatsoever) is the truth.

Marcus's critique of Goldman's book, however, should *not* be thought of as flawed just because it doesn't establish what Phillips really said. On the contrary, Marcus's arguments here are compelling,[2] and the seriousness of the issues he raises should not be ignored or underestimated: even in the intolerant environment of the South in the early 1950s, there is a world of difference between calling someone "a Negro" and calling them "a nigger." Ultimately, however, Goldman's revision of the story is offensive to Marcus, not so much because Goldman gets the facts wrong, but because his racist and defamatory version of the story threatens to displace the more commonly accepted myth. What Phillips did or didn't really say is almost irrelevant (which is why it's reasonable to relegate such epistemological questions to the marginal space of a footnote); of infinitely greater significance is what people believe he said and the effects of such beliefs. Even the subtitle of Marcus's review of Goldman's book – which describes Marcus's version of the story not as "The Truth" or even as "The Truth behind the Legend" but as "*The Myth* behind the Truth behind the Legend" (emphasis added)[3] – displays a greater concern for myth than fact, reflecting (albeit probably unconsciously) the famous creed of the newspaper editor in *The Man Who Shot Liberty Valance* (1962): "When the legend becomes fact, print the legend." For while a myth may be a complete fabrication with no basis whatsoever in "the truth" (whatever that may be), it can – and generally will – still function as if it were true. This is in fact the very nature of myth; it "has the task of giving an historical intention a natural justification" (Barthes, 1957: 142). In spite of its artificiality, myth succeeds in passing itself off as a natural fact.

To underscore this last point, I want to turn briefly to another oft-quoted comment, one attributed to Elvis himself. Perhaps the most damning account of the statement in question comes from V.S. Naipaul's *A Turn in the South*, in which an elderly black man from Nashville claims that "To talk to Presley about blacks was like talking to Adolf Hitler about the Jews. You know what he said? 'All I want from blacks is for them to buy my records and shine my shoes.' That's in the record" (1989: 228). Now, even in Hopkins's version of the "if I could" quote, one can find

traces of racism lurking in the cracks: while Phillips's intentions may have been entirely honorable,[4] his recognition that it would take a white performer to turn a profit selling records to a mainstream (i.e., white) audience points to institutionalized patterns of prejudice that permeated both the music industry and US culture in the 1950s. The "shoe shine" statement, however, is nowhere near as subtle: its bigotry is too malicious to be passed off as mere ignorance, too forceful to be overlooked as an offhand slur. Even if Elvis was a firm believer in civil rights and racial equality, and even if it could be proven that he uttered these words in jest, the prejudice at the core of this statement is too great, and offered too unashamedly, to overwhelm any such excuses one might try to offer for it. No one, however, can prove that Elvis intended these words as a joke, largely because no one seems able to prove that he said them at all.

In this respect, the "shoe shine" legend has a lot in common with the "if I could" legend: both are widely known, both have appeared in a variety of forms, and the facts behind both are difficult (if not impossible) to pin down. The parallels between the two stories, however, end here. While the "if I could" statement almost invariably appears in one of the three forms presented above, the "shoe shine" quote never seems to appear the same way twice. For example, in contrast to the version of the statement offered by Naipaul's informant ("All I want from blacks is for them to buy my records and shine my shoes"), *Michigan Daily* columnist N.M. Zuberi reports the quote as "The only thing niggers can do for me is shine my shoes and buy my records" (1990: 8), Marcus understands the statement to be "The only thing niggers are good for is to shine my shoes" (Heilman, 1992: 32), comedian Eddie Murphy claims Elvis said, "The only thing they [blacks] can do is shine my shoes and buy my records" (Lee, 1990: 34), and rock critic Dave Marsh says the alleged slur was "The only thing a nigger is good for is to shine my shoes" (1992: x). While the statement's general theme of contemptuous prejudice is certainly consistent from one version to the next, the precise words that Elvis reportedly said vary an extraordinary amount for a statement that's "in the record."

In fact, the inconsistencies between the various versions of this statement can be partially attributed to the fact that, contrary to the claims of Naipaul's informant, there's no record into which this statement was ever placed: citing Peter Guralnick's research into the question, Marcus reports that the statement comes from an unspecified issue of *Jet* "a number of years ago" (Heilman, 1992: 32), but even this "citation" is probably not the original source for the story. For instance, Richard Cohen reported the "shoe shine" myth as an established fact in the *Washington Post* within a week of Elvis's death in 1977 (Gregory and Gregory, 1980: 108). Similarly, University of Iowa Professor Venise Berry recalls Elvis being very popular in the black community where she grew up – until the "shoe shine" story reached her neighborhood (circa 1964) and instantly dissolved any fan

base Elvis had had there (personal communication, 5 February 1993). Meanwhile, *Chicago Reader* music critic Bill Wyman reports hearing a variant of the "shoe shine" story (one in which Elvis said something along the lines of "I wouldn't even let niggers shine my shoes") from an African-American woman who first heard the tale around 1956 (personal communication, 4 February 1993).

Further compounding the difficulty in tracking down the "shoe shine" quote is the absence of any witness (e.g., a reporter, a fan, a member of Elvis's "Memphis Mafia") in the anecdotes surrounding the statement. In the case of the "if I could" quote, what Sam Phillips said to Marion Keisker back in 1952 (or whenever) may be a matter of contention, but what Keisker said to Jerry Hopkins *is* "in the record": once upon a time, at least, tapes of the interviews Hopkins conducted for his book were available at the Memphis State University library (Marcus, 1981: 16n) and could be used to verify the accuracy, if not of Keisker's quotation of Phillips, then of Hopkins's quotation of Keisker. No such fact-checking, however, seems possible with the "shoe shine" quote, as none of the story's innumerable versions provide any clues as to whom Elvis was speaking with when (and if) he made this statement.

That parenthetical "if" deserves closer attention. Zuberi flatly claims that "there's no evidence to prove Elvis ever said this" (1990: 8), though the only evidence he offers that Elvis *didn't* utter these words is his own faith in Elvis's sterling character. James Brown (who was a longtime friend of Elvis's) offers a similar "blind faith" denial of (yet another variant of) the "shoe shine" myth: "They say that one time Elvis said, 'A black can't do nothing but shine my shoes.' He never said nothing like that. He never said that" (quoted in Gregory and Gregory, 1980: 110). Drawing – at least indirectly – on something more substantial than a mere belief in Elvis's non-racist nature, Marcus points out that Guralnick apparently "wasted six weeks trying to track this statement down and find out if he could make a chain going back to Elvis, and he wasn't able to" (Heilman, 1992: 32). Guralnick's ultimate conclusion (again, according to Marcus) is that if Elvis really said such a thing, "it would have been unlikely and out of character" (Marcus, 1992b: 4). Perhaps the most convincing refutation of the "shoe shine" myth, however, comes from rock critic Dave Marsh. While acknowledging that it's impossible to prove that Elvis never said these words, Marsh offers a plausible – if admittedly circumstantial – argument to justify his own faith in Elvis's innocence:

> The Million Dollar Quartet sessions, which catch him completely off guard (none of the musicians knew the tape was running), find Elvis telling a tale about being in Las Vegas and hearing a black singer with Billy Ward's Dominoes – Jackie Wilson, it turns out – who completely outdoes him on "Don't Be Cruel." Elvis never uses the word "nigger" here; he refers to

Wilson at first just as a "guy," then, in passing, as "a colored guy." . . . Elvis readily acknowledges that he's been beaten at his own game. The man who uttered the judgment of black people contained in the fable could never have made any such admission. Not in 1957, and not today.

<div align="right">(Marsh, 1992: x)</div>

Marcus, however, is not entirely convinced that the "shoe shine" quote is spurious, nor is he as willing as Marsh to dismiss these words as something that can – and should – be ignored:

It's very possible [Elvis] could have said that. But there doesn't seem to be any evidence at all that he did. On the other hand, there are a lot of people who believe it. Believe me, Vernon Reid [of Living Colour] has heard that story. Spike Lee has heard that story. Chuck D [of Public Enemy] has heard that story. I don't criticize them for believing it, because that's a big thing. That's a big rock to get over.

<div align="right">(Heilman, 1992: 32)</div>

It would be easy to conclude from Marcus's comments here that he has undergone a dramatic shift in position from his Goldman-bashing days. Where once he had argued passionately against a racist version of rock 'n' roll's history, here he seems to back away from the fray altogether, accepting a racist slur attributed to Elvis as a story it would be pointless to argue against. Where once he was willing to fight over the myths he (like Bangs) saw at the heart of rock 'n' roll in order to trans-form them into what he felt to be a better story, here he seems willing to allow – however reluctantly – the same sort of bigotry he railed against a decade before to be added to the accepted canon of Elvis legends.

Such an interpretation of Marcus's words, however, overlooks some important consistencies between his discussions of the "if I could" and "shoe shine" legends: consistencies that reflect a more theoretically stable position than that suggested above. In both cases, Marcus's argument is centered not around facts (e.g., what Phillips or Presley really said), but around myths (e.g., what people believe Phillips or Presley really said). The facts, Marcus implicitly argues, whatever they may actually be, are ultimately inadequate weapons against the myths they seek to displace. In making such a case, Marcus unconsciously rephrases an older argument about myth made by Roland Barthes:

It is extremely difficult to vanquish myth from the inside: for the very effort one makes in order to escape its stranglehold becomes in its turn the prey of myth: myth can always, as a last resort, signify the resistance brought to bear against it. Truth to tell, the best weapon against myth is perhaps to mythify it in its turn, and to produce an *artificial myth*: and this reconstituted myth will in fact be a mythology.

<div align="right">(Barthes, 1957: 135)</div>

Marcus's discussion of the "shoe shine" myth implicitly recognizes the invulnerability of myth that Barthes describes here: even if one could establish beyond all doubt that Elvis never uttered that damning sentence, such proof wouldn't suffice to undermine – much less negate – the widespread image of Elvis-as-racist, if for no other reason than that this myth ultimately rests on a broader base of facts (and other myths) than just a single statement. As *Village Voice* writer Joe Wood argues, "It doesn't even matter if Elvis made that ignorant statement about colored people and shoe-shining because the icon, not Elvis the man, is the Elvis we all know" (1991: 10).

Similarly, as Barthes' discussion of myth would suggest, Marcus's most effective weapon against Goldman's distortion of the "if I could" quote is not factual (e.g., what Phillips really said), it's mythical (e.g., the legend of what Phillips really said, as told by Keisker and Hopkins). Even here, however, Marcus implicitly acknowledges that his struggle over the nature of the myth is doomed to fail, as his discussion of the impact of Goldman's book is filled, not with tentative and conditional statements describing the book's *possible* effects ("it *might* be quoted," "it *could* defame," "he *may* contribute," etc.), but with straightforwardly declarative statements explaining the book's *inevitable* effects ("it *will* be quoted," "it *will* defame," "he *will* contribute," etc.). While Marcus consciously and deliberately attempts to reshape the myth, he nevertheless assumes not only that he is powerless to beat the fable Goldman concocts, but that what little he can do to minimize that fable's damage depends on his use, not of better facts, but of better myths.

In the end, then, facts matter only because they can be (and generally are) articulated to larger myths. More to the point, *which* facts matter – and *how* they matter – ultimately depends more on the nature of the myths they are bound up with than on the facts themselves. To return to the example I used at the outset of this chapter, even a fact as seemingly straightforward as "Elvis had his first national hit with 'Heartbreak Hotel'" is significant only because it has been stitched into larger mythical narratives – myths concerning Elvis's career, the birth of rock 'n' roll, the rise of teenagers as an increasingly important market for commodity consumption, the appropriation of black music and culture by white musicians and entrepreneurs, the conflict between "high" culture and "popular" culture, and so on – so that ultimately the precise way in which this fact matters varies according to the demands of the myth(s) to which it is articulated in a particular context. Outside of such narratives, however, this fact is little more than the answer to a hypothetical trivia question: it may be true, but it is not terribly significant.

Thus, it's not surprising that the facts one might use to describe Elvis as a man, as a musician, or as a historical figure are almost completely absent from the various sightings that constitute his current presence on the terrain of US culture.

When Elvis appears today, it is largely as a mythical figure, a signifier whose signifieds are ultimately not connected to his life or his art. To borrow a phrase from novelist Don DeLillo, Elvis the man is merely "the false character that follows the name around" (1985: 17). Elvis the myth, on the other hand, may be the perfect physical embodiment of Barthes' description of myth: "a language which does not want to die: it wrests from the meanings which give it its sustenance an insidious, degraded survival, it provokes in them an artificial reprieve in which it settles comfortably, it turns them into speaking corpses" (1957: 133). The contemporary Elvis *is* Barthes' speaking corpse, whose "insidious, degraded survival" finds him "ooz[ing] from the fissures of culture, voracious and blind, . . . engorged and bleeding dope" (Marcus, 1990b: 118). As Burt Kearns describes it in the pages of *Spin*:

> As bureaucrats are trying to decide if Elvis Aron Presley *the man* has stood the test of time and deserves to be shrunk down to the size of a stamp, Elvis *the legend* has bulked up and got bigger than ever in 1988. It was as if someone rattled the flush handle one too many times and spewed all the embarrassing contents of *Elvis World* [Stern and Stern, 1987] up all over the seat, across the tabloids, and down respectable Main Street in a flood of news and merchandise. And as the muck rose, it overwhelmed the mortal we thought we knew, covering him, leaving him unrecognizable. . . . [In 1988] there were enough Elvises to go around for just about everybody. You had your Elvis as miniseries villain (thanks to Priscilla), Elvis as bestselling book, Elvis as MasterCard, Elvis as 900 phone number, Elvis as Las Vegas musical, Elvis as bedroom ghost haunting Priscilla's boyfriend, Elvis as victim of "prescription medication," Elvis as E.T., Elvis as illegitimate father, Elvis as father-in-law, Elvis as granddaddy, Elvis as *religion* There was even Elvis as rock'n'roller in "Huh-huh-huh Hershey's" TV commercial.
>
> (1988: 72)

Kearns's throwaway line at the end of this list – made as if his appearance as a musician is sufficiently rare these days to provoke genuine surprise – is a particularly telling observation, for if there *is* anything actually missing from (or at least strikingly under-represented across) the range of Elvis's recent appearances, it is the image of Elvis-as-artist.[5]

As I'll argue later in this chapter (and, in somewhat different terms, in chapter 4), one reason for this unusual gap in Elvis's current image is the widespread inability of many people to see anything that Elvis did as art. One of the reasons that Elvis the artist is largely invisible today, however, is that, no matter how compelling much of his music actually was (and still is), his impact on US culture was never exclusively musical. While the number of musicians who have publicly

acknowledged Elvis as their main inspiration is certainly large enough to support the claim that Elvis had a major impact on the shape of post-war popular music,[6] it's important to remember that music's impact on its audiences often manifests itself in non-musical ways. Bruce Springsteen once sang that "we learned more from a three minute record . . . than we ever learned in school" ("No Surrender," 1984). As interesting as many of Elvis's records are, one of the reasons they play such a minor role in Elvis's strange posthumous career may very well be that what we learned from those records is more interesting still. Without trying to claim that Elvis's music doesn't matter – on the contrary, it does – I would like to suggest that his myths may matter much more.

What I want to argue in the remainder of this chapter, then, is that Elvis's unusual second life is, to a significant extent, made possible by the ways in which his myths dovetail so easily with many, if not most, of the major strands of cultural mythology in contemporary US society. Elvis is seemingly everywhere on the cultural landscape because his myths are already present all across (or are readily appropriated onto) the mythscape of post-World War II US culture. Pick a crucial site of cultural struggle during this period and you'll find that if Elvis isn't already a seemingly natural player in that struggle, then he and his myths can be (and often are) readily articulated to the specific mythological formations in question in a natural-seeming way.

This isn't to say, however, that Elvis is somehow an "empty signifier" that can mean absolutely anything at all. On the contrary, what I want to argue here is that Elvis is an incredibly full signifier, one that is already intimately bound up with many of the most important cultural myths of our time. While there *is* a certain Rorschach-like quality to Elvis and his myths,[7] Elvis is not (and never has been) merely a blank slate onto which fans and critics can simply write their own stories. As Linda Ray Pratt puts it, "those who have argued that people projected onto Elvis anything they liked because his image was essentially vacuous are mistaken; if anything, the image is too rich in suggestion to be acknowledged fully or directly" (1979: 43). This emphasis on the multi-faceted nature of Elvis's mythology – that it is a multiplicity of myths, rather than a single myth writ large – is important, not only because "no one myth is large enough to contain Elvis" (Marsh, 1982: xiii), but because this very plurality is itself central to many of the myths that comprise the mythological formation centered on Elvis:

> As myth, Elvis is different things for different people, though for most of his fans, there seemed to be a ready tolerance for and acceptance of others, especially other Elvisites, regardless of background or origin. In fact, the more diverse the background, the more it verified the universal validity of Elvis and what they thought he stood for and made them stand for.
>
> (Brock, 1979: 121)

Thus, to reduce Elvis's mythology to a single myth, no matter how large or all-encompassing that myth is made out to be, is to misrepresent the phenomenon, offering too simple an answer to a highly complicated set of questions.

At the very least, Elvis's myths have long been articulated in significant (and often contradictory) ways to broader mythological formations surrounding race, gender, and class. Thus, we have the common mythical images of Elvis, not only as the "white boy singin' the blues" who broke down the color barriers of pop music, but also as the white man who stole black culture and was crowned "King" by a racist society for doing so; not only as the leather-clad, pelvis-swinging, rock 'n' roll embodiment of raw, masculine sexual energy, but also as the baby-faced, "teddy bear" crooner of tender, romantic ballads for moon-eyed teenaged girls; not only as the hard-working country boy who went to the city and found fame and fortune beyond his wildest dreams, but also as the epitome of the masses' misguided respect for a transplanted redneck who wore his passion for schlock and tackiness like a badge of honor. The vast body of Elvis's mythology manages to contain all of these contradictory images and then some: Elvis has also been articulated to mythical struggles between high culture and low culture, youth culture and adult culture, rural culture and urban culture, rebellion and conformity, North and South, the sacred and the secular, and so on. In fact, virtually no topic at all seems to be immune to Elvis's presence, as he has found his way into such seemingly "Elvis-proof" topics as the Gulf War,[8] the fall of Communism in the Eastern bloc,[9] and even abortion.[10] Potentially overarching all of these myths, and incorporating many of them within its realm, is that of Elvis as the embodiment of the American Dream (and thus, by extension, as the embodiment of America itself): a figure who simultaneously stands as a symbol for all that is most wonderful and all that is most horrible about that dream.

Thus, it is more than just Elvis's status as a cultural icon that makes him such a ubiquitous presence across the terrain of contemporary US culture; more crucial to Elvis's lingering presence are the range and diversity of cultural myths surrounding him – not only today, but throughout his lifetime – and the multiple, even contradictory ways in which he is articulated to those myths. Other stars can be (and have been) linked to a number of these major sites of cultural mythology (e.g., Marilyn Monroe and sexuality, James Dean and youthful rebellion) – one could in fact argue that one of the principal distinctions between mere celebrities and *bona fide* stars is that the latter are visibly articulated to the most culturally significant mythological formations – but only Elvis manages to encompass (and be encompassed by) so many of them simultaneously. Perhaps even more important, however, is the fact that only the mythological formation around Elvis seems flexible enough to be invoked across the entire spectrum of political positions associated with these broader mythological formations: while other stars tend to be articulated to myths in stable and monolithic ways, Elvis is consistently linked

to several mutually incompatible myths within a given formation simultaneously. In the remainder of this chapter, then, I want to examine the various ways in which Elvis and his myths have been articulated to four specific mythological formations: those centered around questions of race, sexuality, class, and the American Dream. While there may not be a single dominant myth that wholly explains Elvis's cultural significance, these formations simultaneously give rise to the most prominent themes in Elvis's own mythology and are among the most important sites of cultural tension and conflict in the US since World War II.[11] In the interests of presenting a clearer and more intelligible argument, I will discuss Elvis's current relationship to each of these formations separately. This is not to imply, however, that important connections do not exist between these formations, as each of them is, in a number of crucial ways, articulated to each of the others, and any specific textual example is likely to bear traces of more than one of them.

Additionally, the notion that Elvis's current ubiquity stems from the ease with which his myths have been articulated to broader cultural mythologies is admittedly an inadequate explanation for the entire phenomenon. Numerous and diverse though they may be, the links between Elvis and the mythological formations mentioned above still fail to account for a sizable portion of Elvis's contemporary manifestations. For example, one would be hard-pressed to explain the existence of Elvis Vegiforms (Shulruff, 1991) in terms of the links between Elvis's myths and any of the broader cultural myths discussed here. While Elvis's name, image, and myths may be invoked with great regularity across the cultural terrain, it's not obvious that all of these manifestations are connected to larger discursive struggles over cultural myths.

But while the ease with which Elvis can be (and has been) appropriated in the service of a diverse range of mythological formations is not *sufficient* to explain the phenomenon of Elvis's current ubiquity in its entirety, it is a *necessary* condition for that phenomenon to exist. Even those Elvis sightings that aren't linked to broader cultural myths in any obvious fashion depend, to a great extent, on those sightings that are linked to such myths for their existence. The fact that Elvis can be (and has been) readily appropriated as an iconic figure in discursive struggles over myths of race, gender, class, and the American Dream (among others) matters because such articulations serve to increase Elvis's active circulation within the economy of cultural icons. Elvis the Vegiform, for instance, may have no direct connections to questions of racial politics or any of the other mythical struggles described here, but without the cultural visibility that such struggles have given the posthumous Elvis (or, perhaps more accurately, the visibility they've helped him maintain), it's unlikely that Richard Tweddell, the inventor of Vegiforms, would have thought to include Elvis among those celebrities whose images he appropriated for his product. Thus, while not all contemporary Elvis

sightings are obviously linked to discursive struggles over broader cultural myths, Elvis's prominence in such struggles makes him a likely figure to be invoked in other, less obviously contested areas of the cultural terrain.

KING CREOLE

As the above discussion of the "if I could" and "shoe shine" myths would imply, the history of mythical connections between Elvis and discourses on race is a long one, dating back as far as Elvis's first commercial releases for Sun in the mid-1950s and continuing many years after his death into the present day. It would be a mistake, however, to assume that this history is characterized by a seamless, evolutionary progression of causal links between past myths and present ones. "The entanglement of now and then," after all, "is fundamentally a mystery" (Marcus, 1989: 23), and the path from the intertwined myths of Elvis and race as they existed in the 1950s to the analogous relationship between those mythological formations today is as often marked by fragmentation and non-dialectical ruptures as it is by continuity and simple evolutionary connections.

Such discontinuity stems in part from the ways in which myth frequently works to create and sustain a fictional vision of the past, one that ultimately serves to limit and shape both the ways in which people understand the world they currently inhabit as well as the possibilities they can imagine for their future. Marsh, for example, interprets the "shoe shine" story, not as a historical example of past racial prejudice, but as a barometer of current racial tensions in the US and a potential indicator of what the future may hold for black/white relations:

> The ["shoe shine"] fable is held as gospel by some of the finest contemporary black musicians, including Vernon Reid of Living Colour and Public Enemy's Chuck D It's a significant symbolic switch, from James Brown, the most revered soul musician, who boasted of his personal closeness to Elvis, to Chuck D, the most respected leader of the hip-hop movement, who disdains any worth Elvis might possess at all. Part of it has to do with the depths of racism to which America has once again descended and the genuine need for black artists to create and sustain a separatist cultural mythology. Elvis was a figure of integration and that figure must now be destroyed or at least diminished On a symbolic scale, this claim that Elvis was nothing but a Klansman in blue suede shoes may be the greatest Elvis-related tragedy of all. For if Elvis, as I say at the end of this book, was the sort of indispensable cultural pioneer who made the only kind of map we can trust, what does it mean when pioneers of a later generation have to willfully torch that map?
>
> (1992: xi)

Marsh's comments here bear closer examination, but before I can address his argument in a productive fashion, it's necessary to take a closer look at some of the recent articulations between Elvis's myths and racial politics, including the specific musical rejections of Elvis's legacy that disturb Marsh: Public Enemy's "Fight the Power" (1989) and Living Colour's "Elvis Is Dead" (1990).

"Fight the Power" is nothing less than a call to arms – made by the most outspoken and militant rap group in contemporary popular music – against the ideas, institutions, and practices that maintain the political, social, economic, and cultural inequalities between whites and blacks in the US today.[12] The song served as the musical centerpiece of *Do the Right Thing* (1989), Spike Lee's critically acclaimed film depicting twenty-four hours of racial tension in a predominantly black Brooklyn neighborhood, and it subsequently appeared on Public Enemy's best-selling album, *Fear of a Black Planet*. "Fight the Power" is probably the most widely known and recognized of all of Public Enemy's songs,[13] and its most frequently quoted lyrics are undoubtedly those concerning Elvis:

> Elvis was a hero to most
> But he never meant shit to me
> He's straight up racist
> That sucker was simple and plain
> Motherfuck him *and* John Wayne.

This unequivocal rejection of Elvis and all that he stands for is more than an expression of Chuck D's distaste for Elvis's particular brand of rock 'n' roll: for Public Enemy, Elvis symbolizes more than 400 years of redneck racism and thus neither deserves nor receives the tiniest shred of respect from the band. Underscoring this particular stance on the racial politics of Elvis is Lee's use of the song in *Do the Right Thing*. The verse containing Public Enemy's musical assault on Elvis is the "goddamned noise" blaring from Radio Raheem's boom box at the climactic moment when he and Buggin' Out enter Sal's Pizzeria to shut it down, and Lee's choice of this verse as the first salvo in this pivotal confrontation works to emphasize and reaffirm Public Enemy's claims regarding Elvis's racism, turning the group's wholly unsympathetic condemnation of Elvis into a revolutionary motto for black America to rally around.

A little more than a year after the initial release of "Fight the Power," the hard rock group Living Colour added its voice to the conversation with "Elvis Is Dead." Self-consciously quoting Public Enemy, the band proclaims that "Elvis was a hero to most," but then finishes Chuck D's original couplet with a more generous interpretation of Elvis's racial politics: "But that's beside the point / A black man taught him how to sing / And then he was crowned King." While this certainly isn't an adulatory whitewash of Elvis's image (the song underscores its slam at Elvis's mythical status by concluding – in a clear rebuttal to Paul Simon's "Graceland"

(1986) and its vision of all-embracing acceptance – that "I've got a reason to believe / We all *won't* be received at Graceland"), it's also not the unequivocal rejection of Elvis that Public Enemy calls for.

If nothing else, Living Colour grants that Elvis had a certain measure of talent (even if he acquired that by imitating black musicians), and the accusations of racism the band levels here are directed less at Elvis than at those who crowned him. The band's point isn't that Elvis doesn't deserve any respect at all, but that his coronation as "The King" diminishes the perceived value of contributions made by other artists – particularly blacks – to the birth and development of rock 'n' roll. As guitarist Vernon Reid told *Rolling Stone* in 1990, "it's not enough for the powers that be to love Elvis, for him to be *their* king of rock & roll. Elvis has to be the king of rock & roll for everybody. And that is something I cannot swallow" (Fricke, 1990: 56). Reid expanded on this argument to *Spin* that same year, claiming that "Elvis was great at the beginning . . . but the crown thing is something else. If he's the King of rock 'n'roll, who is Fats Domino? The court jester?" (Jones, 1990: 94). James Bernard, associate editor of the *Source*, offers a similar interpretation both of "Elvis Is Dead" and of Living Colour's position on Elvis and racial politics:

> Yes, [Elvis] was a great performer but let's not cheapen his contribution with these tabloid-fueled cults. The real Elvis was lonely, drugged and obese, and not many of us even knew until fame killed him. With [lead singer] Corey [Glover]'s James Brown imitation, Little Richard's rap and Maceo [Parker]'s cameo, Living Colour points to other legends who should be just as large – and are still living.
>
> (1990: 2)

Neither Reid nor Bernard accept the notion that it's proper to call Elvis "The King" while artists possessing equal, and probably greater, musical talent (e.g., Little Richard, James Brown) are treated as lesser figures in the rock 'n' roll pantheon, but both also point the finger of blame for such injustices away from Elvis, implicitly arguing that those who built a pedestal only big enough for one (white) artist – and then placed Elvis upon it – deserve the brunt of the scorn.[14]

Living Colour's position on Elvis is further complicated by the group's own status as four black men playing a style of music (hard rock) typically seen to be the exclusive province of white artists. As Marcus describes it, Living Colour is "a black rock 'n' roll band bent on smashing the same racial barriers Elvis once smashed, the same racial barriers that had reformed around him" (1991: 187). Elvis's initial success in the 1950s helped to integrate the previously segregated world of US popular music by reinforcing the notion that rock 'n' roll was a style of music that both blacks and whites could play and enjoy. But this (relatively) peaceful co-mingling of black and white cultures didn't last. The sounds that had been attacked by some in the 1950s as "nigger music" had by the 1970s (and

possibly sooner, depending on which version of popular music history one believes) become primarily music made by and for whites: a resegregation of the musical terrain that has remained largely unchallenged ever since.[15]

Seen in this context, Living Colour's career has been marked by struggles for acceptance and respect above and beyond those normally faced by up-and-coming artists. In a 1990 *Spin* interview, the band members explained some of the additional problems they've had to face this way:

> [Bass player Muzz] Skillings: Whenever we did a load-in, right before a soundcheck, without fail . . . somebody would come up to us and say "Are you guys a rap band?"
>
> [Drummer William] Calhoun: No.
>
> Skillings: "You guys are a funk band?"
>
> Calhoun: No.
>
> Skillings: "A dance band?" They'd go down the list: jazz, reggae, calypso. They'd list every conceivable thing before they'd say rock. In fact, they never said rock.
>
> [. . .]
>
> Calhoun: People ask us, "Why are you playing rock'n'roll?" I never read an article on George Michael asking him why he was singing R&B. A lot of press we get is as "Black Rock"; "Black Band Brings Down Barriers." Why can't we just be a rock band? Why can't we just be Living Colour?
>
> <div align="right">(Jones, 1990: 50, 94)</div>

Bernard is possibly even more incensed than the band over the widespread disbelief that black musicians might actually want to play rock (much less that they could do so successfully):

> I'm not one for colorblindness – the worst thing anyone has ever said to me is that "I don't think of you as Black, you're so *normal*." But with Living Colour, the title "Black rockers" has *not* been offered by the rock press to acknowledge and honor the heritage of popular music, including rock. Instead, it's a slur – used, intentionally or not, to shelve them and mute their potential impact as artists and thinkers. The reality is that they rock harder, with more passion and ability, embracing more musical styles more deftly than any other band in the post-Zeppelin era.
>
> <div align="right">(1990: 2)</div>

Thus, Living Colour's criticism of "the crown thing" is not merely that a white man has been accorded respect and honors that have systematically been denied to equally deserving black musicians, but that Elvis's coronation implicitly helps to reinforce the resegregation of the musical world into neat and (supposedly) mutually exclusive racial categories. Similar arguments also surfaced in the

discourse surrounding the US Postal Service's "Legends of American Music" series of stamps (of which Elvis's was the first). Noting that the Postal Service's initial announcements concerning the series failed to mention *any* black musicians, even as potential candidates for this honor, *Washington Post Book World* editor David Nicholson expressed concern that "while black artists may be part of an as-yet-undecided blues, rhythm-and-blues and jazz series, excluding them from the rock series would further the segregation of pop music into mutually exclusive racial genres" (1992: 5).

Village Voice writer Joe Wood's interpretation of Elvis's coronation takes the arguments made by Living Colour and Nicholson a step further, implying that Elvis could only have been named "The King" within a culture steeped in racism and prejudice. While acknowledging that Elvis, especially in his early days, was a great artist, Wood argues that "Elvis's crowning wouldn't have made any sense if black performers had been as salable as he." Elvis is called the "King of Rock 'n' Roll," however, not because he was talented, but

> because he consumed black music and lived. He "mastered" it, giving white folk "license" to rock, by making a basically black form of popular music "accessible" to many whites. Making it beaucoup salable Way past those first few records when his music was any good, Elvis kept generating big bucks and attention – already an icon of chauvinistic white culture consumption Which makes him the Greatest in a long line of White American Consumers. Dust off those Paul Whiteman (the King of Jazz) records, or listen to Benny Goodman's (the King of Swing) watered swing, and you'll catch a drift of the tradition of the drift.
>
> (1991: 10)

The flip side of Wood's point, however, is perhaps the more crucial one: that the unsalability of black musicians stems less from a fear of what black music would do to white audiences (though there was – and still is – certainly more than enough of this to go around) than from "a huge conceptual failure" by whites to see blacks as consumers of culture:

> Fear of the black consumer: then, as now, black artists – culture consumers who took in stuff and made it theirs, and expressed it – did not really exist in the popular imagination. Chuck Berry as "the black artist who took in country music" did not exist. Neither did cultural literates Howling Wolf, or Fats Domino, or Bo Diddley Instead, their stuff – a blues-based performance music informed by myriad American influences – was seen as "natural black stuff" and not African-American art, or American art, as Presley's rock and roll would be. Not American art worthy of mainstream attention. (Chuck D. an American poet? Hah!)
>
> (1991: 10)

What's particularly striking about this argument is the prominent role that Wood assigns to Elvis in an article that ostensibly has nothing whatsoever to do with either Elvis or rock 'n' roll. The piece's title ("Who Says a White Band Can't Play Rap?") and the accompanying photo both indicate that the story's supposed focal point is a white rap group called the Young Black Teenagers . . . and yet Wood doesn't even mention the YBTs until more than halfway through the article, instead choosing to write an Elvis-centered "introduction" that's longer than the rest of the piece. On the one hand, the connections that Wood makes between Elvis and the YBTs are very natural: the link between the racial politics of five white boys rapping in the 1990s and "a white man with the Negro sound and the Negro feel" in the 1950s is very powerful and very commonsensical. On the other hand, such "natural" connections are entirely mythical, as Wood doesn't need to mention Elvis here at all, much less give him as many column inches as he does. Elvis, after all, died before rap was born and probably before most of the YBTs were out of diapers, yet here he is anyway, appearing as nothing less than *the* grand metaphor for the racial (and racist) politics of US popular music. In the end, then, Wood's discussion of Elvis is actually not about Elvis as much as it is about questions of race and culture (and the relationships between the two) in the US since World War II.

Buried not very far below the surface of all these arguments about the racial politics of Elvis is the old argument that the "invention" of rock 'n' roll in the 1950s was actually no such thing at all. Instead, rock 'n' roll came about when various white musicians and entrepreneurs began playing and recording what had previously been an authentically black music (i.e., rhythm 'n' blues), frequently watering it down (i.e., smoothing out its rough edges) in order to make it more palatable to white audiences. Calling the music "rock 'n' roll" simultaneously worked to erase the connotations of blackness associated with the "rhythm 'n' blues" label and to create the fiction that white musicians had in fact invented this "new" music themselves. In this way, scores, perhaps even hundreds, of white artists and record label executives rode to vast fame and fortune on the backs of black singers, songwriters, musicians, and businesspeople without similar rewards accruing to the music's true creators.

Or so the story goes. My goal here isn't to discredit this myth altogether: one need only compare Pat Boone's pedestrian version of "Tutti Frutti" (1956) to Little Richard's rollicking original (1956) – noting that Boone's record outsold and outcharted Little Richard's – to see that there's more than a little validity to such claims. That Little Richard, and not Boone, is widely celebrated today as one of the founding figures of rock 'n' roll doesn't erase the fact that the history of popular music is littered with tales of racial injustice. While Little Richard doesn't seem to bear Boone any particular malice today, the fact that history has been kinder to him than to Boone gives Richard the luxury to be generous. Other black

artists of the 1950s who saw white cover versions of their records outsell theirs have typically not been so fortunate, and tales of such artists being "found" years later, living in squalor and obscurity, while the white musicians who had "borrowed" their music became rich and famous are sufficiently common to have become one of the standard clichés of rock 'n' roll history. More crucially, Little Richard's public statements of gratitude towards Pat Boone and Elvis for "opening the door" so that his music could be heard and appreciated by white audiences[16] are counterbalanced by his recognition that racism *did* play an important role in shaping the careers of rock 'n' roll's pioneers. "I think that Elvis was more acceptable being white back in that period," Little Richard told *Rolling Stone* in 1990:

> I believe that if Elvis had been black, he wouldn't have been as big as he was. If I was white, do you know how huge I'd be? If I was white, I'd be able to sit on top of the White House! A lot of things they would do for Elvis and Pat Boone, they wouldn't do for me.
>
> <div align="right">(Puterbaugh, 1990: 126)</div>

Two years later, when *Life* asked if he thought Elvis was the King of Rock 'n' Roll, Little Richard replied (with characteristic outspokenness):

> I know they call him the King, but if he is, who crowned him? When was the ceremony – and why was I not invited? How can a white boy be the King of Rock and Roll? I'm not downin' white singers. But I been imitated by more people. I, too, have been called the King of Rock and Roll. I been called the Queen. I earned the throne 'cause I am the Originator, the Architect, the Emancipator – *The* Founding Father of Rock and Roll.
>
> <div align="right">(Jerome, 1992: 50)</div>

A 1991 episode of *President Bill* (a weekly one-panel cartoon drawn by William L. Brown and originating in the *Chicago Reader*) tells a similar tale, albeit one with a different black musical hero at its center. The cartoon in question depicts a presidential press conference where a muck-raking reporter asks the president if it's true he doesn't think Elvis is King. "That's right!" Bill replies before his staff can intercede, "Elvis got rich ripping off African-American music. Chuck Berry is King! Elvis was a sleazeba . . . mff!" The aide who belatedly muffles the President's last word by placing her hand over his mouth makes a vain attempt at damage control: "The President misspoke!" she frantically explains, "He *does* think Elvis is King!" but it's too late. The damage has already been done, and the reporters race off to contact their editors so that Bill's gaffe can be used as a press-stopping, program-interrupting news bulletin (see plate 17).[17]

In the end, however, the problem with the myth of rock 'n' roll as rhythm 'n' blues in whiteface is not that there are no facts to support it, but that it represents

far too simplified an interpretation of those facts: the issues involved here, both literally and figuratively, can't be boiled down to an uncomplicated opposition between black and white. For example, one of the facts overlooked by contemporary claims that Elvis "stole the blues" is that his music was as antagonistic towards the white mainstream of the 1950s as Public Enemy's is today. The complaint, "That's not *real* music, it's just noise," was leveled against Elvis and his peers in the 1950s at least as often – and with strikingly similar undercurrents of prejudice – as similar comments are used today as dismissive indictments of Public Enemy and other rap acts. When Sal takes a baseball bat to Radio Raheem's "fuckin' radio" and the "goddamned noise" it makes in *Do the Right Thing*, he's echoing the response of many whites in the 1950s to the playing of so-called "nigger music" by Elvis and other early rock 'n' roll artists, both white *and* black.[18] Whatever Elvis may have become later in his career, and whatever injustices were perpetrated upon black rhythm 'n' blues artists by the white-dominated music industry in the 1950s (and beyond), the early pioneers of rock 'n' roll *did* transform a mainstream pop music scene dominated by the white-bread sounds of Perry Como and Frank Sinatra into a more integrated and diverse beast than it had ever been before.

Writing more than twenty years ago, at a point when rock 'n' roll had just barely begun to become respectable (and when Elvis was just beginning to lose the respect of the mainstream rock audience for the second time), Marcus openly rejects the claim that Elvis stole the blues:

> The implication, always there when [Arthur "Big Boy"] Crudup or Willie Mae Thornton . . . looked out at the white world that gave them only obscurity in exchange for their music and penned them off from getting anything for themselves, is that Elvis would have been nothing without them, that he climbed to fame on their backs. It is probably time to say that this is nonsense; the mysteries of black and white in American music are just not that simple.
>
> (1990a: 155)

He then goes on to tell the tale of "Hound Dog" – or part of it anyway (further discussion of this can be found in chapter 4) – pointing out that while the song was a number one rhythm 'n' blues hit for Thornton (1953), it was written by Jerry Leiber and Mike Stoller, two "Jewish boys from the East Coast" who loved rhythm 'n' blues, and the band behind Thornton belonged to Johnny Otis, "a dark-skinned white man from Berkeley who many thought was black" (1990a: 155) but who was actually of Greek-American extraction. What Marcus leaves out of the story only adds to the confusion, as Elvis's version of "Hound Dog" (1956) came about, not as an attempt to cover Thornton's record, but as an imitation of *a parody* of her record performed by Freddie Bell and the Bellboys, a white band

Elvis had seen during his less than successful attempt to play Las Vegas in 1956. The words, the tempo, and the arrangement of Elvis's "Hound Dog" come not from Thornton's version of the song, but from the Bellboys', and thus the only "real" black people to touch the song at all – from the moment it was written to the moment when it topped the pop charts – were Thornton and a member or two of Otis's band. As Marcus puts it,

> whites wrote it; a white made it a hit. And yet there is no denying that "Hound Dog" is a "black" song, unthinkable outside the impulses of black music, and probably a rewrite of an old piece of juke joint fury that dated far beyond the birth of any of these people. Can you pull justice out of *that* maze? What *does* Huck owe Jim, especially when Jim is really Huck in blackface and everyone smells loot? All you can say is this was Elvis's music because he made it his own.
>
> (1990a: 155)

To talk about Elvis's music as "black" or "white" is problematic because it's difficult (if not impossible) to describe a specific form of music – or a specific culture – as racially pure. Wood, for instance, points out that this sort of cultural cross-pollination has been going on between blacks and whites ever since the first slaves were forcibly transported to the American colonies, so that today "most 'black' folk have lots of 'white' inside, and vice-versa (we've been consuming each other for a long time)" (1991: 11). Even Nelson George, former Black Music editor for *Billboard* and one of the more vitriolic critics of Elvis's racial politics, acknowledges that the tangled web of racial influences on Elvis is far too complicated for his music or style to be easily described as "black" or "white":

> Even before he made his first record, Elvis was wearing one of black America's favorite products, Royal Crown Pomade hair grease, used by hep cats to create the shiny, slick hairstyles of the day. The famous rockabilly cut, a style also sported by more flamboyant hipsters, was clearly his interpretation of the black "process," where blacks had their hair straightened and curled into curious shapes. Some charge that the process hairstyle was a black attempt to look white. So, in a typical pop music example of cross-cultural collision, there was Elvis adapting black styles from blacks adapting white looks.
>
> (1988: 62)

Seen in this context, the myth of rock 'n' roll as an unforgivable act of cultural poaching ultimately depends on selective cultural amnesia concerning several historical facts. It's worth remembering, for instance, that during the early days of Elvis's career, when he was still only a regional phenomenon, a lot of black rhythm 'n' blues deejays refused to play his records because they sounded "too

country," while at least as many white pop deejays thought Elvis sounded "too black" to include on their playlists.[19] As early as his first Sun releases, Elvis was commonly recognized as a artist whose music sprang from a convoluted tangle of influences: rhythm 'n' blues, country, gospel (both black and white), blues, Tin Pan Alley – all of these (and then some) can be heard in Elvis's early records. The September 1955 issue of *Country Song Roundup*, for instance, describes Elvis's first commercial release as "something new in records: [an] unusual pairing of an R&B number ['That's All Right'] with a Country standard ['Blue Moon of Kentucky']" (quoted in DeNight *et al.*, 1991: 35). As many commentators since the 1950s have noted, what was new about Elvis wasn't so much that he was a "white boy singin' the blues," but that he refused to separate black music from white music in his recordings and performances. Not only did all of Elvis's Sun releases involve the "unusual pairing" of a country song on the flip side of a rhythm 'n' blues tune, but these records all involved a blurring of these generic boundaries *within* individual songs. As Marsh puts it,

> There was nothing shameful about appropriating the work of black people, anyway. If Elvis had simply stolen rhythm & blues from Negro culture, as pop music ignoramuses have for years maintained, there would have been *no reason* for Southern outrage over his new music But Elvis did something more daring and dangerous: He not only "sounded like a nigger," he was actively and clearly engaged in race-mixing. The crime of Elvis' rock & roll was that he proved that black and white tendencies could coexist and that the product of their coexistence was not just palatable but thrilling.
>
> (1982: 38–47)

Such observations, however, were being made as early as February 1955, when a *Memphis Press-Scimitar* story on Elvis's growing popularity described his first single with the claim that

> Sam Phillips still hasn't figured out which was the big side. "That's All Right" was in the R&B idiom of negro field jazz, "Blue Moon [of Kentucky]" more in the country field, but there was a curious blending of the two different musics in both.
>
> (quoted in DeNight *et al.*, 1991: 28)

However much Elvis may have "borrowed" from black blues performers (e.g., "Big Boy" Crudup, "Big Mama" Thornton), he borrowed no less from white country stars (e.g., Ernest Tubb, Bill Monroe) and white pop singers (e.g., Mario Lanza, Dean Martin), and he made no attempt whatsoever to segregate the styles he'd appropriated from one another.

No less significant than the hybrid quality of Elvis's early music, however, is the fact that Elvis's popularity didn't follow the traditional patterns of tastes

determined by (and segregated along lines of) racial identity. For instance, shortly after the release of Elvis's first record in July 1954, Marion Keisker told the *Press-Scimitar* that "both sides seem to be equally popular on popular, folk and race record programs. This boy has something that seems to appeal to everybody" (quoted in DeNight *et al.*, 1991: 18). Similarly, in his history of Memphis's WDIA, the first all-black radio station in the US, Louis Cantor describes the "spontaneous mass hysteria" that erupted when Elvis made an unadvertised appearance in front of a black audience at the station's 1956 Goodwill Revue:

> [Emcee and WDIA radio personality] Nat D. Williams said: "Folks, we have a special treat for you tonight – here is Elvis Presley." That did it. Elvis didn't even get out on stage. He merely walked out from behind the curtain and shook his leg. That's all it took. At that point, thousands of black people leaped to their feet and started coming directly toward Elvis from both sides of the auditorium.
>
> (1992: 194)

Cantor goes on to quote Williams's newspaper column on this surprising display of Presleymania from Memphis blacks:

> "A thousand black, brown and beige teenage girls in that audience blended their alto and soprano voices in one wild crescendo of sound that rent the rafters," he wrote, "and took off like scalded cats in the direction of Elvis."
> . . . [Williams's] conclusion was that Beale Streeters should now wonder if this black teenage outburst over Presley "doesn't reflect a basic integration in attitude and aspiration which has been festering in the minds of most of your folks' women-folk all along. Huhhh?"
>
> (1992: 196)

Elvis's interracial appeal, however, wasn't limited to Memphis or the South. An often-mentioned, but little analyzed, early achievement of Elvis's career is that "Don't Be Cruel" (1956) was the first record ever to sit atop *Billboard*'s pop, country, and rhythm 'n' blues charts simultaneously. What's generally left unsaid about this record's unprecedented success on all three of the trade journal's major charts, however, is that Elvis's ability to transcend the major genre categories of the (popular) music world in the mid-1950s demonstrates the extent to which his popularity transcended divisions, not only between blacks and whites, but also between North and South, teens and adults, and urban and rural populations.

But while Elvis was certainly popular with blacks, it was whites who crowned him King. A common thread running through virtually all the critiques of Elvis's coronation, no matter what stance individual critics may take on the question of whether Elvis was himself a racist, is the accusation that those who put Elvis on his royal pedestal have been far too quick to reject black rock 'n' roll artists

– Little Richard, Chuck Berry, James Brown, Fats Domino, and Bo Diddley are those most frequently mentioned – as legitimate contenders for the crown. Regardless of whom Elvis's critics offer as alternate candidates for his throne, however, the criticisms leveled at Elvis's coronation point to very serious, and very real, flaws in the ways in which the history of rock 'n' roll has come to be accepted and understood. That black artists have systematically and repeatedly been denied the respect and rewards that they deserved in exchange for their musical labors is, lamentably, all too true, and what Vernon Reid describes as "the crown thing" is, perhaps, the most obvious and clear-cut symbol of such denials.

This, then, is where Marsh's interpretation of the racial politics behind the "shoe shine" story begins to run aground. For while Elvis's ability to blend elements of black and white musics together into a new sound that had a large following on both sides of the color line does support Marsh's assessment of Elvis as a "figure of integration," at the very least, Marsh still overestimates the degree to which the general public shares his vision of Elvis as a progressive force in the arena of racial politics:

> The wholeness of our appreciation for Elvis has reached a presumable end; there are now believers and non-believers, in a permanent stand-off. . . . I now know that when Lester Bangs said that he guaranteed we would never agree on anything else as we agreed on Elvis, he meant that we would never agree on anything at all.
>
> (Marsh, 1992: xi)

Marsh's interpretation of Bangs's comment (which comes from the conclusion to Bangs's 1977 obituary of Elvis) is only half correct, as we never entirely agreed on Elvis in the first place: not only does the rest of Bangs's essay make this abundantly clear, but it's the recognition that we didn't really agree on Elvis all that much that makes his conclusion all the more poignant. One can almost hear Chuck D responding to Marsh's lament about "the wholeness of our appreciation for Elvis" with that clichéd, but still appropriate, punchline, "What you mean 'we,' white man?"[20] Similarly, Marsh's confident assertion that "Elvis was a figure of integration" overlooks two important facts. First, however widespread such a vision of Elvis might be now (or might have been in the past), it has never been a universally held truth: the argument that Elvis "stole the blues" is itself sufficiently old and widespread that when Marcus – who is too meticulous a scholar *not* to cite sources when he should – refutes it in the mid-1970s in *Mystery Train*, he doesn't feel the need to refer to any specific texts or critics to do so. Second, that Elvis did in fact signify racial integration for many people is no guarantee that those who saw him this way celebrated that vision. For many whites, racial integration was (and is) seen as a nightmare to be avoided rather than a dream to be embraced, while for many blacks, integration was (and is) nothing more than

a code-word used to disguise the destruction of black culture through its forced assimilation into white culture.

More troublesome, though, is the fact that Marsh posits a rigidly polar opposition between "believers and non-believers," an opposition in which the former are for integration, freedom, and liberation, while the latter reject such ideals in favor of "a separatist cultural mythology." As useful as these categories may be in helping us think about the range of positions found in contemporary US racial politics, they are less than helpful when it comes to describing real people and their positions on questions of race. If Marsh conceived of these particular categories as endpoints on a continuum – one with an infinite number of gradations in between those endpoints – then his argument here might be more compelling. As it is, however, his too-neat division of the world into "us" (believers) and "them" (non-believers) creates two major problems for his analysis. First, such an argument implicitly denies the fact that the positions people take on the issue of Elvis and racial politics (or almost anything else, for that matter) are rarely reducible to a binary opposition between black and white, or between acceptance and rejection. Both Living Colour and Joe Wood, for example, call Elvis a great artist – significantly, they do so primarily on the basis of the racially integrated music he made in the 1950s – while critiquing his coronation as the "King of Rock 'n' Roll." Second, by describing all "non-believers" as proponents of "a separatist cultural mythology," Marsh's argument ultimately erases the very real, and very important, distinctions that exist between Elvis's critics, and thus unfairly tars them all with the same brush. For example, Living Colour – four black men playing what many people feel to be white music – is hardly the symbol of cultural separatism that Marsh makes them out to be. Moreover, Public Enemy's position on Elvis, while certainly more antagonistic than Living Colour's, is also a far cry from the cultural separatist position that Marsh ascribes to both groups, as there is no necessary correspondence between the group's pro-black rhetoric and a separatist, anti-white worldview. Chuck D's primary concern with "whites dabbling in black musical styles," for instance, is not with maintaining some sort of mythical cultural purity (in which whites make "white music," blacks make "black music," and never the twain shall meet), but with where the profits from such cross-cultural ventures go: "I'm not making fun of white people picking up on black things: all I'm saying is that black people should get paid when this shit goes mainstream" (Owen, 1990: 60).

Ultimately, then, Marsh is at least partially right: Elvis *is* a figure of integration. But he's also simultaneously a figure of racist appropriation, of musical mis-cegenation, and of cultural assimilation (at the very least), and the main problem with Marsh's argument is that he exerts too much effort trying to fight the myths he doesn't believe in with facts inadequate to the task. The fact that matters here, however, is that all of these articulations between myths of Elvis and myths of race

are currently active on the terrain of US culture, and have been since the earliest days of Elvis's career. This is not to say that all of these myths are equally true, but that they all work: for different audiences, in different contexts, each of these interpretations of Elvis's racial politics serves to explain (at least in part) the cultural significance of Elvis Presley. Moreover, the "effects" of these myths (i.e., the ways that they encourage certain views of the world while discouraging others) are unevenly distributed across the cultural terrain, as at any given point in time, one (or more) of these myths may circulate more widely or be held in higher esteem than the others: the "shoe shine" fable, for instance, has given the myth of Elvis-as-racist a renewed vigor. Despite the various contradictions that exist between these myths, however, none seems either to have completely died off or to have become so firmly lodged in the public imagination that it might safely be described as the dominant myth describing the racial politics of Elvis. Peter Guralnick once wrote that "anyone you interview, anyone in life, really, could be portrayed in exactly the opposite manner with exactly the same information" (1979: 10), and part of what keeps Elvis "alive" on the terrain of US culture today is the way in which "exactly the same information" concerning his career has been mythologized and subsequently articulated to a diverse – and even contradictory – range of broader cultural myths.

U.S. MALE

As important as questions of racial politics are to the mythological formation surrounding Elvis, they are by no means the only (or even necessarily the primary) determining factor in the construction and maintenance of that formation. Bangs, for instance, acknowledges the importance of black music to Elvis's success, but he insists that questions of gender and sexuality ultimately matter more than questions of race when it comes to explaining Elvis's impact upon US culture:

> It has been said that [Elvis] was the first white to sing like a black person, which is untrue in terms of hard facts but totally true in terms of cultural impact what's more crucial is that when Elvis started wiggling his hips and Ed Sullivan refused to show it, the entire country went into a paroxysm of sexual frustration leading to abiding discontent which culminated in the explosion of psychedelic-militant folklore which was the sixties.
>
> (1977: 215)

But while the eroticism of Elvis's gyrating pelvis may have mattered more to Bangs than the multi-cultural gumbo of his music, not all observers – fans or otherwise – would agree with such a claim. Elvis meant (and means) too many different things to too many people to be summed up quite so neatly and, at best, arguments over which mythological formations are the most crucial to our understanding

of Elvis ultimately tell us more about the value systems of the people who put forth such claims than they reveal about what Elvis meant (or means) to the culture as a whole.

Bangs's claim here is overly simplistic insofar as the connections between myths of race and sexuality not only pre-date Elvis by several centuries, but are so inextricably intertwined that determining where one leaves off and the other begins is often impossible. For example, Nelson George argues that Elvis's status as a sex symbol was actually a byproduct of his appropriation of black music and style:

> Elvis's reverse integration was so complete that on stage he adopted the symbolic fornication blacks had unashamedly brought to American entertainment. Elvis was sexy; not clean-cut, wholesome, white-bread, Hollywood sexy but sexy in the aggressive earthy manner associated with black males. In fact, as a young man Presley came closer than any other rock & roll star to capturing the swaggering sexuality projected by so many R&B vocalists.
>
> (1988: 62–3)

George's comments here also help to shed light on why the initial backlash against Elvis was so strong, insofar as they remind us that Elvis violated the dominant racial *and* sexual taboos of 1950s US culture simultaneously. To be sure, in the eyes of many people the fact that Elvis was a white boy singing the blues was in itself a serious threat to the nation's moral fiber. Similarly, the sexually charged mania that Elvis induced in legions of his teenage fans struck many observers as more than enough reason to be alarmed by his rising star. Arguably, however, it was the fact that he did both these things at once – that he excited *white* girls with *black* music (or, more accurately, with what was commonly thought of as black music) – that resulted in the intensity of the moral panic surrounding him. After all, one of the gravest sins imaginable against the patriarchal and racist values that dominated mainstream US culture in the 1950s was for a black man to do *anything* that might sexually arouse white women – particularly if, as was the case with a vast number of Elvis's fans, those women were underage.

Related though they may be, however, myths of sexuality and myths of racial politics are not simply interchangeable parts of the larger mythological formation surrounding Elvis: though the two frequently overlap, it would be a mistake simply to map them onto each other as if they were entirely equivalent. Thus, while Bangs's argument can be faulted for the way in which it artificially separates questions of race and sexuality, George's argument is no less flawed for the way in which it constructs a simple equivalence between these two categories. What myths of race and sexuality *do* have in common with respect to Elvis is that neither can safely be reduced to a simple statement of fact (e.g., "Elvis was a racist," or "Elvis was

macho"). As Marcus puts it, "When the stakes are as high as they always were with Elvis, the neat phrase is not to be trusted; always, it will obscure more than it will reveal" (1991: 9). Pithy one-line summaries of Elvis's impact or importance generally don't explain Elvis as much as they explain him away; rather than addressing the questions raised by Elvis's success, they evade them completely.

Take, for example, the strand of Elvis's mythology that sees him as the raw embodiment of masculine sexuality, a folk hero at the forefront of the sexual revolution's first assault on the prudish constraints of 1950s US culture. As Marcus describes it, the rockabilly sound and style that Elvis helped to create during his tenure at Sun Records "fixed the crucial image of rock 'n' roll: the sexy, half-crazed fool standing on stage singing his guts out" (1990a: 143). Viewed from this perspective, Elvis can be seen as one of the founding fathers of the musical subgenre that Simon Frith and Angela McRobbie describe as "cock rock,"[21]

> music making in which performance is an explicit, crude, and often aggressive expression of male sexuality – it's the style of rock presentation that links a rock and roller like Elvis Presley to rock stars like Mick Jagger, Roger Daltrey, and Robert Plant.
>
> (1978: 374)

Evocations of this particular vision of Elvis's sexuality are innumerable. George Melly, for instance, argues that

> Presley's breakthrough was that he was the first male white singer to propose that fucking was a desirable activity in itself He was the master of the sexual simile, treating his guitar as both phallus and girl, punctuating his lyrics with the animal grunts and groans of the male approaching an orgasm.
>
> (1970: 34–5)

Similarly, Glenn O'Brien argues that, "Elvis was a sex star. He didn't have to study it. He knew it – a twitch of the hips brought screams to throats of a thousand girls, and tears to their eyes. Elvis knew what it was that interested these young women. He didn't need a theory" (1982: 11). Country music historian Bill Malone attributes Elvis's initial success to the fact that, "along with talent and energy, Elvis brought a sexual charisma into the music business that his colleagues did not possess. Certainly no country entertainer before him had exhibited such raw masculine appeal" (1985: 249). Describing the frenzy of Elvis's concerts circa 1955, Marsh states that "the sensuality of his stage show, the pure fuck-me splendor of his movements, his athletic grace, began to strike sparks. Passion smoldered; occasionally it burst into flame: Boys became as hostile as their girlfriends became aroused" (1982: 55). And, in what may be the most blunt expression of this particular myth, Bangs claims that

Elvis Presley was the man who brought overt blatant vulgar sexual frenzy to the popular arts in America Elvis alerted America to the fact that it had a groin with imperatives that had been stifled Elvis kicked "How Much Is That Doggie in the Window" *out* the window and replaced it with "Let's fuck."

(1977: 215–16)

According to this particular version of the myth, Elvis was an incredibly virile super-stud that women were powerless to resist,[22] and the gift that he bestowed upon US culture in the 1950s was the freedom to engage in – and to celebrate – raw, uninhibited, animal passion: the so-called sexual revolution that would eventually come to the forefront of public consciousness in the 1960s begins here in the mid-1950s with a well-placed thrust from Elvis's much-celebrated pelvis.

Like most myths, the vision of Elvis as the prototypical "cock rocker" comes with a wealth of factual evidence to back it up: one can find ample support for this particular myth in most (though certainly not all) of Elvis's pre-army music, in his stunning December 1968 "comeback" special on NBC, and in a sizable portion of the records he produced in the first few years immediately following that special. More important than the various facts behind the myth, however, is the simple truth that innumerable critics and fans believe Elvis to be a macho folk hero: as is the case with the question of his alleged racism, whatever Elvis actually was is far less significant than what people thought him to be. Nevertheless, like many myths, this version of Elvis's story often ignores (or dismisses as irrelevant) a great deal of evidence that contradicts its basic premise, and it's here that Marcus's warning about what "the neat phrase . . . will obscure" becomes particularly relevant.

For example, the myth of Elvis-as-cock-rocker inevitably depicts the years between his discharge from the army and his "comeback" (1960–8) as a period of stagnation and decline where Elvis made music that was bad and movies that were worse. The most obvious problem with this myth, however, is that millions of Elvis's fans "failed" to believe in the (cock-)rock-oriented sense of aesthetics upon which it depends: these fans eagerly bought these "bad" records and attended these "bad" films, cheerfully oblivious to (or, perhaps, willfully defiant of) the fact that this body of work was held in contempt by a sizable portion of the rock audience. During this supposedly fallow period, no other artist had as many Top 40 hits as Elvis did,[23] and not a single one of his movies – no matter how abysmal most critics, some fans, and even Elvis himself thought they were – failed to return a substantial profit.[24] The fans that flocked to buy these records and see these films were evidently not interested in Elvis for "the pure fuck-me splendor of his movements": at the very least, the success of unthreatening pop songs such as "Do the Clam" (1965) and lightweight films such as *The Trouble with Girls (And How to*

Get into It) (1969) indicates that a staggering number of Elvis fans celebrated their idol for something other than his status as an irresistible super-stud.[25]

So who were these fans that remained devout followers of Elvis in the midst of his "decline"? And what was so appealing about the Elvis of this period that was visible to them, but completely eluded those folks mesmerized by Elvis's swivelling hips? A partial answer to these questions can be found in a tale that Marcus tells concerning one of his former colleagues at *Rolling Stone*: "It was during this period, as Langdon Winner once put it, that Elvis 'sold out to girls,' by which Winner meant that Elvis had stopped threatening and begun pleading" (1990a: 242).[26] As *Village Voice* writer Gregory Sandow points out, Winner's argument here is a particularly telling example of the way in which the myth of Elvis-as-cock-rocker completely ignores Elvis's female fans:

> Here we have an astonishing restatement of what it meant for Elvis to be tamed – astonishing since normally rock critics like to say that Elvis challenged nothing less than the sexual, social, and by implication even political limitations of the culture *all* Americans share.
>
> (1987: 71)

Linda Ray Pratt takes this argument a step further, claiming that the vision of Elvis as the embodiment of raw, libidinal energy is one predominantly (though not exclusively) created and adhered to by men, while Elvis's female fans, for the most part, hold an altogether different view of Elvis's sexuality. For such fans, Pratt argues,

> Elvis might be "nice looking" or "cute" or perhaps "sexy," but not sexual. The sexuality he projected was complicated because it combined character-istics and appeals traditionally associated with both males and females. On one hand, he projected masculine aggression and an image of abandoned pleasure, illicit thrills, back alley liaisons and, on the other hand, a quality of tenderness, vulnerability, and romantic emotion Unlike many later rock stars whose music would voice an assault on women, Elvis's music usually portrayed an emotional vulnerability to what women could do *to* him, as well as what he could do *for* them.
>
> (1979: 47)

This particular myth of Elvis's sexual appeal also surfaces in the testimony of Sue Wise, an Elvis fan who gave up her idol when she "got feminism," but nevertheless reacted to the news of Elvis's death with a sadness and a sense of loss that took her completely by surprise:

> Why was I grieving for a "butch god" when he represented everything that I had loathed and fought against? Was it just nostalgia, a yearning for my youth,

or was it more than this? In order to answer these questions for myself I turned to the proliferation of books and articles that appeared to cash in on his disintegration and then death. And, yes, there it was in black and white – Elvis the butch god, Elvis the phallus, Elvis the macho folk hero. And then I turned to my own mementos of Elvis As I listened to records and delved into clippings, cuttings, and photos they evoked memories and feelings from my youth. And the memories that were evoked had nothing to do with sex, nothing even to do with romance. The overwhelming feelings and memories were of warmth and affection for a very deep friend.

(1984: 395)

Similarly, *Village Voice* film and television critic Amy Taubin admits that her first reaction to Elvis (inspired by one of his many appearances on national television in 1956) was a lustful one, but argues that her response wasn't an example of the phallocentric desire typically ascribed to Elvis's female fans:

I never desired Elvis nor did I identify with him. I simply could not help miming, at an all but invisible level of muscular contraction and release – after all, my parents were in the room – his rhythms, his breathing, and his facial expressions. And I was astonished to discover that when I dropped my lower lip, my clit twitched From the beginning, I was out of sync with Elvis's audience. The combination deep-knee bend/groin grind which they treated, like a cue card, as a signal for passionate screams, I took as irony. My release came after the song and in response to Elvis's smile.

(1987: 43)

In discussing Elvis's final appearance on *The Ed Sullivan Show* in 1957, Sandow points out that the teenage girls in the studio audience screamed not only in response to Elvis's performance, but also to his host's statement that Elvis was "a real decent, fine boy." For Sandow, this particular reaction to Sullivan's words suggests that these girls didn't adhere to the myth of Elvis as a macho folk hero at all; rather they screamed because

Sullivan spoke a wish they might have had in their deepest hearts: that Elvis could be the most exciting man alive, but also the most dependable; that if, somehow, any one of them should marry him, he'd stay with her on Saturday night, and not go catting about with pickups and whores.

(1987: 74)

It is only by taking into account these versions of the story that we can begin to understand Elvis's continued appeal throughout the period of his supposed decline. The accounts provided by fans/critics such as Pratt, Taubin, and Wise – especially when considered alongside Elvis's strong performance on the charts and

at the box office throughout the 1960s – indicate that the competing myths of Elvis as a "butch god" and Elvis as a "teddy bear" (to use Wise's terms for the dichotomy at work here) are probably more evenly distributed across the population as a whole than the standard (i.e., male) rock criticism version of Elvis's story would have us believe. Of the two, the butch god is undoubtedly the more prominent figure in mainstream media depictions of Elvis, but this doesn't mean that the majority of Elvis's fans actually saw (or see) their idol this way.

To rephrase a portion of Wood's argument concerning Elvis's racial politics, the invisibility of the Elvis-as-teddy-bear myth across the surface of US culture can be seen as the result of a "huge conceptual failure" by men to see women and girls as consumers of culture. As Sheryl Garratt points out in her discussion of the "teenybopper" fans who screamed for the Bay City Rollers,

> like a lot of female experience, our teen infatuations have been trivialized, dismissed, and so silenced What the press or any of the self-appointed analysts of "popular culture" fail to reflect is that the whole pop structure rests on the backs of these "silly, screaming girls." They bought the records in millions and made a massive contribution to the early success of Elvis, the Beatles, the Stones, Marc Bolan, Michael Jackson, and many of the others who have since been accepted by the grownups and become monuments, serious reference points in the rock hierarchy. Before you sneer again, boys, remember that it's often their money that allows you your pretensions.
>
> (1984: 400)

Similarly, Wise, in attempting to reclaim Elvis and his image from the butch god worshippers who have dominated the public discourse on Elvis, claims that what his female fans actually thought and felt about Elvis has never really been taken into consideration in accounts of his cultural impact:

> It was men who claimed Elvis as their butch god, men who bathed in his reflected glory, men who felt betrayed when the girls stopped screaming, men who depicted this phallic hero as having worldwide cultural significance. What women thought then and now is largely unknown because, quite simply, no one bothered to ask or even thought that our views were worth anything. After all, what is the point of talking to someone, let alone taking what they say seriously, who merely *reacts* to male cues?
>
> (1984: 396–7)

It would be safe, then, to say that our collective vision of Elvis has been circumscribed by the limitations of male-dominated rock criticism, and that a fuller understanding of Elvis's impact upon US culture is only possible if we attempt to reconstruct what he meant (and means) to his female fans and to incorporate those visions of Elvis into the broader mosaic of his mythology.

I should emphasize here that it would be a mistake to argue that either of the two myths of Elvis described above is somehow closer to "the real Elvis." In the same way that the articulations of Elvis to questions of race are too complex to make him an unambiguous figure of either integration or racism, the links between Elvis and cultural myths of gender and sexuality are too diverse to allow for neat categorizations of Elvis (or his appeal) as "masculine" or "feminine." As Wise puts it,

> the two accounts of Elvis, as butch god and as teddy bear, are so dissimilar that one could be forgiven for thinking they describe two different people. But of course they are describing the same person from two quite different perspectives, and *neither* can be said to be the "true" or "real" picture of what Elvis "meant" in terms of popular culture.
>
> (1984: 396)

In a special issue on "50 Years of Teen Idols," *People* magazine (surprisingly enough) succinctly captures the tension between these two versions of Elvis's sexual mythology with the witticism that Elvis "was the King all right, sometimes the King of Hearts, sometimes King Leer" ("Elvis Presley," 1992: 49). It is probably Elvis's ability to occupy both of these positions simultaneously (or, at the very least, his ability to move back and forth between them in the same breath) that accounts for his lingering impact as a sex symbol.

Some of the more obvious contemporary examples of Elvis's androgynous nature can be found in his persistent re-emergence on the cultural terrain in the bodies of women. At the 1984 Grammy Awards, for instance, the Eurythmics performed their then-current hit single "Sweet Dreams (Are Made of This)" with lead singer Annie Lennox dressed up (convincingly) as Elvis circa 1969, complete with bushy sideburns. More recently, the Cucaracha Theater in Manhattan played host to a stage version of *Viva Las Vegas!* featuring a woman in the role played by Elvis in the original film: "And not just *any* woman," *Village Voice* columnist Michael Musto gushed, "the pouty, pompadoured Julie Wheeler captures Elvis's machismo and stolid acting style with gorgeous understatement – in fact, she's even butcher than he was" (1995: 26) (see plate 18). In *Generation X*, Douglas Coupland's (1991) best-selling debut novel, we find a character named Elvissa:

> Elvissa isn't her *real* name. Her real name is Catherine. *Elvissa* was my creation, a name that stuck from the very first time I ever used it (much to her pleasure) when Claire brought her home for lunch months ago. The name stems from her large, anatomically, disproportionate head, like that of a woman who points to merchandise on a TV game show. This head is capped by an Elvis-oidal Mattel toy doll jet-black hairdo that frames her skull like a pair of inverted single quotes. And while she may not be *beautiful* per se, like most big-eyed women, she's compelling.
>
> (1991: 88)

Meanwhile, William McCranor Henderson's *Stark Raving Elvis* (1984), the fictionalized account of the rise and fall of an Elvis impersonator named Byron, features a character known only as "the Elvis Woman":

> The door suddenly shoved open and an apparition blew in: an Elvis Woman, dressed in a jeweled white jumpsuit slashed to the waist so that her breasts heaved and bounced freely in the bare cleft of the V. Her hair was swept back into a version of Elvis's and her eyes were hinted behind purple-tinted aviator shades. Ignoring everyone else, she rushed straight at Byron, throwing him off balance as she pressed against him and kissed hard. Wendy staggered back a step, the breath taken out of her – first by the woman's sheer boldness, then by Byron's response, as she saw his hands grasp her butt. Then by a larger, more sickening version of the whole thing: Byron locked with Elvis in a hungry mutual embrace.
>
> (1984: 145)

The image Henderson presents us with here, of twin Elvisses – one male, one female – joined together in a narcissistic *pas de deux* is of course fictional, but it nevertheless bears an eerie resemblance to a somewhat tamer image from a real-life story in the *Washington Post* about the Virginia woman (mentioned in chapter 1) who legally changed her name to Elvis A. Presley (Pressley, 1991). The main photo accompanying this story shows Elvis and her husband holding one another and gazing into each other's eyes affectionately. While the former Lilly May Painter looks nothing at all like her famous namesake, her husband would need only a white jumpsuit to go along with his sideburns, puffy cheeks, and slight middle-age spread in order to pass for Elvis (or, more likely, for an Elvis impersonator). This is not quite the "hungry mutual embrace" between two self-absorbed Elvis clones that Henderson describes, but this photo of two Elvisses – one in name, one in appearance – is still a striking representation of the ways that the real Elvis can be simultaneously read as both masculine and feminine.[27]

A more blatant real-life appropriation of Elvis's androgynous sexuality can be found in the way that the mainstream fashion industry has recently transformed Elvis's look (or, more accurately, a range of his various looks) into a blueprint for women's clothing. Such a move isn't entirely without precedent: one of the standard clichéd images from Elvis's early career is that of a crowd of teenage girls dressed in skirts decorated with Elvis's name and picture, and today one can find female fans of all ages wearing countless updated versions of this homegrown fashion statement as they wander through the giftshops and exhibits at Graceland. Elvis-inspired clothing, however, has gone from a do-it-yourself expression of devotion to a mass-produced commodity promoted on the fashion pages of mainstream newspapers such as the *Washington Post* (Anders, 1992) and even the industry's major trade paper, *Women's Wear Daily* ("Elvis Is Everywhere," 1992).

While the former Lilly May Painter may be a female Elvis in name only, the women who populate *WWD*'s two-page spread on Elvis fashion – garbed in white jumpsuits, black leather jackets, lots of sequins and rhinestones, and "a bevy of Priscilla looks" – have appropriated his look instead, as if the female Elvisses described by Henderson and Coupland decided to quit their jobs as fictional characters in favor of employment as *WWD* models (see plates 19a–b).[28]

If there really is a female version of Elvis in US culture today, it would have to be Madonna. (For the record, Madonna has already cast her vote for this title in favor of fellow gender-bending singer k.d. lang.)[29] In the realm of contemporary popular culture, only Her Materialness can legitimately claim to have achieved the sort of boundless iconographic status that Elvis has. When Marcus first claimed, in 1975, that Elvis was "a supreme figure in American life, one whose presence, no matter how banal or predictable, brooks no real comparisons" (1990a: 120), he was probably right. On tour promoting *Dead Elvis* seventeen years later, however, Marcus wasn't quite willing to claim that Madonna has become "the next Elvis," but he did argue that "she's the only possible parallel" to Elvis's talent and success (Arnold, 1992: 20). Like Elvis, Madonna is an unavoidable and inescapable presence across the cultural terrain: you may love her, you may hate her, but unless you can successfully dismiss the entire field of popular culture as irrelevant, it is virtually impossible to ignore her.[30]

Comparisons between Elvis and Madonna, however, are nothing new; if anything, they've become relatively commonplace, appearing everywhere from satirical swipes at pop culture in the pages of the *New York Times* ("Sticky Questions . . . ," 1992) to academic essays on pop stardom (Seigworth, 1993), from Jim Jarmusch's use of juxtaposed photos in *Mystery Train* (1989) to "prove" that Elvis and Madonna are really one and the same person to Virgin America co-president Jeff Ayeroff's claim that Madonna is the Elvis of the 1980s and (possibly) the 1990s (Pond, 1990: 114). There are a number of parallels between the respective stardoms of Elvis and Madonna that help to account for the frequency with which the two are compared to one another: both have achieved sufficient worldwide popularity that they are readily identifiable by their first names alone, both have been the focal points for national moral panics over their "outrageous" public displays of sexuality, both attracted sizable followings of "silly, screaming girls" in the early part of their careers, both are known for making great music and bad movies, and so on. What's particularly interesting about these comparisons is the consistency with which Elvis is called upon as a reference point for calculating and evaluating Madonna's current position as a cultural icon. Ayeroff, for instance, claims that Madonna is as influential today as Elvis was in the 1950s, only "she's better than Elvis was, because Elvis was manipulated as opposed to being a manipulator . . . [and because] his intentions were misguided, where I think Madonna's are very well focused. She is politically correct, where Elvis was

politically incorrect" (Pond, 1990: 114, 116). Greg Seigworth, on the other hand, argues that the more crucial difference between the two manifests itself in the relationship each has to discourses of authenticity and in the ways that the value placed on authenticity by pop fans and critics has changed in the years between Elvis's heyday and Madonna's. For Seigworth, Elvis's inability to escape his own mythology led to his subsequent degeneration into kitsch and self-parody, and his decline serves as the cautionary tale that prevents Madonna from succumbing to similar pitfalls: "It is these lessons – think of them, perhaps, as a variation on what it means to learn from Las Vegas – that Madonna, for one, has followed so well" (1993: 308). *Village Voice* popular music critic Robert Christgau makes a similar, if more understated, argument in discussing Madonna's film *Truth or Dare* (1991):

> Instead of waiting for her own Memphis Mafia to spill the beans, Madonna commissioned Alek Keshishian to act as her authorized Albert Goldman, and at times she's alarmingly cruel, phony, and manipulative. At some level she clearly wanted to humanize and perhaps even debunk herself, yet as the most self-aware celebrity in history, she knew it was impossible – that every revelation would only reinforce a myth she spends half her career shaping and the other half hanging onto for dear life.
>
> (Christgau, 1991: 33)

While Christgau's comparison between Elvis and Madonna doesn't work as well as it might,[31] he too depicts Madonna as a star who uses the maps provided by Elvis's example to steer her own career.

This in fact is the way that the majority of the comparisons made between these two stars seem to function: as if the phenomenon that is Madonna were nothing more than the natural, evolutionary extension of a trajectory begun by Elvis, or as if the phenomenon that is Elvis were already sufficiently well understood that its only value lay in its ability to illuminate the (supposedly) more mysterious phenomenon of Madonna. What I want to suggest here, however, is that the comparisons between Elvis and Madonna only work because the similarities between them flow in *both* directions, and that Madonna can be used as a means by which we might come to a new and better understanding of Elvis at least as well as he can be (and has been) used to help explain her. For example, musicologist Susan McClary, in celebrating the ways that Madonna has challenged traditional gender roles in US culture, writes that

> the particular popular discourse within which Madonna works – that of dance – is the genre of music most closely associated with physical motion. The mind/body-masculine/feminine problem places dance decisively on the side of the "feminine" body rather than with the objective "masculine" intellect. It is for this reason that dance music in general usually is dismissed by music critics, even by "serious" rock critics To the extent that the

appeal is to physicality rather than abstract listening, dance music is often trivialized at the same time that its power to distract and arouse is regarded with anxiety.

(1991: 152–3)

L.A. Weekly columnist Michael Ventura describes Elvis's impact on US culture in the 1950s in much the same terms that McClary addresses Madonna's cultural significance today:

Elvis's singing was so extraordinary because you could *hear* the moves, infer the moves in his singing. No white man and few blacks had ever sung so completely with the whole body Presley's moves were body-shouts, and the way our ears heard his voice our bodies heard his body. Girls instantly understood it and went nuts screaming for more. Boys instantly understood it and started dancing by themselves in front of mirrors in imitation of him. Nobody had ever seen a white boy move like that. He was a flesh-and-blood rent in white reality. A gash in the nature of Western things.

(1985: 152–3)

While Ventura couches his discussion of Elvis's violation of the mind/body split in terms of racial differences (which are, as we've already seen, not necessarily distinct from questions of gender differences), McClary's discussion of Madonna points out that it is no less valid (and perhaps even more so) to think of this dichotomy as a gendered distinction as well. Seen in this light, Elvis's major transgression against the sexual mores of 1950s US culture was not (as adherents to the "butch god" myth would argue) that he persuaded a sexually repressed population to fuck more, but that his style, his fashion sense, and his onstage behavior celebrated the "feminine" pleasures of the body over the more "masculine" practices of the mind. Given the ways that Elvis challenged the traditional gender roles of the 1950s, it isn't unreasonable to suggest that he is the Madonna of his era at least as much as she is the Elvis of hers.[32]

The notion that Elvis rebelled against the normative codes of masculinity that pervaded US culture in the 1950s doesn't, however, require direct comparisons to Madonna in order to work. As David Shumway argues, Elvis was

the first male star to display his body as an overt sexual object. While most male movie stars have doubtless been portrayed as sexually desirable, their bodies have not been the locus of the attraction In calling attention to himself as sexual – that is, in presenting himself as an object of sexual incitement or excitation – he violated not just conventional morality but more importantly the taboo against male sexual display. In violating this taboo, Elvis became, like most women but unlike most men, sexualized.

(1991: 762–3)

Similarly, in *Vested Interests*, a book-length examination of the history and cultural politics of cross-dressing, Marjorie Garber finds important connections between Elvis's sexualized public image and transvestism:

> Elvis's appearance at the Grand Ole Opry, at the very beginning of his career, provoked a double scandal. His music was too black, and he was wearing eyeshadow. He was not asked back Elvis's hair created even more of a furor. It was like a black man's (Little Richard's; James Brown's); it was like a hood's; it was like a woman's. Race, class, gender: Elvis's appearance violated or disrupted them all Elvis mimicking Little Richard is Elvis *as* female impersonator – or rather, as the *impersonator* of a female impersonator.
>
> (1992: 367)

On the face of it, of course, there seems to be a glaring problem with Garber's argument, as the claim that a real and significant link exists between Elvis and transvestism appears highly counter-intuitive. Elvis, after all, was not only undeniably male, but he was never publicly known – not even within the fictionalized contexts of his movies – as a man prone to appearing in drag. And in fact, in a blistering polemic against Garber's work, Camille Paglia claims that one of the most egregious examples of Garber's "tabloid-sloppy reasoning" is the way that "rumors of homosexuality or sexual ambiguity of any kind become evidence of transvestism. Elvis Presley is grotesquely feminized and caricatured to support Garber's ridiculous idea that he was a 'female impersonator'" (1991: 98).

Paglia's seemingly reasonable objection to the connections that Garber makes between Elvis and transvestism, however, relies on a dramatic oversimplification of Garber's case – so much so that when one examines Garber's actual claims regarding Elvis's sexuality more closely, Paglia's argument falls apart entirely. Contrary to the impression one gets from reading Paglia's review, Garber does *not* claim that Elvis consciously and intentionally engaged in gender-bending displays of style and fashion, nor does she pretend to have uncovered some secret "truth" about Elvis (e.g., that he really was a closet transvestite all along). Instead, Garber situates her discussion of Elvis's sexuality in the midst of a chapter that explicitly argues

> for an *unconscious* of transvestism, for transvestism as a language that can be read, and double-read, like a dream, a fantasy, or a slip of the tongue I want to hypothesize what might be called "unmarked" transvestism, to explore the possibility that some entertainers who do not overtly claim to be "female impersonators," for example, may in fact signal their cross-gender identities onstage, and that this quality of crossing – which is fundamentally related to other kinds of boundary-crossing in their performances – can be

more powerful and seductive than explicit "female impersonation," which is often designed to confront, scandalize, titillate, or shock.

(1992: 354)

What Garber offers us here is not a half-baked argument concerning Elvis's "true" nature, but a carefully reasoned examination of the ways in which innumerable commentators have mythologized Elvis over the years. At the tail end of a litany of comments on Elvis's life and public image, all of which describe Elvis in feminine terms, Garber notes that

> critic after critic notices that his sexuality is subject to reassignment, consciously or unconsciously, though the paradox – male sex symbol as female impersonator – remains perplexing and unexamined Elvis moves in the course of his career along a curious continuum from androgyne to transvestite. This male sex symbol is insistently and paradoxically read by the culture as a boy, a eunuch, or a "woman" – as anything but a man.

(1992: 368)

Viewed in this context, the outrage that Paglia expresses at Garber's reading of Elvis's public image is completely unjustified: there is no heinous act of intellectual dishonesty here that Paglia has bravely unearthed, nor are Garber's claims the ridiculous caricatures of the truth that Paglia argues them to be.

In fact, Paglia's objections to Garber's argument are themselves more than a little ridiculous, given the similarities between Garber's claims and Paglia's statements in her own work regarding Elvis's sexuality. In her highly controversial best-seller, *Sexual Personae* (1990), for instance, Paglia repeatedly draws parallels between Elvis and a wide range of androgynous figures from art, history, and literature: the archetypal "beautiful boy" of ancient Greece, the Romantic poet Lord Byron, the charismatic personality of the first Duke of Buckingham, and Heathcliff from Emily Brontë's *Wuthering Heights*. In all of these examples, the primary rationale behind Paglia's comparison of these figures to Elvis is that they all embody a similar blurring of traditional masculine and feminine gender roles:

> The beautiful boy was an adolescent, hovering between a female past and male future He is a girl-boy, masculinity shimmering and blurred, as if seen through a cloudy fragment of ancient glass These youths have a distinctly ancient Greek face: high brow, string straight nose, girlishly fleshy cheeks, full petulant mouth, and short upper lip. It is the face of Elvis Presley, Lord Byron, and Bronzino's Mannerist blue boy.

(1990: 115)

Byron and Presley were world-shapers, conduits of titanic force, yet they were deeply emotional and sentimental in a feminine sense

Psychogenetically, Byron and Presley practice the secret art of feminine self-impairment.

(1990: 362)

Like Byron and Elvis Presley, Heathcliff suffers internal self-impairment. Appearances and reputation to the contrary, Heathcliff as a sexual persona is not conventionally masculine Heathcliff is one of the great hermaphrodite sexual personae of Romanticism, a dream-representation of Emily Brontë as naturalized Byron.

(1990: 453)

I compared the charisma of Lord Byron and Elvis Presley to that of the opportunistic first Duke of Buckingham. . . . Charisma is the radiance produced by the interaction of male and female elements in a gifted personality. The charismatic woman has a masculine force and severity. The charismatic man has an entrancing female beauty.

(1990: 521)

Paglia's consistent reading of Elvis as an androgynous figure is thus no more – and no less – ridiculous than Garber's claim that Elvis is a "male sex symbol as female impersonator" (1992: 374). In fact, ultimately both Garber and Paglia argue not only that Elvis doesn't fit neatly into stereotypical gender roles, but that the tension between the masculine and feminine facets of his image is what made him such a compelling sex symbol in the first place.

But while Paglia works primarily to link Elvis and his ambiguous sexual persona to historical figures, Garber's argument does more to help us understand the gender politics of Elvis's current cultural ubiquity. As Garber points out,

the word "impersonator," in contemporary popular culture, can be modified *either* by "female" *or* by "Elvis." Why should this be? Why is "Elvis," like "woman," that which can be impersonated? From the beginning Elvis is produced and exhibited as parts of a body – detachable (and imitable) parts that have an uncanny life and movement of their own, seemingly independent of their "owner": the curling lip, the pompadour, the hips, the pelvis Elvis is also – like a woman – not only a marked but a *marketed* body, exhibited and put on display, merchandised.

(1992: 372)

The same patriarchal cultural logic that allows women to be objectified, packaged, and displayed as mere body parts (e.g., eyes, lips, hair, breasts, legs, etc.) also reduces Elvis to readily appropriable fragments (e.g., the sideburns, the sneer, the pelvis, the jumpsuit, etc.) and keeps him working long after his death.

This particular logic, however, applies to Elvis only because his sexual persona is sufficiently feminine to make such appropriations feasible: a claim that can't

safely be made of many other male rock stars (Bob Dylan, Axl Rose, Bruce Springsteen, etc.). This is not to say that the feminine aspects of Elvis's sexuality are in and of themselves sufficient to explain his lingering presence across the cultural terrain, as there are numerous female celebrities, all of whom are far more feminine than Elvis ever was, who will most likely never achieve the sort of cultural ubiquity that Elvis enjoys today. In part, this is because the same patriarchal logic that reduces both women and Elvis to appropriable body parts doesn't work precisely the same way for Elvis that it does for women. When, for example, Elvis is reduced to a hairstyle, that detached part still signifies a named and identifiable whole body; when a woman is reduced to a hairstyle, however, that detached part typically works to transform the woman in question into an anonymous and interchangeable object (e.g., a blonde, a redhead, a brunette). Nevertheless, the androgynous nature of Elvis's sexuality is necessary (if not sufficient) to his strange posthumous career, as a more unambiguously masculine Elvis (e.g., Carl Perkins, Jerry Lee Lewis) could never be objectified, fragmented, and repackaged enough to enable him to circulate so freely across the cultural terrain.

HOUND DOG

While the links between Elvis's mythology and broader cultural myths of race and sexuality are fairly easy to find across the terrain of contemporary Elvis sightings, the relative invisibility of class as a marker of difference in US society[33] makes the articulations that exist between Elvis and myths of class harder to locate with any precision. Admittedly, the rags-to-riches saga that describes Elvis's rise from rural poverty to international superstardom is a prominent facet of the mythology, and one of this myth's most important themes is that class boundaries in the US are negotiable. I want, however, to defer comment on this particular articulation between Elvis and class until the next section of this chapter (which focuses on Elvis and the American Dream), not because Elvis's success story is irrelevant to a discussion of class relations in the US, but because the images of upward mobility and social transcendence at the heart of this myth are more directly relevant to Elvis's status as a symbol of America than they are to questions of class politics.

For now, I want to concentrate on the ways that the various markers of socio-economic class in the US that are not directly rooted in questions of economics (e.g., questions of taste, educational level, social background, upbringing) are played out across the terrain of contemporary Elvis sightings. The use of class as an identifying marker, after all, involves far more than a simple calculation of income and net worth. A truck driver, for example, may command an annual income that approaches six figures and own a home in an affluent suburb,[34] but nevertheless be thought of as occupying a less privileged class position than a university professor

who makes a third as much money and rents a two-bedroom apartment because he or she can't afford to own a home. The distinguishing feature between these two individuals' class positions is not economic capital, but cultural capital: stereotypically, at least, the professor is better educated, has more "refined" tastes in art and literature, engages in a form of work (i.e., mental, rather than physical, labor) that is more highly valued by our culture, and so on. Ultimately, it is these non-economic qualities that elevate the professor over the truck driver in the class hierarchy.[35]

Similarly, while Elvis's success as a singer and movie star dramatically increased his economic capital, his cultural capital never expanded enough for him to transcend the stigma of his background as a truck driver from the rural South. As Linda Ray Pratt argues, Elvis's inability to escape his lower/working-class image had profound repercussions on the way that he and his contributions to US culture were perceived: "No matter how successful Elvis became in terms of fame and money, he remained fundamentally disreputable in the minds of many Americans He was the sharecropper's son in the big house, and it always showed" (1979: 43, 45). Rock critic Bill Wyman uses a similar argument to explain what's going on with Elvis today, suggesting that Elvis's posthumous career relies on his status as a kitsch object: that he is currently everywhere on the cultural terrain because of "smart people laughing at dumb people" (personal communication, 4 February 1993).

As an explanation for the entirety of Elvis's current cultural ubiquity, Wyman's argument simply doesn't work, as far too large a percentage of contemporary Elvis sightings can't accurately be described as humorous, much less as kitsch. Chuck D or Vernon Reid, for instance, would disagree vehemently with the claim that their explicitly political arguments about Elvis and racism are merely campy, tongue-in-cheek jibes at "dumb people." Nevertheless, Wyman is right to point out that Elvis has become the butt of a long-running national joke: one of the most common ways that Elvis appears today, after all, is as a punchline or an object of ridicule in comic strips, sitcoms, movies, and the like. In the eyes of many people, Elvis simply isn't an important enough figure – artistically, culturally, or sociologically – to take seriously; thus, he's fair game to be mocked for the bloated excess of his later years, for his tastelessness in interior decorating, for the undignified manner in which he died, for shooting out television sets with handguns, and so on. This is not to say that all Elvis-related humor is as mean-spirited in nature as, say, Marty Wombacher's self-published volume, *Elvis Presley Is a Wormfeast!* (1991), which treats its subject with even less dignity and respect than its title would suggest. As musician and Elvis fan Mojo Nixon points out:

> *It's OK to make fun of Elvis.* My song ["Elvis Is Everywhere," 1987] is a celebration of Elvis, Elvis-mania and his fans. That doesn't mean that Elvis

didn't do some pretty stupid things or that some of his fans aren't completely whacked. Elvis seemed to be able to do the coolest thing & the shlockiest thing in the same five minutes and not know the difference. That's what makes him great; that's what makes him the Great American Zen Riddle.

(Nixon, 1992: xiv)

The fact remains, however, that a great deal (perhaps even the majority) of Elvis-related humor is laughing *at* Elvis and his fans, rather than *with* them.

More specifically, as Marcus pointed out in an interview with the *Boston Phoenix*, hidden at the heart of much of this laughter are a host of classist assumptions about art and culture:

[Zacharek]: A lot of people see Elvis as a sham, a phony, with no value beyond kitsch, which is the way many people see Madonna. Is that because people think that performers who achieve outrageous levels of popularity can't possibly have anything valuable to say?

[Marcus]: I think that question gets cut off before it even reaches Elvis. When people say that he was a fraud, or he just stole black music, or that he was just a product of his times, or he had a smart manager, or whatever – what's really going on is as simple and as ugly as class bigotry. They're saying "We can credit the fact that a popular performer could have real content in his or her art, or work, but this particular performer, Elvis Presley – this dope from the South – could not possibly have meant to communicate *anything*. He was simply a tool." So I think the question of whether something that was so popular for so long could carry strong meaning, doesn't even get addressed.

(Zacharek, 1991: 7)

If we make the mistake of assuming that an individual's class position is simply a function of his or her economic standing, then it becomes impossible to recognize – as we should – that the particular brand of anti-Elvis sentiment alluded to by Zacharek is, at its core, an expression of class-based prejudices. According to a strictly economic formula, Elvis spent the last twenty years of his life as a member of the upper upper class, and thus the only form of class bigotry one would expect him to have suffered would have been the sort of anti-elitist scorn and envy that the "have nots" often display towards the "haves." Such a vision of Elvis, however, is virtually non-existent within the mythological formation that surrounds him, not because he wasn't rich, but because his wealth wasn't the primary determinant of his class position. In the eyes of many (perhaps even most) of his fans, one of Elvis's greatest virtues was that he never strayed terribly far from his working-class roots, that his fame and fortune did not lead him to "put on airs." An oft-cited anecdote from the early days of his career captures this particular

strand of myth especially well. Following a nationally televised appearance on the *Steve Allen Show* in 1956 (where Allen dressed a reluctant Elvis in a tux and tails), Elvis told a crowd of 14,000 hometown fans at a Memphis concert, "Those people in New York are not gonna change me *none!*" For all his newfound fame and fortune, Elvis was determined to remain a good ol' country boy at heart. In the eyes of the arbiters of taste, however, the same refusal to abandon the trappings of his lower-class upbringing – a refusal that many of his fans celebrated – was seen to be a major flaw in Elvis's character: no matter how much money he made, he was still nothing but a hound dog.

The same class bigotry that works against Elvis spills over to tarnish the public image of his fans as well. As Patsy Hammontree points out, "there is a general misconception that only undereducated women on a low socioeconomic level constitute the Elvis Presley audience" (1979: 52), a misguided assumption rooted in the classist (and sexist) notion that only the most vulgar fraction of the masses (and/or women) could possibly find anything appealing in a figure as tacky and tasteless as Elvis. As any number of critics and fans have pointed out over the years (e.g., Sandow, 1987; Smucker, 1979; Wise, 1984), being an Elvis fan has always carried a certain social stigma: while generally very supportive of one another, Elvis fans are frequently looked upon by those outside their global community with intolerance and thinly veiled contempt. In Linda Ray Pratt's words, "although he was the world's most popular entertainer, to like Elvis a lot was suspect, a lapse of taste. It put one in beehives and leisure suits, in company with 'necrophiliacs' and other weird sorts" (1979: 44).

Even critics and scholars who take Elvis seriously (as a singer, as an artist, or as a figure of historical and cultural importance) are subject to scorn and derision – perhaps even more so than "ordinary" fans, as these critics have supposedly accumulated enough cultural capital "to know better." For example, there's a scene in Don DeLillo's novel *White Noise* (1985) where the story's narrator, Jack Gladney (chair of the department of Hitler Studies at the College-on-the-Hill) joins his friend Murray Jay Siskind (a junior faculty member trying to make a name for himself by doing with Elvis what Gladney has done with Hitler) in an impromptu lecture on Hitler, Elvis, and death. Reflecting afterwards on how he has helped to enhance Siskind's scholarly reputation, Gladney offers a telling description of how the intellectual community typically sees Elvis:

> Murray sat across the room. His eyes showed a deep gratitude. I had been generous with the power and madness at my disposal, allowing my subject to be associated with an infinitely lesser figure, a fellow who sat in La-Z-Boy chairs and shot out TVs. It was not a small matter. We all had an aura to maintain, and in sharing mine with a friend I was risking the very things that made me untouchable.
>
> (1985: 73–4)

At the core of Gladney's assessment of Elvis as "an infinitely lesser figure" is the notion that he is simply not a subject worthy of scholarly attention: not only did Elvis have no cultural capital himself, but he actually drains it away from all those who would deign to take him seriously. Siskind, for instance, can't gain either economic or cultural capital (i.e., tenure or a scholarly reputation, respectively) via his work on Elvis without the public aid of an established scholar (i.e., Gladney) whose research deals with a more prestigious historical figure (i.e., Hitler). Moreover, Gladney's comments imply that Elvis is so undeserving of serious intellectual consideration that the brief appearance he makes here in an academic setting is more than just an unwelcome intrusion into the sacred grounds of higher learning: it's a potential threat to the scholarly "aura" and vast store of cultural capital that Gladney has accumulated for himself over the years.

The example of Jack Gladney is, of course, a fictional one, but the phenomenon he represents is very real. Intellectuals have traditionally been unwilling to see Elvis as a figure of sufficient importance to undertake serious critical work on his life, his art, or his cultural impact, and the rare exceptions to this trend have often been met with outrage and condemnation from scandalized observers. For example, when the pop-intellectual journal *Archaeology* saw fit to publish a one-page essay drawing serious (and credible) comparisons between the quasi-religious aura that surrounds Elvis today and the religious rites and customs of ancient Greece and Egypt (Silberman, 1990), the editors were taken to task for debasing the magazine and its intellectual project by treating such an unworthy subject with even a modicum of respect. As one reader complained:

> I was really surprised that you used that article about the boring Elvis cult! You would use one on McDonald's? Surely archaeologists in the distant future will find more interesting things in our culture – our struggle to save the environment, classical music, and art that isn't meaningless.
>
> (H. Ludwig, 1990: 10)

A similar reaction greeted a course taught at the University of Iowa in the spring of 1992 by Peter Nazareth, Professor of English and African-American World Studies, entitled "American Popular Arts: Elvis as Anthology." The course rapidly turned into an international media event,[36] and from the tone of most of the coverage, it would appear that Nazareth spent nearly as much time defending the course as he did teaching it. This onslaught of media attention wasn't, however, an indication that Nazareth or his course were being taken seriously; on the contrary, a "legitimate" university course would most likely not have received any press coverage at all. A course on Elvis, however, is newsworthy for precisely the same reasons as a "Man Bites Dog" story – because of its deviation from the norm – and, not surprisingly, the bulk of the press that the course received was far from respectful in tone. Even the most even-handed coverage depicted the class as little

more than an amusing novelty, while the more openly slanted reports crossed the line into scorn and ridicule. For example, the editors of *Insight* magazine placed a short item on the course in their "Hall of Shame" pages, quoting "eagle-eyed Shame Spotter" Michael Burns's claim that "this is obviously a class to pad the GPA. What relevance does it have to life?" ("Elvis Study," 1992: 29). The *Iowa City Press-Citizen* expressed its disdain for the course in a more subtle way: the paper refused to send one of its own reporters across town to the University of Iowa campus to interview Nazareth in person, running a story off the Associated Press wire instead (Greg Smith, 1992). Even the more straightforward stories on the course implied that the study of Elvis was not an appropriate endeavor for a major research university: a seemingly obligatory aspect of all of these stories was at least one defensive statement from Nazareth to the effect that "this is not a frivolous course by any means" ("Elvis 101," 1992; also see Keller, 1992; "Professor Teaches Class . . . ," 1992; and Woodin, 1992). After several dozen encounters such as these, Nazareth finally turned the "Why Elvis?" question back upon the journalists interviewing him: "The surprise to me is that people are surprised that Elvis is the subject of a university-level course. Here is a figure who has been so much a part of people's consciousness. Shouldn't we examine what that means?" ("Media Clamor Over . . . ," 1992).

The answer to the question implicit in Nazareth's comments here – "Why *not* Elvis?" – lies not so much in whether Elvis really played an important role in the lives of millions of people (even his staunchest critics don't deny that Elvis had such an impact, complaining instead either that he didn't deserve to be such a major figure or that his impact was more negative than positive in nature), but in whether Elvis can legitimately be described as "an artist." Traditionally, the answer that scholarly critics have given to this question is an emphatic "No": in their eyes, Elvis may have been a popular singer, or a highly visible cultural icon, but the fact that he wasn't a creative talent (not in the sense that those words are usually intended, at least) means that what he did could not properly be described as art.

The notion that "Elvis" and "art" are incommensurable terms is fairly widespread, both inside and outside of intellectual circles. To give but a few examples: the November 1990 issue of *Spy* magazine contained a cartoon (p. 26) of a pompadoured streetside art vendor, dressed in a white jumpsuit and striking a stereotypical pose from Elvis's Vegas concert days (i.e., arms outstretched, down on one knee, head bowed), that bears the caption, "Art Imitates Life Imitates Elvis." Here, Elvis is not merely distinct from art, he's twice removed from it (see plate 20). A late 1980s edition of Dan Piraro's comic strip *Bizarro* offers a similar message: set in a very high-culture-oriented art gallery (as indicated by the oversized paintings with ornate frames), the strip's joke is based entirely on the incommensurability of a nerdy-looking patron asking a museum guide, "Which

way to the Elvis paintings?" in a context where Elvis clearly doesn't belong at all (Piraro, 1988: 40) (see plate 21). Perhaps a more telling example of the gap between Elvis and our common-sense notions of what constitutes art comes from a 1992 *Musician* cover story on Elvis's music. The bulk of the article consists of snippets from interviews with nearly two dozen musicians, engineers, and song-writers who had worked with Elvis over the years, but the most interesting revelation comes in the article's introduction, which describes this array of talent as "the men and women who bore witness to Presley's most interesting and perhaps most intimate dimension – making music. Oddly, several of them told *Musician* that no one had ever asked them about *that* before" (Cronin *et al.*, 1992: 52).

Implicit in the refusal to see Elvis as an artist are at least two classist assumptions. The first of these concerns the supposed inability of the lower classes to engage in the kind of serious thought necessary to produce "art that isn't meaningless." As Marcus points out in Elvis's defense, "The reason why it has been nearly impossible to credit Elvis Presley with intention beyond undifferentiated desire, which is also the reason why it remains so difficult to credit his music with meaning, is first of all social: white trash don't think" (1990b: 120). Implicit in the anti-Elvis argument Marcus describes here is the notion that art, as we commonly use and understand the term, is something inherently alien to a lower/working-class way of life: members of the lower classes can become great artists, but to do so they must first transcend the cultural (rather than the economic) limitations of their class background (e.g., they must learn to compose music, or write poetry, or paint portraits, etc.). Art, as we commonly use the term, is only possible under conditions where relative economic prosperity allows people the luxury of a certain degree of leisure, and where those people have also accumulated enough cultural capital to engage in specific forms of leisure practices. As Marsh points out, however, such conditions are far removed from the working-class world of rural Mississippi during the Depression that was Elvis's birthright:

> The ambitions Gladys Presley meant to instill in her only child were the ordinary working-class aspirations for better-paying work with some security and perhaps even a pension. Possibly she imagined that Elvis would go to trade school or apprentice out to learn some skilled job. Judging by how closely she nurtured him, walking him to school every day until he was fifteen, Gladys may even have dreamed that Elvis would become a preacher. But she never imagined he would become an entertainer; *the very idea of any of her kin being regarded as an artist would have been befuddling*. The Presleys worked for a living; they did not honky-tonk, and if they painted, they painted houses and walls.
>
> (1982: 2, emphasis added)

The difficulty in seeing Elvis as a serious artist begins here, with the incommensurability of his working-class background with the social and economic conditions in which art (or, more precisely, the sort of art that is valued as cultural capital) becomes possible.

The second classist assumption hidden within the inability to see Elvis as an artist involves the elitist biases imbedded within our common-sense notions about what can (and can't) properly be considered art. Most of what Elvis contributed to popular music came from well outside the traditionally valued realms of artistic labor: he didn't compose songs or write lyrics, he wasn't a virtuoso instrumentalist, he was never formally credited as a producer for his recording sessions, and so on. And while many critics have described Elvis's singing as the site of his most important aesthetic achievements, Elvis neither worked in a musical genre (such as jazz or opera) where singers are regularly valued as great artists in their own right, nor did his music manage to transform rock 'n' roll into such a genre. Even those critics who claim Elvis's records were great music have not always recognized Elvis himself as a great musician.

In order to see Elvis as a serious artist, then, we must rethink the very grounds upon which we make aesthetic judgments. As Bono, lead singer of the Irish rock group U2, points out, the consistent refusal to see Elvis as a serious artist is a blindspot rooted in classist assumptions about art and creativity:

> I believe Elvis Presley was a genius. He didn't express himself the way the middle classes do, which is with wordplay and being able to explain his actions and reactions. He acted on gut instinct and expressed himself by the way he held the microphone, by the way he moved his hips, by the way he sang down the microphone. That was his genius Elvis Presley could say more in *somebody else's song* than Albert Goldman could say in any book. And this is the thing about rock & roll music, this is what music has that makes it better than all that: it is instinctive And isn't that the way it should be? Elvis had the wisdom that makes wise men look foolish.
>
> (Flanagan, 1987: 451–2)

For Bono's argument about Elvis's artistry to work, however, one must abandon traditional standards of what constitutes art and replace them with a completely different aesthetic, one that is more populist and anti-elitist in spirit. Bangs captures the flavor of this aesthetic succinctly in his description of the music that Elvis, Phillips, and others made in Memphis in the 1950s:

> Sun Records at its peak was like punk rock at its best, the premise and principle of American democracy brought right back home: I/you can do it too. Anybody can do it. All it takes is the spirit and a ton of gall. A quarter of a century later and *still* most people apparently don't realize (or, if they

do, refuse to accept) this basic and transparently obvious fact. It's not about technique. It's not about virtuosity, twenty-five years at Julliard, contrapuntal counterpoint, the use of 6/8 time in a Latin-tinged context. *This stuff is not jazz* This stuff is dirt. Everybody at Sun was white trash. The whole point of American culture is to pick up any old piece of trash and make it shine with more facets than the Hope Diamond. Any other approach is Europeanized, and fuck that – the whole continent's been dead a hundred years. Sid Vicious was the only time it came to life in a century.

(1980: 326–7)

As is clear from the choice of words the commentators cited here use to describe Elvis's genius (e.g., "gut instinct," "spirit," "gall"), this is an aesthetic not of the mind, but of the body, an aesthetic that explicitly rejects the standards of taste traditionally associated with intellectuals and high cultural capital.

At the same time, the fact that Elvis's art functions more viscerally than it does intellectually helps to explain why scholars (and other guardians of "high" culture) have consistently failed to recognize him as an artist. The same classist biases that valorize mental over physical labor when it comes to occupation (e.g., the implicit rules that elevate the academic over the truck driver on the ladder of social class) also help to determine the amount of cultural capital that adheres to artists and works of art. The types of music traditionally celebrated by elite cultural institutions (opera houses, symphony orchestras, conservatories, etc.) are primarily music for the mind, not the body. As Ventura describes it,

Even the greatest Western music, on the order of Bach and Mozart and Beethoven, was spiritual rather than physical. The mind–body split that defined Western culture was in its music as well. When you felt transported by Mozart or Brahms, it wasn't your body that was transported. The sensation often described is a body yearning to follow where its spirit has gone – the sense of a body being tugged upward, rising a little while you sit. And you almost always sit. And, for the most part, you sit comparatively still. The music doesn't change your body.

(1985: 143)

Elvis's early music, on the other hand, ran directly contrary to this aesthetic: the first thing it changed was your body. Like most rock 'n' roll prior to the arrival of Dylan and the Beatles, this was not music for sitting and thinking: this was music for dancing and partying and making out (and so on). It is thus not surprising that, over the years, intellectuals have generally only embraced popular music as an art form worthy of critical commentary in precisely those instances where they have been able to describe the music and artists in question according to aesthetic

principles similar to those that govern classical music: compositional brilliance, instrumental virtuosity, poetic lyrics, and so on. One of the few attempts to redeem Elvis as an Artist-with-a-capital-A, for instance, comes from Gregory Sandow, a self-described "refugee from classical music," who expresses "shock" at his discovery that Elvis's singing actually stands up well when judged "in classical terms" (1987: 71, 75). But while Sandow is ultimately impressed enough by Elvis's vocal range and phrasing to take his music seriously, his analysis is filled with apologetic qualifications and parenthetical asides (e.g., "all this is microphone singing, of course, and doesn't require the full commitment of mind and body needed to project in an opera house" (1987: 75)) that blunt the impact of his argument: Elvis had artistic talent, he seems to be saying, but not quite enough that we need to take him as seriously as we do "real" artists such as Callas or Pavarotti.

More crucial, however, is the fact that, in judging Elvis by the standards of high art, Sandow falls into a common trap of rock criticism: he attempts to assess the artistic value of popular music by using an aesthetic wholly external to it, and thus overlooks the precise aspects of the phenomenon that make it important enough to study in the first place. As Susan McClary and Rob Walser point out in their compelling critique of traditional musicological approaches to popular music,

> the numerous calls for "an aesthetic of rock," [are often] based on precisely the same faulty, unexamined criteria of traditional musicology (rock is great music too – it has transcendental redemptive moments; it has abstract structures too complex for anyone to hear; it should be studied as though it too is autonomous from pressures of social production; etc.).
>
> (1990: 281)

The pattern that McClary and Walser point to here explains why even those scholarly critics who are willing to treat popular culture seriously are reluctant to tackle Elvis as an artistic figure: judged by the standards of so-called high art, Elvis is almost inevitably found to be lacking. Even Sandow's valiant attempt to treat Elvis as an artist with a strong (if untrained) talent for classical vocal stylings ultimately fails to bridge the gap between Elvis's art and his cultural impact: it's highly unlikely, after all, that Elvis's fans bought all those billions of records because they appreciated his quasi-operatic singing abilities. In the eyes of intellectuals, whatever Elvis's cultural impact may have been (and, tellingly, Sandow denies that Elvis had any such impact, referring at one point to Elvis's gentle nature as "qualities we'd still need in our world *even if* (as rock critics might dream) Elvis really had somehow transformed it" (1987: 74, emphasis added)), it had nothing to do with art: it was purely a sociological, not an aesthetic, phenomenon.[37]

The inability to take Elvis seriously as an artistic figure, however, is by no means the exclusive province of academic scholars. This is not to say that those

non-academics and members of the lower and middle classes who aren't Elvis fans necessarily share the same aesthetic values (and classist biases) championed by the intellectual fraction of the upper classes: the fact that Elvis remains a more popular figure than, say, Mozart or Beethoven demonstrates that such isn't the case. Nevertheless, people who possess relatively little cultural capital are typically still savvy enough consumers of culture to recognize that not all forms of artistic expression are accorded equal value within the cultural economy: it doesn't take a doctorate in fine arts to realize that, even in the pop-culture-happy US, Mozart's musical oeuvre is more prestigious than Elvis's. Outside the confines of university campuses and the pages of scholarly journals, the terms used in such debates might be different ("cultural capital," after all, isn't exactly a household phrase), but the same classist biases found in many intellectual debates on the aesthetics (or lack thereof) of popular culture are a prominent feature of the more mainstream discussions of Elvis's artistic significance.

For example, opponents of the Elvis postage stamp often wound up arguing against it for precisely the same reasons that many academics deem Elvis an unworthy subject for scholarly work. To take but one example of many, Richard Cohen, one of the first people to campaign against the stamp, argued in the *Washington Post* that

> there are two ways to approach the Presley issue. The first is to question whether the late greaseball from Graceland did indeed make the sort of cultural contribution that merits a memorial stamp, contributions in the same league as others honored with a stamp – Enrico Caruso or Duke Ellington, for instance But there is yet a second question: Does Presley's private life disqualify him from the honor of having his mug on a stamp?
>
> (1988: 11)

Significantly, Cohen never directly addresses the first question (i.e., what contributions, if any, did Elvis make to US culture and art?). Instead, he points out that "critics may differ as to Presley's musical abilities," and then goes on to define Elvis's cultural contributions as purely sociological and economic in nature: "He was, and remains, enormously popular; his estate will earn an estimated $15 million this year" (1988: 11). Cohen's early rant against the Elvis stamp (which, at the time, was still more than four years away from becoming a reality) serves as a validation of Marcus's argument (Zacharek, 1991) that class bigotry often interferes with the question of whether a figure as popular as Elvis could possibly have anything valuable to say. Ultimately, Cohen justifies his refusal to address the question of Elvis's aesthetic/cultural value on the grounds that "it's impossible to separate Elvis Presley the musical artist from Elvis Presley the inarticulate slug at life's bottom": since Elvis, according to Cohen, was "a pig of a man," his artistic

achievements (which Cohen disparages with the parenthetical aside "such as they were") are wholly irrelevant to the discussion at hand (1988: 11). Moreover, as is the case with Wyman's claim that Elvis's current ubiquity stems from "smart people laughing at dumb people," Cohen's argument is couched in terms that attempt to hide his classist biases: his description of Elvis as "inarticulate" (like Wyman's description of Elvis's supporters as "dumb") is little more than a translation of elitist standards of taste and aesthetics into terms that (supposedly) reflect natural, rather than socially constructed, inadequacies.

The fact that Elvis has been the subject of such abuse, however, both from anti-popular-culture elitists on the right and from hipper-than-thou popular culture celebrants on the left, suggests that Wyman is at least partially correct in linking Elvis's current ubiquity to his status as a kitsch object. While it is overly simplistic to reduce the complex phenomenon of contemporary Elvis sightings to nothing more than "smart people laughing at dumb people," such an argument accurately points to a crucial tension in the mythological formation around Elvis that helps to keep him circulating within the cultural economy: namely, that a significant portion of Elvis's iconic proliferation depends on his current existence as an all-purpose punchline. Elvis doesn't work at the level of a nationwide joke solely because he has (or had) no cultural capital or because many people find it impossible to see him as an important artistic or cultural figure. What makes Elvis funny – and thus what helps to keep him working long after his death – is the fact that so many people (i.e., his fans) take him seriously *despite* his "obvious" irrelevance and unimportance. Ironically, then, the same classist biases that consistently deny Elvis recognition as a figure of artistic or cultural significance also help to keep him a prominent and active figure across the contemporary terrain of US culture.

FOLLOW THAT DREAM

Overshadowing, if not encompassing, all of the myths described above is that of Elvis as the embodiment of the American Dream and thus, by extension, as a symbol of America itself. In recent years, discursive links between Elvis and America have become so commonplace as to be almost trite; precisely what these articulations mean, however, varies wildly, as Elvis is frequently described as an example of both the best and the worst that America has to offer. In part, this seeming contradiction arises because Elvis's mythology is itself a multiplicity of contradictory stories, but no less important here is the fact that the term "America" doesn't function as a denotative label: rather, it stands in relation to "the United States" as myth does to fact. The United States, as a real political entity, has existed without interruption since the late eighteenth century; America, on the other hand, as a collective myth describing what the United

States could (or should) be, is something that must be (and is) reinvented on an almost daily basis. As Ventura puts it:

> To remember. To re-member. To put the pieces back together. America is being forgotten. America must be remembered. But can the pieces be put *back* together, or must we imagine them all over again, every generation, every day? Is our failure to *be* America literally a failure of the imagination? Because America was an act of imagination to begin with. There had been nothing like it; there was no model. Our revolutionaries were clearly "imagining things."
>
> (1985: 78)

Viewed in this light, the phrase "the American Dream" borders on redundancy, as America itself is nothing but a dream in the first place. As it's commonly used, however, the phrase is too ambiguous to be read as just a synonym for "America": in some people's eyes (such as Ventura's), the Dream is a collective dream *of* America, rooted in broadly defined notions of community and based on hopes for a better way of life for broad segments (if not the entirety) of the population; for others, however, the Dream is a dream *by* individual Americans, rooted in notions of individualism and based on hopes for upward mobility for atomized pockets of the population. To put it too simply, the former version of the American Dream can be described using the phrase, "We're all in this thing together," while the latter is better demonstrated by the maxim, "Every man [*sic*] for himself." To depict Elvis as the embodiment of the American Dream (or as the ultimate symbol of America) is thus to complicate an already tangled web of signification even further, allowing one fragmented and contradictory mythological formation to stand in for another. As Marcus puts it, the process of mutually reinforcing mythification that takes place between Elvis and America "is finally elusive . . . just like all good stories. It surrounds its subject, without quite revealing it. But it resonates; it evokes like cazy [*sic*]" (1990a: 128).

Marcus's original vision of Elvis's relationship to the American Dream, as described in *Mystery Train* (1990a), resonates quite strongly with the collective vision of America that permeates Ventura's work (1985: *passim*, but especially pp. 78–84). Anticipating (or perhaps inspiring) Bangs's scathing comments about "Europeanized" approaches to the aesthetics of popular music, Marcus argues that rock 'n' roll is a quintessentially American art form and needs to be understood as such. Thus, in Marcus's eyes, Elvis's artistic achievements and his status as a great American are inextricably intertwined: the best of his music simultaneously captured, reflected, and illuminated what was most valuable about the quintessentially American culture in which Elvis grew up, while his meteoric rise to cultural prominence in the 1950s helped to reshape and reinvigorate what it meant to be an American in the first place:

Elvis Presley's very first Tennessee singles . . . dramatize a sense of what it is to be an American; what it means, what it's worth, and what the stakes of life in America might be As a poor white Southern boy, Elvis created a personal culture out of the hillbilly world that was his as a given. Ultimately, he made that personal culture public in such an explosive way that he transformed not only his own culture, but America's.

(Marcus, 1990a: 4, 129)

Marsh offers a similar interpretation of Elvis's inflection (and absorption) of the American Dream, claiming that:

Elvis represents the boundaries of America's capacity for self-invention on the one hand and for the creation of communities on the other. His story is the ultimate account of cowboy individualism, for where most American pioneers had to invent only themselves, Elvis had to invent his own frontier as well, before he could begin to work on his self. There is no way one man will ever achieve more, working with himself, by himself, than Elvis Presley did. Throughout our history, the best and bravest Americans have lit out for the frontier. Few of them survived, and fewer still prospered, unless they were able to find a supportive community in which to integrate their values and discoveries – unless they were able to build something much larger than themselves out on the ultrapersonal frontier.

(1982: xv)

The version of the American Dream that Marcus and Marsh find in Elvis's story is thus not so much concerned with questions of economic gain and social mobility (though these aren't entirely irrelevant) as it is with questions of character (self-respect, humility, piety, etc.) and broader cultural values (community, democracy, equality, etc.). This is a vision of the American Dream as a collective project, and what makes Elvis such a compelling figure to Marcus and Marsh is not simply that he built a better world for himself, but that he helped to build a better world for all of us.

Other critics, however, view Elvis's inflection of the American Dream as one more firmly rooted in individualistic desires for financial security and class ascendancy. Guralnick, for instance, describes the saga of Elvis's upward mobility as "the classic American success story. Elvis, a desperately lonely, desperately ambitious child of the Depression, rising from that two-room Tupelo shack to a marble-pillared mansion on the hill" (1979: 142). Linda Ray Pratt puts a particularly Southern twist on this tale, describing Elvis as "the sharecropper's son who made millions, the Horatio Alger story in drawl" (1979: 41). Meanwhile, *Saturday Night Live*'s A. Whitney Brown describes – quite bluntly – the American Dream that Elvis embodied as a purely capitalistic fantasy:

And what *is* the American dream? It's different things to different people. To a farmer, it's a bountiful harvest, that he can sell, for a lotta money. To a photographer, it's a beautiful picture, that he can sell, for a lotta money. To a soldier, it's becoming a general, so that he can sell weapons to a foreign country, for a lotta money. But maybe I can best express the American dream in a story. It's about a kid who grew up in Tupelo, Mississippi, in the early 1950s. He was a poor kid, but he had a rockin' guitar, some flashy clothes, and a wiggle in his hips – and he had that certain something, called "talent." Of course, he never made a nickel, because he was black, but two years later Elvis Presley made a fortune doing the same thing.

<div align="right">(quoted in Marcus, 1991: 129–30)</div>

While there is certainly more to these particular visions of Elvis and the American Dream than merely making "a lotta money," the bottom line to living out that dream is invariably described in economic terms: the American Dream may bring you more than just financial rewards, but it is impossible to achieve the Dream without first making "a lotta money."

Regardless of how one conceives of the American Dream, however, Elvis's decline and fall (whether it's seen to be embodied in his induction into the army, the shallowness of his Hollywood period, the bloated excess and laziness of his later years, or the gruesome and undignified manner of his premature death) inevitably transforms his story and its relationship to the American Dream into a cautionary tale. Whatever the American Dream might be, it isn't supposed to end the way that Elvis did: in isolation, loneliness, paranoia, obesity, and drug abuse. Consequently, one of the more common themes running through the discourse surrounding Elvis's status as a quintessentially American icon is an attempt to give the fable of his life story its proper moral. Did the American Dream fail Elvis? Is the American Dream really a lie or, even worse, a nightmare? Or did Elvis abandon the American Dream? Did he somehow stray from the path that would have brought him to the Dream's inevitable happy ending? While different critics and commentators take a variety of positions on these questions, they all seem to agree that, somewhere along the line, something went horribly wrong: the question that needs to be answered, then, is where we should lay the blame for the derailment of the American Dream that Elvis's decline represents.

The most commonly offered answer to this question is one that accepts the American Dream as basically sound, but faults Elvis (at least indirectly) for not following the Dream in as diligent a fashion as he should have. Marsh, for instance, points out that "there are those who claim that [Elvis's] final acquiescence proves the American Dream a nightmare, but they're wrong. What Elvis Presley's story really proves is that all dreams become nightmares unless they're carefully nurtured" (1982: xv). There are almost as many different opinions as to what it

was that Elvis should have nurtured more carefully (or what it was that led Elvis to neglect his responsibilities) as there are critics and fans who have wrestled with these questions. Marcus provides a particularly succinct summary of the most commonly offered explanations for Elvis's decline:

> There is a deep need to believe that Elvis (or any exemplar of American culture one cares about) began in a context of purity, unsullied by greed or ambition or vulgarity, somehow outside of and in opposition to American life as most of us know it and live it It is virtually a critical canon that Elvis's folk purity, and therefore his talent, was ruined by (a) his transmogrification from naïve country boy into corrupt pop star (he sold his soul to Colonel Tom, or Parker just stole it), (b) Hollywood, (c) the Army, (d) money and soft living, (e) all of the above.
>
> (1990a: 158–9)

This lost purity takes many forms but, whatever its shape, it's an essential part of any version of the Elvis myth that still wants to hold onto the American Dream as valid. As Marcus puts it,

> this Faustian scenario is an absolutely vital part of Elvis's legend, especially for all those who took part in Elvis's event and felt bewildered and betrayed by his stagnation and decline. We could hardly believe that a figure of such natural strength could dissolve into such a harmless nonentity; it had to be some kind of trick. Even a decade after the fact, Phil Spector was convinced that Colonel Parker hypnotized Elvis.
>
> (1990a: 159n.)

According to this school of thought, whatever went wrong with Elvis's story was ultimately the result of some problem with the way that Elvis tried to live out the American Dream, rather than a problem with the Dream itself.

Bangs, however, suggests that Elvis's decline was not so much his fault as it was that of critics and fans. Writing as if he were Elvis, Bangs says:

> I'm sorry. Wait a second, no I'm not; you're just as much to blame for this hopeless cipherdom as I am, since you made me the biggest star in the world, believed in me, pinned all these false hopes on me I couldn'ta fulfilled even if I'd understood what you meant, that asshole Peter Guralnick and his friends: what the hell did they think I was, a slacker or something? . . . And fuck all the rest of you too, you "true fans" who bought any shit RCA slung out with my name on and made yourselves love it or say you did or pretend to You think you're paying tribute but that's the world's *worst possible* insult. I'd rather you told me I was shit, some of the time, or even shit all the time. *Anything.* But to say you love everything, indiscriminately, just because it was

me or had my name on it – well, that just says to me that you never cared about the music from day one. You couldn't have, or you woulda complained *somewhere* down the line, like maybe by *Harum Scarum* [1965], I dunno, they're all the same to me, too. But if you never cared whether I tried or not, then why in the hell should I?

(Bangs, 1980: 334–5)

Bruce Springsteen presents a defense of Elvis similar to the one that Bangs fantasizes Elvis would have offered for himself, one where the fault lies not in our stars, but in ourselves:

I don't think that Elvis let anybody down. Personally, I don't think he owed anything to anybody. I think that, as it was, he did more for most people than they'll ever have done for them in their lives. The trouble that he ran into, that's the trouble that you run into. It's hard to keep your head above the water, but sometimes it's not right for people to judge the way that they do I don't think Elvis sold out when he lived in Graceland – people never sold out by *buying* something. It wasn't ever something they bought, it was something they *thought* that changed.

(quoted in Marsh, 1987: 251)

It would be a stretch to claim that the arguments cited above are full-fledged critiques of the American Dream, but both Bangs and Springsteen implicitly recognize that the version of the Dream in which Elvis believed wasn't necessarily the same as that imposed upon him by his fans or critics. Viewed in this light, the American Dream is a site of continuous struggle between competing visions of what it means to be an American, and Elvis's problem wasn't that he lost sight of the Dream, but that he got caught in the crossfire. At the very least, Bangs and Springsteen are correct to point out that fans and critics placed a massive burden of unreasonable hopes and aspirations on Elvis's shoulders. As early as 1970, for instance, singer/songwriter Phil Ochs claimed that, "If there's any hope for a Revolution in America, it relies on getting Elvis Presley to become Che Guevara" (quoted in Cutler, 1985: 14). Similarly, a 1979 article in a Thailand newspaper quoted an unnamed person-in-the-street as saying, "America could bring peace to the world only when Elvis Presley was still alive. Just as they cannot bring that poor boy back, they can't bring peace to this part of the world" (quoted in Kanchanawan, 1979: 167).

The notions that Elvis should have been the next Che Guevara or that he alone could have brought peace to Southeast Asia are ludicrous ones. It is precisely the absurdity of such claims, however, that demonstrates the extent to which Elvis's image as a quintessentially American icon can be (and has been) invoked in arguments that have nothing whatsoever to do with Elvis *per se*, but everything to

do with people's hopes and aspirations for America. By 1987, this tendency had become so commonplace that Marcus was driven to denigrate the notion that Elvis embodied the American Dream as "a now-horrible cliché" (1991: 129). Given that Marcus had been one of the (if not *the*) first critics to celebrate Elvis as both a great artist and a great American, it seems safe to say that this claim is less a statement about Elvis (e.g., "Elvis didn't *really* live out the American Dream," or some such) than it is a rejection of what "America" and "the American Dream" had come to mean during the Reagan era. At a time when a scathing musical indictment of US governmental policy towards Vietnam veterans (Bruce Springsteen, "Born in the U.S.A.," 1984) could be routinely taken up as a celebratory anthem of national pride, the version of the American Dream that dominated the cultural terrain was one characterized, not by values of community, equality, and democracy, but by jingoistic, flag-waving patriotism and rapacious, self-centered greed. In such a context, Marcus's reluctance to describe Elvis as a great American reflects the difficulty that a large portion of the liberal community in the US had with celebrating *anything* in explicitly nationalistic terms during the Reagan/Bush era. In *Mystery Train*, Marcus argued that, "History without myth is surely a wasteland; but myths are compelling only when they are at odds with history. When they replace the need to make history, they too are a dead end, and merely smug" (1990a: 123). In the midst of the Reagan era, the myth of Elvis-as-the-American-Dream had simply become too smug for Marcus to see it as anything but an annoying cliché.

Such an interpretation of Marcus's recent commentary on Elvis is supported not only by his citation of A. Whitney Brown's description of the American Dream ("a lotta money") as the best summation of this "now-horrible cliché," but by his choice of Springsteen's vision of the American Dream as a rebuttal to Brown:

> the TV, the cars, the houses – that's not the American dream. Those are the booby prizes. And if you fall for them – if, when you achieve them, you believe this is the end in and of itself – then you've been suckered in. Because those are the consolation prizes, if you're not careful, for letting yourself out or lettin' the best of yourself slip away.
>
> (Marcus, 1991: 130)

In the midst of Ronald Reagan's second term in the White House (and with the prospects for anyone other than Vice President George Bush succeeding Reagan already looking very grim), versions of the American Dream such as Springsteen's – ones rooted in democracy and equality rather than in personal financial gain – were few and far between. What Marcus sees as "horrible" about linking Elvis to the American Dream at this historical moment is the likelihood that such a vision, regardless of the intentions behind it (or how obvious those intentions seem to be),

would become nothing more than a celebration of the economic success story that Elvis lived out. Everything else that Marcus finds valuable in Elvis's mythology (e.g., the sense of freedom captured in the best of Elvis's music, the feelings of empowerment and hope that music gave to countless listeners, etc.) would simply be ignored or erased from the myth altogether. It's for this reason, then, that – a mere dozen years after celebrating Elvis as a great American – Marcus claims that the myth of Elvis-as-the-American-Dream has reached a dead end.

In 1992, however, this clichéd myth briefly found new life again, as this was the year that Elvis appeared as both a surprisingly conspicuous player in the campaign to elect the next president of the US and as the subject of a forthcoming commemorative postage stamp from the US Postal Service (USPS). Thanks to the media attention devoted to these two events, Elvis remained firmly in the public eye for most of 1992 and into January 1993: the month when the Elvis stamp was officially released and President Clinton was inaugurated. Moreover, throughout this period, the most consistently recurring theme in the discourses surrounding these subjects was the question of Elvis's relationship to America and the American Dream. The facts of the situation were fairly straightforward: the USPS announced that it would issue an Elvis stamp and Bill Clinton proudly admitted that he was an Elvis fan. What kept these stories alive in the media, however, were the myths connected to them. Was Elvis's contribution to American culture sufficiently important that he should be accorded the honor of appearing on a stamp? Was he a suitable hero for a man who wanted to be the leader of the nation? What values did Elvis represent, and how did those values coincide (or fail to coincide) with the basic values of American culture?

These questions were not merely academic concerns. For example, many members of the general public expressed their distaste for the Elvis stamp not by expressing their lack of interest in Elvis (though this was often implicitly obvious anyway), but by arguing that the stamp would somehow do irreparable harm to America – though precisely how or why this was so was never made very clear. One letter to the editors of *Time* magazine stated that, "After reading that more than 1 million votes were cast to decide which new Elvis Presley stamp the U.S Postal Service should use, I guess more people believe that Elvis was alive than I previously thought. *I fear for America's future*" ("Ain't Nothing But . . . ," 1992, emphasis added). The author of a similar letter published in the *Chicago Tribune* claimed to be "truly disgusted that a drug addict such as Elvis will be honored with his own commemorative stamp. *This says a lot about America* and what we teach our children" (Dorsch, 1992, emphasis added). This last letter is a typical example of countless arguments that were made against putting "a drug addict such as Elvis" on a stamp in the midst of "our" war on drugs. The main rhetorical purpose of such commentary, however, was not so much to illuminate Elvis's character flaws as it was to reinforce the myth of America as a drug-free nation.

Meanwhile, in the realm of electoral politics, the articulation between the Elvis stamp and the presidential campaign was forged very early on. In part, this linkage can be attributed not only to the Postal Service's decision to hold an election of its own to choose the design of the Elvis stamp, but also to the fact that the initial public announcement about the stamp took place during the first few weeks of the presidential primary season. The simultaneous presence of two national elections receiving extensive media coverage made it easy for even the most unimaginative observers to make connections between the choice to be made between Young Elvis and Old Elvis and that to be made between George Bush, Bill Clinton, and Ross Perot. Shortly after the stamp run-off was announced, the press corps following Clinton's campaign privately nicknamed the candidate "Elvis," an in-joke that the Clinton organization played up to by issuing credentials featuring a slightly modified image of the young Elvis stamp to that same contingent of journalists. By June, when Clinton made his much-discussed appearance on *The Arsenio Hall Show*, the discursive overlap between the two elections was almost complete. Hall's very first question for Clinton was not about the economy, or the Democratic platform, or any other facet of the political campaign: instead, Hall wanted Clinton to justify his decision to back the younger version of the Elvis stamp. Later on, when Clinton had the Democratic nomination all but officially in hand, Elvis was formally listed as the "Entertainment Coordinator" for the party's July convention, and Clinton's running mate, Tennessee Senator Al Gore, Jr, opened his speech accepting the nomination by claiming that his dream had always been to come "to Madison Square Garden and be the warm-up act for Elvis."

Meanwhile, on the Republican side of the political fence, Bush repeatedly tried to use Elvis as a way to attack Clinton. For example, in accepting the nomination at the Republican Party's August convention, Bush said of Clinton that, "he says he's for balanced budgets. But he came out against the [balanced budget] amendment. He's like that on a lot of issues, first one side, then the other. He's been spotted in more places than Elvis Presley." Later in that same speech, Bush claimed that Clinton's economic "plan really is 'Elvis economics.' America will be checking into the 'Heartbreak Hotel'" ("Text of President's . . . ," 1992: 10). Six weeks after this, Bush quipped, "I finally figured out why [Clinton] compares himself to Elvis. The minute he has to take a stand on something, he starts wiggling" ("The King & I," 1992/3: 115; Marcus, 1992a: 15). Clinton responded to this last statement a few days later with the comment that "Bush is always comparing me to Elvis in unflattering ways. I don't think Bush would have liked Elvis very much, and that's just another thing that's wrong with him" ("The King & I," 1992/3: 115).

The voting public, at least, seems to have agreed with Clinton's assessment of Bush: as more than one commentator has argued ("The King & I," 1992/3; Marcus, 1992a), Clinton's affinity for Elvis (or, perhaps, Bush's antipathy towards him) may have been the deciding factor in winning the election for the Arkansas

governor. As Marcus put it, Bush effectively "alienat[ed] working-class white Southerners [i.e., the very constituency that had been pivotal in putting Reagan and Bush into office in the first place] with remarks that disparaged a cultural hero," while the Democrats were "clearly helped" by Elvis:

> After the primaries, when [Clinton] had fallen drastically behind Mr. Bush and Mr. Perot, he took his saxophone onto "The Arsenio Hall Show" and blew "Heartbreak Hotel." That moment may have turned the race around. Mr. Clinton stepped forward as if to say: *All right. Who cares. Let's rip it up.* For the first time in the campaign Bill Clinton was more Elvis than calculator. The spirit of freedom in Elvis's best music is a freedom of self-discovery – and that night Bill Clinton accepted the gift. Playing the old song as best he could, he was more fan than star, more himself than Elvis, but perhaps just Elvis enough.
>
> (1992a: 15)

The countless (and seemingly inescapable) articulations between the Elvis stamp and the presidential campaign led many columnists and cartoonists ("political" and otherwise) to suggest that the election to choose the stamp was more important (or, at least, more interesting) than the election to choose the country's next president. Moreover, commentary on the former frequently served as a thinly veiled allegory for commentary on the latter. For instance, with tongue planted firmly in cheek, syndicated columnist Calvin Trillin bemoaned the fact that the Elvis stamp run-off had rapidly turned into a "dirty" campaign, and that the exchanges of mudslinging and character assassination between the "Young Elvis" and the "Somewhat Older Elvis" camps had gotten out of hand: "Are we ever going to get to the point in the political life of this country," Trillin asked, "where a campaign is fought on the issues?" While Trillin was ostensibly describing the debate over Elvis's suitability for "display on first class mail," the reference to the name-calling and issue-dodging that characterized the other election attracting media attention at this time was hard to miss (1992: 2).[38] Probably the most common site where the discourses surrounding these two elections came together, however, was in cartoons, both on and off the editorial page: the Elvis stamp served, at the very least, as a metaphor for the changes in George Bush's public image,[39] a bellwether for choosing which candidate to vote for,[40] a symbol of the difficult (or perhaps irrelevant) choices to be made in the political election,[41] and a litmus test for determining when the time was right for trailing candidates to abandon their campaigns (see plate 22).[42]

Perhaps the most common theme in the various intersections between the discourses surrounding the Elvis stamp run-off and the presidential campaign was that the misplaced priorities that rendered the stamp more interesting to the public than the presidency indicated that *something* must be wrong with (a) the

public, (b) the candidates, (c) the electoral process, (d) America, or (e) all of the above. Humorist Beth Lapides, for instance, in a satirical piece on the inadequacies (and inanities) of the twisted process for choosing our nation's political leaders, claims that "fewer people are going to vote for President than voted for an Elvis stamp. And they had to pay 29 cents for their Elvis stamp vote" (Lapides, 1992). Meanwhile, Marcus argued that "the intensity of the national joke-cum-struggle over the choice between the old and young Elvis revealed, among other things, a profound dissatisfaction with the candidates actually on view" (1992a: 15). For both Lapides and Marcus, the combination of the strong public interest in the Elvis stamp and the public's overwhelming apathy toward presidential politics indicates that the electoral system, as it currently exists, is riddled with problems: at the very least, the system fails to satisfy the needs and desires of the majority of the US voting public and, as such, Lapides's and Marcus's comments can be read as implicit critiques of the insufficiently democratic nature of the system.

Harper's editor Lewis Lapham also sees Elvis's ubiquitous presence in the presidential campaign as an indication that the US political system is in trouble, but his assessment of the problem runs directly contrary to that suggested by Lapides and Marcus. While Lapham would probably agree that the way the Elvis stamp overshadowed the presidential campaign represents the public's over-whelming dissatisfaction with electoral politics, he places the blame for this widespread political apathy not on the political system or the politicians who abuse it, but on the general public and, as accomplices to this crime, the mass media that so willingly cater to the infantile desires and whims of that public. For Lapham, Elvis's persistent intrusions into the sacred realm of the presidential campaign symbolize the degeneration of "real" American politics (i.e., where the issues matter, and what the candidates have to say about those issues is of primary importance) into a barbaric orgy of celebrity worship and superficial images:

> At their respective nominating conventions in New York and Houston, Governor Clinton and President Bush both invoked the holy names of God and Elvis Presley, but it was clear from the tenor of their remarks that as between the two deities they placed their greater trust in the one with the rhinestones and the electric guitar Over the course of a generation the popular worship of images has become so habitual that we find it easy to imagine celebrities enthroned in a broadcasting studio on Mount Olympus, idly conversing with one another on an eternal talk show What they say matters less than who they are. Any statement is equal to any other statement, and the question of what Mikhail Gorbachev said to Ronald Reagan about thermonuclear war at a summit meeting in Iceland is of no more or less consequence than the question of what Madonna ordered for breakfast – raspberries or strawberries – in a suite at the Highlands Inn on

the morning after her marriage to Sean Penn. What matters is the presence of immortality. Elvis lives, and so does anybody else who can promote the corruptions of the private flesh into the incorruptibility of the public image.

(1992: 11–13)

Thus, in much the same way that the mere mention of Elvis in an academic context constitutes a threat to Jack Gladney's professional aura, Elvis's repeated appearances in the presidential campaign constitute a threat to Lapham's mythical vision of American politics and thus, by extension, to his vision of America itself.[43]

More than a decade ago, Marcus claimed that "American culture has never permitted itself to be exemplified by Elvis Presley, and it never will" (1981: 17). Postage stamps and presidential nicknames notwithstanding, Lapham's disgust at the "barbarism" of Elvis's role in the 1992 presidential campaign and the outraged indignation of critics such as Ralph Schoenstein (1992) over the Elvis stamp[44] serve as ample evidence that Marcus's claim has more than a grain of truth to it.[45] Nevertheless, I want to suggest here that Marcus's argument is only partially correct: that, whether it has permitted itself to be or not, America today is exemplified by Elvis Presley, albeit in a somewhat twisted fashion. True to the spirit of Marcus's statement, this act of symbolism doesn't find America embracing and celebrating Elvis as a figure worthy of honor and respect: the Elvis that epitomizes contemporary America isn't the Young Elvis chosen for the stamp design or the Older Elvis that lost the postal primary. Instead, the Elvis that exemplifies America today is the one who, against all odds and expectations, haunts the terrain of US culture decades after he was supposed to be just another dead rock star. As Marcus puts it:

There is no central figure to define the music or against whom the music could be defined, no one everybody feels compelled to love or hate, nobody everyone wants to argue about (what is pop music if not an argument everyone can join?), unless it's the undead Elvis Presley. . . . dripping fifteen years of rot.

(1992c: 69)

Admittedly, Marcus's comments here serve as a description not of America, but of his "image of the death of rock – or of rock as something that ought to be killed" (1992c: 68). Nevertheless, given "the rock 'n' roll fantasy Elvis made of the American dream" (Marcus, 1990a: 134) and the importance of rock ('n' roll) to the shape of US culture since the 1950s, arguments concerning the supposed death of rock invariably have important implications for the myths of America and the American Dream as well. To put it another way, if rock really is "something that ought to be killed," then the American Dream is in more or less the same

condition (i.e., it has mutated into the "now horrible cliché" that Marcus rails against) for precisely the same reasons. Compare, for example, the following two passages – the first on the death of rock, the second on the waning of the American Dream:

> The question of the death of rock comes up because rock 'n' roll – as a cultural force rather than as a catchphrase – no longer seems to mean anything. It no longer seems to speak in unknown tongues that turn into new and common languages, to say anything that is not instantly translated back into the dominant discourse of our day: the discourse of corporatism, selfishness, crime, racism, sexism, homophobia, government propaganda, scapegoating, and happy endings.
>
> (Marcus, 1992c: 68)

> As the American dream has dissolved into the postmodern frontier, the nation has been left with only an empty paranoia about America. Consequently, without knowing what it is they are to defend, people can only defend its symbols – emptied of any meaning or difference: the Constitution, the Statue of Liberty, the flag, and even its language. And these symbols, wherever they are, become little more than the signs of a staunch defense against something that they cannot name, something they know was not supposed to happen to them, but has already happened: we have become American.
>
> (Grossberg, 1992b: 290–1)

The terms that Marcus uses to describe rock's demise are strikingly similar to those Grossberg invokes in his assessment of the current state of the American Dream. According to these critics, not only have both "rock" and "America" been reduced to meaningless clichés, but both terms have largely been deprived of any critical or oppositional force they may have once had. To argue for something in the name of "rock" or "America" today is to close off debate, not extend it: America and rock have become self-contained categories that are too deeply entrenched in the repressive discourses that Marcus lists to be called into question.

I should emphasize here that to speak of "the death of rock" is not to claim that nobody is making (or listening to) rock music anymore, nor is it to say that the music being made today under the banner of rock is uniformly less inventive or exciting than that which came before it. Similarly, to speak of the waning of the American Dream is not to suggest that the Dream no longer ever comes true, or that the myth of America doesn't still function as a powerful guiding force in the lives of millions of people. On the contrary, there is still plenty of great rock (and rock 'n' roll) being made today, just as there are still countless people actively living out some version of the American Dream. The question, however, is not

one of facts (e.g., does rock/America exist?), but one of myths (e.g., what does rock/America mean these days?). And, at the level of myth, both rock and America are currently in a profound state of crisis. More to the point, these two crises are connected to the dramatic changes that both rock and the American Dream have gone through in response to the equally dramatic shifts in the social, cultural, and historical conditions that originally gave rise to them. In particular, the waning of the American Dream and the death of rock can largely be attributed to the aging of the baby-boom generation and the transformation of that genera-tion's collective ideals for a more egalitarian and harmonious America (e.g., "we will change the world") into the more selfish and conservative goals of an America built around entrepreneurial greed and individual financial security (e.g., "we are the world"). For instance, in his critique of the general public response to Lawrence Kasdan's film *The Big Chill* (1983), Ventura argues that the audience –

> innocent only by virtue of its refusal to consider the consequences of its life-style – finds in the film a permission to be increasingly lifeless. For [the film's] characters are dead to the world. They can make all the jogging shoes, real-estate deals and television series they want, but every day they just become more a part of the very thing they're accumulating wealth to defend themselves against. Which is the fate of most Americans – our baby-boom generation in particular. So *The Big Chill* pretends to be an exercise in nostalgia when it is really an exercise in surrender – both for the people who made it and the people who decide they can see themselves in it.
>
> (1985: 60–1)

Meanwhile, in describing the radical ways in which "the very conditions which enabled rock have been transformed," Grossberg (1993b) points to the fact that "the baby boom and the privileged position of youth in American society have given way to the increasing disempowerment of young people," largely because of "baby boomers who are desperately trying to hold onto their self-identity as being somehow youthful."

Where does Elvis fit into all of this? The answer to this question is perhaps best captured in the words of "one of the great Elvis Presley tributes" (Tannenbaum, 1992: 69), John Trudell's song/poem "Baby Boom Ché" (1992):[46]

> We were the first wave in the post-war baby boom
> The generation before had just come out of the Great Depression and
> World War II
> [. . .]
> Their music – you know, the songs life always carries,
> You know, every culture has songs –

Well, anyway, their music was restrained emotion
You know, like, you didn't wanna dance if you didn't
 know how
Which says something strange . . .
[. . .]
I mean, Elvis made us *move*
Instead of standing mute, he raised our voice
And when we heard ourselves, something was changing
You know, like for the first time we made a collective
 decision about choices
[. . .]
It's like we were the baby boom because life needed a
 fresher start
I mean, two world wars in a row is really crazy, man
And Elvis, even though he didn't know he said it, he showed
 it to us anyway
And even though we didn't know we heard it, we heard it
 anyway
Man, like, he woke us up
And now they're trying to put us back to sleep
So we'll see how it goes

Viewed in this light, the version of Elvis that graces a US postage stamp or resides in the White House bears a striking resemblance to Ventura's reading of *The Big Chill*: they pretend "to be an exercise in nostalgia when [they are] really an exercise in surrender," they are part of the dominant culture's efforts to try "to put us back to sleep." Elvis exemplifies America (whether America wants him to or not) because, like America (and like rock 'n' roll), he exists today as an often invoked but rarely examined mythical figure. With only rare exceptions, Elvis is celebrated (and condemned) in sufficiently superficial fashion that he has become an almost meaningless cliché: Elvis-the-stamp and Elvis-the-president are merely the image of Elvis without any of the affective investment behind them that the image once entailed. The question that remains is whether or not this process is reversible: if, as has occasionally happened to both rock and America in the past when they have been in a state of mythological crisis, it is possible to revive and reinvigorate Elvis's mythology so that it is no longer the "merely smug" dead end that Marcus warns us against. This is not, however, a question for which I can pretend to have a good answer, though I certainly have strong hopes: the best I can offer here is the same uncertain statement that Trudell provides: "So we'll see how it goes . . . "

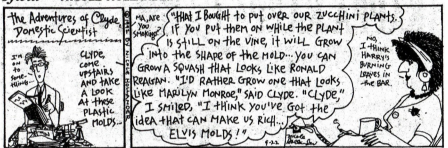

Plate 1 *Sylvia* comic strip (22 September 1992)
© 1992 by Nicole Hollander

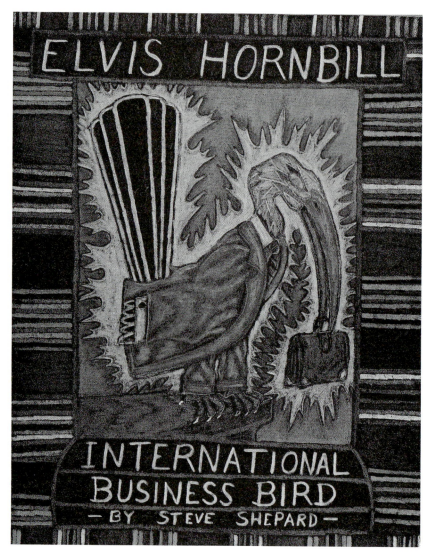

Plate 2a Elvis Hornbill: International Business Bird: front cover

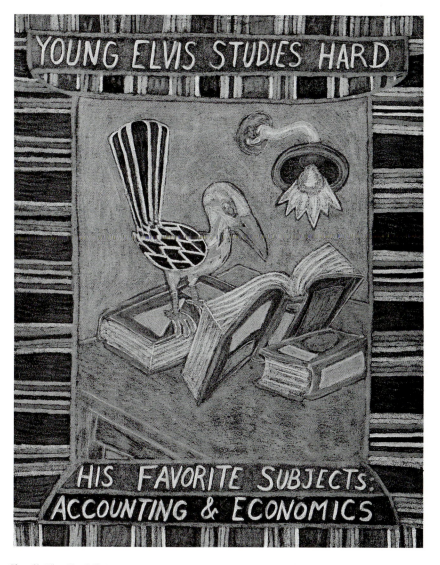

Plate 2b Elvis Hornbill: International Business Bird: "I beg Elvis to study music"

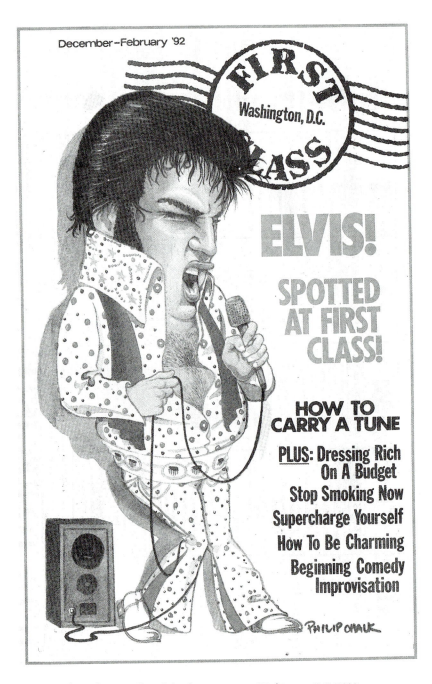

Plate 3 Catalogue for First Class adult education center, Washington, DC (1992)

Plate 4 SilverPlatter CD ROM databases, magazine advertisement (1991)

FALLEN EMPIRE

WE NEED TO WRITE SOMETHING IN THIS SPACE

BOOKART UNDER THE BENEVOLENT GAZE OF ELVIS
Elvis seems to be quietly dead of late. In an effort to reverse this trend, we've included a zany Elvis motif along with our sales pitch. Bookart is for displaying and transporting books. It may hang on walls or freestand. It looks great sitting on desks. Bookart is sturdy Poplar with Birch dowel rods. It comes with two sliding bookends which fit over the dowels and hold things securely in place. Able to hold the weightiest text book and the slimmest pulp fiction, Bookart is truly for book lovers and those short of space.
Color: natural
Size: 2' x 3'
#12100**$34.00**

Plate 5 Fallen Empire mail-order catalogue entry (1991)

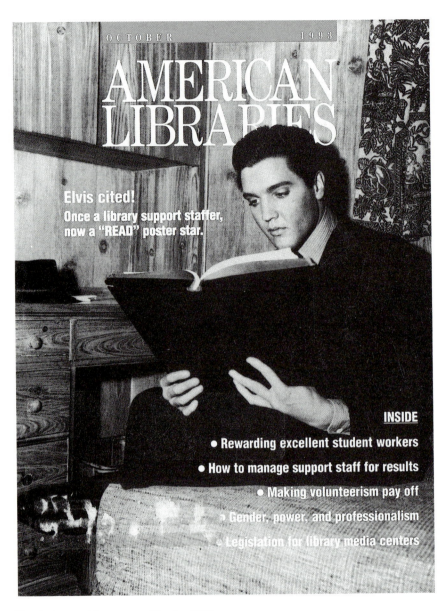

OCTOBER 1993

AMERICAN LIBRARIES

Elvis cited!
Once a library support staffer, now a "READ" poster star.

Plate 6 American Libraries cover (October 1993)

Plate 7 Angel Times cover (1995)
Painted by Kevin Roeckl for *Angel Times* magazine (Atlanta, GA). Used with permission.

Plate 8 Chile Pepper cover (October 1993)

Plate 9 The Humanist cover (May/June 1995). Photocollage and Illustration by Mimi Heft

"LOVE
ME
TENDER
LOVE
ME
COOKED!"

It ain' nothin' but a hot dog at

The Great
WALLINGFORD
WURST FESTIVAL

September 17, 18 & 19

**Eleven Years of Rockin' at
St. Benedict School
49th & Wallingford Ave. N.**

Plate 10 "The Great Wallingford Wurst Festival," special advertising insert in the *North Seattle Press* (September 1993)

**The MT120 with 5-band EQ.
Creative freedom. And a bit more.**

Quite a bit more. Like getting a rock solid bottom end
from the kick drum. Like bringing more brilliance to a cymbal.
Like making a dull guitar track scream. All from a four track
cassette recorder with an integrated mixer and a 5-band
graphic equalizer. When you go in to your local dealer,
don't ask for the MT120. Demand it.

YAMAHA®

Plate 11 Yamaha MT120 mixer/equalizer, magazine advertisement (1991)

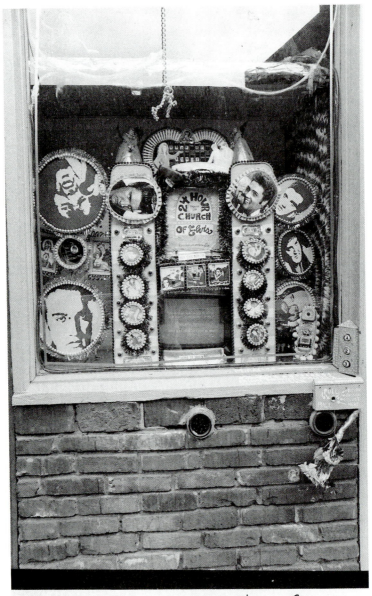

Portland, Oregon Photo by Krisanne Carnovale

Plate 12a The 24-Hour Coin-Operated Church of Elvis, Portland, Oregon.
Photograph © Krisanne Carnovale, 1989. Used with permission.

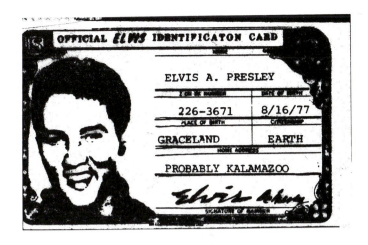

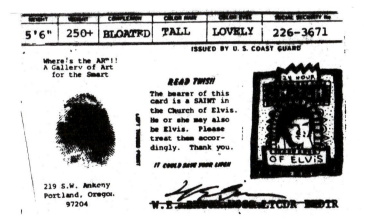

Plate 12b "Official Elvis Identification Card" (front and back) from the 24-Hour Coin-Operated Church of Elvis, Portland, Oregon

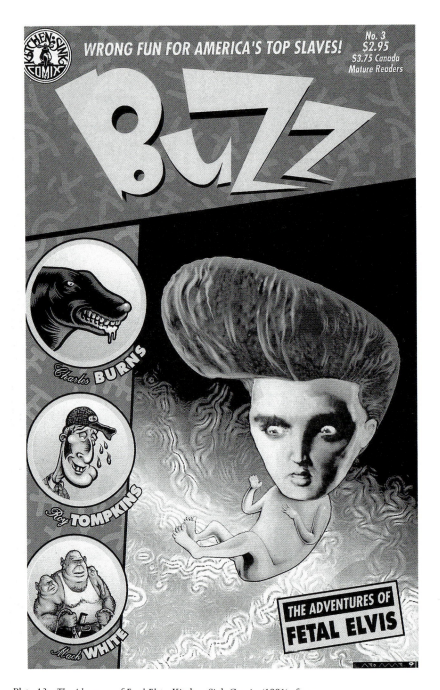

Plate 13a *The Adventures of Fetal Elvis*, Kitchen Sink Comix (1991): front cover

Plate 13b The Adventures of Fetal Elvis, Kitchen Sink Comix (1991): A happy ending

Plate 14 Elvis Shrugged, Revolutionary Comics (1993)

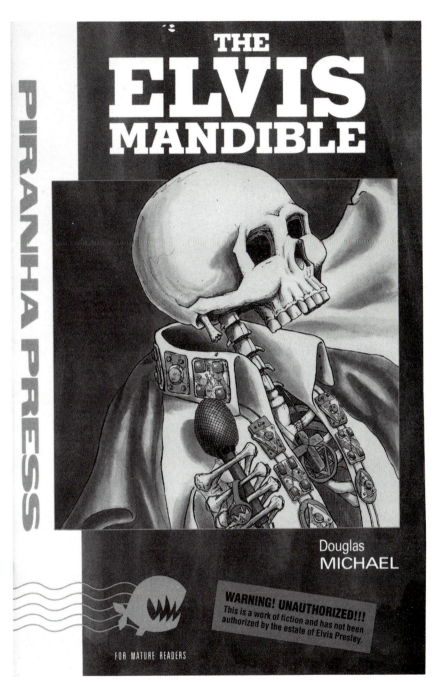

Plate 15 The Elvis Mandible, Piranha Press (1990). The Elvis Mandible copyright © Douglas Michael. Used with permission of DC comics. All rights reserved.

"MY ELVIS IMPERSONATIONS ALMOST BECAME A TRAGEDY— UNTIL I LOST 100 POUNDS"

By Leigh Thompson
Special Writer

Brad Bailey knew his entertainment career was about to hit bottom, his 305-pound body pulling him down as surely as a lead anchor.

He could feel it as he spun his body, as he gyrated his hips, as his chest heaved with each breath that shaped the lyrics to Elvis Presley's *Suspicious Minds*.

There he was—as if in a dream—on the stage in the crowded night club north of Phoenix. He looked, he sounded like his idol at the moment the King of Rock 'n Roll died, an obese hulk at the age of 42.

BEFORE **AFTER**

But this Elvis impersonator was only 28. Shy and retiring off stage, he was a bachelor afraid to ask a girl out on a date.

Days, he earned a decent living running his own business. Nights, for the pure joy of it, he would recreate the magic and excitement of *Elvis*. "I felt more comfortable portraying him than being myself," Brad admits today.

Brad remembers his first performance singing *Blue Suede Shoes*. " The applause hooked me right away." But once off the platform, out of the glare of the spotlight, he had trouble connecting with his admiring public. "I was too timid to look people in the eye," he recalls.

Moderately overweight as a youth, Brad started to put on excess pounds when he was sidelined from playing baseball two years ago with a knee injury. "Being single, it was easy to make a steady diet out of cheeseburgers, french fries, and soft drinks." Card games with friends featured pizza smothered with sausage, Canadian bacon, and extra cheese. "I could wolf down seven or eight pieces real quick," he recalls.

With his body straining to carry his weight, Brad was too winded to play softball, the sport that helped him burn calories. He had trouble breathing when he slept. His size 44 jeans were so tight circulation was almost cut off. Yet pride kept him from buying specially-tailored clothes.

Brad wanted to date but he was too embarrassed to even ask. "I knew that if I wasn't attractive, how would an attractive girl want to go out with me? I had no self-confidence and I wouldn't even try," he says. "There were times I just wanted to call it quits . . . I mean life."

Then came the night a year ago in that club near Phoenix, the night that became Brad Bailey's personal watershed, his turning point.

As always, he was doing his thing. But this time, it was harder to make the turns, to do the splits, even breathe. His face was drenched with perspiration, and suddenly Brad Bailey was taken with the notion that he would die that night like his idol.

"At that moment I realized something had to be done," Brad recalls. "Otherwise, I would never make it to my 42nd birthday. I didn't want to leave this world looking like Elvis."

Encouraged by a disc-jockey friend at a local radio station who had lost weight and kept it off, Brad tried something revolutionary that week a year ago. It was not another failed diet but the Nutri/System® Program, a weight loss plan that's been working for millions for nearly 20 years.

Brad walked into his nearby Nutri/System® Weight Loss Center. "I was determined. If this didn't work for me, there'd be nothing left," he remembers.

"The difference I found there," he says, "is that I never got hungry and the food wasn't cardboard. It was delicious. For a bachelor used to junk food, it was perfect." Each meal was prepared in convenient calorie- and portion-controlled servings. There were three nutritionally-balanced meals, as well as three snacks each day as part of the Flavor-Set Point™ Meal Plan.

Brad loved the Ravioli, Lasagna and Spaghetti with Meatballs. He was able to choose from a smorgasbord of tempting entrees such as Barbecue Beef, Spicy Oriental Chicken, and Beef Enchiladas. Even his favorite—Thick Crust Extra Cheesy Pizza. For desserts Brad feasted on Fudge Cupcakes, Vanilla and Chocolate Pudding and Caramel Popcorn. "Before Nutri/System I couldn't believe I could eat all that delicious food and still lose weight," he laughs.

He credits Nutri/System's professionals—his personal Nutritional Specialist and Behavior Breakthrough™ Counselor—for providing the motivation and support to see him through. A major tool employed was Nutri/System's Personalized Weight Loss Profile™ questionnaire that helped Brad's counselors pinpoint the attitudes and behaviors which had prevented him in the past from reaching his ideal weight.

"The pounds just vanished," says Brad. The first week on the Nutri/System Program I lost seven pounds. It felt great. The next week I lost six. Then I started to feel my pants getting real loose. I knew I was on my way."

As he continued to shed more and more weight, Brad also gained insight into how to make his losses permanent. He attended weekly Nutri/System Behavior Breakthrough™ classes. There he learned a whole battery of weight maintenance strategies: chewing slowly, making an occasion out of each meal, and other easy-to-do attitudes to eating.

In all, Brad lost 100 pounds, nose-diving from a 44 to a 34 inch waist. 6 foot 1 inch Brad Bailey weighs 205 today. He sees a girl now. And he's back playing baseball.

On stage, Brad has retired the huge jump suit used for his Elvis impressions. What the audience sees is a younger, leaner version of the Legend of Rock. "The splits come easy now," smiles Brad Bailey, as he sizzles in the role of the man in the *Blue Suede Shoes*.

We Succeed Where Diets Fail You.®

nutri/system
weight loss centers

Plate 16 Nutri/System weight loss centers, newspaper advertisement (1989)

PRESIDENT BILL, BY WILLIAM L. BROWN

I had hoped to keep ★ the election campaign from falling prey to the sensationalistic, simplistic media, which lay in wait, ready to pounce. They hadn't the intelligence or the patience to investigate real issues in depth, so they reduced everything to a lurid, bastardized form, which they then fed to the public. The public in turn regurgitated the media's pabulum through public opinion polls. In this way, the media kept voters focused on flashy, superficial topics. So, I had to beware of reporters eager to stir up politically pointless but highly popular sensational issues. ★

Plate 17 *President Bill* comic strip (25 October 1991)
© 1991 William L. Brown

Lez dance: Julie Wheeler dips Maggie Moore in *Viva Las Vegas!*

Plate 18 *Viva Las Vegas!* on stage (photo from *The Village Voice*, 10 October 1995)

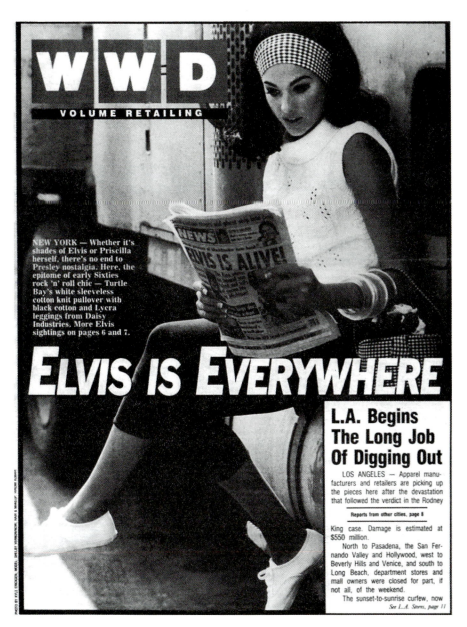

Plate 19a Women's Wear Daily (4 May 1992): "Elvis Is Everywhere" cover

ELVIS

IS

Plate 19b Women's Wear Daily (4 May 1992) "Elvis is Everywhere" centerfold spread

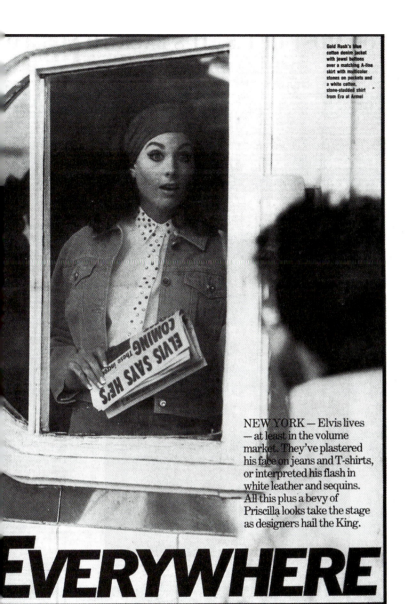

NEW YORK — Elvis lives
— at least in the volume
market. They've plastered
his face on jeans and T-shirts,
or interpreted his flash in
white leather and sequins.
All this plus a bevy of
Priscilla looks take the stage
as designers hail the King.

EVERYWHERE

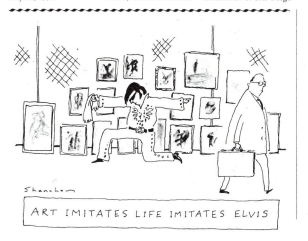

Plate 20 "Art Imitates Life Imitates Elvis" (from *Spy* magazine, November 1990)

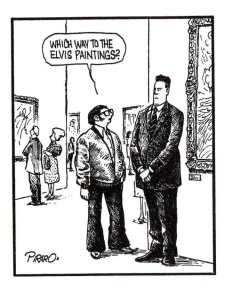

Plate 21 *Bizarro* comic strip: "Which way to the Elvis paintings?"

Plate 22 Shoe comic strip (2 May 1992). Reprinted by permission: Tribune Media Services

Plate 23 Mike Luckovich political cartoon (September 1991)

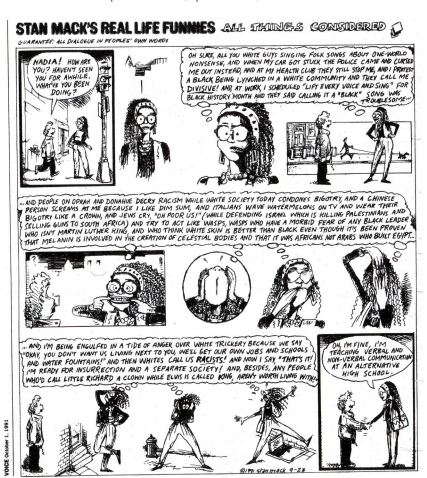

Plate 24 Stan Mack's Real Life Funnies (1 October 1991)

Plate 25 Elvis "Soldier Boy" poster

Plate 26 Madonna poster

Plate 27 ElvisTown magazine/tourist guide (1991)

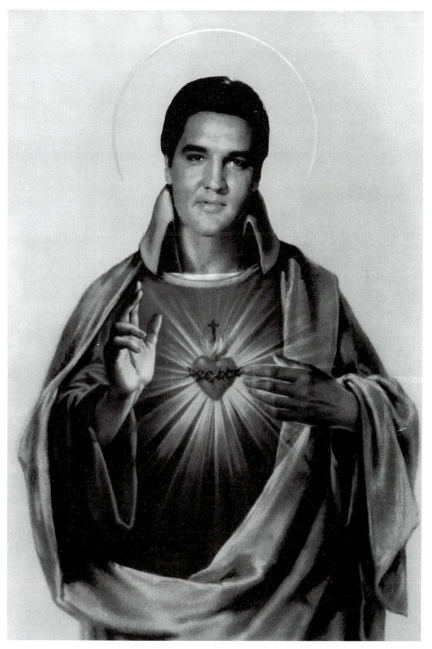

Plate 28a "The Sacred Heart of Elvis," artwork found on the World Wide Web at
http://www.stevens-tech.edu/~jformoso/sacred_heart_elvis.html
© Christopher Rywalt, 1996. Used with permission.

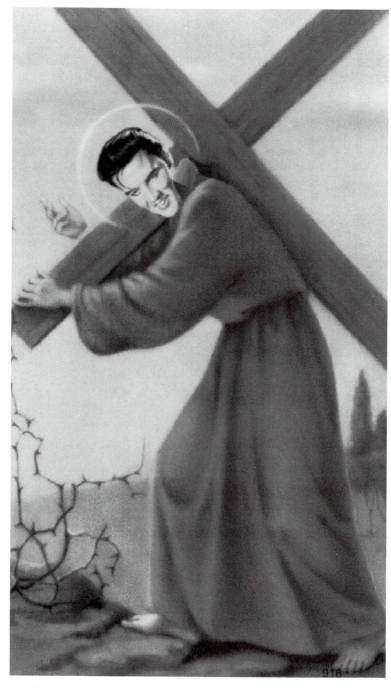

Plate 28b "Elvis Bearing the Cross," artwork found on the World Wide Web at
http://www.stevens-tech.edu/~jformoso/large_cross_elvis.gif
© Christopher Rywalt, 1996. Used with permission.

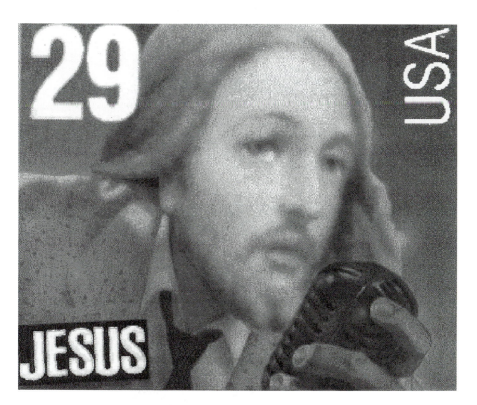

Plate 28c "Jesus Stamp," artwork found on the World Wide Web at
http://www.stevens-tech.edu/~jformoso/jesus_stamp.html
© Christopher Rywalt, 1996. Used with permission.

Was Elvis Presley "the greatest cultural force in the 20th century?"

That's what Leonard Bernstein once called him. And if that doesn't make you think about the influence of pop culture on society, consider this:

•Time Inc. is testing a new celebrity photo magazine—its second stab at a periodical for "readers" who find *People* magazine too cerebral.

•When Bill Clinton was elected president, he gave his first interview not to Peter Jennings or Tom Brokaw—but to Tabitha Soren of MTV.

•An entire generation is growing up convinced that Raphael, Donatello, Leonardo, and Michelangelo are only Teenage Mutant Ninja Turtles.

•A survey of 10-year-olds found that they could name more brands of beer than presidents of the United States.

"Pop! Goes the Culture" will be the theme of a lively program Saturday, Oct. 9, from 10 a.m. to 2 p.m. highlighting Fall Weekend at Swarthmore. Faculty members, students, parents, and alumni will look at aspects of pop culture in the '90s. Also scheduled are Homecoming sports events and a Saturday evening performance by the award-winning San Francisco Mime Troupe. Plan to be at Swarthmore for this special October weekend.

SWARTHMORE
FALL WEEKEND
OCTOBER 8, 9, 10

Plate 29 "Pop! Goes the Culture" symposium, advertisement from the *Swarthmore College Bulletin* (August 1993)

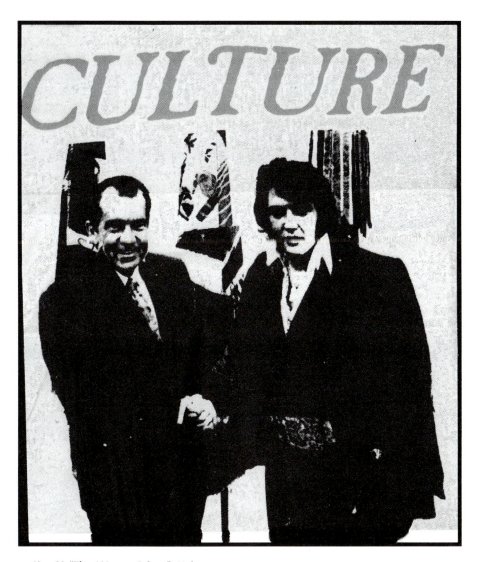

Plate 30 "Elvis+Nixon=Culture" (T-shirt)

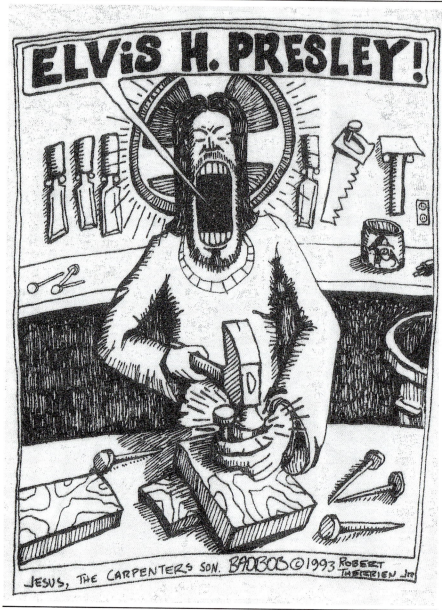

Plate 31 "Elvis H. Presley!" (T-shirt)

3

ELVIS SPACE

Soon the signs started appearing. THE MOST PHOTOGRAPHED BARN IN AMERICA. We counted five signs before we reached the site. There were forty cars and a tour bus in the makeshift lot. We walked along a cowpath to the slightly elevated spot set aside for viewing and photographing. All the people had cameras; some had tripods, telephoto lenses, filter kits. A man in a booth sold postcards and slides – pictures of the barn taken from the elevated spot. We stood near a grove of trees and watched the photographers. Murray maintained a prolonged silence, occasionally scrawling some notes in a little book.

"No one sees the barn," he said finally.

A long silence followed.

"Once you've seen the signs about the barn, it becomes impossible to see the barn."

He fell silent once more. People with cameras left the elevated site, replaced at once by others.

"We're not here to capture an image, we're here to maintain one. Every photograph reinforces the aura. Can you feel it, Jack? An accumulation of nameless energies."

(DeLillo, 1985: 12)

BABY, LET'S PLAY HOUSE

Taken at face value, DeLillo's fictional anecdote about the Most Photographed Barn in America depicts tourism as a closed system that can refer only to itself. The tourists described here, after all, are ultimately unable to see the barn in any terms other than those already determined for them by the institutional structure of tourism and traditional patterns of sightseeing behavior. The barn's "aura" (i.e., its status as a famous place) may be readily visible, but the barn itself goes unnoticed. In the eyes of DeLillo's tourists, the barn has no intrinsic value of its

own and no unique qualities that might distinguish it from other tourist attractions; instead, in a postmodern logic of self-referentiality, what makes this site a hot tourist spot is simply the fact that it's a hot tourist spot – or, perhaps more precisely, that it publicly proclaims itself to be such. According to DeLillo's fable, then, there is no one quite so blind as a tourist . . .

. . . except, perhaps, for academics and other cultural critics. For while DeLillo may be poking fun at the inability of tourists to recognize the specificity of the very sights that they've traveled across the country (if not the world) to experience, his account of Jack Gladney and Murray Jay Siskind's sightseeing trip ultimately reveals the two professors to be even more short-sighted than the tourists they critique. For instance, despite its careful attention to detail (e.g., "five signs," "forty cars and a tour bus," "tripods, telephoto lenses, filter kits," etc.), Gladney's narration of this scene describes everything present *except* the barn: there's no hint at all as to what the building in question actually looks like (what color it is, how large it is, if it's in good repair, etc.), much less why it's considered to be so photogenic. Similarly, while he offers an insightful commentary on the general failure of tourists to *really* see the sites that they most want to look at, he's curiously silent on the question of what it is about the barn that people *should* see: ultimately, all Siskind sees himself are the signs about the signs about the barn, and thus he actually winds up a step further away from seeing "the real barn" (whatever that might be) than the tourists he deigns to criticize.

With this in mind, then, I want to use this chapter to move back towards the barn a bit: rather than analyzing the signs about the barn in order to explain how it's a typical example of something (i.e., tourism) that we (supposedly) already understand, I want to concentrate instead on what makes the barn a unique site on both the geographical and cultural terrain. The particular barn that I want to discuss here is not (to the best of my knowledge) the most photographed in America – for that matter, it's not really a barn at all. It *is*, however, the most visited private home in the country: Elvis's Memphis mansion, Graceland. In the same way that, as a whole, this project is interested in how Elvis differs from other stars (as opposed to how he's just like them), in this chapter I'm primarily concerned with how Graceland differs from other tourist sites and how those differences have played themselves out in the (re)shaping of Elvis's stardom.

Like the barn in DeLillo's novel, Graceland is an icon so widely recognized, so famous for being famous, as to have become effectively invisible: though signs about Graceland are familiar sights on the US cultural terrain, what we typically see in such signs is not Graceland, but Elvis. At one level, this slippage of signifiers makes a great deal of sense: the building in question, after all, is famous because of its association with Elvis, not the other way around. What I want to suggest here, however, is that this commonsensical understanding of the relationship

between Elvis's stardom and his Memphis home is only partially correct: that Graceland isn't simply a passive and neutral space where Elvis's already constructed stardom just happened to make itself visible over the years. While Graceland certainly didn't make Elvis into a star (after all, it was the money he made from his first year of national stardom that allowed him to buy the five-bedroom mansion), the house has had a significant – and largely unacknowledged – impact on the shape of Elvis's stardom ever since he purchased it in March 1957. Graceland gave Elvis something no other US celebrity of the twentieth century had: a permanent place to call "home" that was as well known as its celebrity resident.[1] As trivial as this difference between Elvis and other stars may seem to be at first glance (after all, it's not as if one typically imagines stars *not* to have homes), what I want to argue in this chapter is that the nature of the public link between Elvis and Graceland altered the shape of his stardom in such a way as to ultimately give rise to his unusual posthumous career.

Perhaps the single most important effect that Graceland had on Elvis's public image is that it gave his stardom a stable, highly visible, *physical* anchor in the real world. Stardom, after all, is a phenomenon entirely dependent on the mass media for its existence: without a strong infrastructure of interrelated media institutions (film studios, radio and television networks, newspaper chains, journalistic wire services, etc.), stardom is simply impossible. The sort of non-reciprocal familiarity that the general public has with stars – what Richard Dyer describes as the way that "stars cannot know everyone, but everyone can know stars" (1979b: 7) – simply can't take place in a society that lacks a significant mass media presence.[2] In fact, one could argue that it's the relationship of stardom to the mass media that produces the most significant difference between stardom and "ordinary" fame. While it may be difficult to achieve true fame (at least today) without the help of the mass media – if nothing else, it's the dissemination of an individual's name, face, and/or story through the media that helps to make that person well known to the general public – it's still possible (and common) for people to become famous for achievements and events that are not themselves media-related. Hillary Rodham Clinton, Bill Gates, Rodney King, Lee Harvey Oswald, Colin Powell, Nicole Brown Simpson, Margaret Thatcher, and Donald Trump (to give but a few examples) are all famous, but none of them can safely be said to be stars: though their fame may be largely propagated through the mass media, the circumstances that initially made them famous are not themselves media phenomena.

Stars, on the other hand, are famous primarily because of their activities *within* the realm of the mass media: particularly film, television, radio, and recorded music. In terms of their occupation, stars tend to be entertainers, rather than politicians, scientists, entrepreneurs, or the like. While a star's non-media-related activities (e.g., their political activism, their personal life) may come to play a

crucial role in their fame (such activities, after all, provide important news items for celebrity gossip magazines and supermarket tabloids), the public's interest in such activities is invariably the *result* of a star's already existing fame, not the *cause* of it. This is not to say, by any means, that a particularly juicy scandal (or some such) can't help to turn a minor star into a major one, but such instances still require the principal figure(s) involved to have already achieved a certain level of stardom for such scandals to be truly noteworthy.[3]

Even professional athletes and fashion supermodels – the two types of celebrity that would seem to provide the most obvious exceptions to the rule that stars work within the media – tend only to acquire true star status via substantial media exposure (e.g., endorsements and licensing deals, speaking roles in major motion pictures, recording albums, etc.) above and beyond their exploits on the playing field or the fashion runway. To be sure, athletes and models can become more famous and publicly recognizable while still staying within the confines of their respective occupational fields. Hitting the home run that wins the World Series or appearing on the covers of *Cosmopolitan* and *Vogue* enough times will certainly enhance the ability of the general public to recognize one's name and/or face. Unless such exploits lead to other media exposure, however, most of the trappings of true stardom (fan clubs, tabloid stories on one's personal life, etc.) remain elusive.[4]

For my purposes here, what matters most about the distinction I'm making between stardom and other forms of fame is the different relationship to *space* associated with the former. In particular, it's necessary to recognize that the mass media don't so much occupy space as they transcend it, and that, because it relies so heavily on the media for its own existence, stardom is typically an ethereal, non-spatial phenomenon. As McKenzie Wark puts it, "the immaterial space of recorded culture is a great crosser of edges, a pervasive network through the walls" (1989: 26). For instance, a question such as "Where is NBC?" has no satisfactory answer: while one can point to Rockefeller Center in New York as the place where the network's executive offices and main studios are, NBC's effective "location" is actually anywhere and everywhere that its television and radio programming reaches. Even more localized forms of mass media – which, at some level, can be seen to occupy (and even to help define) the regional space(s) in which they broadcast and circulate – ultimately manage to transcend a diverse range of geographic spaces. The typical metropolitan newspaper, local nightly newscast, or FM radio station, for instance, crosses over a number of major boundaries – for instance, those between an impoverished city and its wealthier suburbs, or between neighborhoods that are otherwise physically separated along lines of race, ethnicity, class, age, and so on – in terms of the spatially distinct communities that it addresses. Wark's comments above, for example, are made as part of a larger argument explaining how Elvis, as a white boy growing up in the

racially segregated South, could come to be so familiar with the predominantly black sounds of rhythm 'n' blues music: namely that, despite his physical separation from the black communities of post-war Memphis, Elvis could hear rhythm 'n' blues simply by listening to the right radio stations (e.g., Memphis's own WDIA, the first all-black radio station in the US, or Dewey Phillips's "Red, Hot, and Blue" program on WHBQ).

One could, in fact, argue that the mass media are the major (and perhaps the only) form of shared culture in the US today: that without the media's ability to transcend the broad expanses of space between, say, Alaska and Florida – or even the more proximate, but no less distinct, spaces of Harlem and the Upper East Side – the "imagined community" (to borrow Benedict Anderson's (1983) evocative phrase) of the nation would be a difficult (if not impossible) one to maintain. "The mass media," as Paige Baty argues, "represent a body politic that corresponds to the narration of the nation: battles over the state of the real are waged on the common ground of the media" (1995: 46). Ultimately, however, what allows the media to address such a diverse range of spaces and communities meaningfully is the fact that the media transcend space more than they remain rooted in any specific local context.

Thus, unlike their counterparts in the night sky, media stars typically don't exist in space. This is not to say that they're wholly fictional entities (e.g., that there was never really an Elvis Presley), but that there's an important distinction to be made between the real flesh-and-blood body of a given star and the mediated public persona that is all of that star that the general public is ever likely to see or know. While stars may walk and talk and move about in the same world as "ordinary" people, the fact that the phenomenon of stardom is dependent on the media means that they can only exist *as stars* in the ethereal non-spaces of media texts and public imagination. In fact, the various connections that do exist in the public eye between stars and fixed geographic locations tend to be fairly nebulous. To be sure, movie stars are traditionally associated with Hollywood, while sports stars are often linked to the cities their teams call home,[5] but even these seemingly concrete connections are ultimately not very tangible: to recognize, for instance, that Michael Jordan is a Chicago sports star – and thus to articulate his stardom to a particular location on the map – only narrows the geographic space associated with him down to a metropolitan area of more than 1,500 square miles. Even if one goes so far as to posit a publicly recognizable link between a major sports figure and his[6] home stadium (e.g., Yankee Stadium as "The House that Ruth Built," or the more recently forged link between Jordan and the United Center in Chicago), such articulations are, at best, intermittent ones: when that same stadium is being used for a rock concert or a boat show (or when it's not being used at all), the connections between the building and the local sports hero fade away, at least until the next home game.

Thus, even for the biggest and most visible of stars, the public links that exist between them and specific "real world" sites tend to be tenuous and fleeting. The existence of maps identifying the "Homes of the Stars" in southern California, for instance, is more than just a testament to the number of stars who live in the greater Los Angeles area: it also demonstrates the absence of publicly recognized links between most stars and particular physical spaces. Without a map to point it out to you, you can drive by Jack Nicholson's (or Susan Sarandon's, or Denzel Washington's, etc.) home every day of your life without ever realizing it. And while there *are* a number of houses, buildings, and tourist attractions that are prominently associated with particular celebrities, such links are typically either circumstantial (e.g., the link between the White House and whoever happens to be president at the moment), based on a momentary historical conjunction between a public figure and a given place (e.g., the connections between assassination sites (Dealey Plaza, the Lorraine Motel, and the Dakota) and those who were slain at them), or deliberate commercial efforts (e.g., the association of Dolly Parton with the Dollywood amusement park in Tennessee, or of Spike Lee with the Spike's Joint boutique in Brooklyn).

The only real exception to this rule is Graceland, which has been linked in the public eye with Elvis and his stardom from the day that he bought it in 1957 until the day that he died there twenty years later . . . and beyond. From almost the first moment of his stardom, Elvis was associated with a very specific site on the map (i.e., not just a region or a city, but an actual street address) in a way that no other star ever was – or has been since – with the longstanding connection between these two icons working to transform the private, domestic space of Elvis's home into a publicly visible site of pilgrimage and congregation. Over the course of the past four decades, the gradual "accumulation of nameless energies" (to borrow DeLillo's phrase) resulting from the almost constant flow of fans and tourists through the grounds of Elvis's former residence has worked to affect not only Graceland's public image, but the ways that Elvis's icon has circulated in the broader cultural economy of signs.

In the rest of this chapter, then, I want to examine three specific transformations that Graceland has helped to bring about in Elvis's stardom, with a particular eye on how these changes have contributed to his contemporary cultural ubiquity. First, the actual physical location of Graceland – in terms of both its distance from the media centers of New York and Los Angeles and its position on a major highway on the edge of the mid-South's largest city – shortened the apparent distance (physical, emotional, and psychological) between Elvis and his fans: a transformation that simultaneously encouraged the Elvis faithful (or even just the curious) to visit Graceland in greater numbers than is the case for other celebrity homes and encouraged Elvis himself to lead a life that was reclusive even by the higher standards of privacy often adopted by

fan-weary stars. Second, the longstanding status of Graceland (and, on a some-what smaller scale, the Elvis Presley Birthplace in Tupelo as well) as a site of pilgrimage for fans has helped to strengthen the quasi-religious aspects of Elvis's stardom to a point above and beyond the "normal" processes of deification that take place between stars and their fans. Third, Graceland has served as a physical point of articulation where a global community of Elvis fans could regularly congregate and acquire a true sense of themselves as a self-defined community (something generally not possible for fans of other popular culture phenomena) and, simultaneously, as a mediated point of articulation visible enough to the general population that even non-fans recognize – and, more importantly, publicly respond to – the existence of the community of Elvis fans.

STRANGER IN MY OWN HOMETOWN

Memphis is not an easy place to describe. One can wax eloquent about the city's long and storied musical heritage, or the joys of its down-home cooking, or its laid-back brand of Southern charm and hospitality, but such words typically don't come close to capturing the experience of Memphis effectively. As musician and native Memphian Jim Dickinson puts it, "Memphis is not something you just see or hear. You feel Memphis. Walk around downtown and let it soak up through your feet. Eat some Bar-B-Q. Put some gin in your glass. Sit back and let it happen" (*Kreature Comforts*, 1992: n.p.). Along similar lines, former Stax/Volt mainstay Isaac Hayes once argued that the unique sound of Memphis music "wasn't something you studied up on . . . you breathed it, is all" (quoted in Hirshey, 1985: 299). Such claims, of course, aren't unique to Memphis, as most cities have a rhythm and a feel to them that are easier to understand in the flesh than via the written word. To explain the impact of Graceland on Elvis's stardom in any truly meaningful way, however, it's necessary to recognize both the unique nature of Memphis as a geographic and cultural space, and the various ways that being in the unique space that is Memphis affected Elvis's life and career.

In particular, I want to argue that the differences between Memphis and the star-studded metropolises of New York and Los Angeles had important ramifica-tions for the shape and nature of Elvis's stardom. Stereotypically anyway, the media centers of New York and Los Angeles are the two primary geographic locations in the US where stars are made. The classic mythical narrative of a star's ascendancy finds the celebrity wannabe packing their bags and leaving the small heartland town where they grew up for either the bright lights of Broadway or the dream factory of Hollywood. And, in the long run, if that young hopeful is lucky and/or talented enough to achieve their dreams of fame and fortune, they'll frequently adopt New York or Los Angeles as their new hometown as well. These two cities, after all, are where most of the major broadcast, motion picture, and recording studios (not to

mention the executive offices of the media conglomerates that own and run those studios) are concentrated: a scenario that lends a certain pragmatic appeal to living in the general vicinity of either New York or Los Angeles.

Elvis, however, represents a significant exception to this rule. As mythically perfect as his rags-to-riches success story might have been in most respects ("so classically American," as Marcus describes it, "that his press agents never bothered to improve on it" (1990a: 128)), his decision to buy Graceland represented a significant break from the traditional narrative of the rising star. By the time he moved into the house in 1957, Elvis – the small-town boy who hit the big time – had made several trips to both New York and Los Angeles for concert performances, national television broadcasts, recording sessions, and a screen test for Paramount. Thus, not only had he seen the bright lights of the big cities, but he'd done so in ways that underscored the importance of these places to the career he wanted to follow in the entertainment business – and then he made a deliberate decision to stay in Memphis anyway.

At one level, Elvis's loyalty to his adopted hometown isn't a divergence from traditional myths of media stardom at all. While, on the one hand, stars are often seen to be "special" or "extraordinary" people, insofar as they're more talented, charismatic, attractive, glamorous (and so on) than the average person (Dyer, 1979b: 38–45), such an image of stardom exists in a state of constant tension with the equally common myth that anyone can become a star: that stars are simply ordinary people who have worked hard enough (or been lucky enough) to become rich and famous (Dyer, 1979b: 49–50). In the eyes of many of his fans, after all, Elvis's decision not to leave Memphis (re)affirmed his essentially non-pretentious character: rather than letting his newfound fame go to his head and moving off to some fancy mansion in the Hollywood Hills, Elvis, the dutiful mama's boy, took the money he made from rock 'n' roll and bought a nice house in his hometown where he could live with his parents. "Those people in New York," he told the crowd at a Memphis concert shortly after his July 1956 appearance on *The Steve Allen Show* in tux and tails, "are not gonna change me *none!*" Even today, it's not unusual to hear Elvis fans talk about how important it was that he never left Memphis (and the rest of the South) behind.

But while Elvis's decision to remain in Memphis helped to reinforce the public's image of him as simply "regular folks," it also served to place him on a more prominent pedestal than would have been possible had he chosen to live in New York or Los Angeles. In the 1950s (and, to a certain extent, even today, despite forty years of being steeped in Elvis's aura), Memphis wasn't a city used to the presence of internationally known stars in its midst. Prior to 1956, the biggest thing ever to come out of the city was actor and comedian Danny Thomas, and Elvis's meteoric ride to fame and fortune easily made the young singer the biggest and most visible celebrity fish in a very small pond. Consequently, the sort of public

anonymity that many stars claim to experience (and enjoy) in the more cosmopolitan, media-saturated environments of Manhattan and Hollywood was simply impossible for Elvis to find in Memphis.

In fact, as the only real game in town when it came to stardom, Elvis was, in many ways, more publicly visible in Memphis on a day-to-day basis than he could ever have been in either New York or Los Angeles. From almost the beginning of his post-Sun career, Elvis's fame made it virtually impossible for him to manage even the most mundane sort of public outing in Memphis without attracting a spontaneous throng of hysterical fans. Elvis quickly discovered that if he wanted to engage in the relatively simple pleasures of going out to the movies, skating at a local roller-rink, or enjoying the rides at the fairgrounds, he had to rent out such facilities late at night to avoid the disruptions (both to the businesses in question and his own attempts to relax) his presence would cause during normal business hours.

As at least one well-known anecdote from Elvis's career indicates, however, such problems probably wouldn't have plagued Elvis in New York or Los Angeles. In planning the December 1968 television broadcast that would later come to be known as Elvis's "Comeback Special," producer Steve Binder wanted a fast-paced, up-tempo, sexy show – arguing that such an approach was the best route to follow if Elvis really wanted to reassert himself as the King of Rock 'n' Roll. Colonel Parker, on the other hand, wanted his one and only client to play it safe by performing a more family-friendly hour of innocuous Christmas songs. In an effort to prove to Elvis that his star appeal had slipped (and thus that Binder's plan for the show was needed for Elvis to regain his edge), Binder took Elvis out for a unplanned walk on Sunset Strip in the middle of the afternoon. As Marsh describes the incident:

> Elvis was undoubtedly wary – he hadn't dared such a daylight visit to a public streetcorner in a decade – but he agreed to the test. So, for perhaps ten or fifteen minutes, Elvis loitered outside a topless bar. Pedestrians strolled on by in the midday heat. Incredulous, Elvis began to cut up, trying to call attention to himself. As time passed, his antics became less and less subtle. Nothing worked. Chastened, he returned to Binder's office.
>
> (1982: 169)

What Binder realized (though Elvis didn't) was that the spontaneous outbursts of Presley-mania that had made Elvis such a reclusive figure in Memphis were unlikely to happen in Hollywood: on the Strip, stars are far more commonplace sights – and the average passerby is far less likely to gush over them publicly – than would be the case in smaller towns. In fact, if anything, Elvis's attempts to draw attention to himself were almost guaranteed to convince the typical Hollywood pedestrian to work even harder to ignore him. Elvis could probably have

wandered around Hollywood for hours without attracting more than a passing murmur or two, but life in the fishbowl that (for him, anyway) was Memphis had taught him that such behavior was still likely to provoke a minor riot.

Living at Graceland did more than just change Elvis's vision of his own stardom and the way that he moved through his daily life: it also made him far more accessible to the general public than most stars are. Graceland, after all, is a sizable (and thus visible) house located on a major highway (US Route 51) at the edge of the largest city in the mid-South: while the building itself is set back from the road and the grounds are surrounded by fences and gates (i.e., the house has never been so accessible that the average passerby could simply walk up to the front door unannounced), the actual property has always been fairly easy to find and (up to a certain point) approach. By way of contrast, had Elvis chosen to move to a more traditional star dwelling such as a luxury high-rise apartment in Manhattan, he would have effectively been shielded from close public scrutiny amidst the densely packed throngs of New York City. In such a scenario, curious fans might have been able to get as close to Elvis as the main entrance to the building in question, but that would still leave forty to fifty stories of concrete and steel (as opposed to a few dozen feet of gently sloping lawn) between him and his admirers. Similarly, had Elvis chosen to live in a mansion on some obscure Bel Air cul-de-sac (which he actually did do for brief periods during his movie-making days), he would have been safely hidden from the general public in a hard-to-reach corner of the urban sprawl that is southern California. Here, the average fan would have found it relatively difficult not only to find out where Elvis lived, but to get close enough to his front door to make his or her presence felt: the secluded and sidewalk-free neighborhoods of the Hollywood Hills are not readily accessible to casual tourists or curious passersby in the same way that Graceland – sitting on (what is now) a heavily trafficked six-lane arterial road – has always been.[7]

More importantly, Graceland's particular geographic location – not just with respect to the big coastal cities, but also in relation to the greater Memphis area and the surrounding countryside – has always made Elvis's home accessible to a more diverse range of tourists and fans than would normally be the case for a star's home. Even assuming that would-be visitors could find their way to them, the elite residential areas of New York and Los Angeles aren't spaces where members of the social groups who (stereotypically) comprise the core of the community of Elvis fans are likely to have easy or comfortable access. For instance, the teenage girls who flocked to Graceland's gates in the 1950s and 1960s (according to popular legend, during Elvis's heyday Graceland was one of the first places that the FBI checked whenever a runaway girl was reported from anywhere in the country) wouldn't have found it as easy to negotiate the social, geographic, and institutional barriers that protect the privacy of the rich and famous people who live in Beverly Hills or on New York's Upper East Side. Similarly, Elvis tourists

who came from rural areas and/or lower socio-economic backgrounds (two of the demographic groups who make up the stereotypical core of Elvis fans today) are already close enough – not just geographically (one can still find sizable chunks of land devoted to farms and ranches within a few minutes drive of Graceland), but socially – to the space of Graceland to feel at home visiting Elvis's former neighborhood: a sense of comfort that's unlikely to hold for such fans in either the urban jungles of Manhattan or the well-to-do enclaves of southern California.

Moreover, as a city, Memphis is far less certain how to handle the intertwined phenomena of stars-as-permanent-residents and fans-as-tourists than either New York or Los Angeles is. The two larger cities are crowded enough (and, in Los Angeles' case, spread out enough) to provide a significant physical and social buffer zone between stars and fans: one that grants stars enough privacy to let them lead something resembling a so-called "normal life" without excessive interference from fans, tourists, and autograph-seekers. The New York and Los Angeles metropolitan areas are also home to a critical mass of celebrity residents: enough so that the general population is relatively nonchalant about seeing stars out and about in public. In fact, one often-cited reason why many celebrities choose to live in New York or Los Angeles is that they can do so with relatively little fear of being accosted by star-struck strangers every time they go out: while celebrities in these cities may still have to field the occasional autograph request, it's unlikely that they'll have to worry (as Elvis often did) about being swarmed by mobs of fans every time they go out for dinner or duck down to the corner grocery store. Thus, at one level, stars actually *are* ordinary people in New York and Los Angeles, at least insofar as they are a relatively commonplace aspect of everyday life in these cities. Living in Memphis, however, where celebrities are much rarer sights, Elvis was never able to be ordinary (at least not in public), which effectively left him two choices: either to suffer the throngs that surrounded his every uncontrolled public appearance or to remain in hiding behind the wrought-iron gates and stone fences of Graceland.

Over the years, Memphis has never been entirely sure what to do about Elvis, and a curious sort of love/hate relationship developed – and continues to this day – between the city and its most famous resident. On the one hand, Memphis takes noticeable pride in being Elvis's hometown and in his role in making the city an important (and, in many eyes, the most important)[8] site in the early history of rock 'n' roll. At the very least, Memphis loves Elvis because he's easily the city's (and, for that matter, the state's) biggest tourist draw and, as such, he represents a seemingly bottomless goldmine of tourist revenue for the city and its businesses. Memphis's pride in Elvis manifests itself in such promotional materials as *ElvisTown*, a 1991 magazine[9] wholly devoted to boosting the city's appeal as a tourist destination (see plate 27). The particular means that the magazine took to this end, however, is perhaps best summed up by its title. Not only did the

magazine rename the city after its most famous son (effectively declaring Memphis to be synonymous with Elvis), but more than half of the first issue's editorial and advertising content was devoted to promoting Elvis-related sites and/or attracting Elvis fans/tourists into other places of business (such as Piggly Wiggly, the Memphis-based supermarket chain).[10]

At the same time, however, Memphis residents often seem to be less than thrilled about Elvis and the constant flood of tourists who come to town to visit Graceland. For instance, Shangri-La, one of the city's funkiest "record stores,"[11] has published its own tourist guide to the area (*Kreature Comforts*, 1992), filled with pointed jibes at the Elvis tourist industry that's grown up in Memphis. Why, the guide asks, would anyone in their right mind actually want to spend their vacation time "in line with 800 Elvis Zombies waiting to shell $15 out to smell Elvis' bicycle seat at Graceland during the hottest, most dreadfully humid weather of the summer" (1992: no page number) when there are so many other, more interesting things to do in Memphis? Such barbs notwithstanding, the folks at Shangri-La may actually appreciate Elvis *more* than most Memphians: at the very least, the authors of the guide acknowledge that Elvis was an important figure in rock 'n' roll history, even if they're not all that fond of the way his estate has packaged and sold his musical legacy to tourists. The general population of Memphis, however, seems unwilling to grant Elvis even that much respect. Such, at least, are the implications of a national demographic survey of Elvis fan club members undertaken by Direct Image Concepts (a marketing research firm based in Texas) in 1993. According to this survey, Shelby County (which consists primarily of the greater Memphis area) is the only county in all of Tennessee that ranks on the anti-Elvis end of the scale ("All the King's Fans," 1993). On a five-point scale – Elvis Lovers, Elvis Likers, Elvis Who?, Elvis Dislikers, and Elvis Loathers – Shelby County was rated a "Disliker" county. By way of contrast, only two counties in the state were placed in the "Who?" range, six were rated "Liker" counties, with the rest (about 70 in total) being "Lover" counties.[12]

While the average Elvis tourist might come away from a visit to Memphis convinced that the city is engaged in a veritable non-stop love affair with everything Elvis, a brief detour off of the well-worn path of Elvis tourism reveals a very different Memphis than the one visible from the south end of Elvis Presley Boulevard or sitting at a booth in the 1950s-style soda shop adjacent to Sun Studio. The contrast between the increasingly antiseptic glitter of the Graceland giftshops and the nitty-gritty, slightly run-down, working-class flavor of much of the rest of Memphis (a flavor captured quite well in Jim Jarmusch's 1989 film, *Mystery Train*) is striking: wandering around town, one gets the distinct impression that the average Memphian would be quite happy to see all the "Elvis Zombies" wither up and blow away so that the city could get over Elvis already and go about more interesting business.

Undoubtedly, some of the resentment that many Memphis residents feel towards Elvis is a side effect of the disdain that natives often have for tourists who (1) come to enjoy themselves in the places that the locals think of as home and (2) inevitably seek out all the "wrong" sights (i.e., those that no self-respecting native would ever visit on their own). Part of the rationale behind the *Kreature Comforts* guide, for instance, is to direct the discerning Memphis visitor to all the unique and wonderful things one can do in Memphis that the more traditional tourist guide-books aren't likely to know about (much less actually mention). "We wrote this guide," the authors note, "as we would like a foreign city described to us. The things we would want to do were we visiting other places have been handpicked for your reading pleasure. We included the fun stuff and left out the junk" (*Kreature Comforts*, 1992: no page number).

At the same time, however, there's an edge to the local backlash against Elvis that seems to go beyond the disdain that permanent residents of a place often feel for tourists. In particular, part of the problem many Memphians have with the Elvis phenomenon may be connected to the fact that, for a city as rich in musical heritage as Memphis, most of the non-Elvis-related traces of that heritage have been sadly neglected – and even destroyed. Beale Street, the birthplace of the blues (or at least one of the major contenders for the title), was almost completely demolished decades ago as part of urban renewal efforts that involved far more bulldozing than rebuilding. And while it's *slowly* coming back to life,[13] the new Beale Street is largely a tourist-oriented neon parody of its former self. WDIA and WHBQ, two of the most innovative and influential radio stations in the history of US popular music,[14] have abandoned their cutting edge ways in favor of Adult Contemporary music and sports programming, respectively, while the rest of the current Memphis radio scene (at least according to *Kreature Comforts*) consists of "preprogrammed, follow-the-payola-line, dull, sanitized top 40. . . . a vast franchise of nothingness" (1992: no page number). Stax Studios, source of some of the greatest soul music of the 1960s, was torn down in 1989 to make way for a soup kitchen.[15] American Studios – the longtime musical home of producer/writer Chips Moman; the spawning ground for the Box Tops and Alex Chilton; and the studio that Neil Diamond, Dusty Springfield, Dionne Warwick, and Elvis (among others) turned to in the late 1960s and early 1970s when they wanted to get that special Memphis sound – was demolished shortly after Stax's appointment with the wrecking ball. Even Sun Studio was basically an abandoned shell of a building until the mid-1980s, when a handful of entrepreneurs brought it back to life as both an active recording studio (U2 recorded several tracks for *Rattle and Hum* (1988) there) and a tourist attraction.

Thanks to Graceland, however, and the steady stream of Elvis tourists it brings to town (a stream that turns into an overpowering flood during Tribute Week every August), there's little chance that Elvis will suffer the same sort of neglect

that the rest of Memphis's musical heritage has. This isn't to imply that there's something inherently wrong with the city catering to – and even courting – Elvis tourism. On the contrary, Elvis is easily a significant enough figure in Memphis's history (musical and otherwise) to merit a sizable measure of attention and respect. Nevertheless, the fact that virtually every other major landmark representing Memphis's rich musical history has been, not just neglected, but actually demolished breeds a certain level of resentment among native Memphians towards the Elvis legacy. In much the same way that, for many observers, "the crown thang" represents a (racist) refusal to acknowledge the contributions of musicians other than Elvis to the birth of rock 'n' roll (see chapter 2), the fact that Memphis can market itself as "ElvisTown" while allowing historically and musically significant sites such as Beale Street and Stax to be razed is an unforgivable sin.

The *Kreature Comforts* guide, for instance, plays up its suggestions for the musically minded Memphis visitor by contrasting them to the plastic hype of Graceland, but there's a recurring sentiment of frustration and resentment here: despite the authors' obvious desire to celebrate the rich variety of Memphis's musical heritage, they're constantly forced to admit that the sites they're recommending are now abandoned buildings and vacant lots, or that they've been torn down and replaced with other, less notable enterprises (e.g., print shops, auto parts stores, fast food restaurants). In such a context, the relatively gentle jabs that the guide takes at Elvis tourism become a bit more stinging and scornful, as it becomes more and more apparent that the legitimate alternatives to Elvis-centric tourism in Memphis are few and far between.

Ultimately, then, Elvis's decision to remain a Memphis resident worked to place him on a highly visible pedestal more than it helped him blend back in to the role of an "ordinary" citizen. And, in many people's eyes – especially those of his fellow musicians – it was Elvis's isolation from the real world that was responsible for his eventual downfall:

> I get chased all over the world. . . . Get my clothes ripped up, people screamin'. But in my home, in Augusta, everything is cool. I wouldn't have it no other way, couldn't live if I couldn't walk the streets I grew up on. Now Elvis, he got so far away from it he couldn't do that. . . . He was a country boy. But the way they had him livin', they never turned off the air condition'. Took away all that good air. You get sick from that.
>
> (James Brown, quoted in Hirshey, 1985: 57)

> God didn't put all those fish out there just to swim around. He wanted man to have sense enough to enjoy watchin' that cork bob. The greatest mindeasers are stars at night. Elvis couldn't see that. How could he see it from behind a wall at Graceland with guys paid to laugh at his jokes?
>
> (Carl Perkins, quoted in Flanagan, 1987: 17)

> Elvis is a classic example of the celebrity running headlong away from reality. His whole world eventually was bordered by the insides of some of those hotels he stayed in for months at a time. His world was right there inside those walls and that was the way he wanted it.
>
> (Conway Twitty, quoted in Choron and Oskam, 1991: 76)

While one of the facets of Elvis's career most celebrated by his fans is his refusal to abandon his Southern roots, living in Memphis ultimately did Elvis a dual disservice: the public visibility and accessible location of Graceland robbed him of his privacy, while its gates and fences allowed him to hide from the outside world to the point where he finally lost touch with it. Counter-intuitively, then, staying close to home actually alienated Elvis from the community, his fans, and the world far more than would probably have been possible had he let "those folks in New York" (or Los Angeles) change him in the first place.

PROMISED LAND

In *Life after God*, novelist Douglas Coupland claims that ours is "the first generation raised without religion" (1994: 161): that, unlike our parents (and our parents' parents, and their parents before them, and so on), those of us who belong to "Generation X" (to use Coupland's (1991) label of choice for the post-baby-boom crowd) have grown up in a society where organized and institutionalized religion no longer plays the dominant role it once did. This is not to say that Coupland's vision of "life after God" isn't one where spiritual things matter: on the contrary, he insists that "we are living creatures – we have religious impulses – we *must* . . ." The problem with this statement, however, is that it begs a larger question: " . . . and yet into what cracks do these impulses flow in a world without religion?" (1994: 273–4). One possible answer to this question would be that those religious impulses often lead people to invest themselves in the mass media, particularly in the form of the idolatrous worship of stars.

For better or worse, discussions of stardom have long invoked religious metaphors in order to explain the role that stars play in US culture and/or the nature of the relationship between stars and their fans. There are, after all, just enough plausible parallels between the two to suggest that stars are the closest thing that contemporary US culture has to living gods and goddesses: they're highly charismatic, larger than life figures; they're deeply embedded in cultural myths and legends (one could in fact argue that a crucial part of what transforms an "ordinary" celebrity into a star is the articulation of his or her public image to one or more major strand of cultural mythology); and the behavior that fans exhibit towards them is often nothing less than worshipful in its adulatory and awestruck quality.

Horror author and filmmaker Clive Barker even goes so far as to suggest that media stars fill a niche in US culture similar to that occupied by religious saints in Europe:

> We in Europe have had religion in a fundamental, as opposed to fundamentalist, form for a very long time. It is very much a part of the way our state is run, very much a part of the texture of our lives. And religious needs have been answered, I think, at least up until recently, more readily in European than American society. So perhaps the hunger to take innocent secular artists like Elvis Presley or Jim Morrison and make them objects of religious devotion is not present in the same degree in Europe because the pantheon of European saints is already fixed. Is already there, and has been there for many hundreds of years.
>
> (1994: 212–13)

With respect to the US, at least, Barker is describing a society much like the one in Coupland's book: a society where religious needs and impulses still exist, but they aren't being adequately served by organized religion. In an age of waning public faith in more traditional forms of worship,[16] then, it's easy to see the intensity of many people's affective investments in stars as a substitute for the spiritual commitment that has gone out of these people's lives.

Nevertheless, whatever parallels may exist between stardom and holiness, in most cases the religious metaphor for stardom is overblown to the point of banality. While stars may inspire powerful devotional feelings in their fans, they typically don't find themselves as the focus of spiritual teachings or organized religious institutions: there is no Church of the Sacred Heart of Bogart, no priesthood of Lennon, no scripture based on the life and teachings of Marilyn – or at least such things don't exist in publicly visible enough form to have attained anything more than highly marginalized cult status. The cases of devotional fervor for media figures documented by researchers such as Fred and Judy Vermorel (1985, 1992) or described by Barker (1994: 212) aren't examples of even a loosely organized religion as much as they are instances of private and highly personal obsessions. Thus, despite the occasional extreme display of devotion made by fans in the name of a particular celebrity, the oft-invoked religious metaphor for stardom is, in the final analysis, nothing more than hyperbole . . .

. . . except, that is, in the case of Elvis. When it comes to him (Him?), this otherwise banal metaphor actually has a great deal of substance behind it: enough so that his case needs to be distinguished from that of other stars. Lest I be misunderstood, I should emphasize that I'm not claiming that Elvis really was a divine or supernatural being; rather, I'm arguing that his role in many of his fans' lives is similar to that which might be played by a major religious figure. While Elvis was, to a certain extent, deified even in life,[17] since his death this process has

accelerated and intensified to the point where Elvis's quasi-religious status is now one of the more common themes running through his posthumous career. Admittedly, not all of the recent Elvis sightings that invoke this metaphor do so in good faith: images of "St Elvis" or "Elvis Christ" appearing on the contemporary cultural terrain are satirical or mocking in nature as often as not.[18] Nevertheless, even when presented as a joke, the notion that Elvis has become a quasi-religious figure in US culture manages to give additional life to the idea of Elvis's divinity simply by keeping the question on the table for discussion.[19]

For example, a recent book by former BBC religious affairs correspondent Ted Harrison (1992) argues quite earnestly that the various spiritual activities currently centered around Elvis may very well be an example of "a religion in embryo" (1992: 9), with Elvis potentially shaping up to become the next Christ. Admittedly, Harrison's actual argument is a jumbled mish-mash of solid sociological insight[20] (on the one hand) with tabloid-esque leaps of logic[21] and laughably lame speculation[22] (on the other) that ultimately delivers far less than it promises: at best, Harrison raises the question, points to a little bit of data, and then says, "it *could* happen . . . couldn't it?" But while it would be easy to dismiss Harrison's book out of hand for the spottiness of its argument or the tenuousness of its claims, the questions that he raises *do* point to a crucial set of differences between Elvis and other stars: weak though Harrison's case for Elvis's (impending) deification might be, for any other star such a claim would simply have been a non-starter.[23] In the end, Harrison does manage to demonstrate that *something* of a quasi-religious nature is going on with Elvis today that can't be simply dismissed as another example of the overblown star-as-holy-figure metaphor.

A more convincing discussion of the religious element to Elvis's contemporary cultural presence is that found in Lynn Spigel's (1990) study of Elvis impersonators. These performers, Spigel argues, serve as a conduit between the spirit of Elvis and gatherings of his fans, many of whom are quite explicit about the religious aspect of their relationship to Elvis:

> [Head of the Oklahoma Elvis fan club, Mae] Gutter sets strict limits on the borders between Elvis and God, yet her love for Elvis serves to make her faith meaningful in the present. Elvis becomes a concrete example of Christian morality; he is generous, kind of spirit, devoted to his kingdom and benevolent, but never so for worldly ends. He is, in short, a Christ figure – someone who Gutter believes mediates between heaven and earth and fills his followers with love.
>
> (1990: 191–2)

The role of the impersonator is that of "a medium who channels the spirit of a savior, all the while opening up a public space where people can express their mutual faith in an abstract principle that no one can name" (1990: 193). A

performance by an Elvis impersonator is thus much more than just another concert or nightclub act; it's a spiritual revival: a ritualized ceremony that brings the Elvis faithful together in order to make a public expression (and reaffirmation) of their devotion. In fact, Spigel's interpretation of the religious aspects of the impersonator phenomenon may even be a bit understated. More than a decade ago, Tom Corboy's video *Mondo Elvis* (1984) explored similar territory by featuring footage of impersonator Artie Mentz describing his chosen profession not as a job, but as a "calling" in the most spiritual sense of the term. As Mentz explains it, his relationship to Elvis parallels that which a priest has to God, insofar as both priests and impersonators are standing in for "someone not there in body."

But while Corboy originally played this line largely for laughs, such ideas are being put forth today in all seriousness by institutions as hallowed as the *New York Times Magazine*. In a cover story for the *Magazine*, Ron Rosenbaum describes the impersonator phenomenon as nothing less than a form of spiritual healing:

> It's a way of coming to terms with our own sense of loss, with what's become of us as a nation – the transition America has made from the young, vital, innocent pioneer nation we once were (the young, vital Elvis we put on our stamps) to the bloated colossus we feel we've become: the Fat Elvis of nations.
>
> (1995: 64)

Following the work of sociologist Mark Gottdiener, Rosenbaum views the typical impersonator concert as a religious ritual for both the performer and his (or her)[24] audience of Elvis fans:

> The impersonator experience [is] the central communion, the agape, or love feast, of Elvis spirituality, an emotionally liberating opening to a feeling of intimacy. The impersonator gives permission in his hokey setting for people to invoke love, the emotion, the feeling of intimacy that they might not give into otherwise.
>
> (1995: 62)

To be sure, Rosenbaum isn't entirely above taking a scornful jab or two at the Elvis phenomenon: his use of the word "hokey" to describe the stereotypical impersonator's act and his deliberate substitution of "Death Week" for "Tribute Week" as the label for the annual August gathering of the Elvis faithful make it clear that this author isn't entirely ready to accept Elvis as a serious (much less a sacred) figure. On the other hand, when an admittedly skeptical observer such as Rosenbaum can come away from "two weeks' total immersion in Elvis country" (1995: 51)[25] and claim in all earnestness that there's a genuinely spiritual aspect to the Elvis phenomenon, such a testimonial speaks more convincingly to the actual sacralization of Elvis than even the most ardent words of a true believer.

And, in fact, even people who don't necessarily accept the notion that Elvis is (or should be) a sacred figure have invoked such images often enough in recent years to give the metaphor extra life: nothing quickens a faith, after all, quite like public expressions of mock and disbelief from skeptics. For instance, the 24-Hour Coin-Operated Church of Elvis in Portland, Oregon was started by Stephanie Pierce, not as an expression of genuine religious devotion to Elvis – Pierce is actually not an Elvis fan at all – but as a humorous art project. The Church, however, proved to be more popular with the general public than any of Pierce's other artworks, and she maintains it to this day (complete with an extended line of Church-related merchandise) because the demand for it pays the bills more effectively than her other works. A similar example of a joke about Elvis's divinity that's taken on a life of its own can be found in the case of A.J. Jacobs. Perhaps inspired by the warped logic that some Elvis fans have used to "prove" that Elvis is still alive,[26] Jacobs wrote a brief series of humorous, two-sentence comparisons between Elvis and Jesus ("The Two Kings") that was published by the satirical magazine *The Nose* in 1992. For instance:

> Jesus lived in a state of grace in a near eastern land
> Elvis lived in Graceland in a nearly eastern state
> [. . .]
> Elvis' father, Vernon, was a drifter and moved around quite a bit
> Jesus' father is everywhere
> [. . .]
> There is much confusion about Elvis' middle name – was it Aron or Aaron?
> There is much confusion about Jesus' middle name – what does the "H" stand for?
>
> (Jacobs, 1992a)

Not only was this one-page list subsequently reprinted (in a slightly abbreviated form) in the *Utne Reader* (Jacobs, 1992b), but it was actually transformed (via the magic of small pages, large typefaces, and a handful of illustrations) into an entire book (Jacobs, 1994). More recently, Jacobs's satire has become a widely (if not quite legally) circulated piece of e-mail humor: in late 1994 and early 1995, I received copies of his list (stripped of any identifying markers to indicate either its source or its copyright status) from at least four distinct and unrelated sources.[27] It seems safe to say that Pierce, Jacobs, and the various other people[28] who've mockingly observed that Elvis has taken on a visible religious aura are not trying to promote this vision of Elvis seriously: if anything, the point of many of these invocations of Elvis's holy status is to demonstrate how ridiculous the whole idea of treating Elvis as a god (or even a saint) is. Nevertheless, the frequency with which even non-believers feel compelled to raise the subject of Elvis's potential

divinity – even in jest – speaks to the prominence of this aspect of Elvis's current ubiquity.

Without actually delving into the thorny (and unanswerable) theological question of whether Elvis really might become the godhead of a new religion,[29] what I want to suggest here is that, between them, Graceland and the Elvis Presley Birthplace (located a short ways down US Route 78 from Memphis in Tupelo) play a major role in contributing to the ongoing processes of Elvis's deification and canonization. More specifically, I would argue that these two sites simultaneously function in two different ways to place Elvis on a sacred pedestal: (1) as *passive* sites where fans are able to sanctify Elvis themselves and (2) as *active* participants in the sanctification process that are structured, organized, and promoted in such a way as to instill and accentuate a spiritual attitude toward Elvis in the visitor.

The first of these is perhaps the most obvious way that Graceland and the Birthplace reinforce the religious aura that has settled around Elvis: namely that, simply by being open to the public, they serve as destinations for holy pilgrimage, sacred places that the true Elvis devotee is compelled to experience firsthand. As Harrison (in one of his less tabloid-esque moments) puts it:

> Do Elvis fans feel obliged to visit Graceland in the way that a Muslim is obliged to go on Haj, pilgrimage, to Mecca? Obviously there is no formal requirement as there is in Islam, but echoes of the Islamic obligation are to be found. This call comes from an editorial in an edition of *Elvisly Yours*: "You MUST visit Graceland, this year, next year, or in your lifetime – just to see what this man achieved."
>
> (1992: 81–2)

What makes these locations sacred, then, is not so much the central roles that they played in Elvis's life as the practices of the Elvis faithful with respect to these sites. As Gary Vikan argues, "the *locus sanctus* [sacred place] is identifiable not by any single set of physical characteristics, but rather by what people do in relationship to it" (1994: 158). One could argue, for instance, that in many ways Graceland is similar to George Washington's Virginia plantation, Mount Vernon: both are Southern mansions; both belonged to internationally renowned and heavily mythologized figures; both are consistently popular tourist sites; and both are the final resting places of their former owners. Despite its being the home of a figure revered enough to be called "the Father of his Country," however, Mount Vernon is more akin to a public park than to holy ground: it's a site that lends itself not to quiet prayer and spiritual reflection, but to family picnics and grade-school field trips. By way of contrast, the overall mood permeating Graceland – even in the gift shops – is closer to the sort of quietly charged reverence that one might experience at a shrine or in a cathedral than to the "family outing" chaos typical of most other tourist sites.

Ultimately, though, the holiness of Graceland isn't a function of the institutional structures or physical spaces involved as much as it's the product of differences in the behaviors and attitudes displayed by the visitors in question. The Graceland tourist is much more likely to participate in Elvis-inspired spiritual rituals of some sort than the typical Mount Vernon tourist is to do the same for Washington. For example, the all-night Candlelight Vigil that occurs at Graceland every year during Tribute Week is perhaps best understood in comparison to explicitly religious ceremonies. Archaeologist Neil Asher Silberman describes the ceremony this way:

> Anyone who has ever witnessed the Holy Fire on Easter Sunday in Jerusalem or has studied the fire rituals connected with ancient solar heroes will immediately sense the eerie familiarity of the annual procession held in Graceland's "Meditation Gardens" [where Elvis is buried] the night before the anniversary of Elvis's death. Every August 16, in the predawn darkness, the faithful circle Elvis's grave with lighted candles – extinguishing the flames with the first glimpse of the rising sun.
>
> (1990: 80)[30]

Even a rock star as widely revered and deeply mourned as John Lennon doesn't inspire this sort of display of devotional fervor: whereas 50,000 Elvis fans gathered at Graceland on the tenth anniversary of his death, the analogous ceremony marking the tenth anniversary of Lennon's murder found only a few hundred fans gathered outside the Dakota apartment building in New York to commemorate the occasion (Vikan, 1994: 166).[31]

Another example of fan behavior that helps to mark Graceland as a sacred place is the votive offering. Like Christian pilgrims of the first millennium, Elvis fans visiting Memphis frequently leave behind tokens symbolizing their faith, love, and devotion. The simplest examples of these offerings can be found on the stone wall that borders the west side of the Graceland property. Here, virtually every square inch of stone and mortar is covered with the graffitied thoughts, prayers, and wishes of Graceland visitors.[32] Admittedly, some of these messages are harsh in tone – not everyone who takes pen in hand to leave their mark on the wall, after all, is an Elvis fan[33] – but most are respectful and many are unmistakably worshipful.[34] More substantial markers of the sacred light in which many people view their trips to Graceland, however, are the various objects left by pilgrims and fans at Elvis's gravesite. These run the gamut from hand-scribbled notes and lone flowers to elaborate posterboard collages and box dioramas depicting key scenes in Elvis's life or explaining to the world how much Elvis meant to the pilgrim in question. While much of the wall graffiti could plausibly be interpreted as the spontaneous offerings of casual tourists, the more elaborate votive offerings left by Elvis's grave are more clearly heartfelt expressions of the deep love and

devotion felt by the fans who made them and, in many cases, carried them thousands of miles specifically to be left at Graceland. As involved and complicated as these offerings might sound, however, such efforts are far from unusual; on the contrary, even during the off-season, one can always find dozens of these hand-crafted homages to Elvis left alongside his grave by worshipful fans.

Yet another important distinction between pilgrims and tourists has to do with the different ways that they organize their travels. Tourists frequently arrange their itineraries with an eye towards seeing a variety of sites/sights that happen to be geographically accessible from a given location; thus, visitors to Washington, DC are likely to pick and choose from the various tourist attractions they can reach easily, regardless of how disparate in spirit those might be (e.g., touring a government building such as the Capitol in the morning and then visiting an art museum such as the National Gallery in the afternoon). Pilgrims, on the other hand, are more likely to focus their travels on a single sacred destination, while allotting time along the way (or during a prolonged stay) for side trips to "ancillary holy places" (Vikan, 1994: 158). Thus, for example, while a *tourist* visiting Memphis might stop at Graceland, he or she would also be likely to investigate other, non-Elvis-related tourist sites in the area (e.g., the Peabody Hotel, the Memphis Pyramid, the National Civil Rights Museum). The *pilgrim*, however, will be more inclined to focus his or her energies on Graceland and Elvis-related side trips (e.g., the Birthplace, Sun Studio, the statue of Elvis at the foot of Beale Street). The frequency with which Elvis fans organize their visits to the area around "ancillary" Elvis sites is evident in the publication of special maps that guide the Elvis pilgrim to various spaces (some of which, such as his pre-Graceland residences, aren't formally organized tourist sites at all) associated with his life and career. *ElvisTown*, for instance, offers the Memphis visitor four pages of maps: two that cover all the city's major tourist attractions, and two devoted exclusively to Elvis sites. Travel writer Jack Barth (1991) has taken the notion of ancillary Elvis tourism a step further, publishing an entire book that consists of nothing but Elvis-related sites, major and minor, from thirty-eight states and six foreign countries.

In much the same way that pilgrims organize the space of their travels around the sacred figure in question, so too do they schedule their pilgrimages around holy days related to that figure. While tourists are more likely to arrange their trips around externally imposed vacation schedules (when they can get two consecutive weeks off from work, when their children's spring break begins, etc.), pilgrims will try to time their visits to coincide with special anniversaries or holidays (birthdays, death dates, anniversaries of important events in the saint's life, etc.) related to the figure or place in question. Christian pilgrims, for instance, may feel that any visit to Jerusalem, with the opportunity to actually "see and touch the places where Christ was present in the body" (Paulinus of Nola,

quoted in Vikan, 1994: 155), is an important spiritual occasion, but to stand in those same places on Good Friday or Easter Sunday brings the pilgrim even closer to God than would be the case on a more ordinary day.

Similarly, Elvis pilgrims are more likely to undertake the journey to Memphis and Tupelo so as to be present on the holy days of Elvis's life calendar. While one can find the Elvis faithful visiting Graceland and the Birthplace in significant numbers at any time of the year, the peak times for such pilgrimages are Tribute Week in August (the seven days leading up to the anniversary of Elvis's death on the 16th) and, to a slightly lesser extent, early January (around his birthday on the 8th). As Vikan notes, "during Tribute Week alone there are fifty thousand visitors to Graceland, and one senses immediately that as a group they stand apart; these make up the most concentrated pool of Elvis Friends, and these, disproportionately, account for the pilgrimage activity [at Graceland]" (1994: 158).

These are some of the many ways that Elvis fans and pilgrims help to transform Graceland and the Birthplace into sacred places. And, if you believe the official line from Elvis Presley Enterprises (the incorporated wing of the Presley estate that, among other things, handles the day-to-day operation of Graceland) and the Elvis Presley Commission (the curators of the Tupelo home), that's where the process of sanctifying Elvis ends: with the fans. Neither organization sees itself as one dedicated to building a religious or spiritual aura around Elvis, and spokespersons for each are often forced to take great pains to explain that they're not in the business of making Elvis into a god.

But while deification might not be the actual intent of either of these organizations, many of the practices they engage in to keep these sites open, accessible, and (perhaps most importantly) profitable nevertheless reinforce the quasi-religious aura around Elvis in significant ways. Some of these practices are subtle: they don't work to deify Elvis directly as much as they make it easier for his fans to engage in the various sanctifying practices discussed above. Graceland, for instance, encourages visits to "ancillary holy places" by providing a regular shuttle bus service to and from Sun Studio and, during peak pilgrimage seasons, organizing day trips to the Birthplace in Tupelo. Similarly, the estate implicitly encourages fans to leave graffitied votive offerings on Graceland's front wall by providing a drive-up lane adjacent to the grounds (so that fans can pull over without blocking traffic on Elvis Presley Boulevard) and by periodically sandblasting sections of the wall in order to make room for another wave of fans/pilgrims to leave new graffiti behind. One can also see the elaborate display of Christmas lights and decorations that adorns Graceland's lawn each year as an implicitly forged link between one holy figure (Elvis) and another (Jesus), insofar as the estate waits to remove the display until 9 January: the day after Elvis's birthday, when (apparently) the holiday season is formally over.

Perhaps the main way that the estate actively sanctifies Elvis, however, is through its increasing "sanitization" of his image and life story (as presented at Graceland) over the past decade or so. Between each of the four trips I've made to Graceland since 1988, the gift shops in Graceland Plaza (the area directly across Elvis Presley Boulevard from the house itself, where the ticket window for the mansion tour and assorted mini-museums are also located) have become more sterile and predictable. Where once it was possible to wander through these shops and find a wide range of unique and unusual souvenirs (including Elvis-shaped whiskey decanters, Elvis board games, Elvis shampoo and conditioner, etc.), the souvenir fare available when last I was in Memphis (January 1993) was almost all of the kind common to any ordinary tourist trap: ceramic mugs, glassware, miniature spoons, ballpoint pens, postcards, T-shirts, and so on. The most offbeat paraphernalia I could find at Graceland proper on this last trip was an Elvis "mailbox coverup" (i.e., a plastic slipcover for a standard rural mailbox) being sold for $12.99: the more unique and twisted (and, to my mind, the more interesting) Elvis souvenirs had all been banished to the "unofficial" (i.e., those not run by the estate) gift shops that are now primarily located in a strip mall (Graceland Crossing) just north of Graceland.

Even on my earliest visit to Graceland, however, the story of Elvis's life and career (presented in piecemeal fashion via tour guide spiels, museum displays, a brief documentary video, and the like) was one that had been "cleaned up" for mass consumption. There was little to no mention of either the racial or sexual aspects of the national controversy created by Elvis's initial rise to stardom, scant mention of the fact that he and Priscilla divorced four years prior to his death, and (unsurprisingly) no mention at all of Elvis's prescription drug (ab)use. When asked where and how Elvis died, a Graceland tour guide will (if following company policy) simply say that he suffered a cardiac arrest on the second floor of the mansion; when pressed, he or she will admit that Elvis died in the master bedroom suite: words that the tourist will *not* hear in connection with Elvis's death include "bathroom," "drugs," or "overdose," at least not from the mouths of a Graceland employee. If a persistent tourist asks specifically about such things, the tour guide will typically either claim ignorance (e.g., "I don't know for sure, sir, I've never been upstairs") or offer a polite denial that matches the formal coroner's verdict (e.g., "Elvis *was* taking prescription medication, but this did not contribute to his heart failure"). Practices such as these, while ostensibly good faith efforts to put forward a positive image for Elvis and not to upset fans who've traveled thousands of miles to see Graceland, ultimately work to reinforce the image of Elvis as a martyr. As Vikan argues:

> Purged from the singer's factual life history are any references to drug abuse, obesity, or paranoic violence. The *vitae* . . . speak instead of a dirt-poor

southern boy who rose to fame and glory, of the love of a son for his mother, of humility and generosity, and of superhuman achievement in the face of adversity. They emphasize Elvis's profound spiritualism and his painful, premature death.

(1994: 150)

In presenting a sanitized version of Elvis's life story, Graceland and the Birthplace (where the story of Elvis' life and career is told in much the same way as it is at Graceland) help to mythologize the man as an almost flawless saint figure, rather than a real and imperfect human being.

The ultimate example of how Elvis tourism works to sanctify Elvis, however, is the Elvis Presley Memorial Chapel adjacent to the Birthplace in Tupelo. Diane Brown, one of the Birthplace's managerial staff, describes the idea behind the chapel this way:

The chapel is peaceful and quiet and was built by his friends. Some of the fans spend a long time there. It is a good place to sit down and meditate and collect your thoughts. It was intended that the chapel be a special place to pray. That is the spirit in which fans come here. He had himself said that he would like one day to see a little meditation garden or chapel here in the park in Tupelo, so that when fans visited his house they could visit a place of prayer. That was the inspiration for it. . . . I hope they don't go into the chapel to pray to Elvis. That was not the intention. That is not the spirit of the place.

(quoted in Harrison, 1992: 87–8)

As is the case at Graceland, the Birthplace is ostensibly not intended to make Elvis into a holy figure. Nevertheless, intentions and effects don't always match up well: a fact that the Chapel bears out admirably. The Birthplace itself, after all, is *very* small (i.e., two tiny rooms) and even the most devout Elvis fan would be hard-pressed to linger in the house itself for much more than a few minutes. Until 1992 (when a small museum of Elvis memorabilia was opened on the grounds), the only other building associated with the Birthplace (other than an equally tiny gift shop) was the Chapel: a situation that implicitly encouraged visitors to spend more time in the Chapel than they did at the Birthplace itself. Inside the Chapel, a large stained glass window depicts a pop-art-esque version of the Crucifixion . . . or does it? The white-robed figure with outstretched arms is ostensibly Jesus on the Cross, but the absence of any facial details makes it plausible – especially in light of the Chapel's location and the type of people (i.e., Elvis fans) who are most likely to visit it – to see this image as that of Elvis, clad in one of his trademark white jumpsuits, bowing at the end of a concert. Even if the ambiguous Jesus/Elvis figure in the stained glass is an honest accident, however, the

geographic alignment of the Chapel is too perfect not to have been a deliberate gesture: behind the pulpit is a narrow floor-to-ceiling picture window – the only clear glass window in the portion of the building open to the public – that provides a neatly framed view of Elvis's Birthplace. Brown's claims regarding the intentions behind the Chapel notwithstanding, if the Elvis Presley Commission had wanted to arrange the buildings in question so as to promote the worship of Elvis as a holy figure, they could not have improved on what they achieved by accident.

TRYIN' TO GET TO YOU

In his examination of the various fan/pilgrim practices and rituals that help to transform Graceland from an ordinary tourist attraction to a *locus sanctus* (i.e., sacred place), Gary Vikan notes that the crowds who flock to Elvis's former home exhibit a much stronger sense of *community* than does the average gathering of tourists:

> Nothing could be more unlike the anonymity and dispassion of tourist travel than the intense bonding that takes place among the faithful during Tribute Week. Anthropologists speak of the *communitas* of pilgrimage, and emphasize the liminoid nature of the experience, which like a rite of passage takes the pilgrim out of the flow of his [sic] day-to-day existence and leaves him [sic] in some measure transformed.

> (1995: 159)

While Vikan is specifically describing the most intense form of social bonding that takes place at Graceland (i.e., that which occurs between the Elvis faithful during Tribute Week each August), a similar feeling of community pervades Graceland year round. In fact, in the end, perhaps the most crucial contribution that Graceland has made to Elvis's stardom is its role as a physical site where an international community of Elvis fans can congregate and actually come to have a sense of themselves *as a community*.

Of course, Elvis's is not the only community of fans centered around popular culture phenomena – far from it. One could in fact argue that the very notion of fandom is unthinkable outside of the realm of the popular,[35] and that any commercially successful example of popular culture will, almost by definition, attract enough fans to form some semblance of a community. Some critics would even go so far as to suggest that the mass media as a whole work to transform the geographically far-flung and culturally diverse amalgamation of peoples that is the US into a cohesive community. For instance, Paige Baty argues that

> hundreds of millions of people who have little physical contact with one another become members of the same community because they are literate

in the network of stories, characters, and figures that populate the terrain of the mass-mediated common ground. . . . The community lives *in medias res*, linked across time and space through viewing, reading, and listening practices that substitute for what Bellah et al. [1985] term "practices of commitment."

<div align="right">(1995: 41, 43)</div>

While I agree with Baty that the media provide the general population with a broadly shared body of knowledge and information – and that we shouldn't underestimate the value of such common ground when it comes to questions of community-building – I would also argue that it takes more than just a widespread familiarity with a set of "stories, characters, and figures" to bring an actual community into existence.

The phenomenon that Baty is describing above is actually a form of cultural literacy: a potentially necessary – but by no means sufficient – condition for the formation of a viable community. For example, an inability to identify a prominent public figure (e.g., Elvis, Hillary Rodham Clinton, Spike Lee) may instantly brand one as an outsider to a particular community, but the converse of this statement is generally false: not everyone who is familiar with, say, Princess Diana can reasonably be said to belong to the same community as a result of that knowledge. At the very least, if a geographically separated population is going to be brought and held together (in spirit, anyway) as a community, it's necessary for there to be some sort of *affective investment* (in a celebrity, a myth, a cultural phenomenon, etc.) shared by the members of that population.

This, then, is why it makes sense to talk about communities of *fans*: unlike "ordinary" audience members, fans have made a strong affective investment in a given star or phenomenon (Grossberg, 1992a). For instance, while most people (i.e., non-fans) may be moderately familiar with Elvis and his music, he doesn't *matter* to their daily lives and self-identities in the same way that he does for his fans. Similar affective investments can be found for a broad range of popular culture phenomena: professional and collegiate sports teams (especially in baseball, basketball, and football), popular culture genres (e.g., romance novels, science fiction, soap operas), textual formations (those centered around James Bond, Monty Python, *Star Trek*, etc.), and other stars (especially those associated with popular music) have all inspired prominent fan communities of one sort or another. For all their affective similarities, however, these other popular-culture-centered communities and Elvis's differ in significant ways. In particular, the community of Elvis fans is far more *fixed*, both in space and time, than are other fan communities, and this heightened sense of permanence helps not only to render Elvis's stardom unique, but also to make his posthumous career possible.

Because, for the most part, the various popular culture phenomena mentioned above are not well grounded in physical space, the communities that form around them tend to be spread very thin across a wide expanse of geographic territory (one that is usually national, if not global, in scope). For example, there is no specific site on the map that is linked to *Star Trek* tightly enough to be a permanent location where the national community of Trekkies could regularly come together. And while there are certainly spaces (e.g., convention centers, hotels, college and university campuses) where such communities can manifest themselves, such sites typically have no special significance to the community in question, and the moments when such communities are formed tend to be fleeting. A *Star Trek* convention, for instance, may afford an otherwise diffuse population of fans the opportunity to congregate as a community, but the lifespan of that community is brief (a few days at most) and the site in question isn't likely to be one that has any pre-existing (or lasting) association with either *Trek* or Trekkies. While the sense of community that pervades such a gathering is very real, the space occupied by that community isn't theirs in any sense other than that they've rented it for the occasion.

Describing the nature of fan communities associated with media stars and other celebrities, Baty argues that "the 'subculture' that forms around a cult figure has no specific geographic locus, nor is it necessarily related to the exigencies of daily life, nor does it require some of the conventional charges of community" (1995: 43n). Because such communities lack a fixed geographic center, they exist primarily in a discursive realm: one that is typically organized around the body of media texts associated with the star or cultural phenomenon in question (i.e., texts produced both for and by fans).

Significantly, the one exception that Baty notes to this rule is that of Elvis, insofar as those "fans who regularly visit Graceland and attend Elvis conventions participate in practices of commitment that bind them to other 'followers' of Elvis" (1995: 43n). While there's certainly a mediated aspect to the global community of Elvis admirers – not all of his fans make the pilgrimage/trip to Graceland, and even those who do generally first come to Elvis via his music and movies – one of Graceland's more important functions is that it serves as a "real world" site where the type of temporary community that arises at fan conventions can take on a more stable and permanent existence. The specific fans who are at Graceland will, of course, change from day to day – and even from hour to hour – (i.e., this is not a residential community in the same way that a town or neighborhood is), but *some* critical mass of Elvis fans can almost always be found there: a fan presence that provides enough continuity to foster a lasting, tangible sense of an Elvis-centered community. In marked contrast to the rented spaces of fan conventions, one never gets the feeling at Graceland that next week (if not tomorrow) will find a completely different "community" occupying the space.

Perhaps the best way to explain the difference that Graceland makes to Elvis's stardom, however, is to compare it to two other potential exceptions to the rule that communities of fans are discursive, rather than physical, in nature: namely, those fan communities associated with sports teams and the Grateful Dead. Sports fans can point to the arenas and stadiums where their teams play and rightfully claim these spaces as a "home" for their team and the associated community of fans in a way that isn't possible for Trekkies (or the like) to do with the rented hotel ballrooms where their gatherings take place. In fact, one of the principal purposes of such buildings is to provide sites where fan communities can congregate; moreover, for teams with substantial numbers of season ticket holders, such communities can actually be fairly stable (in terms of who their members are) over time.[36] Nevertheless, the link between communities of sports fans and the spaces where they come together remains an intermittent one, and thus, at best, sports teams provide a partial exception to the "no-fixed-space" rule for fan communities. For instance, an arena that is home to a basketball game (and its attendant community of fans) on one night will tend to play host to a wide range of events – rock concerts, boat shows, circuses, figure skating exhibitions, and the like – on other nights, thus weakening the link between the arena and the specific community of basketball fans in question. Even single-use facilities (e.g., Chicago's Wrigley Field and Comiskey Park or Baltimore's Camden Yards, which rarely (if ever) play host to non-baseball events) only function as sites where fan communities exist on a few days each year (i.e., for those days during the appropriate sports season when the team in question has a home game).[37] Moreover, sports-centered fan communities are, to a large extent, pre-constituted, insofar as they draw upon already existing geographic communities (e.g., the population of a state, metropolitan area, or university town). While not all fans of the Chicago Bulls (for example) are Chicago area residents (and, similarly, not all Chicagoans care about basketball), the *community* of fans in question – i.e., those people who regularly attend Bulls games and/or gather in sports bars to collectively root for their team – is initially (and primarily) defined by the team's use of Chicago as its home base of operations. Were the Bulls to relocate to another city (as professional sports teams are increasingly wont to do these days), their fan base in the Chicago area would probably not disappear entirely, but the team's primary community of fans – i.e., those who would most regularly be able to gather in one place to watch the team play – would shift away from Chicago and towards residents of the team's new hometown.

The other potential exception of note to the rule that fan communities are primarily discursive in nature is the community of fans and (quite literally) fellow travelers who attached themselves to the Grateful Dead over the years. For more than two decades prior to Jerry Garcia's death in 1995 and the band's subsequent break-up, Deadheads constituted a sizable and highly visible sub-

culture of fans who followed the band around the country as they toured. As stable as the Deadhead community may have been over time, however, it never enjoyed any real stability in terms of space: at its most tangible, it was always a mobile community that only manifested itself physically at the times and places coinciding with the band's touring itinerary. To be sure, the Deadheads were a much more tangible community than the fans of most other musicians ever were or could be. For example, millions of people may have seen Bruce Springsteen in concert during the height of his popularity in the 1980s, but when his tours moved from one city to the next, they didn't carry large numbers of fans with them: the "community" of Springsteen fans who gathered to see him in city A on one night would be replaced by an almost entirely different community of fans in city B the next night. And while not everyone (or even necessarily most people) who attended Dead concerts did so night after night, city after city, as the band moved across the country, enough fans did so on a regular basis to create a significant sense of continuity in the audience from one tour stop to the next.

Nevertheless, the community of Deadheads was still never firmly rooted in any geographic location. As Howard Rheingold writes,

> the Deadheads, many of whom weren't born when the band started touring, have a strong feeling of community that they can manifest only in large groups when the band has concerts. Deadheads can spot each other on the road via the semiotics of window decals and bumper stickers, or on the streets via tie-dyed uniforms, but Deadheads didn't have a *place*.
>
> (1993: 49)

Rheingold goes on to argue that it wasn't until Deadheads began joining the cyberspace community known as "The WELL" (The Whole Earth 'Lectronic Link) in large numbers that their subculture, for all the "strong feeling of community" they may have shared, actually came to have a stable space they could call their own.[38]

The uniqueness of Graceland, then, lies in its longstanding role as a fixed geographic site where Elvis fans could congregate: the epicenter for what Jane and Michael Stern (1987) have described simply as "Elvis World." Unlike the Deadhead community, Elvis fans have a place where they can (and do) regularly gather. And, unlike fan communities associated with sports teams, the Elvis faithful don't have to share their space with events peripheral to their fandom (e.g., dog shows, tractor pulls, rodeos, professional wrestling exhibitions, etc.) *and* they have access to that space year round.[39]

Now one could still argue that the unique factor here is not the physical presence of Graceland as much as the unusual tenacity of Elvis's admirers: that it's the extreme fanaticism of the Elvis faithful that has transformed his former home

into a public icon, rather than Graceland that has given these fans a fixed site where they could gather and reinforce one another's devotion. Elvis fans, after all, constitute what is probably the largest population of fans in the world and, as the quasi-religious nature of many fans' devotion would indicate, many of them seem to be obsessed with their idol to the point that he has taken over large portions of their daily lives. Given their sheer numbers and the devotional fervor that often characterizes their fandom, it's still possible that, in a world without Graceland, Elvis's fans would have turned any home of his, regardless of its location, into a pilgrimage site and public icon.

The main problem with this argument, however, is that it assumes that Elvis fans are fundamentally different from those who've hitched their wagons to other stars: that their admiration for their idol is more obsessive, more fanatical, more tenacious than those of other fans. As I've already argued in chapter 1, however, such is not the case. The work of Fred and Judy Vermorel (1985, 1992), for instance, demonstrates that the "obsessive" behavior of Elvis fans is a general characteristic of fandom more than it is a property linked to particularly charismatic stars. For instance, the female fan cited by the Vermorels who won't sleep with her husband because that would make her "unfaithful to Barry [Manilow]" (1985: 80) is no less tenacious or fanatic than Frankie Horrocks, the New Jersey woman who moved to Memphis as soon as she heard that Elvis had died, leaving her teenage son behind to finish high school on his own (*Mondo Elvis*, 1984).

Where Graceland factors into the equation (and where it becomes safe to talk about the qualitative differences between Elvis fans and those of other stars) is in the way its physical space allows Elvis fans – obsessive or otherwise – to reinforce the validity of their devotion to Elvis. In most cases, the social stigma attached to the sort of "extreme" behavior discussed above, combined with the relative isolation of individual members of a community of fans from one another, works to keep the more obsessive examples of star worship hidden from public view. The "Manilover" from the Vermorels' study, for instance, recognizes that others are likely to see her behavior as "rather silly and stupid" (1985: 80); while she may continue to save herself for Barry anyway, the quasi-apologetic way in which she describes her devotion suggests that she's not entirely comfortable with parading her relationship to her idol publicly. Other stars' fans are no less likely to engage in obsessive practices and fantasies than Elvis's are, but they *are* more likely to censor themselves when it comes to public displays of such behavior.

Thanks to Graceland, however, the fanatic Elvis follower is less likely to harbor such reservations. Graceland gives "Elvis World" a geographic center that other fan communities lack: an environment where the type of "extreme" adulation that fans of other stars can't openly express is able to flourish comfortably with relatively little fear of public censure. The steady stream of visitors to Graceland – day after

day, year after year – does more than just swell the coffers of the Presley estate; it creates a physical (if somewhat fluid) community of fans who help to reinforce for one another the feeling that their personal obsession is shared by thousands, if not millions, of other people. To be sure, fans of most stars recognize that there are other people like them elsewhere in the world (at least as far as their dedication to the star in question goes). For example, the woman who will "never be unfaithful to Barry" knows, at the very least, that millions of other people have bought his albums and seen him in concert; while she may not be able to assume that all (or any) of these fans will refuse to have sex with anyone besides Manilow, she can safely assume that a significant portion of this community shares some semblance of her love and respect for her idol. Unlike most Elvis fans, however, she can't assume that the general public will recognize either the existence of the fan community to which she belongs or the depth of its collective feeling for the star at its center. By way of contrast, even though the average Elvis fan may not be surrounded by like-minded folks in his or her daily life, such a fan *can* safely point to Graceland – and the fan-based community that (re)manifests itself there on a daily basis – as public evidence that his or her devotion is more than just an obsessive, idiosyncratic personality quirk.

This, then, is DeLillo's notion of "an accumulation of nameless energies" (1985: 12) come to life. While particularly fanatic Elvis fans may still recognize that their love for Elvis carries with it a certain social stigma – that the general public doesn't necessarily find such behavior and attitudes "normal" – they are also less likely to be ashamed of their "extreme" fandom than other fans because they have the implicit support and approval of a visible community behind them. Moreover, it's precisely this strong sense of community that ultimately makes Elvis's posthumous career possible. In part, this is simply a function of the relative lack of self-censorship that the community of Elvis fans exhibit when it comes to public displays of their fandom: being less inhibited than other fans about expressing their feelings for their hero, Elvis fans have relatively few qualms about promoting Elvis publicly.

Perhaps more interesting, however, is the frequency with which "non-believers" use the community of Elvis fans (and their excesses) as the butt of a running national joke. Such skeptics may not be able to understand how or why Elvis fans focus so much time and energy on their hero, but they also have a hard time denying that a sizable population of hardcore Elvis fans exists, or that this population has some sense of itself as a relatively cohesive (if geographically dispersed) community. And, in the end, one of the reasons why Elvis appears so often these days in contexts other than those where he more obviously "belongs" (i.e., those texts and sites most clearly connected to his career and his stardom) is that many of these invocations of his name and image come, not from fans who refuse to let go of their idol, but from skeptics making fun of such fans. For the

skeptics' satirical jabs at the excesses of Elvis fans to be effective, the general public has to have some broader understanding of the community of Elvis fans (and their practices) in the first place: an understanding that's only possible because Graceland exists to help put (and keep) that community of fans in the public eye.

4

ELVIS CULTURE

No detail must be left out, not even a dog with ticks or a neighbor's boy who ate an insect on a dare. The smell of pantries, the sense of empty afternoons, the feel of things as they rained across our skin, things as facts and passions, the feel of pain, loss, disappointment, breathless delight. In these night recitations we create a space between things as we felt them at the time and as we speak them now. This is the space reserved for irony, sympathy and fond amusement, the means by which we rescue ourselves from the past.

(DeLillo, 1985: 30)

I WAS THE ONE

In 1993, Swarthmore College (a prestigious liberal arts college in suburban Philadelphia) sponsored a symposium entitled "Pop! Goes the Culture," a forum centered around the notion that US culture is now little more than trivial entertainment and pop superficiality. As partial evidence for this trend, the full-page ad for the symposium that ran on the back cover of the August 1993 issue of the *Swarthmore College Bulletin* (see plate 29) noted that:

- Time Inc. is testing a new celebrity photo magazine – its second stab at a periodical for "readers" who find *People* magazine too cerebral.
- When Bill Clinton was elected president, he gave his first interview not to Peter Jennings or Tom Brokaw – but to Tabitha Soren of MTV.
- An entire generation is growing up convinced that Raphael, Donatello, Leonardo, and Michelangelo are only Teenage Mutant Ninja Turtles.
- A survey of 10-year-olds found that they could name more brands of beer than presidents of the United States.

The boldface headline above this portrait of a culture in decline, however, is what interests me most here. Quoting renowned composer/conductor Leonard

Bernstein, the ad asks the provocative question, "Was Elvis Presley 'the greatest cultural force in the twentieth century?'" Combined with the text of the ad, it's clear that the symposium's organizers aren't asking this question in an open-ended way. From their perspective, the idea that Elvis (of all people!) might be a significant cultural force can be seen in two ways: either as a preposterous, but not very funny, joke (in much the same way that it's laughable to describe *People* magazine as "cerebral" and its audience as "readers") or as a poignant demonstration of just how far US culture has sunk. Either way, however, the idea that the name "Elvis" might seriously be uttered in the same breath as the word "culture" is beyond the pale of reasonable thought.

A similar theme plays itself out in David Morrell's short story "Presley 45" (1994). Though the narrative doesn't make explicit reference to the Bernstein quote, its protagonist, English professor Fred Hopkins, shares Bernstein's belief that Elvis was *the* central figure in twentieth-century US culture. And, like Bernstein, Hopkins's ideas about Elvis are greeted with scorn and disbelief. The chair of his department, for example, responds to Hopkins's initial request to teach "a culture course" on Elvis in a haughtily dismissive manner:

> How could I justify teaching Elvis in the *English* department? The subtlety of the lyrics? The poetry of "Jailhouse Rock"? Give me a break. The dean would think I'd lost my mind. He'd ask me to resign as chair. . . . Fred, don't you think you're interpreting "culture" rather broadly? I mean, listen to what you're saying. Elvis Presley, for God's sake. The department would be a laughingstock.
>
> (Morrell, 1994: 279)

But eventually the department chair relents . . . and Hopkins's Elvis course is immediately overenrolled. The previously unassuming professor becomes a minor celebrity himself, enough so that the *Today* show sends a crew to campus to do a story on Hopkins and his class. During the course of the interview, however, Hopkins goes off the deep end: one minute he's desperately trying to explain Elvis's cultural significance to host Bryant Gumbel ("*Nothing* about Elvis can be overstated," Hopkins gushes, in a hyperbolic echo of Bernstein's words, "For a brief moment in the middle of this century, he *changed* this century" (1994: 286)); the next minute he pulls out a pistol, shoots out ("in Elvis' name") the lens of the television camera being used for the broadcast, and goes on a cross-town shooting rampage that leaves at least nine people (including Hopkins) dead. In the end, Morrell's story takes the anti-Elvis skepticism voiced by the Swarthmore symposium organizers a step further: not only is it foolhardy to claim that Elvis was an important cultural force, but anyone who might actually believe such a claim is only a step away from being a murderous lunatic.

What I want to suggest here, however, is that Bernstein's estimation of Elvis's

cultural significance is far more accurate than the Morrells and Swarthmores of the world regularly make it out to be, and – most crucially – that this fact should not be taken as a sign of some larger cultural decay: a world in which Elvis never became a public figure *would* be a vastly different world from the one in which we live today and, contrary to what Elvis skeptics would argue, such a world would *not* be an improvement on the one in which we currently live. The primary argument that I want to make here is twofold. First, I want to claim that Elvis's rise to stardom reshaped US culture in dramatic and unprecedented ways: that he served as the point of articulation around which a new cultural formation – one ultimately central to US culture as a whole – could come into existence. Second, I want to argue that Elvis is everywhere on the contemporary cultural terrain precisely because he played such a crucial role in (re)building that terrain forty years ago. In fact, given the extent of the cultural transformations that followed in Elvis's wake, it would be surprising if there *weren't* visible traces of him and if (for lack of a better term) his aura *weren't* scattered widely across the cultural terrain today – not only in places where his lingering presence would seem to be the most "natural" (i.e., those connected to popular music or the entertainment industry), but also in places where he doesn't seem to belong at all.

Before I can tackle either of these points directly, however, it's necessary to briefly examine the concept of "culture" as it's commonly used and understood in the US today. At the heart of the widespread inability to see Elvis as a culturally significant figure, after all, is a deeper problem: not so much with our under-standing of Elvis and his talents, but with our understanding of the concept of "culture." More specifically, I want to argue that our common-sense notions concerning "culture" (what it is, how it works, how it changes, etc.) are seriously flawed, and that the nature of these flaws makes it extraordinarily difficult (if not impossible) to recognize the nature and extent of Elvis's impact on US culture – though, as we'll see, those same flaws are also partially responsible for Elvis's unusual posthumous career.

RECONSIDER BABY

Over the past decade or so, "culture" has played a highly prominent role in US public discourse. Cultural literacy, cultural values, cultural imperialism, cultural democracy, cultural diversity, cultural pluralism, multiculturalism, our common culture, the cultural elite, the cultural left, and other such topics have all been the subject of ongoing, impassioned debates waged (among other places) in best selling books, on college and university campuses, on the op/ed pages of major newspapers and magazines, and on television talk shows: debates that have themselves been described on numerous occasions as "the culture wars." Scholars, critics, politicians, and pundits have argued heatedly with one another about what

values lie (or should lie) at the heart of US culture; what (if any) canonical body of knowledge constitutes the bedrock of that culture; and who is empowered to make such judgments in the first place. For all the debate raging around such questions, however, the concept of culture itself remains "a weak and evanescent notion in American social thought" (Carey, 1989: 19), and virtually no one involved in the culture wars has been willing to broach – much less answer – the crucial definitional question: what is culture anyway?

I should emphasize that I'm primarily concerned here with the ways that the concept of "culture" has been invoked in the broader sphere of US public discourse. To be sure, there are a number of US scholars who have devoted a great deal of time and energy to theoretical questions around the abstract notion of "culture" (e.g., Carey, 1988, 1989; Geertz, 1973; Grossberg, 1988a, 1989a, 1989b, 1992b; E.T. Hall, 1976; and Slobin, 1993). Even within the relatively small sphere of the academic community, however, the extent to which these ideas have been taken up is somewhat limited; in the so-called "real world" of public discourse, these ideas have not traveled very far at all: as James Carey has noted, in the US "the notion of culture is not a hard-edged term of intellectual discourse for domestic purposes" (1989: 19). Thus, while there are certainly critics whose discussions of culture don't fit neatly into the scenario that I describe below, it's also the case that their work has had little (if any) impact on the ways that the term is commonly used and understood in the US today.

Upon first glance, the gap between scholarly and popular notions of culture would appear to be a relatively trivial one; while specialized theoretical concepts such as "hegemony," "interpellation," or "poststructuralism" would undoubtedly require some sort of "academese"-to-English translation before they could safely be used in the average newspaper column or magazine article, "culture" crops up frequently enough in everyday usage (and seemingly without any major confusion for those who use it) that defining the term hardly seems to be necessary. The seeming transparency of culture as a critical term, however, is exceptionally misleading; in the words of Raymond Williams (who probably devoted more time and energy to addressing the theoretical questions surrounding "culture" than any other scholar of the past half century),[1] "culture is one of the two or three most complicated words in the English language" (1983: 87). There are at least two distinct models of culture in active circulation in the US today – the *social* and the *textual* – corresponding roughly to the two most commonly used senses of the term that Williams described almost forty years ago.[2] But while, in Williams's work, these two visions of culture referred to competing schools of thought regarding the term's definition (i.e., he observed that some people saw culture as a social phenomenon, while others saw it as a textual one), how the term is currently used in the US depends less on who is speaking than it does on whom the subject of that speech is.

For example, in contemporary US public discourse the notion of culture as a *social* phenomenon is almost always reserved for discussions of "other" people: those groups who, for one reason or another, are seen to exist somewhere outside of the "mainstream" US population. Thus, this category includes not only all non-US citizens (grouped together in a wide variety of ways – by nationality (Japanese, Australian, etc.), region (Caribbean, Middle Eastern, etc.), ethnicity (Arabic, Slavic, etc.), religion (Islamic, Hindu, etc.), and so on), but most of the marginalized groups (African-Americans, homosexuals, etc.) living within the country as well. Used in this way, "culture" refers to the various customs, codes, rituals, and patterns that form the basis of (other) people's daily existence; what Williams describes as "a whole way of life – the common meanings" (1958b: 4). In many respects, the social model is closely linked to traditional anthropological notions of culture, not only because of its focus on the behavioral patterns and belief systems at the heart of people's daily lives, but also because of its fascination with (some might say "fetishization of") the various differences that exist between other peoples' ways of life and our own – particularly those that can be labeled as "exotic," "quaint," "primitive," "abnormal," and so on. Consequently, US critics tend to examine their own culture as a social (rather than a textual) phenomenon only when (1) they can hold it up as the unquestioned (and unquestionable) norm from which other cultures are seen to deviate or (2) aspects of that culture are deemed to be a problem or threat of some sort. As Carey observes, "We understand that *other people* have culture in the anthropological sense and we regularly record it – often mischievously and patronizingly" (1989: 19, emphasis added). The notion that *we* have beliefs and customs that other people find strange (i.e., that US culture might be the deviant object of someone else's normative gaze), however, remains largely unexamined in US public thought.[3]

More commonly, when US commentators refer to their own culture (or, more precisely, to "mainstream" US culture), they almost always treat it as a *textual* phenomenon. In these instances, the term refers not to a whole way of life but to books, plays, music, films, and other forms of intellectual and artistic expression: what Williams describes as "the arts and learning – the special processes of discovery and creative effort" (1958b: 4). For instance, when critics decry the commodification of US culture (e.g., Rieff, 1993; Schiller, 1989), they're typically expressing concern over the (alleged) decline of "art for art's sake" and the (also alleged) increasing dependence of art on the marketplace,[4] but they have very little (if anything) to say about the penetration of commercial activity into the non-textual aspects of the average citizen's lifestyle.

Ultimately, this division of "culture" into separate spheres (where "our" culture is embodied in art and literature, while other cultures are exemplified by people and practices) is problematic, not because the term is used in different ways (the English

language, after all, is filled with words that have multiple meanings), but because the gap between these two senses of the term serves to perpetuate a highly ethnocentric and hierarchical vision of the world: one in which other cultures are condescendingly seen to consist of "exotic" customs and "quaint" rituals, while "our" culture is a noble collection of artistic and intellectual work (what Matthew Arnold once described as "the best that is known and thought in the world").[5] Thus, while all the world's peoples may have rituals and customs, only "we" have art and philosophy that is deemed valuable enough to describe as "culture." This is why Nobel Laureate Saul Bellow, for instance, in questioning the need to expand "the canon" to include examples of non-Western literature, can sneer that "When the Zulus have a Tolstoy, *we* will read him" (quoted in M.L. Pratt, 1990: 15).[6] According to this line of reasoning, the Zulus (and, presumably, most other non-Western peoples as well) will only be worthy of consideration as a valuable source of culture when and if (with the unspoken sentiment being that this is an unlikely "if") their artistic and literary output meets the (supposedly) higher standard already set by the West. Viewed from a slightly different perspective, the split between the textual and social models of culture can be seen as a reflection of the hierarchical mind/body split that dominates so much of Western thought. As a textual phenomenon rooted in the rational, intellectual, and artistic products of mental activity, US culture is regarded as "better" or "more advanced" than other peoples' cultures, which are seen to consist of little more than the social codes governing various bodily practices (dietary restrictions, table manners, courtship rituals, nudity taboos, etc.).

Even if we ignore the condescending attitude toward the rest of the world implicit in this divisive use of the term, however, and concentrate instead on culture as a strictly domestic phenomenon, we're still left with a politically troublesome vision of what culture is, as the overwhelming dominance of the textual model in the US works to create and maintain elitist and patronizing attitudes towards the un(der)educated portions of the US population. Because culture is typically seen to be something that people can only learn and absorb through years of careful study, it's inevitable that some people are seen to have culture, while others don't, with the bulk of the population falling somewhere on the "uncultured" end of this spectrum.

For example, the primary impetus for literary scholar E.D. Hirsch, Jr to write his now (in)famous best-seller, *Cultural Literacy* (1987) was his belief that an ever-expanding number of people simply lacked culture: that they were passing through the US educational system without sufficient exposure to (much less mastery of) the basic texts and facts that constitute the very essence of US culture. At its most pragmatic level, *Cultural Literacy* is little more than a call for educational reform and, as such, it's not particularly unusual or noteworthy. Hirsch, after all, is hardly the first critic to complain that US students are being

inadequately educated and that dramatic revisions to the nation's curricula are necessary to reverse this trend. What distinguishes Hirsch's manifesto from most other critiques of the US educational system, however, is that he frames his argument in cultural, rather than educational, terms. According to Hirsch, the problem with those people who enter adulthood without having been exposed to enough of the items in his sixty-four page list of "what every American needs to know" is not that they are poorly educated in basic skills (e.g., they can't read above a third-grade level, write a grammatically correct sentence, or do the simple math necessary to make change), but that they're "illiterate" with respect to "the basic information needed to thrive in the modern world" (1987: xiii). They don't know, for example, who Albert Einstein was, the years in which World War II was fought, or what the capital of Florida is.[7]

Anticipating the objections of some of his critics, Hirsch insists that he's not attempting to create (or reinstate) a required reading list of canonical works for US students:

Those who examine the Appendix to this book [Hirsch's list of "what literate Americans know"] will be able to judge for themselves how thoroughly mistaken such an assumption is. Very few specific titles appear on the list, and they usually appear as words, not works, because they represent writings that culturally literate people have read about but haven't read. . . . Cultural literacy is represented not by a *prescriptive* list of books but rather by a *descriptive* list of the information actually possessed by literate Americans.

(1987: xiv)

Hirsch's defensiveness on this point, however, doesn't change the fact that his list of (supposedly) vital knowledge is composed entirely of facts (rather than skills) and that, as such, it differs very little from the list of "great books" that he claims not to have constructed. In fact, Hirsch's list is actually far more contemptuous of the intellectual abilities of "ordinary people" than most versions of the traditional canon are: rather than providing a list of "classic" texts and then assuming that the public can read and interpret those works on their own, Hirsch actually pre-digests the canon (or at least his version of it) on behalf of the culturally illiterate masses and then, Cliff-Notes-style, condenses the crucial information within those texts into a compact and easy-to-read list of Western civilization's "greatest hits."

As one of the more surprising bestsellers of 1987, Hirsch's book helped to fuel a series of nationwide debates over "the canon," and over which examples of Western art and thought should (or shouldn't) be considered required reading for someone who wants to be "culturally literate."[8] What is perhaps most striking about these debates, however, is that virtually everyone who participated in them – regardless of whether they argued for a broad canon, a narrow canon, a new canon, an old canon, or no canon at all – seemed willing to accept (at least

implicitly) the notion that culture resides primarily in a body of artistic and intellectual texts. Those who objected to the traditional Western canon, for instance, argued that while those texts might provide an accurate description of a white, upper-middle-class, heterosexual, Judeo-Christian culture, the US is a more diverse country than that, and thus it would take a very different compendium of books to reflect with any accuracy the cultures of Hispanic-Americans, lesbians, migrant farm workers, or any of the other disenfranchised groups living within the US. This particular counter-argument is valuable insofar as it recognizes that "the arts and learning" is a culturally specific (and not a universal) phenomenon; nevertheless, it still overlooks the possibility that culture can – and should – be thought of as something other than a collection of books, plays, pieces of music, and so on. Because even the most progressive and democratic arguments for a new and improved canon are still based upon the problematic premise that a culture is defined by its arts and learning, the various attempts at canon revision ultimately do little (if anything) to alter the patronizing message behind the very idea of a canon: namely, that some people have culture, while others don't.[9]

Following Raymond Williams (1958b), then, I want to argue that culture is not the exclusive province of the privileged few; instead, culture is something that everyone has. We are all born into one culture or another (or, more likely than not, into several overlapping cultures, each defined by race, ethnicity, class, nationality, region, and so forth), and we all acquire particular knowledges, skills, customs, beliefs, and behaviors associated with these cultures as we grow up within – and shuttle back and forth between – them. I should make it clear, however, that in emphasizing the ubiquity and ordinariness of culture, I am not arguing that we should simply reject the textual model of culture in favor of its social counterpart. This sort of shift might help to compensate for the lack of attention given to the non-textual aspects of US culture over the years, but ultimately it would only serve to replace one inadequate model of culture with another and to perpetuate the fiction that life and art are somehow mutually exclusive and entirely unrelated categories. The problem with the split that exists in our commonsensical understanding of "culture" is not that one of these two senses of the term is more accurate than the other (and that we have focused too much of our attention on the wrong one), but that neither of them is sufficiently complete on its own to serve as the only viable model of culture. As Williams argues:

> Faced by this complex and still active history of the word, it is easy to react by selecting one "true" or "proper" or "scientific" sense and dismissing other senses as loose or confused. . . . But in general *it is the range and overlap of meanings that is significant*. The complex of senses indicates a complex argument about the relations between general human development and a particular way of life, and between both and the works and practices of art and intelligence. . . . Within this complex argument there are fundamentally opposed as well as effectively overlapping positions; there are also,

understandably, many unresolved questions and confused answers. But these arguments and questions cannot be resolved by reducing the complexity of actual usage.

(1983: 91, emphasis added)

We need, as Williams says elsewhere, to "insist on both [these senses of culture], and on the significance of their conjunction" (1958b: 4): culture does not reside exclusively in the artistic and intellectual texts produced by a particular society, nor can it only be said to exist in the codes, traditions, and rituals that shape the daily lives of a particular community, region, or nation. Instead, we need to understand culture as a *processual* phenomenon, one that exists in the ongoing dialectical tension between a society's "arts and learning" and its "whole way of life." As Michael Ventura puts it, "culture always proceeds from two poles: one is the people of the land and the street; the other is the thinker. . . . The two poles can exist without each other, but they cannot be effective without each other" (1985: 102). While we can – and all too often do – think of culture *either* as what people (on the land or in the streets) do in their daily lives *or* as what people think (i.e., the art and philosophy that they create and consume), any conception of culture that ignores the complex relationships between these two spheres is ultimately incomplete.

Similarly, Carey argues that "culture must first be seen as a set of practices, a mode of human activity, a process whereby reality is created, maintained, and transformed" (1989: 65), which is to say that culture is an arena where a particular society engages in an ongoing, transformative dialogue with itself about itself; that its arts and learning inevitably both reflect and shape the daily lives of its inhabitants, and vice versa. Because such a model recognizes that any given culture always exists in a state of flux, it does *not* see cultural change as a phenomenon that needs to be attributed to external, non-cultural forces. While the degree and nature of cultural change may itself be highly variable (i.e., a particular culture will change at different speeds at different points in its history; some changes will be more extensive and dramatic than others; and the distribution of such changes over the cultural terrain will never be entirely even), the *fact* that culture is always changing remains constant.

One of the more problematic consequences of the widespread assumption that US culture resides primarily – if not exclusively – in a (relatively static) body of texts is that, over the years, a wide range of phenomena that has deserved serious critical attention has been neglected. Most typically, such phenomena have either been dismissed as culturally irrelevant (e.g., the stereotypical assessment of romance novels as a trivial, and thus ignorable, phenomenon) or they've been explained away as the mere byproducts of some non-cultural phenomenon that *does* matter (e.g., the oft-made claim that disco's primary significance was its

demonstration of multi-national media conglomerates' ability to sell mindless, formulaic music to a gullible public).[10] In part, this oversight is yet another manifestation of the hierarchical split between "high" and "low" (aka "mass" or "popular") culture. It's no coincidence, after all, that most of the phenomena that fall on the "undeserving" side of the line being drawn here (not only romance novels and disco, but also soap operas, the "girl group" music of the early 1960s, science fiction, comic books, professional sports, and – of course – Elvis) are examples of popular culture. Frequently, the popular arts are seen to be too commercial (i.e., not artistic enough), too shallow (i.e., not intellectual enough), and too ephemeral (i.e., unable "to stand the test of time") to be taken seriously as examples of "real" culture. Consequently, Elvis – as a figure firmly entrenched in the quagmire of "the popular" – doesn't even need to be dealt with by name in order to be dismissed out of hand as culturally irrelevant. As a musician who played rock 'n' roll (rather than, say, chamber music) and an actor who worked in mainstream Hollywood films (rather than, say, a member of a company of Shakespearean players), Elvis is always already outside the realm of culture.

At the same time, however, the division of the field of cultural texts with which I'm concerned here is more complicated than a simple opposition between the high and the low. Outside of the realm of traditional high culture hardliners (who still exist, to be sure, but who also don't occupy as prominent – or as dominant – a place in the public sphere as they used to), there are very few people who would still argue that all popular culture is aesthetically inferior to all high culture. Yet while the mass culture critique, in its classic form,[11] may have all but disappeared, many of its fundamental assumptions concerning textual aesthetics can still be found in the criteria that people use to evaluate the vast sea of popular culture texts in which they swim every day. As Simon Frith argues, the basic standards by which people judge such texts are more or less the same regardless of whether the texts in question are examples of "high" or "low" culture: "There are obvious differences between operas and soap operas, between classical and country music, but the fact that the objects of judgment are different does not mean that the processes of judgment are" (1991: 105). For example, many rock fans in the 1970s relegated disco to the trash heap of culture (sometimes quite literally)[12] because, to their ears, disco was boring, repetitive, commercialized music with mindless, apolitical lyrics and thus it had no redeeming artistic qualities whatsoever. Rock, on the other hand, was held up as a paragon of aesthetic virtue, authenticity, and political relevance. Few (if any) of the fans and critics who made such arguments, however, seemed to recognize that these were precisely the same charges that classical music lovers had been leveling against rock for years in order to demonstrate the aesthetic and cultural superiority of their music; the texts being judged here may have been different, but the criteria used in making those judgments were identical.

In the end, then, even for those critics willing to entertain the notion that popular culture might include certain works and artists worthy of recognition as examples of "the arts and learning," Elvis and his "art" (e.g., his music and movies) are generally found to be lacking because they "fail" to meet the standards of aesthetic and cultural value (borrowed wholesale from high culture) by which the popular arts are typically measured. By these standards, the various musical, cinematic, and televisual texts that Elvis produced during his career simply aren't complex or innovative enough to support the hypothesis that he was a crucial figure in the history of US art – popular or otherwise. "Hound Dog," for instance, may be a catchy pop tune, but unlike more self-conscious attempts to create aesthetically complex examples of popular music (e.g., the recognizably poetic and/or political efforts of singer/songwriters such as Bob Dylan's *Blonde on Blonde* (1966) or textually dense concept albums such as the Beatles' *Sergeant Pepper's Lonely Hearts Club Band* (1967)),[13] it doesn't stand up very well under the weight of detailed scholarly analysis and therefore can't be taken terribly seriously as culture.

A large part of the problem here is that it's difficult (if not impossible) for many people to see Elvis as the self-aware author of his art in the same way that they can recognize Lennon and McCartney or Dylan (for instance) as the creative geniuses behind their respective oeuvres. To be sure, over the years a number of fans, musicians, and critics have tried to put together a case for Elvis as a musical *auteur* of one sort or another: various commentators have pointed out that Elvis often worked out his own arrangements,[14] that he effectively served as the producer of his own recording sessions,[15] that he had an inventive and innovative singing style,[16] or that his interpretations of other people's songs were frequently so powerful and evocative that one could hear these performances as authentic expressions of Elvis's (and not the original songwriters') lived experiences.[17] Such arguments for Elvis-as-*auteur* typically fall apart, however, because they are strained attempts to portray Elvis's art in terms alien to those that governed its initial production and reception. To give but one example, while it may very well be true that "Elvis could (almost) sing classical music" (Sandow, 1987: 75) and that therefore it's a mistake for high-culture aficionados to dismiss him out of hand as a mere pop culture hack, Elvis's latent talent for semi-classical singing hardly accounts for his success as a rock 'n' roll star, nor does it explain why he actually mattered (and still matters) so much to so many people. However well Elvis's art might actually stack up to the aesthetic standards of high culture, these are typically not the standards by which it succeeded (or failed) with audiences and critics in its own time. The Beatles, Bob Dylan, and countless other rock musicians may have been celebrated in their respective heydays for the brilliance of their artistic visions and compositional skills, but the various efforts to describe Elvis in such terms ignore the fact that his impact on US culture had little, if anything, to do with such an author-centered vision of art (except, perhaps,

insofar as Elvis's example may have served as an implicit rejection of such a vision). Such arguments almost always seem either to be full of holes (e.g., if he was such a brilliant musician, then why did he make so much bad music?) or to miss the point entirely (e.g., what does his skill as a record producer have to do with his impact on US culture?).

One of the reasons why fans and critics continue to try to redeem Elvis (if not in their own eyes, then in the eyes of those who thumb their noses at him) by forcing him into the ill-fitting costume of the *auteur* may simply be that this is the critical framework most readily available to them: these are the terms by which major cultural forces and figures in the US are generally deemed to be worthy of notice and respect. Only great art (the argument goes) can produce cultural changes of any significance, and only great artists can produce great art. Ultimately, however, attempts to portray Elvis as a traditional musical *auteur* invariably fail because his significance to US culture can't readily be traced to the artistic texts that he left behind. At one level, such a claim is no more true for Elvis than it is for any other figure: the cultural changes that Bob Dylan or the Beatles brought about in the 1960s, for instance, can't simply be reduced to the music that they made. At the same time, however, it's far easier to map the non-musical aspects of the Beatles' or Dylan's cultural impact back onto their musical texts than it is to do the same for Elvis. Because the Beatles (or, at least, Lennon and McCartney) and Dylan can be readily viewed as *auteurs*, it's relatively easy to see homologous relationships between the songs that they wrote and their other spheres of activity: the Beatles' post-*Rubber Soul* (1965) musical efforts can be read as reflections of the group's immersion in various aspects of the counter-culture, while Dylan's songs can be interpreted as authentic expressions of his liberal, populist politics. Elvis, on the other hand, was never a plausible candidate for *auteur* status, and thus fans and critics have been less willing (and less able) to forge links between the specific musical texts he made and the various changes that he wrought upon US culture.

Even those critics who recognize that Elvis's cultural significance can't adequately be explained using traditional notions of artistry and authorship, however, have frequently attempted to describe Elvis as the primary architect of his stardom; if Elvis wasn't quite the mastermind behind his art, the argument goes, then he was at least the principal guiding force behind his career and his success. According to this school of thought, Elvis was a visionary pioneer who first recognized a gaping need in US culture and then went on to fill that need; consequently, whatever changes in US culture that followed in Elvis's wake only took place because that was the way he planned things. Dave Marsh, for instance, describes Elvis as a trailblazing figure who had no

> map to guide him, so he had to invent himself over and over, come up with new terms for dealing with each situation. In the process, *he invented us*,

whether or not we all know it. We are a hero-worshipping, thrill-crazy mob, I suppose, but at our best, one that's tuned into the heart of things – open, honest, unpretentious. Which is to say that *he made us in his image*.

(1977: 306, emphasis added)

Elvis would probably have denied the grandiose claims that Marsh makes here on his behalf; at the very least, as a good Christian, he would certainly have objected to the blasphemous comparison between himself and God implicit in Marsh's last sentence. What Elvis might have thought, however, is irrelevant to this argument, as is evident from the variation on it advanced by Peter Guralnick. Though he acknowledges that, "over and over again in the course of his life [Elvis] refused to speculate on the reasons for his success, putting it down to luck, blind instinct, anything but plan" (1979: 119), Guralnick simply brushes aside these disclaimers as nothing more than the humble modesty of a Dixie-bred mama's boy:

> In many ways I am sure that the picture is accurate, and it undoubtedly conforms to the image that Elvis Presley had of himself. It tends to leave something out, however. What it leaves out is the drive and consuming ambition of the nineteen-year-old Elvis Presley, who possessed a sweeping musical intelligence, energies that could barely be contained, and a ferocious determination to escape the mold that had seemingly been set for him at birth.
>
> (1979: 120)

For Guralnick, Elvis's ambition, energy, and determination can only signify a willful and deliberate effort on his part to remake the world around him; the possibility that Elvis could have achieved so much without planning to do so is simply inconceivable. Even more so than Marsh or Guralnick, however, the most insistent advocate for Elvis as a self-conscious agent of cultural change is Marcus, who states quite bluntly that Elvis

> knew what he was doing. If he redefined what it means to be an American, it was because he meant to. He wanted change. He wanted to confuse, to disrupt, to tear it up. . . . Watch him as he first appeared on television in 1956, watch the way he moves, what he says, how he says it: the willfulness, the purpose is unmistakable. And yet so many of us missed it: As we watched, we drew a veil over the man bent on saying what he meant.
>
> (1991: 30–1)

For these critics, chance, luck, and historical accident may very well exist, but they don't play an important role in Elvis's story; other cultural transformations might be the result of serendipity and happenstance, but the changes that Elvis wrought upon the world could only have taken place by design.

Ultimately, this sort of attribution of willful intentionality to Elvis isn't very convincing, if for no other reason than that it's inadequate to the task of explaining either Elvis's personal success or his broader cultural impact. After all, countless people have made conscious, deliberate efforts to change the culture(s) in which they lived, but very few of them actually managed to do so even at a local level, much less on the national (and international) scale that Elvis did. Even if Elvis really did plot out his conquest of US culture in advance, the crucial questions of how and why he succeeded in achieving such a goal, when so many others before him had tried and failed, remain unanswered.

Nevertheless, I don't want to reject the arguments made by these critics completely, as I think that there's more than a grain of truth in their vision of Elvis as an active subject (rather than a passive object) of cultural change, particularly when such a vision is examined alongside the version of Elvis's story that their arguments attempt to refute. In many people's eyes, after all, Elvis is a vastly overrated figure in the history of rock 'n' roll, and the banality of the movies and music that he made during his decade in Hollywood and the bloated excess of the Vegas years serve as overwhelming proof that what he accomplished in the 1950s was nothing more than a fluke occurrence. The *real* Elvis, according to this school of thought, was the one who gave us ridiculous fluff such as *Clambake* (1967) and "(There's) No Room to Rhumba in a Sports Car" (1963); the much-celebrated Elvis who produced more compelling music such as "Mystery Train" (1955) or "Hound Dog" (1956), or even a few respectable films (such as *Jailhouse Rock* (1957) or *King Creole* (1958)), was merely the vehicle for the genius of Sam Phillips, Jerry Leiber and Mike Stoller, and a handful of other "real" artists working behind the scenes over the years. Consequently, Elvis is often seen to be nothing more than a good-looking kid who was lucky enough to be in the right place at the right time; if he hadn't been there, then someone else (e.g., Buddy Holly, Jerry Lee Lewis, Carl Perkins) would have filled his blue suede shoes just as well. The growth in the white audience for rhythm 'n' blues, the increasing willingness of musicians to experiment with amalgamations of black and white popular musical styles, and the culture industry's discovery (or, if you prefer, its invention) of the untapped and highly profitable youth market all combined to create the conditions under which rock 'n' roll could grow and flourish. Elvis was an important part of this process, but the key word in this statement (at least according to this vision of rock 'n' roll history) is "part," insofar as Elvis was ultimately nothing more than an interchangeable and highly replaceable cog in a larger machine.

Guralnick, Marcus, and Marsh would undoubtedly agree that a wide variety of forces came together in the 1950s to make rock 'n' roll possible (and, in the process, to transform US culture), and that most of these forces pre-date Elvis's arrival on the scene. They would probably also agree that the various claims

occasionally made by other critics and fans that Elvis single-handedly invented rock 'n' roll are overstated and inaccurate, precisely because they ignore the broader social, economic, and cultural changes that laid the groundwork for the rise of rock 'n' roll. Where these critics begin to part company with a model of history built entirely around shifts in demographics and the industry is over the question of individual human agency in bringing about historical change:

> I had a glimmer for the first time in a long time of the unlikely notion that history is not necessarily an accident, that the self-willed individual can affect his environment, and his times, in ways that we cannot even calculate.
>
> (Guralnick, 1979: 328)[18]

> The question of history may have been settled on the side of process, not personality, but it is not a settlement I much appreciate. Historical forces . . . might tell us why rock 'n' roll emerged when it did, but they don't explain Elvis any more than they explain Little Peggy March.
>
> (Marcus, 1990a: 128)

> Of course, it's unquestionable that there would have been rock and roll music without Elvis Presley. But it's just as unquestionable that the kind of rock and roll we have – a music of dreams and visions, not just facts and figures or even songs, and singers – was shaped by him in its most fundamental features.
>
> (Marsh, 1977: 306)

What these critics are implicitly arguing is that any version of rock 'n' roll history that focuses exclusively on broad cultural forces and social trends can only provide us with a sketchy and impersonal version of past events that entirely misses crucial parts of the story. Such forces might explain the emergence of rock 'n' roll as a new musical genre, but they're inadequate to the task of explaining why the broader cultural formation around this new music took the specific shape(s) that it did. A world without Elvis, such critics would argue, would still have witnessed a phenomenon known as "rock 'n' roll," but the shape and trajectory of that phenomenon would have been very different from that which actually came to pass: enough so to undermine the notion that Elvis's absence wouldn't have mattered.

The main problem with these arguments isn't that Elvis wasn't a figure of inestimable importance to US culture, but that they assume that his cultural significance depends on his having intended to have such an impact on that culture. While it's fairly easy to believe that Elvis had enough drive, determination, willpower, and talent to transform himself from a nobody into a somebody — and even that, in the process of improving his own station in life, he also managed to change US culture in significant ways – it's far less plausible that Elvis could have

mapped out his conquest of US culture quite so neatly in advance. As Lester Bangs puts it,

> Fuck it, who's to say what [his] "real" motives were? Might they not have been as confused and unplanned and even self-contradictory as anything anybody else thought and then went and did some other time some other place? I mean, does everybody always sit down with this slide-ruled *plan* and a ten-point moral code on the wall behind 'em and then go into battle for the clear-cut Cause with all this pat as that and never deviating?
>
> (1980: 325)[19]

Marx's oft-quoted comments on the processes of historical change seem particularly relevant here: "Men make their own history, but they do not make it just as they please; they do not make it under circumstances chosen by themselves, but under circumstances directly found, given and transmitted from the past" (1852: 595). The problem with the commonly made claim that Elvis is an irrelevant figure in the history of rock 'n' roll (and thus, by extension, an even more irrelevant figure in the history of US culture) is that it emphasizes the latter part of Marx's statement (i.e., that history is made under conditions beyond the control of individuals) to such an extent that actual people drop out of the picture altogether, and history simply becomes an empty stage upon which broad and impersonal forces play out a preordained storyline.[20] But while the various critics cited above are correct to insist that a history that ignores questions of individual human agency is flawed, their counter-arguments ultimately give far too much credence to the notion that individuals can plot out and bring about sweeping changes in their respective cultures. Such arguments acknowledge the fact that people make their own history, but they overlook the fact that those people invariably make that history under conditions beyond their control.

The question that remains, then, is this: if we can't safely view Elvis either as the *auteur* who shaped and defined his artistic oeuvre or as the self-conscious mastermind behind his stardom, then how is it possible (much less reasonable) to view him as a figure who had any sort of significant impact on US culture? Elvis didn't invent (and then build) a new culture all by himself; however much he may have intended to be provocative, and however conscious he may have been of "what was at stake," there was still no way that he could predict or control what the cultural consequences of his actions would be with any certainty. Whatever Elvis did – either as a private individual or as the most prominent of rock 'n' roll's early public heroes – he was forced to make it up as he went along, just like most of us do each and every day of our lives.

The fact that the cultural revolution Elvis helped to bring about didn't take place according to some grandiose, preordained plan, however, shouldn't detract

in any way from our recognition (and appreciation) of what he was able to achieve. On the contrary, the fact that he brought about more significant cultural changes through his day-to-day improvisation than most people could do if their carefully calculated "slide-ruled plans" and "ten-point moral codes" worked out just right only serves to make his accomplishments all the more extraordinary and impressive. Insofar as he made a deliberate effort to pull himself out of the station in life that was his birthright, it is safe to talk about what Elvis intended to achieve. It's probably even reasonable to suggest that he knew that what he was doing on stage, screen, and record in 1956 was inflammatory and provocative, and that this is precisely why he engaged in such behavior. To suggest that Elvis deliberately set out to rebuild the cultural terrain, however, carries these arguments too far: even if, in his wildest flights of fancy, Elvis dreamed that he might achieve such a goal, he could only accomplish such a feat by accident. The question that needs to be addressed here, then, is not whether Elvis *meant* to transform US culture, but what the nature of the changes that he brought about actually was. With this question in mind, then, I want to explain Elvis's impact on US culture by turning my attention (briefly) to that moment in his early career when he first began reshaping that culture in recognizable ways.

I FORGOT TO REMEMBER TO FORGET

The year is 1956, the date is 5 June, and a twenty-one-year-old former truck driver from Memphis named Elvis Presley is enjoying his first real taste of national success as a pop singer. "Heartbreak Hotel," his first record for RCA Victor since the label bought his contract from Sam Phillips's Sun Records last November, is currently in its sixth week as the number one song in the nation. His second RCA single, "I Want You, I Need You, I Love You," has just been released and is beginning its own climb up the charts. In the past two months alone, Elvis has given more than fifty live performances over a territory stretching from Ohio to California, signed a seven-year/three-movie contract with Paramount Pictures, and been the featured subject of articles in three of the nation's most widely read magazines: *Life* ("A Howling Hillbilly Success," 1956), *Newsweek* ("Hillbilly on a Pedestal," 1956), and *Time* ("Teeners' Hero," 1956).[21] On top of these impressive achievements – and probably more important to the advancement of his career than all of them combined – Elvis has also made seven prime time appearances on national television since January. Tonight, he adds an eighth such performance to his burgeoning résumé with his second visit to *The Milton Berle Show*. Given Elvis's roots in the working-class South and the prohibitively long odds against his rising more than a notch above the station in life into which he was born, it would be fair to describe Elvis's newfound success as an exceptionally surprising accomplishment. After all, in 1956 there are no real precedents for the transformation

of a Mississippi sharecropper's son into a nationally known pop star. In spite of the odds, however, and seemingly overnight, Elvis has left behind the anonymous poverty of his life as a Memphis truck driver and found at least a small portion of fame and fortune at the top of the pop charts.

Nevertheless, Elvis's recent success does nothing to guarantee that he has a viable future as a professional musician: the entertainment business remains a notoriously fickle one and, given the speed with which pop stars rise and fall, it's still quite possible that by year's end people will hear his name and ask, "Elvis who?" This is especially true given the fact that Elvis's accomplishments to date have been tempered by their fair share of setbacks and disappointments. For instance, it was only a month ago that Elvis bombed so badly during a four-week booking in Las Vegas that the engagement was canceled before it was half over.[22] Moreover, rock 'n' roll (Elvis's principal meal ticket to date) is a new and unproven phenomenon; enough so that many observers remain convinced that it, too, will pass and that pop music will once again become the sedate and well-behaved form of family entertainment that it was before odd characters such as Elvis, Little Richard, Carl Perkins, and Chuck Berry began roaming the airwaves and the pop charts. After all, "Heartbreak Hotel" is only the second record to date to have topped the *Billboard* charts that can plausibly be called "rock 'n' roll" (the first was Bill Haley's "Rock around the Clock" (1955)), and the likes of Dean Martin, Kay Starr, and Nelson Riddle are still doing well enough when it comes to record sales, jukebox selections, and radio airplay that it would be premature to write them and their style of pop music off entirely.

Even RCA Victor, which was impressed enough by Elvis's talent and his regional success to pay the unprecedented sum of $40,000 for his contract and the master tapes of everything he recorded at Sun, doesn't seem all that confident that its investment in Elvis will yield long-term dividends. Having hired photographer Alfred Wertheimer to travel with Elvis in order to come up with some semi-candid promotional pictures of the young singer in action, the powers that be at RCA nevertheless decide that color film is too costly to waste on someone who has yet to show any staying power as a pop star; consequently, they instruct Wertheimer to save the company some money by using black and white film as much as he can.[23] Nor does Elvis seem willing to speak of his future with brash confidence. Admitting that rock 'n' roll may be nothing more than a passing musical fad, he tells one reporter that, "*When* it's gone, I'll switch to something else. I like to sing ballads the way Eddie Fisher does and the way Perry Como does. But the way I'm singing now is what makes the money. Would you change if you was me?" (quoted in Guralnick, 1994: 289, emphasis added).[24] Right now, however, rock 'n' roll is the rising wave in popular music, and Elvis is the hottest rock 'n' roll musician in the country. Though his future may be far from certain, Elvis is currently on top of the world and determined to make the most of his

success while he still can, since for all he (or anyone else) knows, tomorrow he may have to go back to driving a truck for a living again.[25]

This, at least, is where Elvis's career stands prior to his second visit to Berle's program, but after appearing in front of 40 million people[26] tonight on national television, the possibility that Elvis will simply fade back into the woodwork becomes very remote, as it's during this broadcast that Elvis and his band (Scotty Moore, lead guitar; Bill Black, stand-up bass; D.J. Fontana, drums) first perform "Hound Dog" for a national audience. Originally written by Leiber and Stoller for Willie Mae "Big Mama" Thornton (who took the song to the top of the rhythm 'n' blues charts in 1953), "Hound Dog" is a very recent addition to Elvis's stage act, one made only after he saw a relatively unknown band (Freddie Bell and the Bellboys) perform a parodic version of it during his ill-fated engagement in Las Vegas a month ago. The song has rapidly become one of the best-received numbers of Elvis's live shows, but to date it's still nothing more than that. Thornton's rendition of the song (which actually has very little in common with Elvis's version besides its title)[27] remains the most widely known, though this isn't saying very much: as a three-year-old rhythm 'n' blues hit, her record remains on the margins of a musical landscape still very much dominated by the Tin Pan Alley tastes of middle-class white audiences. As for Elvis's interpretation of the song, a few thousand people (at the very most) scattered over a dozen or so concerts on his current tour have seen him perform it over the past few weeks. After this evening's broadcast, however, "Hound Dog" will never again be an obscure tune, as the flurry of media attention that centers around Elvis following tonight's program makes the song composition – which Elvis had not previously planned to record at all – the obvious and inevitable choice for his next RCA single. *That* record (backed with an Otis Blackwell-penned tune called "Don't Be Cruel") will go on to become the biggest single of 1956 (and the first double-sided number one hit of the rock era), while the *Berle Show* performance that sparks the massive public demand for that record will eventually come to be thought of by many critics as the single most controversial performance of Elvis's entire career.

What makes this particular broadcast so different from those that came before it isn't Elvis's singing, or his band's musicianship, or even his choice of a rhythm 'n' blues tune as musical fare for a prime time national television (read: predominantly white) audience: after all, by these standards, Elvis's performance on Berle's show fits very well into the pattern established by his previous appearances on network television.[28] Where tonight's performance departs from its predecessors (and where the controversy that it sparks ultimately lies) is in the way that Elvis *moves*. In all of his prior television appearances, Elvis's freedom to move about the stage was limited by the fact that he played rhythm guitar while he sang: while the physical presence of an instrument never forced Elvis to stand completely still during those shows, the need to carry and play his guitar placed unavoidable restrictions on how

much he could move and the ways in which he could do so. Moreover, that guitar blocked (at least in part) the view that Elvis's audiences had of his increasingly scandalous pelvis, and thus much of his hip-shaking was not clearly visible to the public at large. Tonight, however, the only instrument Elvis has to play is his voice and the only prop he has to work with is a floor microphone; for the first time in eight appearances on national television, Elvis is free to dance, to twitch, to gyrate, to bump and grind, and to shake, rattle, and roll to his heart's content. During the two and a half minutes that it takes the band to rip through its version of "Hound Dog," Elvis does all of these things and more.[29]

Berle begins to introduce Elvis, but the young man from Memphis isn't content to wait for the formalities to end before claiming center stage for himself. Berle is still reading his cue cards when Scotty Moore chimes in from offscreen with a short burst of sound from his guitar and the band leaps into the song at full speed. By the time the close-up on Berle's retreating face fades into a medium shot of Elvis and the band, the foursome has raced almost halfway through the song's first verse. Wearing dark, baggy pants, an oversized, light-colored jacket (it may be beige or off-white, but given Elvis's penchant for flashy clothing, it's just as likely that it's bright pink; it's hard to tell for sure from a black-and-white kinescope), and a two-tone, wide-collared, open-necked shirt, Elvis is in constant motion, as if his very existence depends on his refusal to stand still. No matter what claims Elvis may make about his musical influences, the performance that he gives tonight is totally incommensurable with the examples of staid calmness provided by Eddie Fisher, Perry Como, or the other pop crooners (Dean Martin, Mario Lanza, etc.) that he speaks of with so much respect and reverence. Those singers dress conservatively, stand stiffly before their microphones, and are seemingly unable (or perhaps merely unwilling) to move any part of their bodies that doesn't directly contribute to the production of musical sounds from their vocal cords. At their most energetic, they might snap their fingers or sway back and forth ever so slightly in time to the music, but never to such an extent that the words "dignified," "respectable," and "reserved" could not safely be used to describe their performances.

Elvis, on the other hand, shakes and shimmies more in the first verse of "Hound Dog" alone than an entire army of Como-esque crooners could manage over the course of a year-long concert tour. His shoulders twitch as if he were trying to shake an eight-armed monkey off his back. His feet dart about frantically, unable to stay where he puts them for more than a fraction of a second at a time. He uses both his hands to readjust the microphone (which clearly isn't designed to accommodate the flurry of music and motion that is Elvis's stage act) and then he plants the left one in the air at waist level, where it quivers ever so slightly . . . and ever so suggestively. The verse ends with a machine-gun burst of noise from D.J. Fontana's drum kit that Elvis mimics with an equally rapid series of piston-like spasms from his legs. Suddenly, the drums fall silent and Elvis is still – but

only for the *very* briefest of moments: half standing and half crouching, he straddles the microphone stand with his legs bent at the knees, his left hand clutching the mike for support, his right hand pointing in an almost accusatory fashion towards some unseen figure in the studio audience. There's dramatic tension in this pause, but before the audience has a chance to figure out where that tension is coming from (much less what it might mean), the next verse begins and Elvis's wild dance resumes.

The band tears through the second and third verses, an instrumental break, and two more verses, with Elvis wiggling and gyrating with ever-increasing fervor all the while. At one point early in the song, the television audience is treated to a tight shot of Elvis's face, but the young Memphian is bobbing and weaving far too much to stay within the frame. The close-up is abandoned in favor of a full shot of the band after only a few seconds and is not attempted again – perhaps because the camera operator simply can't keep up with Elvis's spontaneous shifts in direction or perhaps because the show's director realizes that the true entertainment value in Elvis's act lies not in the expression on his face as he sings, but in the incessant movement of his body as the music flows through him. Either way, by the time the band reaches the fifth verse Elvis has worked himself into enough of a frenzy that it seems as if he'll explode from the pressure of restraining himself if he's ever forced to remain motionless again. But the song has to end sometime. "You ain't ever caught a rabbit," Elvis shouts, balancing precariously on his toes and cuing the band into a short moment of silence with a backward swipe of his right arm, "You ain't no friend of mine." The performance ends with a brief fanfare from the band and Elvis steps back from the mike to take a bow . . .

NO! The pause that Elvis requested a split second ago was merely the calm before the storm: he pulls the microphone back with him, glares menacingly, points (once again) at the studio audience with his outstretched right arm, and the band goes into a slow, grinding, bluesy reprise of the song. Elvis begins to shuffle and shimmy his way back to his former position at center stage, almost humping the microphone as he moves forward, his torso twitching suggestively as each syllable of the lyrics explodes from his mouth. The studio audience goes wild with laughter and astonishment. The verse ends with another rapid-fire drum riff, albeit one slowed down to match the song's new pace. Once again, Elvis's legs do a jackhammer imitation of Fontana's beats, but *somehow*, in a motion that seems to defy all known laws of physics and body mechanics, this particular flurry of hip-shaking ends with Elvis pivoting his entire body ninety degrees around, so that now he stands perpendicular to the front of the stage, hovering on tiptoe, knees bent, the microphone in his right hand, his left hand dipping between his legs and grabbing – no, wait . . . *almost* grabbing his crotch. He lingers in this pose for what seems to be an eternity (but is actually barely a second or two) before leaning back to grind his way through one more verse and close the song with a spasm of

lower body motion that shouldn't be possible for someone whose legs are made of flesh and blood instead of rubber. The song over, Berle rushes back onstage shouting, "Elvis Presley! How 'bout my boy! I love him!" He grabs Elvis's right hand and holds it up in the air, as if "his boy" has just gone fifteen bone-crunching rounds with the heavyweight champion of the world and won a dramatic and surprising split decision. Which, after a fashion, is exactly what has just happened: Elvis has taken on mainstream US culture and, against all odds and expectations, he has come out on top.

The precise nature of Elvis's transformation of US culture is not readily apparent at first – not as such, that is – nevertheless, this performance is the pivotal moment after which neither Elvis, nor rock 'n' roll, nor US culture would ever be quite the same again. For now, all that's obvious to most observers is that this evening's broadcast of *The Milton Berle Show* instantly transforms Elvis into a nationally controversial figure. Prior to tonight's program, the young man from Tennessee is little more than an ephemeral blip on the radarscope of US culture; afterwards, however, Elvis becomes a household name (albeit one uttered with anger and revulsion at least as often as it's invoked with reverence and adulation), and it quickly becomes apparent that he's not going to fade away anytime soon.

In the days and weeks that follow this performance, Elvis is commonly described as an immoral degenerate who, under the guise of providing harmless entertainment, is corrupting US teens with shameless displays of filth and per-version. Such, at least, is the contention of Elvis's detractors, who are suddenly far too numerous to count, and who trip all over one another in their hurry to paint the most vivid picture of the grave threat that Elvis poses to the country's moral fiber. For instance, Jack Gould of the *New York Times* responds to Elvis's *Berle Show* performance with the claim that

> He is a rock-and-roll variation on one of the most standard acts in show business: the virtuoso of the hootchy-kootchy. His one specialty is an accented movement of the body that heretofore has been primarily identified with the repertoire of the blonde bombshells of the burlesque runway. The gyration never had anything to do with the world of popular music and still doesn't.
>
> (1956: 67)

Similarly, Jack O'Brien of the *New York Journal-American* complains that

> Elvis Presley wiggled and wriggled with such abdominal gyrations that burlesque bombshell Georgia Southern really deserves equal time to reply in gyrating kind. He can't sing a lick, makes up for his vocal shortcomings with the weirdest and plainly planned, suggestive animation short of an aborigine's mating dance.
>
> (quoted in Hopkins, 1971: 126)

The argument that Elvis's live act is more suited to a peep show than to pop music is also taken up by the *New York Daily News*'s Ben Gross, who describes Elvis's rendition of "Hound Dog" as "an exhibition that was suggestive and vulgar, tinged with the kind of animalism that should be confined to dives and bordellos" (quoted in Martin and Segrave, 1988: 63). Even the Catholic Church, in its weekly magazine, *America*, publicly jumps onto the anti-Elvis bandwagon, suggesting that,

> if his "entertainment" could be confined to records, it might not be too bad an influence on the young, but unfortunately Presley makes personal appearances. . . . The National Broadcasting Company wasn't loathe to bring Presley into the living-rooms of the nation on the evening of June 5 His routine was "in appalling taste" (said the San Francisco *Chronicle*) If the agencies (TV and other) would stop handling such nauseating stuff, all the Presleys of our land would soon be swallowed up in the oblivion they deserve.
>
> <div align="right">("Beware Elvis Presley," 1956: 294–5)</div>

Admittedly, the critics who attack Elvis's "Hound Dog" performance are not the first to condemn the singer for his "bad influence" on teenagers, nor is this the first public outcry against the alleged decadence and depravity of rock 'n' roll: dozens of newspaper columnists have previously responded to Elvis's concert appearances in their own localities with similarly vitriolic prose, while rock 'n' roll has been the target of numerous regional campaigns to restore moral decency to neighborhood jukeboxes and dance halls. Nevertheless, it is only after Elvis forces his way into living rooms nationwide via *The Milton Berle Show* that these relatively isolated complaints are stitched together into a full-fledged, nationwide moral panic over the damage that Elvis and rock 'n' roll will supposedly do to the very fabric of US society.

If this isn't the precise moment when Elvis and rock 'n' roll first stake their claim to something more than just the margins of the cultural terrain, then it's at least the moment when they are first recognized as a threat to mainstream US culture that is too significant simply to be brushed aside or ignored. After tonight's broadcast, the country seems to be divided into two opposing camps, with very little room for neutral or disinterested observers between them. The first (and, by and large, the youngest) of these is far too excited by Elvis and his music to let him fade away quietly. If anything, they want more of Elvis and rock 'n' roll than they ever did before and have become far more vocal about making such demands. The rest of the population, on the other hand, is too outraged and appalled by Elvis's "lewd and lascivious" performance style to keep silent any longer about the danger that he (supposedly) poses to the country. Contrary to the expectations (and hopes) of many people in this latter camp, ignoring Elvis during his rapid rise to the top of the charts didn't lead to his subsequent quiet retreat from the

national consciousness; instead, it gave him the opportunity to reach (and corrupt) US teenagers on a far grander scale than he could ever have managed otherwise. The only thing that all parties seem to agree on at this juncture is that Elvis has become a force that must be reckoned with: you may love him, you may hate him, but it's no longer possible to ignore him or to pretend that his impact on US culture is too negligible to matter.

In the long run, what matters about Elvis's early television appearances is that they dramatically and irreversibly restructure the perspective that vast numbers of people have on the world in which they live. And in changing the ways that people view their culture, that culture is itself changed. For example, writing about one of Elvis's pre-"Hound-Dog" appearances on the Dorsey Brothers' *Stage Show*, Marsh argues (insightfully, if not exactly gracefully) that "this isn't so much an 'act' as an exposé of the emptiness not only of most entertainment but of most *lives*. In the process of watching him, lives are changed" (1982: 96). Texas singer/songwriter Butch Hancock makes a similar claim, describing the cultural changes that Elvis helped to bring about in the 1950s as "the dance that everybody forgot. *It was that the dance was so strong it took an entire civilization to forget it*. And ten seconds on the 'Ed Sullivan Show' to remember" (quoted in Ventura, 1985: 156).

Both Marsh and Hancock are correct to view Elvis's early television appearances as ground-breaking, culture-shattering events, but I would argue that the particular performance for which these critics' words are the most accurate is Elvis's rendition of "Hound Dog" on *The Milton Berle Show*. For while Elvis's half-dozen *Stage Show* appearances may have played a crucial role in exposing the would-be star to a national audience, these broadcasts were consistently swamped in the ratings by the decidedly more conservative fare of *The Perry Como Show* (Worth and Tamerius, 1988: 322–3) and they generated little (if any) controversy when they first aired. To be sure, Elvis's two *Berle Show* appearances might never have occurred if the Dorseys hadn't already taken a chance on the young Memphian, but it was Elvis's final Berle performance (rather than any of his *Stage Show* appearances) that ultimately pushed him over the top into national stardom and notoriety. As for *The Ed Sullivan Show*, most versions of Elvis's legend depict his January 1957 appearance on the program (the last of his three performances on the show, and – contrary to the most frequently repeated version of the legend – the only one where Sullivan refused to film Elvis below the waist) as *the* pivotal moment in the history of rock 'n' roll when Elvis first shocked and thrilled the nation with his public display of uninhibited sexual energy. What this account of Elvis's early career overlooks, however, is that the now-fabled performances he gave on Sullivan's show would probably never have taken place were it not for his earlier appearance on Berle's program and the storm of controversy that followed in its wake. After all, Sullivan's initial (and much-publicized) reaction to that notorious *Berle Show* broadcast was that he would never stoop so low as to have

Elvis on his program. Nevertheless, within two months of his public promise not to book Elvis, Sullivan would find himself offering the singer the mind-boggling fee of $50,000 to make a mere three appearances on his show.[30]

The immediate impetus for this dramatic shift in Sullivan's position was the sudden emergence of *The Steve Allen Show* as a serious threat to Sullivan's stranglehold on the Sunday night ratings crown. Allen's new variety show scored a major coup by trouncing Sullivan in the ratings in only its second week on the air (1 July 1956), an impressive feat that was only made possible by the fact that Allen's featured guest that week was Elvis. Allen, however, had no love for any-one's version of rock 'n' roll, and he had an especially low opinion of Elvis and his onstage antics. Ultimately, Allen gave the up-and-coming singer from Memphis a guest shot on his show only because he believed (correctly) that an appearance by the most controversial public figure of the moment would guarantee his show a larger audience on NBC than Sullivan could muster opposite him on CBS during the same time slot.[31] Significantly, it was only after Elvis's appearance on *The Steve Allen Show* that Sullivan decided – no matter what he may have said before and no matter how much Colonel Parker may have jacked up his client's price as a result – that he simply couldn't afford not to book Elvis himself.[32]

Without the national furor that followed Elvis's performance on Berle's final show, however, it is unlikely that either Allen or Sullivan would have seen Presley as a sufficiently strong audience-magnet to feature him on their own programs. While 54 million people (an unprecedented 82.6 percent of the viewing audience) tuned into *The Ed Sullivan Show* on 9 September 1956 to see the first of Elvis's three appearances on the program, this massive audience only existed because they wanted to see (or see again) what the fuss that had begun with Elvis's *Berle Show* appearance was all about. Elvis's *Sullivan Show* performances were by no means unimportant, but their significance lies primarily in the fact that they solidified the singer's hold on territory that he'd already conquered. As Albert Goldman puts it (in one of his rare moments of genuine insight), by the time of the first Sullivan broadcast, "Elvis's fame and his position as the greatest showbiz sensation of the day had . . . been firmly established. It was Elvis who made this program famous, not the program Elvis" (1981: 241).

I should emphasize here that, in arguing for the pivotal nature of Elvis's performance of "Hound Dog" on *The Milton Berle Show*, I am less concerned with identifying some sort of personal epiphany (i.e., the crucial turning point in the life or career of a particular individual (Denzin, 1989)) for Elvis than I am with describing the cultural epiphany (the point in time when an entire culture under-goes a major transformation of some sort) that he triggered in the US in the 1950s. More so than any of the eleven other nationally televised appearances that he made between January 1956 and January 1957, Elvis's controversial *Berle Show* performance successfully reawakened the nation to "the dance that everybody

forgot" . . . even if – especially if – for many people, the reminder was not a welcome one. From this moment forward, while Elvis's personal future as an entertainer may still have been filled with its fair share of uncertainty, he had nevertheless altered the shape of US culture in a profound and lasting fashion:

> A single look at [the documentaries] *This Is Elvis* [1981] or *Elvis '56* [1987] makes it plain why Elvis's early TV performances caused so much trouble: Elvis, clearly and consciously perceiving the limits of what America had learned to accept as shared culture, set out to shatter them. He turns toward the camera, and suggests a body in freedom, a kind of freedom for which, at the time, there was no acceptable language; then he turns away, and suggests that he is only kidding; then he moves in a manner so outrageous memory cannot hold the image.
>
> (Marcus, 1990a: 240)

Ignoring (once again) Marcus's attribution of self-conscious intentionality to Elvis, this is an insightful interpretation of what made Elvis's early television appearances so significant when they first happened. What matters about these performances is not so much that they popularized a new sound (i.e., rock 'n' roll), but that they introduced audiences to a new attitude and a new style, one that carried with it a new way for Elvis's audiences to view the world and their place within it. Elvis may not have successfully precipitated a full-scale revolution – in his wake, governments did not topple, capitalism did not falter (much less fall), social injustice did not disappear from the face of the Earth, etc. – but he did manage to transform the ways in which people lived their daily lives and dreamed of their futures.

Marcus immediately follows the penetrating analysis of Elvis's early television appearances cited above, however, with a much more debatable claim about the shape of contemporary US culture:

> Were [Elvis] to appear on TV today, for the first time, with the world somehow still changed as he changed it, the spectacle would be no less shocking. "My God," I said to myself as I watched him move a quarter-century after the fact. "They let that on television?"
>
> (1990a: 240)

Such a claim seems untenable, not because it's hard to believe that someone could be stunned by watching twenty-five-year-old videotapes of Elvis's early television appearances – on the contrary, my own reaction to these same images nearly a decade after Marcus first viewed them was strikingly similar to his – but because these performances are nowhere near as shocking to audiences today as they were in 1956, *and they can't be*. It is, in fact, precisely because the world is "somehow still changed as he changed it" that contemporary audiences (particularly those people who were born too late to witness Elvis's rise to stardom firsthand)[33] look

at videotapes from the early days of Elvis's career and see performances that, by current standards, are far too trite and conventional to justify the use of words such as "spectacle" and "shocking" to describe them.

For example, between 1990 and 1995 I showed all or part of the same video documentaries that Marcus finds "shocking" to my undergraduate classes on popular music, placing specific emphasis on the *Berle Show* performance of "Hound Dog." With very few exceptions, my students – all of whom belong to the post-baby-boom generation that has variously been described as "Twentysomethings" (Ellis, 1990), "Generation X" (Coupland, 1991), and "13ers" (Howe and Strauss, 1993) – responded to these scenes from their parents' childhoods not with shock or excitement, but with apathy and boredom. Many older commentators would argue that this lack of response is just another example of the distanced cynicism that supposedly characterizes Generation X's approach to anything and everything that happened before they were born.[34] It's far too easy, however, to claim that these students were indifferent to historical events that they *could* have understood (if only they had been better motivated, less apathetic, etc.) but chose not to. At the very least, this sort of difficulty with understanding the past isn't a characteristic unique to twentysomethings. As Raymond Williams pointed out thirty-five years ago, it's *always* hard to comprehend the "structure of feeling" associated with a past historical period:

> It is only in our own time and place that we can expect to know, in any substantial way, the general organization [of relationships between elements in a whole way of life]. . . . The most difficult thing to get a hold of, in studying any past period, is this felt sense of the quality of life at a particular place and time: a sense of the ways in which the particular activities combined into a way of thinking and living.
>
> (1961: 47)

Given the historical and cultural context in which my students grew up, it's not surprising that they found nothing particularly novel or threatening (much less shocking) in any of Elvis's early television appearances. The vast majority of these students were born in the late 1960s and early 1970s, just as rock 'n' roll was becoming firmly entrenched as the mainstream music of US culture, and they first became actively involved with (or at least aware of) the world of popular music in the early 1980s, just as MTV was beginning to restructure the ideological opposition between television and rock 'n' roll that had (supposedly) existed ever since the music first emerged in the 1950s.[35] With this particular cultural pedigree behind them, and in the context of the entertainment that they encountered on a daily basis (not only on MTV, but in virtually all other corners of the popular culture terrain as well), it would be surprising if my students hadn't found Elvis's bump-and-grind act on *The Milton Berle Show* tame, lame, and even inept.

What lay behind these twentysomethings' apathetic response to this archival footage, however, was more than just their inability to feel what their parents felt (be it wonder and excitement or disgust and revulsion) upon first seeing Elvis. Instead, as our in-class discussions consistently demonstrated, my students' non-response to these video clips was based primarily on their inability even to recognize the things that Elvis did on television in the 1950s as violations of (once-)dominant cultural norms and codes. It isn't simply that my students didn't get it (or that they got it, but didn't give a damn): it's that they didn't understand that there was anything in these performances for *anyone* – be it themselves in the 1990s or their parents in the 1950s – to get. The idea that Elvis might have "gone too far" in 1956 (in the same way that Madonna or Public Enemy "went too far" in the 1980s or 1990s – examples of cultural transgressions that my students were able to recognize as such without any difficulty) was a notion so incomprehensible to them that it might as well have been a nonsense statement uttered in a foreign language.

This "failure" to understand (much less actually feel) the shocks and thrills that Elvis elicited from audiences forty years ago, however, occurs precisely because "the world [is] somehow still changed as he changed it," and because these changes are so tightly stitched into the fabric of our daily lives as to be virtually invisible to most people today. In the obituary that he wrote for *Rolling Stone* following Elvis's death in 1977, Dave Marsh described Elvis's impact on US culture this way:

> if any individual of our time can be said to have changed the world, Elvis Presley is the one. In his wake more than music is different. Nothing and no one looks or sounds the same. His music was the most liberating event of our era because it taught us new possibilities of feeling and perception, new modes of action and appearance, and because it reminded us not only of his greatness but also of our own potential. *If those things were not already so well integrated into our lives that they have become commonplace, it would be simpler to explain how astonishing a feat Elvis Presley's advent really was.*
>
> (1977: 306, emphasis added)

Once the dance that "it took an entire civilization to forget" was remembered, it became exceptionally difficult for most people born and raised in the US to imagine a world in which that dance didn't exist, much less a world in which the sudden appearance of that dance could constitute a serious threat to the dominant social order. In Marcus's words:

> The idea was that, to the degree aesthetic categories could be proven false, social barriers could be revealed as constructed illusions, and the world could be changed. Things are not as they seem: that was the message then, and that is the message now. The difference . . . is that *then the message was shocking, and now it is not even a message.*
>
> (1989: 188, emphasis added)

What Marcus is describing here, however, is not the gap between the culture that Elvis disrupted in 1956 and "the same" culture (the one "somehow still changed as he changed it") as it exists today, but the chasm opened up by the transformation of avant-garde art from World War I (specifically, dadaist Hugo Ball's sound poems from the Cabaret Voltaire in Zurich in 1916) into meaningless fodder for mainstream network television in the mid-1980s (specifically, an appearance by Marie Osmond on *Ripley's Believe It or Not!*).[36] Nevertheless, it is these words, and not Marcus's claims about how "the spectacle would be no less shocking" today, that most accurately describe the ways in which forty-year-old videotapes of a young Elvis in motion would be received by audiences in the 1990s: where there was once a message so shocking that it seemed that Western civilization could not possibly survive its utterance, there is now no message at all.

RIP IT UP

Having unpacked the divisive ways in which "culture" is invoked in US public discourse, and having described (at least in part) the cultural shift between 1956 and today that transformed Elvis's once-controversial performance of "Hound Dog" into just another piece of televisual wallpaper (i.e., something effectively invisible and virtually meaningless to contemporary audiences), it's now possible to return to the question raised by the Bernstein quote from the start of this chapter in a more meaningful way. What I want to argue here is that Bernstein's claim – that Elvis is "the greatest cultural force in the twentieth century" – is a legitimate one, not so much because of the music that Elvis made, but because of the previously unimagined realm of possibilities that Elvis's rise to prominence opened up for the ways that people could live and move through their daily lives.

Put in more theoretically sophisticated terms, my claim here is that Elvis was the point of articulation around which a new *cultural formation* – the one that crystallized around rock 'n' roll and ultimately went on to reshape mainstream US culture in dramatic and unprecedented ways – could come into existence. As Grossberg describes it, a cultural formation is more than just a set of generically related texts; instead, it is defined by the ways in which

> a set of practices comes to congeal and, for a certain period of time, take on an identity of its own which is capable of existing in different social and cultural contexts. Unlike notions of genre, which assume that such identities depend on the existence of necessary formal elements, a formation is a historical articulation, an accumulation or organization of practices. . . . To account for the emergence of the formation, one must look elsewhere, to the context, the dispersed but structured field of practices in which the specific articulation was accomplished and across which it is sustained over time and space. It is not a question of interpreting a body of

texts or tracing out their intertextuality. Rather, the formation has to be read as the articulation of a number of discrete series of events, only some of which are discursive.

(1992b: 69–70)

For example, the term "rock 'n' roll" has long referred to more than just a set of musical texts that shared certain formalistic properties (various rhythmic patterns, vocal and instrumental timbres, lyrical themes, etc.): it's also encompassed a diverse range of extra-musical practices (those around fashions, hairstyles, dance crazes, concerts, recreational drug use, sex, various political movements, etc.) and attitudes associated with the audiences for that music. Consequently, the social, cultural, and political significance of rock 'n' roll has never been a mere function of the messages audible on the surfaces of those texts. Thus, to understand rock 'n' roll properly we need to do more than just interpret the musical texts that (supposedly) comprise it; we also need to examine the complex relationships between those texts and the broader economy of cultural practices in which they typically circulate.[37]

I should emphasize here that while it's not uncommon for cultural formations to coalesce around genres (musical or otherwise), not all genres give rise to corresponding cultural formations; nor are all cultural formations centered around bodies of generically related texts. For example, rock 'n' roll has long been associated with an identifiable (albeit multi-faceted and ever-shifting) set of linked cultural practices in ways that neither the Hollywood musical nor the half-hour situation comedy (to give but two examples of genres without their own cultural formations) ever have. And while it could reasonably be argued that, like rock 'n' roll, both musicals and sitcoms are indelibly stitched into broader economies of cultural practices, the resulting cultural formations are not centered around genres as much as they are around the respective media (i.e., film and television) in question.

In arguing that Elvis served as the point of articulation around which the cultural formation associated with rock 'n' roll came into existence, I'm not claiming that Elvis "invented" this formation all by himself: a cultural formation, after all, isn't something that can be produced in its entirety by just one individual. Describing Elvis as a point of articulation is, in part, a way of recognizing that questions of individual agency are not necessarily the most useful ones to ask here: while Elvis was an active, self-conscious agent who made deliberate efforts to forge certain articulative links and to break others, he was also an unwilling and relatively powerless subject of other people's articulative practices (i.e., those of fans, promoters, deejays, record companies, outraged parents' organizations, etc.). The process I'm describing here was, in many ways, a collective one, in which there was a constant, two-way feedback between Elvis (who made active

choices about what songs to perform, how to perform them, what answers to give to interviewers' questions, etc.) and his audiences (who took up the various texts produced by and about Elvis and incorporated them into their daily lives in a myriad of unpredictable ways). While Elvis's actions worked to place limits on the uses and meanings that people could make of his music (or his movies, his interviews, his stardom, etc.) – the process of articulation is never so wide open that a given phenomenon can be linked to absolutely anything else – there was also never any way to guarantee that audiences would interpret or make use of Elvis's work in a particular way.

Thus, what matters here is not who *meant* to change what, but what changes actually took place. Similarly, I'm not trying to suggest that the current shape(s) of this cultural formation are somehow the inevitable result of a historical process set in motion by Elvis forty years ago (i.e., that ever since 1956 we've all been filling in the gaps of a story primarily written by Elvis). Rather, I want to argue that Elvis is the figure most responsible for transforming rock 'n' roll from a mere musical genre into a full-fledged cultural formation and that, consequently, the initial shape that formation took was, to a large extent, determined (albeit not necessarily in any authorial sense) by Elvis. Put another way, without Elvis the cultural formation around rock 'n' roll would have taken a radically different shape, and thus followed a much different historical trajectory,[38] than it actually did – *if it ever took shape at all.*

To avoid misunderstanding, I should emphasize that there would unquestionably have been rock 'n' roll *music* without Elvis (though even here Elvis's importance often goes unacknowledged), if for no other reason than that a great deal of rock 'n' roll music had already been made prior to Elvis's arrival on the scene. It's not at all clear, however, that this musical genre would have given rise to a cultural formation (or at least not one of any prominence or lasting significance) had Elvis followed some life path other than the one that led him to rock 'n' roll (e.g., if he'd stuck with his career as a truck driver). One can of course point to countless other figures from the early days of rock 'n' roll (e.g., Chuck Berry, Bo Diddley, Fats Domino, Buddy Holly, Jerry Lee Lewis, Little Richard) who had more musical talent (at least as the term is typically understood) than Elvis ever had, and who were thus probably more important to defining the *sound* of rock 'n' roll than he was. Elvis, on the other hand, is a pivotal figure in rock 'n' roll history, not so much for what he contributed musically, but for what he contributed culturally. Put simply, no other musician had anything close to the combination of charisma, ambition, determination, talent, and instinctive media savvy that Elvis did; while other artists may have made greater music, no one else could have accomplished what Elvis did in terms of bringing together a vast range of musical genres, attitudes, styles of dress, behaviors, and other social practices in such a way that a coherent cultural formation could come into existence. Elvis changed the ways that

people viewed the world in which they lived and, in doing so, he brought about significant changes in the ways that those people could – and did – live their lives. It was as if the old map of the cultural terrain had been torn up, the pieces burned, the ashes scattered to the four winds, and the whole thing replaced with a radically different diagram of that same territory – so different that it's easy to believe that this new map described an entirely new territory altogether. Which, after a fashion, it did, as this map opened up vast uncharted regions of possibility for how people could walk and talk and move through their daily lives; and, in doing so, it reshaped the hopes and aspirations of many of those people as to what sort of future they could (and would) build for themselves.

Admittedly, these are broad and sweeping claims to make on Elvis's behalf – so much so, in fact, that it's probably impossible to demonstrate their validity in a rigorous or conclusive fashion. In thinking about culture as a phenomenon in constant flux – one that only exists in the dialectical tensions between a society's "arts and learning" and its "whole way of life" – seemingly the only viable alternative to making overly broad macro-level generalizations is to collect and relate a vast range of individual anecdotes about the changes that took place in the daily lives of otherwise unconnected people. This methodological nightmare (what Barthes once described as the "impossible science of the individual" (quoted in Grossberg, 1988c: 386)) is probably another reason for the widespread acceptance of a strictly textual model of culture: mapping out all (or even most) of the relevant facets of a cultural formation (e.g., describing the complex relationships that exist between a major public figure, his or her work, and the daily lives of the countless people affected by that work) in any detail is a monumental, if not impossible, task. It's much easier – albeit ultimately less accurate – to talk about culture in terms of texts, and to talk about cultural change in terms of the influence that one artist's or critic's texts have on that of other artists or critics.

In the end, however, if those texts actually have a significant impact on the shape of the broader cultural terrain, it's *only* because they generate changes at the more local level of individual people and their daily lives first.[39] Consequently, the place where we need to begin our attempt to comprehend the specific shape of the cultural formation that arose around rock 'n' roll is with the tales that people tell about how their lives were changed by what Elvis did in the mid-1950s. Typically, such testimonials are centered not on specific texts (e.g., "'Don't Be Cruel' came on the radio for the first time and I thought it was the greatest record I'd ever heard") or on Elvis's impact on the broader US soundscape (e.g., "he changed the face of popular music forever"), but on a wider range of more personal – and ultimately more idiosyncratic – social practices: attitudes, dreams, hopes, aspirations, fashions, lifestyles, and so on.

Take, for instance, Sun Records stable-mate Carl Perkins' assessment of Elvis's impact, which doesn't mention music at all: "He never really died and never will.

You don't change as much of the world as Elvis Presley changed – hair styles, clothes, moods, looks, sideburns – dad gum! He cut a path through this world! He's gonna be history, man. And he should be" (quoted in Flanagan, 1987: 21). Similarly, rock critic Tom Smucker recalls Elvis circa 1956 not as a great singer or a charismatic pop star, but as a disruptive force whose rise to prominence called the basic premises of (white, middle-class, suburban) daily life in the US in the 1950s into question at a very personal level. For Smucker, Elvis matters because he was "the man whose TV appearance inspires my brother to threaten to wear *blue jeans to church*" (1979: 162): at the heart of Smucker's story, we don't find Elvis's music; we find his public persona (his attitude, his style, his personality, etc.). Thus, in the end, the most significant changes that Elvis brought about are not textual in nature (e.g., the fact that Elvis's records begat and/or inspired subsequent great music) as much as they are social (e.g., the fact that Elvis could dramatically restructure the perspective that Smucker's brother had on the world in which he lived).

At one level, of course, Smucker's story is merely a trivial (if amusing) anecdote, as it seems safe to say that Elvis didn't inspire an entire generation of teenagers to rebel against the dress codes of their families' places of worship. What matters about this tale, however, isn't the particular incident in an individual's life that it describes as much as the broader shift in the attitudes and behaviors of a larger population that it represents. As Bruce Springsteen once described Elvis's impact, "It was like he came along and whispered a dream in everybody's ear and then we dreamed it" (quoted in Marsh, 1987: 28). One of the reasons why it's so difficult to recognize (much less describe) the extent to which Elvis reshaped US culture, however, is that the specific ways that different people tried to live out the dream that Springsteen mentions varied dramatically from person to person, and these attempts usually didn't take place in highly visible corners of the public sphere. For Smucker's brother, that dream manifested itself in a relatively private act of sartorial rebellion against his parents and their church: a transgression that presumably led to similar acts of rebellion (perhaps on a larger scale) later on in life. For Springsteen, that dream revolved around trying to do with his own life what Elvis was doing: "I remember when I was nine years old," Springsteen told the crowd at a 1981 concert, "and I was sittin' in front of the TV set and my mother had Ed Sullivan on and on came Elvis. I remember right from that time, I looked at her and said, 'I wanna be *just . . . like . . . that*'" (quoted in Marsh, 1987: 40).[40] For millions of others, that dream undoubtedly took millions of other shapes, no two of which were quite the same and very few of which ever attracted widespread public attention (e.g., it was nearly twenty years before Springsteen's attempt to live out that dream became obvious to the general public and, even then, his success in living out that dream is undoubtedly an exception to the rule).

In many respects, this dream was more or less a revamped version of the American Dream: it still involved a fairly idealistic (and perhaps even naïve) vision

of equal opportunity and upward mobility (e.g., anyone can become a star), and its ultimate goal was still firmly tied to the economic rewards of "making it big." What was different about Elvis's version of the Dream, however, was the path to its achievement: eschewing the classic Puritan ethic, where hard work was the necessary (albeit unglamorous) route to the proverbial top, the dream that Elvis whispered in a nation's collective ear was that one could have it all *while* or *by* (rather than *instead of*) having fun:

> the idea (and it was just barely an "idea") that Saturday night [i.e., the brief and transient moments of hedonistic pleasure that are the secondary reward for a never-ending routine of hard work] could be the whole show. You had to be young and a bit insulated to pull it off, but why not? Why not trade pain and boredom for kicks and style? Why not make an escape from a way of life . . . into a way of life?
>
> (Marcus, 1990a: 133–4)

The idea itself isn't entirely new – Elvis undoubtedly picked it up from the comic books and Hollywood movies that he consumed so assiduously as a child, and Marcus points out that Twain closes *Huckleberry Finn* on much the same note – but prior to Elvis that was all it was: a fantasy that worked well on the silver screen and in the pages of novels, but not an idea that one could reasonably expect would ever come to fruition in the real world – not until Elvis came along, that is, and demonstrated otherwise. . . .

. . . or at least he *seemed* to do so. The skeptical reader will no doubt claim that Elvis ultimately served as a very poor example of this dream in action. Fans and critics will probably argue forever about just when Elvis's story began to turn sour on him (was it when he first hooked up with Colonel Parker? the day his draft notice arrived? when he sold his soul to Hollywood and/or Vegas? etc.), but they almost all agree that, at some point, Elvis's dream collapsed back in upon itself and smothered him. The Elvis who died, bloated, full of pills, and on the toilet, was a nightmarish parody of the brash and exciting young upstart who remade US culture with a thrust of his hips twenty years earlier, and thus the moral behind Elvis's story is a reaffirmation of what we'd already known: that dreams such as his only come true in fairy tales and movies. Even Springsteen concludes his anecdote about seeing Elvis on television in the 1950s by saying:

> But then I grew up and I didn't want to be just like that [i.e., like Elvis] no more. . . . I thought a lot about it – how somebody who could've had so much could in the end lose so bad and how dreams don't mean nothin' unless you're strong enough to fight for 'em and make 'em come true. You gotta hold onto yourself.
>
> (quoted in Marsh, 1987: 40)

What Marsh doesn't tell us about this particular moment from Springsteen's 1981 tour is what song he introduced with this story. It's not unreasonable to think that it might have been "Johnny Bye Bye" (a Springsteen B-side from 1985 that describes Elvis's undignified demise in poignant, but unromanticized, terms), or maybe even "Follow that Dream" (a 1962 Elvis hit that Springsteen has been known to perform in concert). The ending that I imagine to this story, however, has Springsteen going on to perform "The River" (1980), which is *not* about Elvis, but it *is* about the disparity between the dreams that people have for their lives and the less than dreamlike ways that those lives often turn out: "Is a dream a lie if it don't come true?" Springsteen asks at the end of the song's final verse, "Or is it something worse?" This, after all, is the question that many people asked – and are still asking – in the wake of Elvis's surprising and undignified death: an event that (coupled with the host of post-mortem revelations concerning Elvis's descent into paranoia, violent outbursts, and prescription drug abuse) called into question the value (and the validity) of the dream that he'd represented to so many people for so long.

But no matter how disillusioning the nature of his decline was, the fact remains that Elvis's primary impact on US culture needs to be measured, not by how his story ended, but by how it began . . . and, in the beginning, Elvis successfully convinced a generation that they didn't have to dream the same dreams – which is to say that they didn't have to live the same lives – that their parents had settled for. Despite the fact that the dream he whispered in a nation's ear was ultimately an unattainable one for most people (i.e., not everyone could become a star of Elvis's – or even Springsteen's – magnitude), the actual process of millions of people trying to follow that dream and make it a reality was enough to transform US culture in untold ways. As Marcus puts it,

> rock 'n' roll caught that romantic conspiracy ["a cosmic conspiracy against reality in favor of romance"] on records and gave it a form. Instead of a possibility within a music, it became the essence; it became, of all things, a tradition. And when that form itself had to deal with reality – which is to say, when its young audience began to grow up – . . . the fantasy had become part of the reality that had to be dealt with; the rules of the game had changed a bit, and it was a better game.
>
> (1990a: 136)[41]

Marcus's last sentence contains an implicit acknowledgment that, at one level, rock 'n' roll fell short of whatever revolutionary goals it purported to have for itself: that its attempt "to make an escape from a way of life . . . into a way of life" didn't actually dismantle the central structures and institutions of the old culture as much as it pretended (or tried to) that those institutions could simply be ignored or dismissed out of hand. At the same time, however, Marcus's

comments point out that the failure of that revolution (i.e., the fact that rock 'n' roll ultimately found itself allied with, and even at the center of, the mainstream culture to which it had supposedly stood in opposition) was only a partial one, insofar as rock 'n' roll *did* manage to alter the shape of mainstream US culture in significant ways: that, despite the fact that the revolutionary threat of rock 'n' roll was quietly nullified and reabsorbed into the mainstream culture, the world was still a more exciting and interesting place *with* rock 'n' roll in it than it could ever have been without it.

In the end, the "better game" to which Marcus alludes played itself out in a number of different ways, as the dream that Elvis gave the country took a wide range of idiosyncratic and personalized forms. And when those dreams met up with one another on the broader terrain of US culture, they added up to more than the sum of their individual parts; they called a new "community" into existence, a community defined by and centered around the budding cultural formation associated with rock 'n' roll:

> When Elvis Presley hit the charts in 1956 there was no such thing as a "youth market." By 1957, almost solely through the demand for his recordings, there was. It was a fundamental, structural change in American society. In a few years we would learn *how* fundamental, as that "market" revealed itself also to have qualities of a community, one that had the power to initiate far-reaching social changes that seemed unimaginable in 1955. The antiwar movement, the second wave of the civil-rights movement, feminism, ecology, and the higher consciousness movement . . . got their impetus from the excitement of people who felt strong because they felt they were part of a national community of youth, a community that had first been defined, and then often inspired, by its affinity for this music. *That* was the public, historical result of those private epiphanies of personal energy we'd felt through this music's form of possession.
>
> (Ventura, 1985: 157)

In essence, Ventura is crediting Elvis with triggering most (if not all) of the social and cultural upheavals that would come into their own in the 1960s – and he's far from alone in making such a claim: Lester Bangs,[42] Leonard Bernstein,[43] and John Trudell[44] (among others) have also argued that Elvis was responsible for the various cultural transformations that took place in the US in the decade after he first burst into national prominence.

Now, at first glance, such an argument seems even more untenable than the notion that a reasonable person could use the words "Elvis" and "culture" in the same sentence with a straight face. Elvis, after all, deliberately shied away from mixing music and politics – or even from expressing his political convictions in public[45] – and he was far too "straight" to be plausibly seen as a hippie sympathizer

(much less as an actual hippie himself). What Ventura *et al.* are claiming, however, is not that Elvis somehow embodied "the Sixties," but that, culturally speaking, he laid the foundation that made "the Sixties" possible in the first place: that, without Elvis, contemporary US culture would look and feel remarkably like the pre-Elvis culture of the early 1950s. Novelist and short story writer Chet Williamson describes such a world this way:

> Everybody on the street looked like their parents. There were square clothes, butch-waxed haircuts, horn-rimmed glasses, and big round cars, like whales in pastel shades, driving down the streets. The gay bookstore [i.e., the one that exists in "our" Elvis-filled world] was a Christian Science Reading Room, and the Hard Rock [Cafe] was, God help me, a Howard Johnson's restaurant and "cocktail lounge." . . . Rock and roll was an underground music, tolerated by society and centered in "Negro" (as they were still called) communities. *All the changes that had come about in the sixties never occurred.* We were still in Nam, civil rights was nothing but a dream for blacks, gays still hid their inclinations, and the Cold War was iced over so hard it would never thaw out. People didn't know how to rebel. And the only conclusion that I can draw is that *it was because they never had an Elvis Presley to teach them, to show them how to sneer, and how to assault their elders with music.*
>
> (1994: 63–4, emphasis added)[46]

Like Smucker, Williamson is arguing for Elvis's importance not on musical grounds as much as he is on social and attitudinal ones: the world that Williamson describes still has rock 'n' roll *music*, but the *cultural formation* centered around that music – if it exists at all – is marginalized in what are presumably separate-but-not-all-that-equal "Negro communities." Elvis changed the world not by introducing (or even popularizing) rock 'n' roll as a musical sound, but by teaching audiences in the 1950s how to question – and, at times, rebel against – authority.

A reasonable (though undoubtedly coincidental) facsimile of Williamson's Elvis-less world also makes an appearance in an early 1990s television commercial for Chevrolet. As string-laden cha-cha music plays softly in the background, the screen glows with languorous images of a neatly trimmed, pastel-drenched suburban landscape populated by squeaky clean and decidedly "square" refugees from 1950s sitcoms. This, the voice-over announcer claims, is what life would have been like today if there had never been such a thing as rock 'n' roll. Then, without warning, the scene shifts to a rapid-fire montage of stylish young adults zipping down sunny stretches of open highway in flashy cars, the soundtrack comes alive with the driving guitar riffs of Jimi Hendrix's "Fire" (1967), and the voice-over proudly announces the arrival of the "new" Chevy Camaro with the

rhetorical question: "What else would you expect from the country that invented rock 'n' roll?"

Admittedly, neither Elvis nor his music makes an explicit appearance here, but this commercial does bring us back to that advertisement for the Swarthmore symposium on "the influence of pop culture on society" – the one centered on the premise that Bernstein's grandiose claim regarding Elvis's cultural impact *had* to be wrong. Above the ad's main text is a four-panel cartoon showing two yuppie types drinking beers and watching television in a bar. One says to the other, "Can you believe it? – They used Lennon's music to sell Nikes . . . Marvin Gaye to peddle raisins . . . and now Hendrix to hype Chevys!!" Coinciding with this last sentence, the television hanging over the bar blares forth with a line from "Fire," presumably as it appears in the ad described above. In the last panel, yuppie number two delivers the somewhat punchless punchline: "That's the legacy of the '60s sex, drugs and demographics" (see plate 29).

This cartoon sets up a curious counter-tension to the rest of the ad's text: one that ultimately runs contrary to Swarthmore's sneering jab at Elvis's cultural significance. While the prose that takes up most of the page raises questions about the general dangers of popular culture as a whole – and the specific danger of popular culture as embodied in and exemplified by Elvis – the cartoon implicitly argues that the sacred center of contemporary US culture (i.e., the body of texts that most need to be protected against rampant commercialization) is, in fact, rock 'n' roll. Whereas in 1956, when Elvis first came along, the notion that rock 'n' roll could be used effectively as a positive marketing tool (especially for big-ticket items such as automobiles) would have been laughable,[47] today one can find rock 'n' roll being used in ads for everything from office supply stores to major charge cards. This shift, however, is only possible because the place of rock 'n' roll in US culture has changed: where once this music and the cultural formation associated with it were perceived as a major threat to mainstream US culture, today they are frequently assumed to be the very essence of that culture (e.g., the part that advertisers can – and do – tap into in order to sell their wares to the general public). Chevrolet, for instance, uses rock 'n' roll in its Camaro ad to replace its once-upon-a-time mantra of "baseball, hot dogs, [and] apple pie" as the epitome of what America is all about. In particular, the ad uses rock 'n' roll as the means to forge an articulative link between Chevrolet and patriotism: the distinctly American sound of rock 'n' roll (the ad implicitly tells us) is a classic example of what makes this country great; the new Camaro is a car with a rock 'n' roll attitude; therefore, buying a Camaro allows the consumer to tap into – and reinforce – the spirits of both America and rock 'n' roll.

On the flip side of the coin, the Swarthmore ad implicitly argues that the decline of US culture can be measured by the use of rock 'n' roll to sell cars and sneakers. This music, according to the Swarthmore cartoon, is a valued part of

US culture, which is precisely why it *shouldn't* be used for commercial purposes. If rock 'n' roll matters to US culture (the argument goes), it's only because it's a distinctly American *art* form (culture as text), which makes it an inappropriate source for commercial exploitation. Chevrolet and Swarthmore both agree that rock 'n' roll – as a style of music and/or as a cultural formation – resides at the center of contemporary US culture. What the Swarthmore symposium organizers fail to recognize, however, is that without Elvis and "the rock 'n' roll fantasy [that he] made of the American Dream" (Marcus, 1990a: 134), there would be no place for rock 'n' roll at, or even near, that center. At a very fundamental level, we live in the culture that Elvis built, even if he didn't necessarily know what he was building at the time – or *that* he was building such a thing. What Elvis did in the last half of the 1950s effectively changed the ways that millions of people looked at and moved through the world – a perceptual and behavioral shift that ultimately led the world itself to change in dramatic ways. Describing what made Elvis different (and, simultaneously, the difference that Elvis made), Ventura claims that

> nobody had ever seen a white boy move like that. He was a flesh-and-blood rent in white reality. A gash in the nature of Western things. Through him, or through his image, a whole culture started to pass from its most strictured, fearful years to our unpredictably fermentive age – a jangled, discordant feeling, at once ultramodern and primitive, modes which have blended to become the mood of our time.
>
> (1985: 153)

It bears (re)emphasizing here that the cultural shift Ventura is describing is *not* primarily textual in nature. While the changes he mentions undoubtedly manifested themselves in a wide variety of texts (musical and otherwise), the most crucial of these changes took place on the far more diffuse terrain of people's daily lives, where they combined to produce the "jangled, discordant feeling" that is the *zeitgeist* of late twentieth-century US culture.

As dramatic as these changes may have been, however, they didn't come about without heavy resistance from the "old" culture. After all, the culture that Elvis built didn't actually replace the pre-Elvis culture as much as it managed to win a space for itself within that culture's heart: a process in which each of the two wound up making concessions of some sort to the other. In recent years, however, with the rise of the New Right and the graying of the baby boom, the cultural formation centered around rock 'n' roll has come under renewed attack on a number of fronts.[48] Following up his claim that Elvis "woke us up," John Trudell notes that "now they're trying to put us back to sleep" ("Baby Boom Ché," 1992): the once-liberating spirit of rock 'n' roll is being actively rearticulated to a kind of nostalgic complacency and un(der)critical acceptance of the status quo.[49] Marcus also posits the rise of a recent backlash against the cultural formation that Elvis built. In

discussing Ventura's *Shadow Dancing in the U.S.A.* (1985), he argues that "in Ventura's book, almost the whole of our culture is presented as a cover-up of what Elvis Presley exposed" (1991: 124): that the unlikely alliance formed over the past fifteen years of old-school conservatives (on the one hand) and aging refugees from the 1960s counter-culture (on the other) has worked diligently to erase the dance that Elvis reminded us of – the one "so strong it took an entire civilization to forget it" – from our cultural repertoire and to negate the lingering threat posed by the rock-'n'-roll-centered cultural formation that arose from that dance.

The proverbial genie, however, is never stuffed back into its bottle easily, and the ideas, moods, emotions, and attitudes that a culture works the hardest to forget and/or repress have a tendency to worm their way back to the surface in surprising ways and unexpected places. It is this tendency that has helped to give Elvis a second lease on life: as one set of forces attempts to cover up what he exposed, those reburied traces of his impact seep back out into the light through whatever cracks are available to them elsewhere.

TOO MUCH

During the first half of the 1990s, if one looked in the right places around the country, one could find a T-shirt for sale bearing the widely reproduced photo of Elvis shaking hands with Richard Nixon at their now (in)famous meeting in December 1970. What makes this shirt interesting, however, is not the image on it (this photo of "the President and the King," after all, has been appropriated for enough different merchandising ventures that, in itself, it's not especially note-worthy),[50] but the lone word in bright red letters emblazoned above that image: CULTURE (see plate 30).[51]

At one level, the idea behind this shirt seems to be little more than a variation on that found in the text of the Swarthmore ad: namely, that culture and Elvis (in this case, with Nixon thrown into the mix)[52] are mutually incompatible categories. Part of what makes the joke here work, after all, is the dissonance created by the conjunction of the high (culture), the low (Elvis), and the corrupt (Nixon).[53] Place that same word above some image more firmly linked to *high* art (e.g. a portrait of Beethoven, a reproduction of the *Mona Lisa*, a photo of Michelangelo's *David*, etc.) and there's no joke here at all. The deliberate juxtaposition of Elvis's picture with such an unlikely label, however, works to re-emphasize the incompatibility between the two, ridiculing the notion that *Elvis* could possibly (or, perhaps more cynically, that he actually does) exemplify (US) *culture*.

But while such an interpretation of this shirt has a certain seductive appeal to it, in the end the message here isn't quite so simple. At the very least, the medium involved is an unlikely one in which to attempt a straightforward critique of popular culture. This is, after all, a *T-shirt*: an article of casual clothing so

inextricably mired in the tar pits of the popular as to be wholly lacking in aesthetic authority. The Swarthmore ad has some hope of success in such a role because it carries with it all the (high) cultural capital of a respected, East Coast, liberal arts college; the Elvis/Nixon/culture shirt, on the other hand, is far too deeply enmeshed in the commodified trappings of popular culture to enjoy such prestige. Even if the message here is *supposed* to be that Elvis and his "art" (insert skeptical snicker here) can't be taken seriously as culture, the placement of this message on a T-shirt ultimately gives that message an ironic spin. After all, the very act of wearing a T-shirt (much less using one to make a statement) typically brands one as too uncultured to issue plausible statements as to what is and isn't culture; similarly, anyone positioned high enough on the food chain of cultural capital to speak with any real authority on such questions would probably not be caught dead in this (or any other) T-shirt.

More important, however, is the fact that this shirt only works as a joke because, at some level, it isn't a joke at all: the bulk of the shirt's humor lies in its audience's recognition that the implicit claim being made here regarding the link between Elvis and culture is, in fact, *true*. We may laugh at the notion that "culture" could be used to describe Elvis (or vice versa), but it's a nervous laughter, one rooted in the unconscious recognition (or, perhaps in some cases, fear) that this is one of those many truths that, as the old saying goes, are spoken in jest. To play the substitution game again: if we replace the picture of Elvis meeting Nixon with that of some other popular culture icon (e.g., a photo of the Beatles, a portrait of the *M*A*S*H* cast, a publicity still from *Casablanca*, etc.), the resulting shirt, if it makes any sense at all, is (again) likely to fall completely flat as a joke. Seen in this light, the dissonance created by the conjunction of Elvis's image and the word "culture" isn't based on the fact that these two signifiers *shouldn't* be linked together, but on the fact that, historically, they *haven't* been. Ultimately, then, this shirt is funny not because its message is false, but because the truth of that message catches us by surprise.

The reason that we're caught by surprise, however, is that we don't have the critical vocabulary with which to explain Elvis's impact on US culture adequately. In describing this particular critical blindspot, Marcus argues that,

> the controlling reason why it is so hard to think about Elvis esthetically rather than sociologically is that his achievement, his cultural conquest, was seemingly so out of proportion to his means. Continents of meaning – of behavior, identity, wish, and betrayal, continents of cultural politics – shifted according to certain gestures made on a television show, according to a few vocal hesitations on a handful of 45s. *No one knows how to think about such a thing*.
>
> (1990b: 121, emphasis added)

Implicit in Marcus's comments here is the recognition that a huge gap exists in US public thought between the ways that we most often think of US culture (e.g., as a textual phenomenon embodied in television shows, pop singles, and the like) and the ways that we live out that culture on a daily basis (e.g., as a social phenomenon comprised of behaviors, identities, hopes, dreams, and so on), and that we don't seem to have the conceptual framework necessary to bridge that gap.

Perhaps paradoxically, the primary effect of this gap hasn't been a prolonged silence settling in around the subject of Elvis, but rather a veritable cacophony of voices, all trying to wrestle with the question that they have no words to answer: "who was he, and why do I still care?" (Marcus, 1985: 67). In the absence of a broader conceptual framework with which to make sense of his cultural conquest, Elvis remains something of a mystery to most of the country – fans and detractors alike. Part of what makes Elvis's unusual posthumous career possible, then, are the ongoing efforts (conscious or otherwise) of countless people to solve that mystery: to bridge the gap between US culture as they live it on a daily basis (i.e., the ways in which they can *feel*, if not quite articulate, Elvis's impact) and the terms in which US culture is typically described and understood (i.e., terms that leave little (if any) room for Elvis's influence to be acknowledged or accepted as such).

The reason this gap produces noise rather than silence is that the stakes here are so high: that when he first came to national prominence in the 1950s, Elvis showed a large percentage of the US population "a new way of walking and a new way of talking" (Marcus, 1989: 398)[54] and – perhaps more importantly – in changing the ways that people viewed and moved through their world, Elvis managed to transform that world as well. These changes, however, can't be readily traced back to the various texts that bear Elvis's name, as his cultural impact cannot easily be described in the (textual) terms that we most commonly use to explain such transformations.[55]

To a certain extent, of course, the above holds true of any number of cultural icons besides Elvis. One of the consequences of viewing culture as a more processual phenomenon, after all, is the recognition that simply collecting and analyzing texts is inevitably inadequate to the task of understanding a particular cultural moment, if for no other reason than that such analysis can never account fully for the complex web of relationships in which those texts were originally produced, distributed, and consumed. The main problem here, however, is not one of taking important cultural texts and resituating them in a broader contextual framework; rather, it's a question of determining what constitutes an important cultural text in the first place. After all, works that seem to be of monumental importance when they first appear often turn out to have little (if any) lasting impact on the culture around them, while texts that initially seem to be trivial and

inconsequential can later come to be recognized as watershed moments in a culture's history. More generally, accepting a processual model of culture forces us to recognize that *all* cultural texts can (and typically do) generate social effects that can't be read off of those texts in any obvious or predictable fashion. Because the ultimate cultural significance of any text (be it musical, literary, cinematic, or otherwise) lies as much in how it is taken up by audiences (and how it comes to be intertwined within the larger fabric of other texts and events) as in the formal qualities of that text itself, one could argue that there is a "secret history" to be written, not just of Elvis and his cultural impact, but of virtually any major cultural figure. For example, the importance of the Beatles (or Bob Dylan, or the Sex Pistols, or Madonna, or whoever) to US culture is ultimately more than just the sum of the meanings of the musical (and/or cinematic, televisual, literary, etc.) texts they produced, as these artists also changed the ways that people walked and talked and moved through the world.

But while new, less textually oriented histories could undoubtedly be written for any number of important cultural figures,[56] the case of Elvis remains a unique one. Looking at the last century of US history, no other individual can fairly be said to have changed US culture so much while receiving so little recognition (much less respect) for having done so: the gap between what Elvis actually accomplished and the degree to which we understood those accomplishments is far wider for him than it is for any other figure. Thus, part of what makes Elvis different from other "neglected" artists is that his impact on US culture far exceeds theirs: one could, for instance, reasonably argue that the cultural significance of "teenybopper" groups such as the Bay City Rollers has been given short shrift in the commonly accepted histories of late twentieth-century music and culture (see Garratt, 1984), but it would also be a mistake to claim that such artists changed US culture to the same extent that Elvis did. Put bluntly, Elvis touched more lives – and did so in more dramatic fashion – than did any other "lost" figure in recent US history. On the other side of the coin, Elvis is markedly different from similarly influential – but more widely celebrated – artists in that the cultural changes he induced can't easily be mapped back onto the texts that bear his name: it's possible, for instance, to listen to "Anarchy in the U.K." (Sex Pistols, 1976) and come away from it with some sense (albeit a necessarily incomplete one) of how this record managed to change people's lives. In Elvis's case, however, the gap between the texts he produced and their social effects is often much harder to bridge (try, for example, to hear "Heartbreak Hotel" (1956) as a song that could inspire an entire generation of youth to rebel). Even in those instances where that gap is seemingly not so wide ("Jailhouse Rock" (1957), for example, is a more plausible candidate for a rebellious anthem), the fact that Elvis can't readily be seen as the primary author of "his" art works to deny him credit for whatever impact that art might have had.

In the end, then, Elvis remains something of a mystery. Because US culture has yet to figure out what Elvis did to it when he first rose to prominence, the challenge he posed to that culture and the questions he raised in people's hearts and minds all remain "as an unsettled debt of history, extending into an unresolved past" (Marcus, 1989: 184).[57] Elvis continues to thrive as a ubiquitous cultural icon because people keep coming back to his story – retelling it, reworking it, reliving it, even rejecting it – in an effort to unravel (or, in some cases, dispose of) its mystery.

With this in mind, what I want to suggest here is that the vast array of Elvis's contemporary cultural manifestations can be roughly subdivided into four categories – unconscious echoes, loving explorations, skeptical dismissals, and ambiguous jokes – each of which embodies a different approach to the subject of Elvis and the riddle that is his cultural impact. To be sure, these are somewhat artificial categories, the boundaries between them are blurred and permeable, and one could undoubtedly point to a number of examples of recent Elvis sightings that don't fit into this typology very well. But while these categories don't encompass the entirety of Elvis's posthumous career (and what they do cover isn't necessarily covered cleanly or without ambiguity), I would maintain that most contemporary Elvis sightings (particularly those that are prominent and significant enough to make the phenomenon worth studying in the first place) can be accounted for by some combination of the four.

Strictly speaking, *unconscious echoes* aren't contemporary efforts to wrestle with the question of Elvis's cultural impact as much as they are the aspects of that impact that continue to be felt on the cultural terrain today. Many of the changes that Elvis brought about in the 1950s have become so thoroughly enmeshed within the fabric of US culture as to now be commonplace, taken-for-granted facets of our daily lives, which is to say that the ways of walking and talking and moving through the world that Elvis originally inspired are still practiced today (albeit not always in forms that are obviously linked to Elvis) by millions of people. The most prominent examples of this legacy include a number of broad cultural changes already discussed above: e.g., the status of the guitar as the definitive instrument of rock 'n' roll, the centrality of rock 'n' roll (as both a musical genre and a cultural formation) to US culture, and the continuing (if ever-shifting) importance of youth culture(s) within contemporary society. At some very crucial level, these phenomena (and the practices associated with them) owe their current shape (if not their very existence) to cultural changes that Elvis first set in motion, even if the connections between the two aren't always obvious.

A more specific example of the often invisible links between Elvis and contemporary cultural phenomena is the case of MTV's irregular series of *Unplugged* concert specials. The basic premise behind this show is simple: find a well-known recording act (often one whose career can use a promotional boost

of some sort),[58] place him or them (but almost never her)[59] in a television studio with a bunch of acoustic instruments, videotape the artist(s) in question performing for a small audience in the round, air the final product on national (cable) television in prime time, and then wait for the kudos (critical and/or financial) to roll in. And roll in they have, as this approach to music programming has become MTV's most recent (and perhaps even its biggest) success story. Since their inception, the various *Unplugged* specials have done much more than attract high ratings and critical praise; they've also resurrected several dormant careers, and spawned a number of best-selling albums.[60]

To the best of my knowledge, however, neither the show's producers at MTV nor the various critics and journalists who've written about *Unplugged* in the national media have commented publicly on the obvious connections between this program and the example of music television from the pre-MTV era that it so strikingly resembles: Elvis's so-called "Comeback Special" from December 1968.[61] To be sure, this hour-long NBC broadcast contained several awkward, overblown production numbers (an early approach to music television that owes far more to Broadway and Hollywood musicals than it does to rock 'n' roll) that have no modern day analog in *Unplugged* (or, to the best of my knowledge, anywhere else on the television dial).[62] The link between the two, however, lies not in these moments of over-choreographed flash, but in the selections from an informal, mostly acoustic jam session featuring Elvis and several of his old bandmates (including Scotty Moore and D.J. Fontana) that comprised the central core of the 1968 special.[63] Recorded live (i.e., without rehearsal or subsequent overdubbing) in the midst of a small studio audience, these are the segments of the program most frequently credited with rescuing Elvis's career. Viewed from the vantage point of the mid-1990s, however, this informal performance resembles nothing so much as an early prototype for *Unplugged*. The once-mighty musician struggling to get back on top; the intimacy of a small audience close enough to the stage to touch the star; the deliberately raw, improvisational approach to the concert itself: these are all the trademarks of an episode of *Unplugged* . . . except for the fact that they took place about twenty-five years too soon.

Of course, the similarities between these two moments in music television history may be purely coincidental. While I would be surprised if the creators of *Unplugged* were completely unfamiliar with Elvis's "Comeback Special," it's also quite possible that the source of their inspiration was nothing more than the well-established (and well-worn) cliché of rock stars doing acoustic sets in concert. My point here, however, is not that MTV "stole" the basic idea behind the Elvis broadcast and built *Unplugged* around it, but that in its basic form (and, given the number of flagging careers it's already helped to rejuvenate, quite frequently its function as well), *Unplugged* is the most recent manifestation of a stripped-down,

bare-bones approach to music television first introduced into our cultural lexicon by Elvis.[64] Thus, whether MTV intends to do so or not, every new *Unplugged* concert it airs not only resurrects the moribund career of the aging rocker *du jour*, but it also helps to keep a little piece of Elvis alive as well.

In stark contrast to unconscious echoes (which, as the name implies, are *not* deliberate references or responses to Elvis), *loving explorations* are much more straightforward attempts to come to grips with the mystery of Elvis and his cultural impact. While the former can be (and are) produced by almost anybody, the latter are almost exclusively the product of Elvis fans. Typically, loving explorations are the most unabashedly sentimental and adulatory of contemporary Elvis sightings: the public expressions of affection and devotion from lifelong admirers, the various attempts to retell his life story (in whole or in part) and breathe new life into his myth, the ongoing efforts to convert (or at least shout down) the "unbelievers," and so on. Here we find such phenomena as the handmade Elvis shrines that can be found on front porches, yards, and roadsides scattered across the rural South;[65] fictionalized versions of his story (or fractions thereof) that offer up glimpses of "the real" Elvis (i.e., tellings of the tale that, at least implicitly, make some claim to explain the "true" nature of Elvis's cultural significance);[66] brief (and often subtle) allusions to Elvis slipped into otherwise Elvis-less artistic projects as tiny gestures of homage;[67] thousands of Elvis impersonators seeking to (re)capture and keep alive the ineffable magic of Elvis's music;[68] fan-created Elvis home pages on the World Wide Web;[69] and so on.

But while loving explorations may be the variety of Elvis sightings that encompasses the most touching and heartfelt tributes to him, it would be wrong to assume that all the sightings belonging to this category are characterized by sticky, saccharine-coated sentiment. Take, for example, the case of "Elvis What Happened?" – not the controversial book of that name written by three disgruntled ex-members of Elvis's "Memphis Mafia" (West *et al.*, 1977), but the 1986 song by Mr Bonus (aka Peter Holsapple). Upon first hearing, this song appears to be anything but loving in its treatment of Elvis, as its first several verses consist of blistering attacks on Elvis and his public image:

> And you made us feel like fools for believing what we saw
> Like how you loved religion, and how you loved your maw.
> [. . .]
> Your acting out a public life was better than your films.
> Colonel Parker took your hand and he catered to your whims.
> You let him be your teddy bear and he made you Frankenstein
> And then you died, you stupid ass, and left it all behind.

There's an unmistakable anger here, not only in Holsapple's words but in his voice as well: an anger that Elvis fans generally reserve for such pariahs as Elvis's

ex-wife Priscilla (for breaking his heart),[70] Albert Goldman (for his muckraking 1981 biography), or that unholy trinity of disloyal Graceland insiders (for writing the book from which this song took its name), but *never* for Elvis. A true fan, the argument goes, wouldn't even *think* of calling Elvis a "stupid ass," much less do so in as public a manner as Holsapple does here.

By the end of the song, however, it becomes clear that Holsapple's bile is not so much an unequivocal condemnation of Elvis as it is the byproduct of the disillusionment he felt at the scandalous revelations surrounding Elvis's death. Holsapple still has a warm place in his heart for Elvis; he's just not sure anymore whether the Elvis he loves actually bears any resemblance to the real thing. Wistfully, he concludes:

> But I'll still visit Graceland whenever I'm in town,
> And through the gate, and up the walk, and lay my flowers down
> Among the thousand million garlands that are laying on the ground,
> And wish that you could be here with us to see what we're going
> through
> When we read that Goldman book, and we think we misread you.

These final verses also put a decidedly different spin on the song's chorus:

> Elvis, what happened?
> What happened was you died
> You showed us how you lived
> And then you died
> And it was not a pretty sight.

In their first few repetitions, these words seem to be a statement of matter-of-fact dismissal, but their final utterance comes across more as the heartfelt efforts of a true fan who wants – and perhaps even needs – to figure out what went wrong with Elvis's story and why it hurt so badly when he died. In the end, then, while "Elvis What Happened?" might strike many Elvis fans as being blasphemously offensive, to my ears, at least, there's more genuine love and feeling for Elvis in the anger that Holsapple expresses than can be found in all of the sweetly reverential Elvis tribute records put together.[71]

This is not to say, however, that there aren't a sizable number of contemporary Elvis sightings whose sole purpose is to mock and/or attack him. On the contrary, such *skeptical dismissals* – which run the gamut from flippant one-liners to lengthy character assassinations – are among the most common (and most prominent) of Elvis's recent manifestations; enough so that, ironically, it may be Elvis's harshest critics who are playing the most important role in keeping him alive on the cultural terrain today. At the very least, skeptical dismissals are among the most surprising and interesting moments in Elvis's posthumous career, in that they are typically

unprovoked denouncements of Elvis made by people who claim not to give a damn about him. It's one thing for someone like Paul Simon – who first took up the guitar out of a desire to be like Elvis (Choron and Oskam, 1991: 36) – to write and record a song celebrating Elvis ("Graceland," 1986); paying homage to one's heroes and inspirations, after all, hardly qualifies as unusual behavior for a rock/pop musician. It's quite another thing, however, to take the trouble to write and record a song slamming Elvis (e.g., Living Colour's "Elvis Is Dead" (1990)) when he (supposedly) doesn't matter to you at all; after all, if you're going to dismiss him anyway, why not just ignore him altogether?

What I want to suggest here is that Elvis's detractors continue to raise his spectre (and, in the process, to pump life into his unusual second career) for precisely the same reasons that his fans do: because they're unable to figure out why Elvis mattered – and continues to matter – so much to US culture. The difference here, of course, is that fans are willing to accept that Elvis changed their world (even if they don't quite understand just how he pulled this feat off), while skeptics are convinced that he didn't matter at all. What befuddles the latter group – and what leads them to speak up on the subject – is that so many people seem to think the opposite is true. For skeptics, the impossibility of seeing Elvis as an active (much less an influential) cultural agent makes it easy to dismiss him, but the visible presence of so many people willing to take him seriously provides an easy (and often irresistible) target for dismissive jokes and biting commentary.[72]

But while the various skeptical dismissals of Elvis that circulate on the cultural terrain today can be seen as something of a backlash against Elvis and his fans, they also serve (albeit inadvertently) to feed the very phenomenon they seek to condemn. Take, for instance, the media coverage of the 1992 course on Elvis taught at the University of Iowa by Peter Nazareth.[73] While the basic assumption underlying the course was that Elvis did, in fact, matter a great deal to US culture, the various news stories covering the course were typically novelty pieces played for laughs. The course itself was newsworthy only because Elvis is (supposedly) so *unworthy* of serious scholarly attention,[74] and most of these news stories were characterized by an undercurrent of dismissiveness towards Elvis and his cultural significance. The irony here, of course, is that the same stories that attempted (at least in part) to bury Elvis by denying that he was important enough to merit serious scholarly attention ultimately worked to thrust him even more squarely into the limelight. (Further discussion of Nazareth's course can be found in chapter 2.)

The fourth and final variety of contemporary Elvis sightings that I want to discuss here, *ambiguous jokes*, is characterized by a willingness to explore the humorous side of the Elvis phenomenon. More important than the sense of humor behind these sightings, however, is the fact that it's never entirely clear whether their authors are laughing *at* Elvis or *with* him. Thus, these particular sightings

might best be understood as existing on some hazy middle ground between loving explorations and skeptical dismissals. While skeptics might seem to be the most likely sources for humorous Elvis sightings (ridicule being one of the most potent rhetorical weapons in any skeptic's arsenal), there's also a sizable subset of the community of Elvis fans who are more than willing to make fun of their hero. Ambiguous jokes raise a question – in this case, one concerned with Elvis's cultural significance – but then leave the answer to that question as an exercise for the audience to figure out.

A prime example of this variety of Elvis sighting is another Elvis-meets-Nixon T-shirt (see note 50), this one bearing the caption: "JUST SAY NO!" Viewed in one light, the conjunction of this image with these words can be read as a civic-minded plea from Elvis and Nixon, and thus part of the shirt's function is to honor Elvis by making him into the anti-drug spokesperson he always wanted to be. Elvis's ostensible reason for meeting with Nixon, after all, was to volunteer his services in the 1970s version of the US government's war on drugs, while "Just say no!" was the vacuous catchphrase first popularized and promoted by Nancy Reagan as part of the government's anti-drug efforts in the early 1980s. It's not at all difficult, however, to read this shirt from a completely opposite perspective, one in which the "Just say no!" caption is intended to be a statement *about* (rather than *by*) Elvis and Nixon. Seen through this lens, what this shirt is warning us against is not drugs, but Elvis. In the end, however, the shirt offers no clear cues as to which of these readings is the "correct" (or even the intended) one, and both seem equally plausible.

Similarly enigmatic in its take on Elvis is Pop Will Eat Itself's version of "Rock-a-Hula Baby" (a minor hit for Elvis in 1961), which appeared on a 1990 Elvis-tribute-collection/charity-fundraiser album called *The Last Temptation of Elvis*. Taken as a whole, *Last Temptation* is itself somewhat ambiguous in its stance towards Elvis, as the performances collected on it run the gamut from unmistakably reverential covers (e.g., Aaron Neville's version of "Young and Beautiful") to amusingly mocking knock-offs (e.g., Vivian Stanshall and the Big Boys' rendition of "(There's) No Room to Rhumba in a Sports Car"). For the most part, however, each individual track takes a fairly clear-cut position *vis à vis* Elvis – with the notable exception of "Rock-a-Hula Baby."

Of the twenty-six tracks on this two-disc set, PWEI's easily takes the most dramatic liberties when it comes to reworking the Elvis original.[75] In fact, the only obvious similarity between the two is that somewhat muddled and slowed-down renditions of parts of the song's original verses (sampled from Elvis?) appear fleetingly within the pulsating mix of samples and drum machine riffs that dominate PWEI's version. The track begins with a booming and heavily echo-laden male voice asking, "What is the truth . . . about rock music?" A second voice replies, "Music, ladies and gentlemen, is the gift of –" but is interrupted by a third voice

that completes this thought with a single word: "Elvis!" The first of a dense layer of drum machine rhythms kicks in and, from here on out, any resemblance between the two versions of this song is purely coincidental. The fragments of the original (sampled or otherwise) that appear only seem to be included as an afterthought to what PWEI *really* want to do here: namely, to build an entire song (rhythm, melody, and harmony) around the stuttered repetition of "Elvis! El-El-El-El-Elvis!"

In and of itself, this strategy represents a somewhat ambiguous attitude towards Elvis. Is his music so disposable that one can "cover" it without actually having to use it (or at least without having to feature it)? Or is he so central a figure to pop music that the mere utterance of his name can result in an irresistibly compelling tune? Adding to this confusion, however, is the revelation that comes at the very end of the song, when PWEI allow the sample they've been using to produce that stuttering repetition of Elvis's name to play through a bit further and it becomes clear that what we've been hearing all along is the start of the now (in)famous line from Public Enemy's "Fight the Power" (1989) proclaiming that "Elvis was a hero to most . . . " This musical punchline can also be read in (at least) two ways: the fact that PWEI use Chuck D (of all people) to finish the claim that music is "the gift of Elvis" and then end with him repeating the words "hero to most" (rather than continuing to say "But he never meant shit to me") can be read as a deliberate attempt to undermine (and even reverse) the thrust of Public Enemy's anti-Elvis commentary. At the same time, however, given the way that PWEI effectively discard the original Elvis tune here (and if that *is* Elvis's voice sampled on the verses, then it's been tweaked enough to make him sound incredibly sluggish and off-key) while ostensibly covering it, the fact that they've chosen to sample the most widely recognized musical attack on Elvis as the very backbone of their track could plausibly be read as the crowning touch on a scathing dismissal of Elvis and his legacy. In the end, then, like all the contemporary Elvis sightings that fall into this category, PWEI don't so much answer the riddle that is Elvis today: rather, they rephrase it and ask it once again, exemplifying Marcus's claim that "real mysteries cannot be solved, but they can be turned into better mysteries" (1989: 24).

So just what is to be made of the mystery of Elvis's posthumous career? To paraphrase Marx once again, Elvis made history – his own and ours – but not under conditions of his own choosing. In the mid-1950s, he took bits of flotsam and jetsam inherited from the culture into which he was born and pieced them together to create the backbone of a new cultural formation: one that went on to infiltrate and transform virtually every facet of mainstream US culture and society. In the years since his death, the culture that Elvis built has, in turn, provided the flotsam and jetsam from which countless other people – fans and skeptics alike – have pieced together their own culture. To put it another way, the cultural formation that first formed around Elvis and rock 'n' roll forty years ago has

become the inherited set of conditions under which we make history today. As Marcus puts it, "Elvis Presley made history; this [*Dead Elvis*] is a book about how, when he died, many people found themselves caught up in the adventure of remaking his history, which is to say their own" (1991: xix). Speaking more generally about questions of culture and community, Ventura succinctly captures the spirit of Marcus's thought when he notes that "we are struggling to share our lives, which is all, finally, that 'culture' means" (1985: 102). At the heart of the lives that we share with one another, however, is the dream that Elvis whispered in a nation's ear . . . the dance so strong it took an entire civilization to forget it . . . a new way of walking and a new way of talking. And thus, in the end, the culture that we reinvent for ourselves on a daily basis doesn't just belong to us: it belongs to Elvis.

NOTES

1 ELVIS STUDIES

1 The 22 September 1992 edition of Nicole Hollander's *Sylvia* comic strip contains an uncanny (and unconscious) echo of the Vegiforms story (at the time she drew the strip, Hollander was not aware of Richard Tweddell's brainchild; personal communication, 4 March 1996). "Clyde, come upstairs and have a look at these plastic molds that I bought to put over our zucchini plants," the strip reads, "If you put them on while the plant is still on the vine, it will grow into the shape of the mold . . . You can grow a squash that looks like Ronald Reagan. 'I'd rather grow one that looks like Marilyn Monroe,' said Clyde. I smiled, 'I think you've got the idea that can make us rich . . . Elvis molds!'" (See plate 1.)

2. This story is particularly interesting given that, fifteen months earlier, the same paper (the *Weekly World News*) reported that Elvis had finally died at the age of 58 ("Elvis Dies!" 1993).

3. One of the oddest of the tabloids' tales (a difficult choice indeed) is a 1990 *Weekly World News* article claiming that Elvis's secret diary had been found. The most bizarre of the excerpted entries purports to be from 27 August 1974: "If I have to kiss one more fat girl I'll puke. Where the hell are my pills?" (Holden, 1990: 26). The prize for "Best Use of Deliberate Irony," however, goes to a *Weekly World News* report on an injury Elvis allegedly sustained in a motorcycle accident in 1992: "It's a stark and frightening reminder that Presley is as fragile and mortal as the rest of us," says "author and investigator" William Stern, "One wrong move, one stupid accident, and he could be taken from us as suddenly as he vanished 15 long years ago. Only this time Elvis wouldn't be faking his own death – he would be gone forever" (Johns, 1992: 5).

4. I use the term "Elvis sightings" throughout this project to refer to any appearance, invocation, or use of Elvis's image, voice, name, myths, or (for lack of a better word) aura anywhere on the cultural terrain. Thus, this category contains, as a subset, the recent wave of alleged post-1977 encounters with a living, breathing Elvis. To avoid confusion, I will refer to the latter phenomenon (when necessary) as "Elvis encounters."

5. Because "Elvis" and "Elvis Presley" are trademarks belonging to the Presley estate, the connection made here between Elvis and the game's "King" is necessarily indirect. Nevertheless, in the context of a rash of claims that Elvis is alive and well and roaming the countryside, it's hard *not* to see the connection between the real Elvis and the fictional King.

6. The one significant difference between the staffs of the two shows is the unexplained absence of Gail Brewer-Giorgio (author of *Is Elvis Alive?* (1988) and *The Elvis Files* (1990) and one of the principal writers for the first show) from the second show. It's unclear, however, whether Brewer-Giorgio's leaving the team that put together *Files* was a cause or an effect of the decision to answer the "Is Elvis alive?" question differently in the *Conspiracy* broadcast. The other minor mystery surrounding *The Elvis Conspiracy* centers on the "adult" music video channel, VH1, which, for no obvious reason, rebroadcast the show in slightly edited form (the references to the premium-rate 900-number that viewers of the original program could call were deleted) on several occasions in 1992.

7. A particularly succinct example of why the tabloids deserve such disrespect can be found in the testimony of *Sun* reporter Manny Silver during the course of a libel lawsuit against the paper. Among other things, Silver admits that "about 90 percent of my stories are off the top of my head" and that he doesn't see how any "reasonable person" could actually believe most of what his paper prints ("Tabloid Journalism 101," 1992).

8. Given their high profile on the magazine racks of virtually every supermarket and convenience store in the country, it seems wrong *not* to think of the tabloids as examples of "mainstream" media. In sheer numerical terms, after all, the *National Enquirer* can (and does) boast "the largest circulation of any paper in America," and its cousins in the tabloid business are probably not all that far behind. In terms of public respect, however, the supermarket papers are still sufficiently marginalized to be thought of as existing somewhere outside the realm of mainstream journalism.

9. These include a 1989 newspaper ad from Nutri/System Weight Loss Centers that carries the headline "My Elvis Impersonations almost Became a Tragedy – until I Lost 100 Pounds" above dramatic "before" and "after" photos of impersonator Brad Bailey and a lengthy story explaining Bailey's saga (see plate 16); a 1990 coupon sheet for Hardee's showing an Elvis wannabe (complete with rhinestone-studded jumpsuit and a karate stance pose) behind several pieces of fried chicken and beneath the (deliberately?) ironic legend "Accept No Substitutes"; 1991 television spots for NutraSweet (in which a photo of an impersonator appears briefly) and Blockbuster Video (in which we're told that "three out of four men can do Elvis" over multiple images of an impersonator – once as himself and thrice in Elvis drag); a 1992 TV ad for IBM computers on sale at Best Buy (in which a parade of garish impersonators serves as a metaphorical argument for buying a genuine IBM computer instead of a clone); and even as a commodity unto themselves, as The Nashville Network has run an ad for an album of Elvis songs as performed by an impersonator on at least one occasion (22 June 1991).

10. The 15 April 1991 edition of the *CBS Evening News* featured a story on tax day around the nation that included footage of "S&Lvis," an impersonator who performed "Whole Lotta Taxin' Goin' On" and "Taxbreak Hotel" in front of the Internal Revenue Service (IRS) building in Washington, DC.

11. Dread Zeppelin earned something of a cult following by playing (mostly) Led Zeppelin songs with a reggae beat. As if this weren't an odd enough mix, for their first two albums (*Un-Led-Ed*, 1990; *5,000,000*, 1991) the band featured an Elvis impersonator named Tortelvis as its lead singer.

12. Victor Solimine, legally prevented from campaigning for any candidate because of his position as a federal employee, donned Elvis garb and went out to greet the

Clinton/Gore bus tour as it passed through Texas in August 1992. "Elvis," however, was promoting the Republican ticket, claiming that "The King supports the President" ("King for a Day," 1992). Subsequently, two Elvis impersonators – one representing the 1950s Elvis and the other representing the 1970s Elvis – participated in Bill Clinton's official inaugural festivities ("Clinton's Inaugural Aims . . . ," 1992).

13. Jesus Christ and Reverend Wayne occupy positions one and three, respectively, in the church's holy trinity. While Elvis's appearance may ultimately be insignificant to the advancement of the book's plot, it has been used by at least one reviewer as an exemplary factoid for capturing the flavor of Stephenson's fictional world (Kelly-Bootle, 1992: 100).

14. A 1992 television spot for one of Volvo's newer models prominently featured a version of "Devil in Disguise" – originally a hit for Elvis in 1963.

15. A 1990 ad campaign for Golden Grahams used a version of "Teddy Bear" (a number one hit for Elvis in 1957) with the lyrics altered to extol the virtues of the cracker.

16. A 1992 series of television commercials featuring Perfect Strangers' Bronson Pinchot included one spot where Pinchot, dressed in cowboy garb, discussed the merits of Domino's Pizza with "his" horse, a palomino he referred to as "Elvis."

17. This 1992 television ad was set (according to its opening caption) in Kalamazoo, MI – the city most prominently linked with the recent wave of Elvis encounters – and featured a series of encounters (at a gas station, in a restaurant, on an elevator) with a decidedly Elvis-like figure, as the voice-over commentary asked, "Why will rock 'n' roll never die?" Strictly speaking, of course, this is another example of an impersonator in an ad, as the real Elvis doesn't appear at all here, though the humor of the ad arises from its willingness to entertain the possibility that Elvis *is* still alive and well and pumping gas in Michigan.

18. An ad that ran in several national magazines in 1991 and 1992 depicts eleven decorated styles of leather jackets in order to represent the wide variety of schnapps flavors that DeKuyper sells. The jacket closest to the center of the display (in at least one version of the ad) is made of black leather and bears the legend "Let's Rock n Roll" above a picture of young Elvis – or, perhaps more accurately, a very close approximation thereof, as the Presley estate would undoubtedly frown on the unauthorized commercial use of an image that was unmistakably Elvis's. It would be hard, however, *not* to see a close resemblance between Elvis and the sneering, singing, sideburned, pompadoured figure on the jacket.

19. "Somewhere between Elvis and Ghandi [sic]," the ad reads, "there is Dylan" (*Village Voice*, 26 November 1991, p. 102; *Musician*, January 1992, p. 66). Exactly what this is supposed to mean (is Dylan supposed to be the happy medium between Gandhi's philosophy of non-violence and Elvis's brand of rock 'n' roll?) or how it might actually convince people that the book in question (Patrick Humphries and John Bauldie's *Absolutely Dylan*) is worth buying (much less actually reading) remain unclear.

20. A December 1991 television ad for Bob Brady Dodge in Springfield began with an announcement of a sale in honor of King's birthday . . . only the King in question wasn't Martin Luther (whose birthday falls on 15 January), but Elvis (whose birthday is 8 January).

21. A December 1992 television spot for Big Sur Waterbeds featured a Dickens-esque Christmas theme with a twist, as it is Elvis's ghost (rather than Marley's) who visits

Ebenezer Scrooge and helps him find the true meaning of the season (which evidently has something to do with discounted waterbed prices).

22. A 1994 ad for *Joseph and the Amazing Technicolor Dreamcoat* in the *Chicago Tribune* featured the headline "Love Me Tender!" over the decidedly Elvis-like image of "Johnny Seaton as 'Pharaoh.'"

23. "Elvis spotted playing miniature golf at Lakeview Links" is the headline for an ad from the 25 October 1991 *Chicago Reader* (section 2, p. 23). The copy of the ad goes on to describe an upcoming Halloween party at the course, saying "Costumes encouraged (Elvis is okay, really)."

24. A 1992 flyer advertising Advanced Copiers Enterprise (4614 Baltimore Avenue) featured a photocopied image of Elvis's head on top of a hand-drawn chest and shoulders. The word balloon emanating from Elvis's mouth proclaims, "A price so low I had to come back and MAKE A COPY!!"

25. The cover of the December 1991/February 1992 catalog for First Class (1522 Connecticut Avenue, NW) features a caricature of Elvis, circa 1975, next to the head-line "ELVIS! SPOTTED AT FIRST CLASS!" The only course listed anywhere in the catalog that could even remotely be seen to have a legitimate connection to Elvis, however, is one entitled "You Can Carry a Tune."

26. An ad appearing in the 9 November 1993 issue of the *Chicago Tribune* (section 2, p. 3) for Saint Xavier University listed the top ten reasons to attend an open house at the school. Coming in at number three: "Elvis has been sighted recently at many on-campus events. Barney has not."

27. See the ad for SilverPlatter Information in the September 1991 issue of *American Libraries* (p. 775), where – beneath a drawing of a king sitting on a throne – the headline reads "Elvis cited 39 times on CD-ROM database."

28. Northwest Airlines kicked off these fare wars by offering same-day round-trip tickets to Memphis on Elvis's birthday for $99 (a king-sized discount off of the usual $748 fare for such a trip). American Airlines responded by offering an additional $20 discount to Memphis flyers who showed up in Elvis garb, while United Airlines gave passengers on their already discounted ($59) Chicago-to-Memphis flights free upgrades to first class if they could sing all the words to "Jailhouse Rock" (Bryant, 1994; Rohn, 1994).

29. The 1991 catalog from Fallen Empire, a New England-based yuppie goods mail order company, explains, "Elvis seems to be quietly dead of late. In an effort to reverse this trend, we've included a zany Elvis motif along with our sales pitch" (p. 10). Aside from these two sentences, the "zany Elvis motif" here consists of an illustration of a corner of a room: one wall is filled by a large hanging featuring a portrait of Elvis, the other is home to two of the shelves being advertised. Otherwise, however, the bulk of the actual sales pitch is a straightforward description of Bookart shelves. Given the company's misconceptions concerning the nature of Elvis's recent activities, however, I have doubts about the reliability of anything they may say about their merchandise. . . .

30. The October 1993 issue showed a picture of a young Elvis (with book in hand) that was used as a poster image for the American Library Association's READ program.

31. Elvis graces the cover of volume 1, issue 4 (1995) of this glossy bimonthly magazine devoted entirely to the subject of angels. His cover appearance is in support of a six-page feature devoted to Elvis's alleged lifelong conversations with angels (Shamayyim, 1995). Many thanks to Johanne Blank for bringing this sighting to my attention.

32. The October 1993 issue showed an Elvis impersonator standing by the side of a highway with his thumb stuck out, presumably in an effort to hitchhike to one of the various spicy food festivals described inside. Besides the cover (including the "All Shook up over Hot Festivals!" headline) and a brief letter from the editor, however, Elvis was nowhere to be found in the magazine.

33. For a cover story critiquing the myth of genetic determinism (Nelkin and Lindee, 1995), the magazine ran a cover image of Elvis's head and torso atop two "legs" comprised of DNA-like double helices. And while the cover headline blared "Elvis' DNA" (which was also the article's title), the actual essay mentions Elvis in the first three (very short) paragraphs (pointing to Elvis biographies by Dundy (1985) and Goldman (1981) as examples of the genetic determinism myth in action) and then never mentions him again – even obliquely – for the remainder of the ten-page article.

34. A special advertising supplement in the *North Seattle Times* (September 1993) for the eleventh annual Great Wallingford Wurst Festival features a mock-up drawing of the 1970s Elvis stamp in which a jumpsuit-clad sausage sings "Love me tender, love me cooked!"

35. The special supplement to the Montgomery County, MD *Journal* for 24 November 1993 used a supermarket tabloid theme (billing itself as the *Energy Examiner*) as an attention-getting device. "EXCLUSIVE PHOTOS," the cover jokingly promised readers, "ELVIS SIGHTED BUYING HEAT PUMP!"

36. This ad, which ran on the back cover of the January 1992 *Musician*, shows a stock photo of a clench-fisted Khrushchev in a suit and tie. An arrow points away from this photo towards a stylized rendition of the Yamaha MT120 mixer's built-in equalizer. Another arrow points away from this image to an altered version of the Khrushchev photo, where the tie has been replaced by a chest medallion, the suit by an open-necked, high-collared, embroidered, white jumpsuit. Khrushchev's clenched fist now bears two gaudy rings and contains a stage microphone, and his previously hairless scalp has been covered by a towering pompadour with mutton-chop sideburns. Presumably, the intended message of the ad is that the MT120 can transform even the most staid ideologue into an exciting rock star.

37. These include *A Tribute to Elvis* (1991), *The Last Temptation of Elvis* (1990), and the Residents' *The King and Eye* (1989) and are tribute albums only in the broadest sense of the term. *Tribute* is a K-Tel collection of a dozen of the many hundreds of tribute singles cut and released by grieving fans in the wake of Elvis's death in 1977. Though the collection is packaged as a sincere tribute to Elvis and his memory, the songs included are so smarmy and saccharine that it is hard to imagine how even the most devout Elvis fan could hear this album in the same spirit in which it was (supposedly) compiled. *Last Temptation* includes twenty-five cover versions of songs from Elvis's movies – which range in tone from reverent and faithful to warped and sardonic – and one actual Elvis track (an out-take of "King of the Whole Wide World"). *The King and Eye* features deliberately discordant renditions of sixteen of Elvis's biggest hits, punctuated by a dialog between several young children and an adult intent on answering the question, "The King of What?" 1995 also saw the release (at least in Finland) of *Ieti Maximi ex Rege*: an album of several Elvis hits sung in Latin by the Finnish Eurovision Choir.

38. The 1990 call for papers for a special issue of *Strategies*, tentatively entitled "Marx after Elvis: The Politics of Popular" made a specific point of stating that "Elvis Presley"

(the quotation marks are theirs) stood here as a token for contemporary popular culture. This would have been less unusual if they'd also added the comment that "Karl Marx" was intended to stand as a token for (left-wing) political thought, but evidently that was supposed to be taken for granted . . . or perhaps it was not what they meant at all. And, perhaps not surprisingly, the resulting issue of the journal (no. 6, 1991) ultimately had lots to say about politics and critical theory, but very little to say about either Elvis specifically or popular culture in general.

39. John F. McDermott, Jr included a brief "editor's note" in one issue of the *Journal of the American Academy of Child and Adolescent Psychiatry* announcing the two recipients of the Rieger Award for Scientific Achievement for 1989 and describing the work that had earned these scholars this honor. Neither the psychiatrists involved nor their research had any remote connection to Elvis whatsoever (at least not any that was described in this brief six-paragraph essay), nor was Elvis ever publicly connected to the field of child and adolescent psychiatry in any obvious fashion. Nevertheless, McDermott's essay is entitled "Elvis Presley and the Rieger Award," begins with a quote from Elvis ("I don't know anything about music. In my line you don't have to"), and includes the somewhat strained analogy that "Elvis had an intuitive style that worked – much like the clinician who relies on intuition in practice." Most of the rest of the essay presents a fairly straightforward description of the award's recipients and their research, but the highly gratuitous Elvis theme returns at the end with the (dubious) conclusion that "Elvis will be impressed" (McDermott, 1989).

40. This is a touring (and ever-growing) collection of Elvis memorabilia, newspaper clippings, craftwork, advertisements, and so on that is more than just a museum display of such items, but an artistic assemblage of them as well. I am indebted to Jon Crane for having brought this cornucopia of Elvis appearances to my attention. While Mabe's exhibit certainly demands more attention than is possible in this brief note, its itinerary has yet to bring it close enough to me geographically to experience it myself.

41. The Church is the most renowned attraction of Stephanie Pierce's one-person gallery, Where's the Art!! (219 SW Ankeny). According to the gallery's 1992 mail order catalogue, "24 Hours a day the faithful congregate on the sidewalk to worship, to get married, or just to witness the Miracle of the Spinning Elvisses. Now you can worship from afar through the Miracle of Mail Order Technology!!" The catalogue then goes on to list a wide variety of items, embossed with the sacred symbol of the Church, available for purchase: stickers, pins, postcards, key chains, amulets, earrings, refrigerator magnets, calendars, rosaries, matches, T-shirts, purses, checkbook covers, Christmas ornaments, footstools, "plastic chalices" (i.e., coffee cups), and "official Elvis identification cards." This last item eloquently captures the irreverent yet still strangely respectful spirit of the Church, proclaiming that "The bearer of this card is a SAINT in the Church of Elvis. He or she may also be Elvis. Please treat them accordingly. Thank you."

42. These include the surreal vision of Mark Landman's "The Adventures of Fetal Elvis" (1991), Patrick McCray's Ayn-Rand-influenced *Elvis Shrugged* (1993), and the conspiratorial satire of Douglas Michael's *The Elvis Mandible* (1990).

43. Legend Video (Canoga Park, CA) distributes a video entitled *Elvis Slept Here*, which (not surprisingly) includes some of the saddest attempts to impersonate Elvis I've ever had the misfortune to see. Much the same could probably be said of *Fucking Elvises* (from Glitz Video, San Clemente, CA), though I've only seen an ad and a catalogue listing for this title.

44. Less than two months after the publication of *Dead Elvis*, Greil Marcus claimed that "just the material . . . I've collected since [the book] was finished makes up a whole new chapter" (personal communication, 10 December 1991). On tour promoting the book that same year, Marcus describes a game he plays with himself in which he sees if he can "get through a single day without an Elvis sighting" (quoted in Romano, 1991: 1), a feat he manages only rarely.

45. A sampling of Elvis-related books published in just the years 1991–5 includes *Dead Elvis* (Marcus, 1991), *The Death of Elvis* (Thompson and Cole, 1991), *"E" Is for Elvis* (Latham and Sakol, 1991), *Elvis Hornbill* (Shepherd, 1991), *Elvis Is Everywhere* (Scherman, 1991), *Elvis: The Last 24 Hours* (Goldman, 1991), *Elvis!: The Last Word* (Choron and Oskam, 1991), *Elvis Presley Is a Wormfeast!* (Wombacher, 1991), *I Am Elvis* (1991), *Roadside Elvis* (Barth, 1991), *Are You Hungry Tonight?* (Butler, 1992), *Elvis for President* (Committee to Elect the King, 1992), *Elvis Presley Calls His Mother after the Ed Sullivan Show* (Charters, 1992), *The Elvis Reader* (Quain, 1992), *Where's Elvis?* (Holladay, 1992), *The World According to Elvis* (Rovin, 1992), *Elvis Rising* (Sloan and Pierce, 1993), *The Elvis Sightings* (Elcher, 1993), *Elvis: The Secret Files* (Parker, 1993), *Elvissey* (Womack, 1993), *The Life and Cuisine of Elvis Presley* (Adler, 1993), *Private Presley* (Schröer, 1993), *The Best of Elvis* (Hazen and Freeman, 1994), *The Day Elvis Met Nixon* (Krogh, 1994), *Don't Ask Forever: My Love Affair with Elvis* (Bova, 1994), *Elvis + Marilyn* (DePaoli, 1994), *The Elvis Encyclopedia* (Stanley, 1994), *Elvis up Close* (Clayton and Heard, 1994), *Elvis's Man Friday* (Gene Smith, 1994), *The Gospel of Elvis* (L. Ludwig, 1994), *The Hitchhiker's Guide to Elvis* (Farren, 1994), *The King Is Dead* (Sammon, 1994), *Last Train to Memphis* (Guralnick, 1994), *Mondo Elvis* (Peabody and Ebersole, 1994), *The Ultimate Elvis* (Pierce, 1994), *Elvis: A Celebration in Pictures* (Hirshberg et al., 1995), *Elvis Aaron Presley: Revelations from the Memphis Mafia* (Nash, 1995), *Elvis in the Army* (W.J. Taylor, 1995), *Elvis: Portrait of the King* (Doll, 1995), and *Everything Elvis* (Bartel, 1995).

46. A complete list of only the *officially* licensed Elvis products over the years is beyond the scope of this project. Between them, however, Hopkins (1971: 147–8), Kendall (1979: 64), Sauers (1984: 122), and Walker (1982: 95–6) provide a sufficiently long catalogue of Elvis memorabilia to support the claim that "there was nothing, it seemed, that couldn't be printed, painted, embroidered, etched or embossed with either Graceland's or Presley's image" (Kendall, 1979: 64). The officially licensed paraphernalia, however, are only the tip of the iceberg when it comes to Elvis merchandising, as both in volume and diversity the vast market in *unauthorized* Elvis product far exceeds that generated by the Presley estate and RCA.

47. James Hay (personal communication, 27 June 1995) argues that an early 1990s series of Diet Coke television ads featuring Paula Abdul and Elton John appearing in classic movie scenes alongside various dead stars (e.g., Louis Armstrong, Fred Astaire, Cary Grant) effectively undermines the notion that Elvis's ongoing marketability is truly unique. While Hay is correct to point out that Diet Coke's appropriation of stars from Hollywood's golden era bears some resemblance to the ways that Elvis has been lifted out of context as a promotional icon, I would maintain that there are significant differences between the two cases. For starters, the Diet Coke ads appear to have been a momentary aberration in the "normal" way of doing things in the advertising game: these ads have seemingly done nothing to resurrect the specific careers of Astaire and company, nor have they kicked off any larger trend of using past icons to sell contemporary products. More to the point, however, is that the *real* stars of these

ads are Abdul and John, with the other celebrities functioning as an unwitting supporting cast. One can imagine (in part, because it actually happened) a Diet Coke ad using only the contemporary figures as pitch-people; it's harder to conceive of a similar ad in which the older stars hogged the spotlight so thoroughly.

48. "There is a world beyond this one, a perfect world in which unfulfilled desire is unknown One attempts to enter [the second world] first of all through consumption. After all, it is not possible to avoid the message that is relentlessly drummed into the consciousness of every sentient American, the message that by consuming product X one will become like those happy and beautiful people depicted in the advertisement. The person in the advertisement is you, depicted as you *could* be" (Stromberg, 1990: 11–12).

49. John Berger (1972), Gans (1974), Leiss *et al.* (1990), and J. Williamson (1978) – among others – all provide more detailed arguments concerning the media's ideological role in perpetuating capitalism as a social system, while Dyer (1979b) addresses more specific questions concerning the function of film stars in such practices.

50. A September 1991 CNN/*Time* poll, for example, claimed that 16 percent of the US population thinks Elvis is still alive. Two years later, a *USA Today* survey (16 August 1993, section A, p. 1) indicated a sharp decline in this number, though a surprising 7 percent of those polled still believed that Elvis could be alive.

51. Horrocks claims she first saw *Blue Hawaii* on 14 November 1966. While this may be an accurate claim, it seems likely that her memory is playing slight tricks with her here, as *Blue Hawaii* was initially released on 14 November 1961. The Elvis film in first-run theatrical release on the date Horrocks mentions, however, is *Paradise, Hawaiian Style.* (To be fair to Horrocks, it could be argued that the differences between these two films is slight enough that confusion over the title in question is more than understandable.)

52. This post, attributed to Jim Nalhandian (jpn@netcom.com), originally appeared on 22 December 1994 under the heading "Fake Stevie Nicks on Leno?"

53. "Pastiche is, like parody, the imitation of a peculiar mask, speech in a dead language: but it is a neutral practice of such mimicry, without any of parody's ulterior motives, amputated of the satiric impulse With the collapse of the high-modernist ideology of style . . . the producers of culture have nowhere to turn but to the past: the imitation of dead styles, speech through all the masks and voices stored up in the imaginary museum of a now global culture" (Jameson, 1984: 64–5).

54. Additionally, *Panic Encyclopedia*'s cover features two juxtaposed photos of Elvis (one in his bloated 1970s incarnation, the other a sleeker publicity still from his 1960s Hollywood days), as if Elvis serves as the perfect example of the book's general theme. Kroker *et al.* also quietly take sides in the "Is Elvis alive?" debates by including him in the book's list of contributors, claiming that "Elvis Presley is . . . slim, fit and tan and ready for '92" (1989: 265).

55. For instance, during the 1990 conference "Cultural Studies: Now and in the Future" (the proceedings of which were published, in a somewhat revised form, as Grossberg *et al.*, 1992), one observer responded to a panel that dealt with popular culture in a serious and non-condescending fashion by complaining that the speakers were simply talking about "stuff they like" (*Star Trek* fan clubs, Australian film, rock 'n' roll, etc.); the implication being that, because these scholars openly identified themselves as fans of what they studied, it was impossible to take anything they had to say seriously. For

this observer, the credibility of these speakers was destroyed, not because their presentations were theoretically unsophisticated or because their arguments were unsound, but simply because the pleasure they took in the objects of their research irreversibly "tainted" their ability to engage in critical reflection on their subject matter.

56. With very few exceptions, such age-based exclusions don't make sense for most other musical genres, as it's hard to take seriously the analogous notion that someone is "too old" for jazz, show tunes, classical music, and so on. Moreover, most of the exceptions to this rule tend to draw their exclusionary boundaries from the other side of the fence: it makes sense, for example, to say that someone is "too young" to appreciate opera or big band jazz.

57. Among the threats (supposedly) represented by rock 'n' roll were cultural miscegenation (i.e., the blurring of the line between black and white cultures), the loosening of sexual mores (through "explicit" lyrics that allegedly promoted sexual activity and promiscuity among teenagers), and the rise of juvenile delinquency — dangers that were made to seem all the greater when linked with protectionist discourses about the effects of such messages on "immature" and "impressionable" youth.

58. For example, much of the music that Chuck Berry made in 1955 and 1956 dealt primarily with adult characters and adult concerns ("Maybellene," "30 Days," "Too Much Monkey Business," "Brown-Eyed Handsome Man," etc.). The years 1957 through 1959, however, saw Berry capitalize on the growing youth market for his music by turning to unmistakably teenage themes ("School Days," "Sweet Little Sixteen," "Sweet Little Rock and Roller," "Little Queenie," "Almost Grown," etc.). See (or, more precisely, hear) *The Great Twenty-Eight* (Chuck Berry, 1984).

59. The most obvious sites where this particular schizophrenia plays itself out are the music video cable channels, MTV and VH1. Though both channels are part of the same corporate family, each works to define rock 'n' roll as the music that belongs to its respective target audience's generation (i.e., the 18–35 "Generation X" crowd for MTV, the 35–49 baby-boomers for VH1) and each has been known to take pointed jabs at the other on the air.

60. I should point out that, despite being marginalized, these musical styles never disappeared from rock 'n' roll completely. For instance, Elton John has been making piano-dominated rock 'n' roll since the 1970s; Clarence Clemons' saxophone playing was a prominent feature of his work with Bruce Springsteen from the mid-1970s through the late 1980s; and tight multi-vocal harmonies have been a staple of California-based rock 'n' roll (e.g. the Beach Boys, the Eagles, Fleetwood Mac, etc.) since the 1960s. For the most part, however, rock 'n' roll has been primarily a guitar-driven music since the early 1960s, and even the exceptions to this rule mentioned here tend to feature guitar more prominently than their 1950s predecessors ever did.

61. In terms of musical influence, for instance, Chuck Berry is a far more important figure in this regard than Elvis. Perhaps the two most prominent examples of Berry's influence on rock ('n' roll) guitar are Keith Richards (who claims that it was Berry's example that inspired him to take up the instrument in the first place; see Kohut and Kohut, 1994: 125) and the Beach Boys (who built a number of their early hits — most notably "Surfin' U.S.A." (1963) and "Fun, Fun, Fun" (1964) — around Berry's signature guitar riff).

62. Artists as varied as Chris Isaak, Ted Nugent, Jimmy Page, Lou Reed, Paul Simon, and

Bruce Springsteen have all claimed that they first chose to play guitar because of Elvis (Kohut and Kohut, 1994: *passim*; L. Reed, 1994).

2 ELVIS MYTHS

1. Marcus claims (personal communication, 30 November 1994) that the issue of giving more credence to Keisker is a non-starter, that he has no idea (or even an opinion on) whether Phillips ever made such a statement, and that his original argument was primarily concerned with Goldman's willful distortion of a well-known quote for his own purposes. Nevertheless, I still find it significant that Marcus's strategy in rebutting Goldman's distortion was to reaffirm the legend (as originally told by Keisker), rather than to accept Phillips's claim that no such statement was ever made at all.

2. For example, Marcus correctly predicts the widespread acceptance of Goldman's version of the statement, which has appeared as unquestioned fact in such places as Jill Pearlman's *Elvis for Beginners* (1986: 59) and Robert Pattison's *The Triumph of Vulgarity* (1987: 32). Marcus also points out that, in Pattison's case, the choice to use the Goldman version of the quote was a deliberate one: "After receiving galleys of the book, I wrote the publisher, pointing out the distortion and insisting on its serious-ness. The publisher replied that the author was sure Goldman's words were correct, because they were 'more vulgar,' and that, in the annals of popular music, 'vulgarity is always closer to the truth'" (1991: 53n).

3. This was the subtitle of Marcus's review as it appeared in the *Voice Literary Supplement* in 1981. When the piece was reprinted in *Dead Elvis* (1991), this was its main (and only) title.

4. Given what evidence can be called upon to attest to Phillips's intentions forty years ago, such an assumption seems quite reasonable. As Marcus describes it, "Sam Phillips was one of the great pioneers of racial decency in this century. He worked with black people, and in Memphis in the '50s, he was ostracized for it Sam Phillips ran the only permanent recording facility in Memphis, and he had opened it in order to record black musicians" (1981: 16).

5. This absence was made all the more obvious in 1992 when RCA released the boxed set, *Elvis: The King of Rock 'n' Roll*, and it was widely lauded as a *reminder* that Elvis had once made music that had a dramatic impact on the world.

6. Between them, Marsh and Stein (1981: 291) and Choron and Oskam (1991: *passim*) quote a diverse pantheon of rock and pop idols – including (but by no means limited to) David Bowie, Bob Dylan, Gary Glitter, Buddy Holly, John Lennon, Paul McCartney, Ted Nugent, Jimmy Page, Tom Petty, Paul Simon, and Bruce Springsteen – who cite Elvis as a major influence on their careers.

7. Marsh claims that "we made him the repository of our boldest dreams and our deepest fears Elvis functioned as a mirror, revealing more about the observer than the observed" (1982: xiii), and thus "when we go seeking Elvis we most often find ourselves" (1992: x). This sentiment is echoed by David Futrelle's review of *Dead Elvis*, which he sees as "less a chronicle of a cultural obsession than it is an exploration of Marcus's own obsessions" (1991: 10); by Van K. Brock's claim that "fans and critics and detractors all seem to ask [Elvis] to fulfill their own personal myths and needs" (1979: 91); by Guralnick's assessment of the vast body of writing on Elvis, "Enough

has been written about Elvis Presley to fuel an industry. Indeed a study could be made of the literature devoted to Elvis, from fanzines and promotional flack to critical and sociological surveys, which would undoubtedly tell us a great deal about ourselves and our iconographic needs" (1979: 118); and by Robert Oermann and Al Cooley's suggestion that "There is a certain fill-in-the-blanks quality to his persona that allowed (and allows) people to invest anything they want into his image. Elvis is perhaps a void that's been filled with the fantasies and the mass adulation of a generation of everyday people" (1982: 125–6).

8. See, for example, the *Doonesbury* comic strip (28 June 1991) in which Elvis is reported "giving autographs to the [Gulf War] refugees"; Mark Alan Stamaty's depiction of General Schwarzkopf in Elvis drag ("Live! On Stage! 'Stormin' Norman' in Vegas!") on the cover of the *Village Voice* (7 January 1992); or the 1992 State of the Union Address, in which George Bush discusses the "Elvis Lives!" graffiti US troops left behind them in the Middle East.

9. See, for example, Heileman's discussion (1991) of Boris Yeltsin finding solace in Elvis's "Are You Lonesome Tonight?" during the aborted 1991 Soviet coup; the print ad for Yamaha's MT120 four track mixing board (described in full in chapter 1, note 36); or the Mike Luckovich political cartoon (*Chicago Tribune*, 27 September 1991, section 1, p. 13) depicting Lenin's tomb where one Soviet can be seen telling another, "Bad news, Graceland doesn't want him . . . "

10. See, for example, the *New York Times* story on Operation Rescue's failed attempt to shut down Buffalo abortion clinics (Manegold, 1992), in which an anti-abortion activist's shouts of "Jesus is King!" are met with the retort that "Elvis was king!"; or "Fetal Elvis!" (Landman, 1991), the alternative comic that implicitly asks the question: if the fetus really is a viable human being, does it have the right to take drugs, carry handguns, and shoot out television sets?

11. One could argue that youth is a fifth mythological formation that deserves serious consideration here. The question of Elvis's *current* relationship to youth, however, is exceptionally murky. In part, this is because myths of youth and youthfulness are rarely foregrounded across the terrain of contemporary Elvis sightings to the same extent as myths of race, gender, class, and the American Dream are. The issue is also confused by the fact that Elvis's career ran from his own youth (he cut his first record at nineteen) to his middle age. Stars such as James Dean and Marilyn Monroe can be seen, even today, as icons of youthfulness because their premature deaths denied us the opportunity to watch them fade away as they grew older. And while Elvis certainly died prematurely, the bloated stupor of his later years evokes the decline and decay of old age more than the exuberance and vitality of youth, rendering Elvis as much an icon of aging (and its pitfalls) as of youth (and its pleasures). The fact that Elvis's 1970s concerts were often nostalgic flashbacks both to his youth and his audiences' further muddles the issue. And, completely tying Elvis's articulation to myths of youthfulness in knots, the latter-day (i.e., the non-youthful) Elvis is now an image from nearly two decades ago, and can thus work as a figure of nostalgia, not only for those who were young in the 1950s (e.g., "do you remember Elvis on *Ed Sullivan*?"), but also for those who were young in the 1970s (e.g., "where were you when Elvis died?"). In the end, then, the current relationship between Elvis and the mythological formation surrounding youth is simply too tangled a web to provide any satisfactory analysis of it here.

12. The title and general theme of Public Enemy's song hark back to a Top 10 hit by the

Isley Brothers from 1975. The fact that 1989 found Public Enemy reformulating the Isleys' fourteen-year-old expression of outrage in an even more confrontational style is a testament to how little race relations in the US have improved (and possibly even how much they've deteriorated) since the 1970s.

13. Given the central role the song plays in *Do the Right Thing* – a movie topped only by *Batman* for media attention during the summer of 1989 – and the fact that Public Enemy's explicitly political lyrics and "harsh" sound have generally worked to keep them off of commercial radio playlists, it seems safe to say that "Fight the Power" was a virtual shoe-in to become the group's best-known song from the moment that Lee chose to feature it so prominently in his movie.

14. The 1 October 1991 edition of *Stan Mack's Real Life Funnies*, a weekly cartoon published in the *Village Voice*, contains a related articulation between Elvis's coronation and current racial tensions in the US. Most of the strip is taken up by a lengthy rant against the various evils perpetrated upon African-Americans by whites – a rant that concludes with the example of "the crown thing" as the ultimate act of US racial injustice: "Oh sure, all you white guys singing folk songs about one-world nonsense, and when my car got stuck the police came and cursed me out instead, and at my health club they still stop me, and I protest a black being lynched in a white community and they call me *divisive*! And, at work, I scheduled 'Lift Every Voice and Sing' for Black History Month and they said calling it a 'black' song was troublesome and people on Oprah and Donahue decry racism while white society today condones bigotry, and a Chinese person screams at me because I like dim sum, and Italians wave watermelons on TV and wear their bigotry like a crown, and Jews cry 'Oh poor us!' (while defending Israel which is killing Palestinians and selling guns to South Africa) and try to act like WASPs, WASPs who have a morbid fear of any black leader who isn't Martin Luther King, and who think white skin is better than black even though it's been proven that melanin is involved in the creation of celestial bodies and that it was Africans not Arabs who built Egypt and I'm being engulfed in a tide of anger over white trickery because we say 'Okay, you don't want us living next to you, we'll get our own jobs and schools and water fountains!' and then whites call us *racists*! And now I say, 'That's it! I'm ready for insurrection and a separate society! And, besides, *any people who'd call Little Richard a clown while Elvis is called King, aren't worth living with*!'" (p. 12, emphasis added) (see plate 24).

15. This isn't to claim that the field of popular music is as rigidly divided into racially defined categories as it was before the rise of rock 'n' roll in the 1950s. On the contrary, it's relatively easy to find prominent examples of "race-mixing" on the contemporary popular music terrain. From the funk/rock fusion of (The Artist Formerly Known as) Prince to the hyper-eclectic hodge-podge of the average Top 40 radio playlist, from the rap/metal combination of Public Enemy and Anthrax (both on tour and in the studio) to the multicultural genre-blending coverage of *Rock and Rap Confidential*, the musical terrain is more integrated today than it was in, say, 1952. Even in this relatively progressive scenario, however, the gap between "black music" and "white music" seems to be far more prominent than the handful of connections that have been forged between black and white musicians and audiences.

16. Asked in 1990 how he thought Boone's cover versions of his music had affected his own career, Little Richard said, "I think it was a blessing. I believe it opened the highway that would have taken a little longer for acceptance. So I love Pat for that" (Puterbaugh, 1990: 54). Two years later, he told *Life* that, in the 1950s, when

Boone's records were originally competing with his own, it infuriated him: "Every time you'd get a hit, they'd cover it and outsell you. If I'd got to Pat, I would've spanked his booty." However, he then went on to say, "Later we became friends, 'cause I saw some logic in it – by his opening a bigger door, more white kids really accepted the music" (Jerome, 1992: 50). As far as Elvis is concerned, Roger Taylor quotes Little Richard as saying, "He was an integrator. Elvis was a blessing. They wouldn't let Black music through. He opened the door for Black music" (1987: no page number), while Sandra Choron and Bob Oskam's collection of quotes about Elvis includes Little Richard's claim that "when I came out they wasn't playing no black artists on no Top 40 stations, I was the first to get played on the Top 40 stations – but it took people like Elvis, Pat Boone, Gene Vincent, to open the door for this kind of music, and I thank God for Elvis Presley. I thank the Lord for sending Elvis to open that door so I could walk down the road, you understand?" (1991: 17).

17. The strip in question appeared in the 25 October 1991 edition of the *Reader* (section 3, p. 21), and was accompanied by the following commentary from President Bill: "I had hoped to keep the election campaign from falling prey to the sensationalistic, simplistic media, which lay in wait, ready to pounce. They hadn't the intelligence or the patience to investigate real issues in depth, so they reduced everything to a lurid, bastardized form, which they then fed to the public. The public in turn regurgitated the media's pabulum through public opinion polls. In this way, the media kept voters focused on flashy, superficial topics. So I had to beware of reporters eager to stir up politically pointless but highly popular sensational issues." While I would dispute the claim that Elvis's coronation is "politically pointless" – if nothing else, the arguments made by Living Colour and Public Enemy serve as evidence of the political relevance of such issues for many people – the strip *does* accurately foreshadow the unusual role that Elvis played in the 1992 presidential campaign.

18. For example, the documentary *This Is Elvis* (1981) contains footage from the mid-to-late 1950s of an unidentified white man – from his accent and his immediate surroundings (which include a gas pump and a sign reading, "We Serve White Customers Only"), presumably the owner of a filling station somewhere in the South – who proudly proclaims that "we've set up a twenty man committee to do away with this vulgar, animalistic, nigger, rock 'n' roll bop. Our committee will check with the restaurant owners and the cafés to see what Presley records is on their machines and then ask them to do away with them." The North Alabama White Citizens Council issued a similar (and now infamous) statement at about the time Elvis was first breaking nationally to the effect that "rock and roll is a means of pulling the white man down to the level of the Negro. It is part of a plot to undermine the morals of the youth of our nation" (Marsh and Stein, 1981: 8).

19. Sam Phillips once said, "Elvis did not break overnight. I traveled widely and got encouragement from only two DJs. The white disc jockeys wouldn't play him because he sounded too black, and the black disc jockeys wouldn't play him because he sounded too white" (quoted in Choron and Oskam, 1991: 8).

20. Given the opportunity in 1990 to tell *Playboy*'s readers what he had against Elvis, Chuck D said, "Elvis' attitudes toward blacks was that of people in the South at that particular time. The point of the song ["Fight the Power"] is not about Elvis so much, and it's not about the people who idolize that motherfucker, like he made no errors and was never wrong. Elvis doesn't mean shit. White America's heroes are different from black America's heroes" (Wyman, 1990: 136).

21. In this particular instance, there are, virtually by definition, no founding mothers.

22. As an anonymous Hollywood starlet once confided to columnist May Mann, "Nature had not only endowed Elvis with talent and a beautiful body, but with a tremendous physical sex organ – that throbbed with heat and energy, as I believe no woman has ever experienced" (quoted in Choron and Oskam, 1991: 54).

23. From the 1960 release of his first post-army single, "Stuck on You," through his last pre-"comeback" hit, "U.S. Male," in 1968, forty-five Elvis singles reached *Billboard*'s Top 40. Admittedly, the Beatles (Elvis's only serious competitors for long-term sales in the 1960s) posted nearly as many Top 40 singles (39), almost twice as many Top 10 hits (26 to 14), and more than three times as many #1 records (16 to 5) as Elvis did during this period. Moreover, the Fab Four's success is all the more impressive for having been accomplished in only half as many years (their first record charted in 1964) as Elvis had to work with. Nevertheless, it's hard to look at Elvis's chart success during this period and argue that he was no longer an exceptionally popular (and profitable) artist: it's only by the phenomenal standards he had set in the four short years prior to this period (32 records in the Top 40, 19 in the Top 10, 12 that hit #1) that Elvis's 1960s track record looks bad. Any other artist who charted so "poorly" would have been heralded as a major force in the pop world.

24. "It is almost a cliché today to speak of how bad Elvis' later films were, but even *while* they were being turned out strong reaction had set in against them. Newspaper reviews when they appeared at all were nearly uniformly damning; and even *Elvis Monthly* had stopped running articles about their idol's films, stating that they were 'puppet shows for not overbright children.' No one is entirely sure how much money these 'puppet shows' brought in, but some estimates place the *profits* at over $200,000,000" (B. Reed, 1982: 123).

25. One could conceivably argue that it was actually lingering traces of Elvis's earlier super-stud image that attracted fans to the films and music of this period, and such an argument might even work to explain Elvis's continued appeal for the first year or two after his 1960 discharge from the army. If Elvis's macho virility were truly at the heart of his appeal, however, then it would follow that even his most devout fans would eventually – after four or five years of "family entertainment" movies and saccharine pop tunes, if not before – have demanded something more exciting than *Harum Scarum* (1965) or "Puppet on a String" (1965).

26. Actually, the specific period Marcus and Winner are referring to is that from 1957 through 1959, rather than 1960 through 1968. Nevertheless, Winner's comments here are a succinct summary of the standard "cock rock" account of Elvis's decline. The exact moment when that decline began, however, as well as who or what deserves the blame for it, is a matter of continuing critical debate.

27. As an aside, it's worth noting that the female Elvis's interest in her namesake never had anything to do with the butch god side of his image. She "hates the hound dog Elvis. Considers 'Love Me Tender' his only decent movie Always fond of Elvis's ballads and gospel songs . . . " (Pressley, 1991: 6).

28. My thanks to Veronica Pontarelli for bringing this Elvis sighting to my attention.

29. According to *Vanity Fair*, Madonna's response to meeting lang for the first time was, "Elvis is alive – and she's beautiful!" (Bennetts, 1993: 98).

30. To be sure, the mid-1990s have found Madonna's omnipresence as a cultural force on the wane, which may place her status as "the next Elvis" in jeopardy. On the other hand, one could read this "slump" as her version of Elvis's Hollywood years: an era

in which her music still sells consistently (if not spectacularly) and her public persona generates less controversy than it once did. If this is in fact the case, and the parallels between the two continue, then it will be most interesting to see what her version of Elvis's "comeback" will look like.

31. Prior to 1977, Elvis's reputation was sufficiently unsullied that it was possible for former members of his Memphis Mafia to do damage to it with revelations about the drugs and violence that lay behind Elvis's public image (West *et al.*, 1977). Madonna, on the other hand, never had a squeaky-clean image to protect, nor was she ever concerned with keeping her image in line with conventional bourgeois standards of morality: when *Playboy* and *Penthouse* unearthed and published old nude photos of her in 1985, it did no noticeable damage whatsoever to her career or her reputation. Moreover, Christgau is wrong to imply that *Truth or Dare* is the film analogue to Albert Goldman's *Elvis* (1981), as Keshishian's film is completely lacking in the smarmy aura of pompous contempt for its subject that characterizes Goldman's 706-page assassination of Elvis's character.

32. A personal anecdote seems particularly relevant here. In the summer of 1992, I ordered two posters – one of Elvis in the army (circa 1959), one of Madonna around the time of "Justify My Love" (1990) and *Sex* (1992) – to replace some wall decorations that I had grown tired of. It was not until the posters arrived in the mail, however, that I realized that I had inadvertently stumbled across a pair of photos akin to those that Jim Jarmusch used in *Mystery Train* (1989) to "prove" that Elvis and Madonna are really the same person. The facial expressions and the positions of the bodies relative to the camera of the principal image in both posters are similar enough that it wouldn't be all that difficult for an uninformed observer to believe the two were at least close cousins – and possibly that they were twins. The most interesting point of comparison between the two images, however – particularly with respect to the question of traditional gender roles – is the fact that Elvis appears to be wearing more mascara than Madonna does (see plates 25–6).

33. This is not to argue, by any means, that there are no class distinctions in the US, but that the dominant myths of class in the US work to minimize the visibility of such differences. As economics professor Rebecca Blank points out, "Everybody in America considers themselves middle class. It's sort of the American psyche that wants to consider everyone equal. One way of being equal is to all be middle class" (quoted in Brandon, 1993: 1, 6). It's this same myth that is responsible for the common claims that all citizens, regardless of their socio-economic standing, are equal before the law, or that the basic democratic principle of "one person, one vote" effectively prevents the wealthiest fraction of the population from usurping the political advantages that would otherwise be theirs in a more authoritarian society. That such claims are patently false, however, doesn't negate the fact that US society isn't as rigidly stratified along lines of class differences as many other capitalist nations, nor does it discredit the notion that the use of class position as an identifying marker, either for individuals or for larger groups of people, operates according to different rules in the US than it does elsewhere.

34. Not all truck drivers live so well as the one described here, of course, but this example is a real one, based on a *Chicago Tribune* story about wealthy families who nevertheless consider themselves to be middle class: "Another couple who asked not to be named, a North Shore truck driver and his wife who does part-time clerical work, have a combined income of just under $100,000. He works lots of overtime,

nights and weekends. They have hefty expenses for day care for their two children. And they have bought a few extras, a boat and a snowmobile" (Brandon, 1993: 6).

35. Cultural capital, of course, isn't entirely unrelated to economic capital, as the rich are much more likely than the poor to have access to the "right" schools and other such institutions of "high" culture. At the same time, however, one's cultural capital is not simply determined by the amount of economic capital one has. While the rich can (and often do) use their financial assets to acquire cultural capital, such transactions are by no means an inevitable consequence of wealth: it is, after all, possible to have a great deal of money without having a great deal of taste – or at least not the sort of taste that qualifies as cultural capital. By the same token, as the example of the university professor highlights, it is possible to have a great deal of cultural capital without having access to a comparable store of economic capital.

36. "During the first three weeks of his new course, . . . Nazareth's 50 students endured the lights, cameras, and microphones of a dozen film crews from local and national media. From a feature-length *Wall Street Journal* article . . . to on-air chats with ABC-TV, the Canadian Broadcasting Corporation, and a network of Australian radio stations . . . " ("Media Clamor Over . . . ," 1992).

37. As Frith (1987) and McClary and Walser (1990) have pointed out, this same false dichotomy characterizes the vast majority of the scholarly work done on popular music.

38. As published in *The Seattle Post-Intelligencer*, at least, the allegorical nature of Trillin's column was made all the more obvious by its proximity on the op/ed page to a political cartoon drawn by Jim Borgman depicting a hypothetical choice between two George Bush stamps, one circa 1988 ("Read my lips! No new taxes!!") and one circa 1992 ("Nevermind.").

39. Besides the Jim Borgman cartoon described in the previous note, an example of this can be found in a Locher cartoon depicting a man and a woman standing in their local post office in front of the two choices for the Elvis stamp design and a sign that says "VOTE." The man says, "I don't know, the younger version was bright and audacious. The older one is obfuscated, lacking in direction, hanging on . . . " The woman replies, "Yes, which Elvis do we want?" The man counters, "I was thinking of Bush" (*Chicago Tribune*, 3 May 1992, section 5, p. 9).

40. See, for example, the Tom Meyer cartoon comparing where Democratic presidential candidates Bill Clinton and Jerry Brown "stand on the really important issues." The second item on Meyer's list is the Elvis stamp: Clinton is described as favoring the "Old Elvis," Brown the "New Elvis" (*New York Times*, 5 April 1992, section 2, p. 18). Similarly, see the Bruce Beattie panel depicting a pollster who has asked a housewife which candidate she prefers and receives the answer, "I won't know who I'm voting for till I hear which Elvis stamp they prefer" (source unknown, originally published in the *Daytona Beach News-Journal*).

41. See, for example, the 6 April 1992 edition of the syndicated daily strip *The Fusco Brothers*, in which one character says that he's off to cast his vote because "'Civic Duty' is my middle name." When asked, "Vote?? Who's running for what??" he replies that "Young, slim Elvis is running against older, enlarged Elvis for a spot on the new Elvis stamp . . . In a slight variation of my usual approach to an election, I'm voting for the lesser of the two Elvises." Similarly, the 31 March 1992 edition of *Frank and Ernest* features the pair of title characters making the following exchange: "Deciding who to support in this year's big election is a real dilemma!" "I'll say! . . . I don't know which 'Elvis' stamp to vote for either!"

42. See the 2 May 1992 edition of the daily comic strip *Shoe*, which depicts a political press conference where a reporter suggests to the candidate that "it's time to get out of the race" because a new poll shows that he's "20 points behind the fat Elvis stamp."

43. A similar note, though one lacking in the presidential election overtones of Lapham, is sounded by James Donnelly in *The Millennium Whole Earth Catalog*. Kicking off the oversized volume's section on "Political Tools" is Donnelly's essay on "Elvis and Activism," where he argues that the Postal Service's Elvis balloting represents the decline and fall of the American political enterprise. "This," he cries, referring to the burning issue of which image of Elvis would grace a postage stamp, "is the sort of thing our vote is held to be good for. We are let to vote, emphatically enjoined to vote, told we are bad citizens not to vote, but the bulk of our choices are Elvis-caliber" (Donnelly, 1994: 282).

44. In a short essay that ran on the opinions page of the *New York Times*, Schoenstein states: "Early next year, the United States post office will issue a stamp for Elvis Presley, the first stamp in the new Fall of Man series, which may also be honoring American trucking with [trade union leader] Jimmy Hoffa and American health care with Typhoid Mary. With the Presley stamp, the post office is saluting a man who lived in vulgar excess, had sexual relations with selected members of the ninth grade and died of enough drugs to stock a Walgreen store, a man whose most memorable socially redeeming act was to support American libraries by shooting his television set" (1992: 11). The remainder of Schoenstein's diatribe makes the passage cited here look like high praise by comparison.

45. Marcus anticipates the potential objections to his argument (e.g., that the enshrinement of Elvis on a US postage stamp and the inauguration of a president who all but ran his campaign on a pro-Elvis ticket could be seen as events that indicate that America has finally accorded Elvis the honor and respect he deserves) by pointing to "that thing that Linda Ray Pratt wrote, where she talks about the 'pinch of ridicule' that's always accompanied Elvis – it doesn't matter if the President awards him a posthumous Medal of Freedom, it doesn't matter if he's on a stamp, it doesn't matter that the government has entered Graceland on the list of historic places, or whatever the official designation was The country will always be split about Elvis until it forgets him" (Heilman, 1992: 11).

46. I'd like to thank Greg Seigworth for calling this particular song to my attention.

3 ELVIS SPACE

1. The only real competition that Graceland might have for this distinction would be Pickfair, but the former mansion of Hollywood stars Mary Pickford and Douglas Fairbanks hasn't fared very well as a popular icon of any lasting significance.

2. My emphasis on the centrality of the mass media to stardom is not meant to imply that this is the only institutional structure required for stardom to arise. Drawing on the work of both Francesco Alberoni and Barry King, Dyer provides a more complete list of the various social, economic, and institutional conditions necessary for stardom, as a cultural phenomenon, to exist than space permits me to give here (1979b: 6–8).

3. For instance, Hugh Grant (and, through her romantic involvement with him, Elizabeth Hurley) could become (at least momentarily) a more visible star as a result

of his 1995 dalliance with a Hollywood prostitute, but only because he'd already acquired a good deal of name and face recognition prior to his arrest. A hypothetical incident such as the Grant affair that involved a previously-unheard-of actor would undoubtedly have done nothing to make the said unknown into even a minor household name.

4. Andie MacDowell, for instance, enjoyed a highly successful modeling career for years, but didn't become a star until her acting career took off. On the flip side of the coin, Joe Carter won the 1993 World Series for the Toronto Blue Jays with a dramatic home run, but since he didn't go on from there to record a rap album (as did the NBA's Shaquille O'Neal), star in any major ad campaigns, or the like, his face and name still remain largely unfamiliar to non-baseball fans.

5. With the ever-widening spread of free agency in US professional sports, however, it's becoming increasingly rare for even the most prominent and successful of professional athletes to spend their entire careers with just one team, thus making the links between particular sports stars and their "home" cities even more tenuous.

6. In the absence of any major US sports league that includes female athletes among its ranks, there are no viable articulations to be made between such stadiums and female athletes.

7. Even when Elvis first moved into Graceland and the surrounding country was still far more rural than urban, Route 51 served as a major highway connecting the city to northwestern Mississippi.

8. "At the first Rock and Roll Hall of Fame Banquet, in January 1986, some months after Cleveland had been chosen as the site for the Rock and Roll Museum, Sam Phillips . . . introduced Carl Perkins with the words, 'It's a late date to be saying it, and I mean no disrespect to the people of Cleveland, who I'm sure are a fine people and a *spira*chul people – but Cleveland ain't ever gonna be Memphis.' He was booed by an audience too young and ignorant to know or care what Memphis, the Mississippi Delta, the South, have meant to music" (Booth, 1991: 15).

9. Ostensibly an annual, but I haven't been able to verify whether publication of this guide continued beyond this first "collectors' edition" issue.

10. Of the 52 pages of editorial content, 31.83 (or 61.2 percent) were devoted to Elvis-related subjects. Out of 18 pages of advertising, 9.83 (54.6 percent) were either ads for Elvis-related tourist sites or direct appeals to Elvis fans. Combining editorial and advertising pages, 41.67 out of 70 total pages (59.5 percent) were Elvis-related.

11. In a post-vinyl age, "record store" is something of a misnomer, but the term seems to be hanging on in popular usage anyway, perhaps because no one has come up with an acceptable replacement yet. "Music store" is already associated with places where instruments are sold, while "pre-recorded music store," for all its precision, doesn't exactly trip off the tongue lightly. My own choice, for now at least, would be to steal a page from Prince's recent name-change shenanigans and use the term "The Places Formerly Known as Record Stores," but I'm not holding my breath on this terminology catching on.

12. Oddly enough, the only two states in the country containing no counties on the pro-Elvis end of the scale both played important roles in his career: Hawaii (site of two of Elvis's most popular movies and his 1973 worldwide satellite broadcast) and Nevada (which played host to the live concert phase of his late 1960s comeback).

13. It's hard to emphasize the word "slowly" in this sentence enough. On my last visit to Memphis (January 1993), Saturday night found the street almost completely empty,

and there were easily as many boarded-up and shelled-out buildings around as there were places open for business. While the clubs were trying real hard to give some sense of excitement to the neighborhood, for all practical purposes, Beale Street was dead.

14. WDIA was the first all-black radio station in the country, the spawning ground for artists such as B.B. King and Rufus Thomas, and perhaps the most important station in spreading the sound of Memphis rhythm 'n' blues to audiences across the South in the 1940s and 1950s. WHBQ was the home of Dewey Phillips, who, among other things, gave Elvis his first public exposure when he played an acetate of what would become Elvis's first Sun single, "That's All Right," on his highly popular (and highly influential) "Red Hot and Blue" rhythm 'n' blues show.

15. As of May 1996, that soup kitchen had yet to materialize.

16. To be sure, organized religion (especially as embodied by the religious right) still exists as a visible presence in the US, but its relatively high profile can plausibly be read as a sign that public faith isn't as great as it used to be. After all, in a society where organized religion was still at the center of most people's lives, it would probably not be necessary for churches to advertise on national television (as the Mormons frequently do) in order to attract worshippers.

17. For instance, writing nearly thirty years ago, Stanley Booth said of Elvis's entourage and fans, "They seem to be quite insane, this meek circle preferring worship and lights, the young ladies trembling under Cadillacs, the tourists outside, standing on the roofs of cars, waiting to be blessed by even a glimpse of this young god, this slightly plump idol, whose face grows more babyish with each passing year" (1968: 43).

18. Granted, in many cases it's not always clear whether the religious tone of some Elvis sightings is supposed to be satirical or reverential. For instance, "The Sacred Treasures of Graceland," Nancy A. Collins's (1994) fictional account of several holy Elvis artifacts as they might be listed in a late twenty-first century museum catalog, is far too serious to be dismissed as simple mockery, but it's also too intentionally funny to deny the fact that Collins is poking fun at the current sacralization of Elvis.

19. Louie Ludwig's *The Gospel of Elvis: The Testament and Apocrypha of the Greater Themes of "The King"* (1994), an extended and impressive effort to retell the story of Elvis and rock 'n' roll in quasi-Biblical prose, came to my attention too late in the final stages of preparing this manuscript to be included in the discussion that follows, though it clearly deserves mention as an example (albeit one made partially tongue in cheek) of the ongoing canonization of Elvis.

20. See, for instance, Harrison's discussion of the fervor and sincerity with which many of the fans that he interviewed revere Elvis (1992: 49–75).

21. For instance, Harrison uses the example of a statue of Elvis erected "on a hill just outside Jerusalem" by a local inn owner (who's also an Elvis fan) to help support the claim that Elvis is a holy figure (1992: 155–6), as if the mere presence of a statue in the Holy Land were enough to confer divinity on the statue's subject.

22. The book's back cover blurb ends with the non-committal statement that "Perhaps, in 2000 years' time, there will be cathedrals to Elvis . . . " While this claim is hard to refute, it's hardly a compelling argument that Elvis is at the center of a burgeoning religion.

23. Would a publishing house as respectable as Harper (the parent imprint of Fount, the press that handled *Elvis People*) have let a book on a religion springing up around, say,

Tony Danza or Morgan Fairchild get beyond the proposal stage? Would such a book even have made it *that* far?

24. There are at least two actively working female Elvis impersonators: Spigel (1990) describes in detail how impersonator Janice Waite negotiates the gender politics of being a female portraying Elvis on stage, while *I Am Elvis*, a book-length guide to Elvis impersonators, includes a four-page spread on "The Lady Elvis," Janice K (1991: 68–71).

25. Rosenbaum's Elvis-drenched fortnight included visits to the Elvis Presley Birthplace, Graceland during Tribute Week, and the First International Conference on Elvis Presley (held at the University of Mississippi).

26. For example, the fact that the letters in Elvis's name can be rearranged to spell "lives" is supposed to be a clue that he's not really dead – as if, way back in 1935, when Gladys and Vernon Presley were deciding what to name their newborn son, they gave serious thought to the possibility that this child might one day fake his death and need such clues planted in his name to alert people to the truth.

27. A version of Jacobs's list (also unidentified as such) can be found on the World Wide Web at http://www.mit.edu:8001/activities/41West/humour/Elvis_vs_Jesus. html.

28. See, for instance, the World Wide Web homepages for "The First Church of Jesus Christ, Elvis" (http://www.stevens-tech.edu/~jformoso/sacred_heart_elvis.html) and its counterpart, "All Have Sinned . . ." (http://www.stevens-tech.edu/~jformoso/jesus_stamp.html) (see plates 28a–c).

29. Lest the reader think this is a cop-out on my part, I should point out that it's simply too early to tell what the future holds for Elvis-as-religious-icon. By way of comparison, the first of the Gospels wasn't written until about forty years after Jesus' death, so perhaps the question of Elvis's deification should be put on the back burner for another couple of decades at least.

30. Doss (1994) and Vikan (1994) offer similar accounts of the Vigil and, like Silberman, Vikan also sees strong similarities between the Graceland ceremony and the Holy Fire.

31. Vikan uses this example, along with that of Jim Morrison's grave in Paris (roughly two dozen visitors per day, compared to 2,000 or more each day at Elvis's grave), to argue that "the cult of the dead Elvis differs from [that associated with other stars] more in degree than in kind" (1994: 166). However, I would be inclined to interpret these statistics in exactly the opposite way, as a gathering of 50,000 is *much* different in kind from a gathering of a few hundred: the two are as distinct as a concert held in a football stadium is from one held in a tiny basement nightclub.

32. This practice dates back to Elvis's death in 1977, when many of the fans who came to Graceland to pay their final respects did so, in part, by leaving farewell messages for their hero on the wall. For a photographic record of some of these messages, see Crane (1977).

33. Marty Wombacher records a 1991 graffiti message from the Graceland wall consisting of a drawing of Elvis on the toilet and the legend, "Distended Anus! The King is dead and I feel fine" (1991: 15). When I visited Graceland in January 1993, I found one message on the wall proclaiming that "Elvis may be the King, but he ain't no Joe Strummer." Another was somewhat less generous: "Elvis – Smoke Crack in Hell, You Fat Dead Fuck! – Brad"

34. Vikan, for example, cites such messages as: "Elvis / Thanks / for all you helped me through./ I wouldn't be me / without you. / See you in heaven. / I love you /

Carla"; "I have seen / Graceland, my life is complete. / Miss you terribly / Soren Skovdal"; and the words "Elvis Lives" scrawled over the image of "a radiating Calvary Cross" (1994: 163, 166).

35. "Being a fan entails a very different relationship to culture, a relationship which seems to exist only in the realm of popular culture. For example, while we can consume or appreciate various forms of 'high culture' or art, it makes little sense to describe someone as a fan of art" (Grossberg, 1992a: 50).

36. For instance, in Washington, DC, where Redskins football games at RFK Stadium have been sold out to season ticket holders since the late 1960s (and the waiting time for new applications for such tickets to be filled is measured in years), those who hold season tickets can expect to be seated amongst the same general crowd of people game after game, and year after year.

37. For instance, a stadium used only for Major League Baseball (i.e., the major US sport with the longest season) will play host to only eighty-one regular season games each year, leaving the stadium otherwise unused (at least by the general public) for more than 75 percent of the year.

38. On first glance, the notion of cyberspace as a "stable" space where viable communities might come into existence is admittedly counter-intuitive. Computers, after all, are just as much an example of the mass media as television or recorded music; the populations of online communities are still far removed from one another geographically; and – perhaps most importantly – there's no clearcut spatiality to such communities (for example, *where* does the community associated with any given listserv or Usenet group exist?). At the same time, however, cyberspace-based communities differ from those associated with other media insofar as the populations involved can participate directly in the dialogue that constitutes the community in the first place (e.g., for the most part, if you have access to a Usenet group that allows you to read it, you also have the means to add your own voice to the discussion; such isn't the case for a community of fans surrounding, say, a television sitcom). Moreover, they can often do this in something approximating real time (e.g., various Internet "sites" make it possible for people to have "live" conversations with one another).

39. As a paying tourist attraction, Graceland is only closed for about three weeks total each year (on Tuesdays from 1 November through 28 February, and for Thanksgiving, Christmas, and New Year's Day), but even when the official tours aren't running, fans can use the drive-up lane adjacent to the grounds of the house to park, take photos, add their graffitied votive offerings to the stone wall, and so on.

4 ELVIS CULTURE

1. In particular, see Williams's *Culture and Society* (1958a), "Culture Is Ordinary" (1958b), "The Analysis of Culture" (from *The Long Revolution*, 1961: 41–71), *Marxism and Literature* (1977), *Culture* (1981), and the entry for "Culture" in *Keywords* (1983: 87–93).

2. In his later work, Williams argues that the modern use of the word "culture" falls into three broad categories, rather than two: the "social" (corresponding to culture as "a whole way of life"), the "documentary" (corresponding to culture as "the arts and learning"), and the "ideal" ("in which culture is a state or process of human perfection, in terms of certain absolute or universal values" (1961: 41)). While this refinement of his earlier argument probably provides a more complete picture of the various ways in

which the notion of "culture" is invoked, Williams himself points out that the "ideal" model of culture is nothing more than the set of abstractions that lie behind the "documentary" model, as the arts and learning that define the latter are valued precisely because they are seen to embody the "absolute or universal values" associated with the former (1983: 90).

3. It is no coincidence that one of the few recent "popular" discussions of US culture (i.e., one not produced by an academic scholar with an academic audience in mind) as a social phenomenon – Robert Hughes's *Culture of Complaint* (1993) – was written not by a US native, but by an expatriate Australian. Even Hughes, however, tends to lean on a more textual model of culture when it suits him, so that by the end of the book he is using "culture" almost exclusively as a synonym for "high art."

4. Herbert Gans (1974) offers a compelling critique of this general argument by pointing out that, historically, art has never been entirely free from economic constraints and thus the notion that contemporary culture/art is somehow more tainted by its entanglements with the marketplace than its predecessors is simply not true.

5. The lines between "us" and "them" are often vague here, as the specific arts and learning that are valued most highly are commonly described as "Western culture," rather than "US culture" or "American culture." Significantly, however, the international nature of this label actually erases the specificity of other nations' contributions to the canon of "great works"; in the US at least, the phrase "German culture" (for instance) is far more likely to evoke images of Oktoberfest, knockwurst, and stocky peasants in lederhosen than it is to inspire thoughts of the works of Beethoven, Hesse, or Schopenhauer. The phrase "Western culture," on the other hand, allows art and literature from a relatively wide range of peoples and historical periods to be subsumed under a single banner. More importantly, it allows "us" to claim "the West's Greatest Hits" as "our" culture, insofar as this body of texts is alleged to be the artistic and intellectual tradition upon which US culture is built (see Fernández, 1991; Hughes, 1993).

6. Lawrence Levine recounts a slightly milder (but still patronizing) version of the same story, in which Bellow's comments are: "Who is the Tolstoy of the Zulus? The Proust of the Papuans? I'd be glad to read them" (Levine, 1988: 256).

7. It is worth noting that Hirsch himself isn't entirely certain about the answer to this last question. The back cover of *The Dictionary of Cultural Literacy* (Hirsch *et al.*, 1988), a one-volume encyclopedia that expands upon Hirsch's unannotated list of "what literate Americans know," proudly proclaims: "*Cultural Literacy* posed the questions; *The Dictionary of Cultural Literacy* provides the answers!" Among the more interesting "answers" provided by the *Dictionary*, however, is the twice-stated "fact" that Jacksonville – and not Tallahassee – is the capital of Florida (Hirsch *et al.*, 1988: 381, 382). The second edition of the dictionary (Hirsch *et al.*, 1993) managed to correct this error.

8. For examples of some of the various positions taken in these debates, see Aufderheide (1992), Berman (1992), Bérubé (1991), Gless and Smith (1992), Hirsch *et al.* (1989), Lipsitz (1990), Margaronis, (1989), Phillips (1989), and J. Williams (1995).

9. To argue, for instance, that African-American culture is better exemplified by the writings of Maya Angelou, James Baldwin, and Toni Morrison than it is by the works of F. Scott Fitzgerald, Ernest Hemingway, and Mark Twain – and to revise or augment "the canon" accordingly – does nothing to account for the fact that a sizable percentage (and quite possibly a majority) of the African-American population is as unfamiliar with the former set of texts as they are with the latter, and thus they

remain as far outside of this supposedly more accurate vision of "their" culture as they were outside the old one. Ultimately, this sort of rebuttal to Hirsch and other conservative canonists boils down to the claim, "That's *your* culture, but it's not *my* culture," when the intervention that most needs to be made is something closer to, "That's not all there is to culture."

10. For rebuttals of the particular arguments alluded to here, see Janice Radway's *Reading the Romance* (1984) and Richard Dyer's "In Defense of Disco" (1979a).

11. See, for example, Adorno (1941, 1954), Greenberg (1946), Howe (1948), Klonsky (1949), MacDonald (1953), and B. Rosenberg (1957, 1968).

12. In the summer of 1979, a rock-oriented Chicago radio station sponsored a "Trash Disco" night at the old Comiskey Park. Fans were offered reduced admission to a White Sox doubleheader if they donated disco records for a between-game ritual in which the collected records were to be destroyed. The ensuing riot of over-zealous rock fans caused so much damage to the field that the second game of the doubleheader had to be cancelled.

13. Bowden (1982), Day (1988), Mellers (1981), and Poague (1974, 1979) represent a sample of the various ways in which Dylan's music and lyrics (mostly the latter) have been taken up as artistically significant aspects of (and contributions to) contemporary US culture. Lyon (1970), Marshall (1969), Mellers (1976), Poirier (1967), and N.V. Rosenberg (1970) are similar examples of serious treatments of the Beatles and their music.

14. "Elvis was not a songwriter although his interpretations were often so radical that he could quite legitimately claim arranger credit" (Marsh, 1982: 77).

15. Drummer D.J. Fontana flatly states, "You know how on his records they'd say, 'produced by so-and-so'? Nobody but Elvis produced those records. Absolutely" (quoted in Cronin *et al.*, 1992: 53). Taking this notion a step further, recording engineer and producer Bones Howe claims that Elvis actually triggered a revolution in the field: "Elvis produced his own records. He came to the session, and if something in the arrangement was changed, he was the one to change it. Everything worked out spontaneously. Nothing was really rehearsed. Many of the important decisions normally made previous to a recording session were made during the session. What it was, was a look at the future. Today everybody makes recordings this way. Back then, Elvis was the only one. He was the forerunner of everything that's record production these days" (quoted in Choron and Oskam, 1991: 64).

16. See, for instance, Richard Middleton's (1979) discussion of Elvis's "notable contributions to the language of rock and roll singing" and Gregory Sandow's (1987) claim that Elvis's incredibly wide vocal range and his seductive phrasing meant that he had the potential to be more than a passably good singer of classical music.

17. "Elvis Presley could say more in *somebody else's song* than Albert Goldman could say in any book" (Bono, lead singer of U2, quoted in Flanagan, 1987: 452).

18. Guralnick's comments here actually refer to Sun Records founder Sam Phillips, but they apply equally well to Guralnick's vision of Elvis as a conscious agent of historical change.

19. Bangs is responding here to an argument that Guralnick makes for Sam Phillips as a visionary instigator of cultural change, but the spirit of Bangs's rebuttal applies equally well to the similar claims that Guralnick (and company) make for Elvis.

20. See Paul Carter's *The Road to Botany Bay* (1987) for an insightful critique of this model of history.

21. These articles, though brief and not altogether flattering, nevertheless constitute an important dose of public exposure for the still largely unknown singer from Memphis.

22. The most basic facts concerning Elvis's 1956 Vegas engagement are subject to some dispute: several sources describe his stint at the New Frontier Hotel as a two-week booking that was cut short after only one week (Hopkins, 1971: 121–2; Marsh, 1982: 96; Pareles and Romanowski, 1983: 439; Sauers, 1984: 14), while others claim that he had a month-long contract that was torn up (to the delight of all concerned parties) after only fourteen days (Worth and Tamerius, 1988: 137). Guralnick offers yet a third version of this story, in which Elvis's Vegas engagement was only scheduled for two weeks (though the Freddy Martin engagement with which Elvis's act was affiliated was for four weeks) and he played out the entire length of his contract, despite the fact that his show didn't go over well at all with audiences (1994: 270–4). All these sources, however, agree that Elvis's first Vegas show was on 23 April and that the overall engagement was a box office disaster.

23. "RCA . . . discouraged [Wertheimer] from shooting too much expensive color film. Worried that Elvis' career might last all of six months, RCA insisted that black and white shots would suffice" (from no. 283 in the recently released series of trading cards, *The Elvis Collection*). Wertheimer's photos are collected in a long-out-of-print volume entitled *Elvis '56: In the Beginning* (Wertheimer, 1979), a book that later served as the inspiration for the video documentary *Elvis '56* (1987).

24. In the interests of historical accuracy, it should be pointed out that this quote is from a newspaper interview Elvis gave on 26 June 1956, three weeks after the moment being described here. It seems safe to say, however, that if Elvis was speaking doubt-fully of the future of rock 'n' roll in late June, he would have been no less uncertain (and perhaps more so) of the music's viability earlier in the month.

25. Today, with the benefit of 20/20 hindsight, the notion that Elvis could have faded back into obscurity so soon after he first appeared only seems implausible. For a convincing – albeit fictional – account of how such a scenario might have played itself out, see Harlan Ellison's novel *Rockabilly* (1961, reprinted in 1975 as *Spider Kiss*), in which an Elvis-like figure named Stag Preston goes from rags to riches and back to rags again in stunningly quick fashion.

26. This figure comes from the documentary *Elvis '56* (1987). It is possible, however, that the video's writers are attributing the audience numbers for Elvis's *first* appearance on Berle's program (3 April 1956) to the June broadcast, as both Jerry Hopkins (1971: 120) and Wendy Sauers (1984: 14) claim that 40 million viewers tuned into the April show. Neither of these sources, however, provides a figure for the size of the June show's audience.

27. By the time the song winds its labyrinthine way from Thornton to Elvis via Bell, all the two performances share is a title, the opening line of the first verse ("You ain't nothing but a hound dog . . . "), the last half of the second verse's first line (" . . . you was high class"), and the basic a-a-b lyrical pattern that is the bread and butter of countless other blues-based tunes as well. Otherwise, the lyrics, the pace, the instru-mentation, and the arrangement of the two are dissimilar enough that it wouldn't be difficult to mistake them for different songs.

28. For example, on his first *Stage Show* appearance (28 January 1956), Elvis performed Ray Charles's "I Got a Woman" and Big Joe Turner's "Shake, Rattle and Roll" (with a verse or two of Turner's "Flip, Flop and Fly" thrown in for good measure); on his

second and fourth *Stage Show* appearances (4 and 18 February 1956), he sang Little Richard's "Tutti Frutti"; for his final *Stage Show* gig (24 March 1956), he played Clyde McPhatter and the Drifters' "Money Honey." His previous *Berle Show* performance (3 April 1956) also included a version of "Shake, Rattle and Roll."

29. The description of Elvis's performance that follows is based on the version that appears in the video documentary *Elvis '56* (1987), as this seems to be both the most complete and the least tampered with of the three readily available versions of this broadcast. Both *This Is Elvis* (1981) and *Elvis, The Great Performances, Volume One* (1990) omit the first two verses of Elvis's performance, and each replaces the second shot of the studio audience (which occurs during the song's reprise) with images that don't match the previous shot of the audience. Moreover, in *This Is Elvis*, the reproduced kinescope images are chopped off at the edges (so that Elvis's feet are never visible) and the soundtrack appears to have been enhanced: there are faint horn riffs audible here that are not present at all in either of the other two videos, and the studio audience's applause and laughter seems to have been sweetened considerably. This is not to say that *Elvis '56* is necessarily more faithful to "The Truth" (whatever that may be) than either of the other two documentaries – '56 contains a fair share of misinformation and recontextualized images and sounds of its own – but that it appears to provide the most faithful simulation of what audiences for this performance would have seen when it was first broadcast.

30. To put this figure in perspective, the total sum that Elvis received for his first nine appearances on national television (six visits to *Stage Show*, the two *Berle Show* appearances, and one gig on *The Steve Allen Show*) was a mere $26,000 (Worth and Tamerius, 1988: 322–4; Sauers, 1984: 14). Sullivan was paying nearly twice this amount for only a third as many performances. Moreover, prior to this date, the highest fee Sullivan had paid anyone to appear on a single show was $5,000 (Hopkins, 1971: 128). Even the Beatles, at the height of the mania surrounding their early career, failed to put such a large dent in Sullivan's budget. For their first appearance on Sullivan's program in 1964, the foursome from Liverpool were paid either $2,400 or $3,500, depending on whose version of the story you believe (the most commonly cited figure (Chapple and Garofalo, 1977: 70; Marsh and Stein, 1981: 14; Ward *et al.*, 1986: 264) is the lower of the two, though Beatles biographer Philip Norman (1981: 204) offers the higher figure as the correct one). Either way, the Beatles' fee is far less than the one that Elvis collected, and is even less impressive when one bears in mind that it had to be split (at least) four ways, while Elvis only had to share his Sullivan paycheck with Colonel Parker (Moore, Black, and Fontana were paid only a weekly salary).

31. If Allen had any motive in booking Elvis other than using him to draw a larger viewing audience, it was to (try to) put the hip-shaking upstart back in his place. Allen straitjacketed Elvis by dressing him in a tuxedo and tails (an outfit decidedly more restrictive and conservative than the flashy, loose-fitting clothes that Elvis preferred), and then placed him in the highly undignified position of singing "Hound Dog" to a live basset hound, similarly attired in top hat and bow tie. Even years later, after Elvis had become comfortably established as a musical superstar (and long after Allen's elitist attitudes toward rock 'n' roll ceased to be an accurate reflection of mainstream opinion toward the music), Allen would gripe: "The fact that someone with so little ability became the most popular singer in history says something significant about our cultural standards" (Choron and Oskam, 1991: 91; Worth and Tamerius, 1988: xi).

32. Even then, however, Sullivan's immediate (albeit short-lived) public response to Elvis's *Allen Show* appearance was that "He is not my cup of tea," and that there was no danger of him ever inviting Elvis onto his show (Guralnick, 1994: 301).

33. To be fair to my fellow "Generation X" members, I should point out that many people who did, in fact live through the cultural changes brought about by Elvis and the rise of rock 'n' roll in the 1950s seem to have forgotten how dramatic those changes were back then. When baby-boomers such as Tipper Gore (1987) complain, on the one hand, that rap and heavy metal are destructive and anti-social influences on today's youth, while, on the other, celebrating the "classic" rock of the 1950s and 1960s as harmless nostalgia, they are overlooking the fact that many of their heroes (Elvis, the Beatles, Bob Dylan, the Rolling Stones, etc.) were routinely condemned in their respective heydays as destructive and anti-social influences on young audiences for precisely the same reasons that rap and heavy metal are slandered today.

34. As Neil Howe and Bill Strauss point out, "Older people could swear that nothing's on [the younger generation's] mind, that they just 'don't care' (*elder translation: selfish, apathetic, uninformed*). It's all a matter of perspective. As the 13ers see it, what elders care about is 'history' (*13er translation: dead, past tense, NOT!*). If you're an old crusader yourself, you might want to argue the point. But think it over and save your breath: After all, they'll just turn up their Walkmen and tune you out" (1993: 132).

35. In the end, the question of whether television and rock 'n' roll were ever actually opposed to one another ideologically may depend on which aspects of these two cultural formations are being examined. In terms of audience uses and practices, the stereotypical television viewer at least *appears* to be a more passive and docile media consumer than the rock 'n' roll fan; but when it comes to questions of economics and institutions, both of these phenomena have served to line the pockets of multi-national corporations. On the other hand, how one understands the nature of television's relationship to rock 'n' roll may simply depend on which way the wind is blowing on any given day. Writing in 1988, Larry Grossberg claimed that "rock and television have traditionally functioned – in terms of the relationship they establish between the performer, the individual fan, and the society – in fundament-ally opposed ways" (1988b: 315). A mere year later, however, he argued that the gap between popular music and television is not all that great, as "rock and roll has always been as much about images – images of stars and performers, of fashion and aesthetics, of the body and romance, of dancing and sex, and, most importantly, of attitudes – as it has been about sounds" (1989c: 257–8).

36. The specific performance that gives rise to Marcus's comments here is now available (at least in the UK) on compact disc (Marie Osmond, "Karawane," 1993).

37. For instance, Grossberg has argued that rock 'n' roll needs to be viewed "as a set of practices . . . of strategic empowerment rather than of signification" (1984: 227), "as an array of strategies with which youth has organised musical practices, social institutions, economies and technologies into 'alliances'" (1985: 452), and as "more than just a conjunction of music and lyrics, commodity production and consumption" (1992b: 131). Similarly, he has also claimed that "more than music is encompassed by [the] term" (1986a: 50), and that it is "not useful to proceed by analyzing the textual structures and signifying relations of rock and roll" (1986b: 182).

38. Though it's true, as I've already argued, that the current shape of the formation in question was not in any way guaranteed by its original shape, it still remains the case that the former inevitably bears historical traces of the latter, and that earlier

moments in the formation's history affected the possible directions that it could follow later on. The past does not guarantee the shape of the future, but it makes certain futures more (or less) likely than others to come to pass.

39. For instance, as Simon Frith argues with respect to music, "For the last fifty years at least, pop music has been an important way in which we have learned to understand ourselves as historical, ethnic, class-bound, gendered subjects. . . . We need to approach this political question . . . by taking seriously pop's individualizing effects. What pop can do is put into play a sense of identity that may or may not fit the way we are placed by other social forces. . . . It may be that, in the end, we want to value most highly that music, popular and serious, which has some sort of collective, disruptive cultural effect. My point is that music only does so through its impact on individuals. That impact is what we first need to understand" (1987: 149).

40. Springsteen's account is slightly off in at least one respect: born in September 1949, Springsteen would have been two weeks shy of his seventh birthday when Elvis made his first appearance on *The Ed Sullivan Show*; by the time Springsteen had turned nine, Elvis was already in the US Army and on his way to Germany.

41. As Gill Creel (1994) argues, the "romantic conspiracy" that Marcus describes here is, to a certain extent, an overly romanticized vision of post-war Southern life and culture. At the same time, however, while Marcus's image of the South may be rooted more in myth than it is in fact, this is not in itself a weakness in Marcus's argument, as it's ultimately the myth – much more than the reality – of the South (as represented by Elvis) that mattered to much of the rest of the country.

42. "In a sense he could be seen . . . as a phenomenon that exploded in the fifties to help shape the psychic jailbreak of the sixties" (Bangs, 1977: 213).

43. The reasoning behind Bernstein's provocative comment about Elvis's cultural importance is that, in Bernstein's eyes, Elvis "changed everything – music, language, clothes, it's a whole new social revolution – the Sixties comes from it" (quoted in Halberstam, 1993: 457).

44. See (or, more precisely, hear) Trudell's "Baby Boom Ché" (1992), which is discussed in more detail in chapter 2.

45. "If I Can Dream" (1968) and "In the Ghetto" (1969) are Elvis's only "blatantly" political records, and even these statements sound exceptionally coy and vague in their political posturing when compared to unabashedly political protest music (e.g., Jefferson Airplane's "Volunteers" (1969), Country Joe McDonald's "The 'Fish' Cheer/I-Feel-Like-I'm-Fixin'-to-Die Rag" (1969), MC5's "Kick out the Jams" (1969), etc.) emanating from various corners of the late 1960s counter-culture. Generally speaking, Elvis felt very uncomfortable with the idea of addressing politically charged topics in public. When asked his opinion about protest music and resistance to the Vietnam War at a Madison Square Garden press conference in the early 1970s, Elvis replied, "I'd just as soon to keep my own personal views about that to myself. I'm just an entertainer and I'd rather not say" (*This Is Elvis* soundtrack, 1981: side D, track 1).

46. In a completely irrelevant aside, thrown in because this tidbit screams out to be acknowledged here, Chet Williamson is also the author of a pulp horror novel entitled *Dreamthorp* (1989), in which the villain is a "crazed sex killer" named Gilbert Rodman. Standing 6'1" and weighing in at 165 pounds, Williamson's Rodman even bears a partial physical resemblance to me. But, of course, "any resemblance to actual events or locales, or persons, living or dead, is entirely coincidental. . . . "

47. The symbolic *destruction* of rock 'n' roll, on the other hand, was used on at least one occasion in 1956 to sell automobiles: a sign displayed in a Cincinnati used car dealer's lot sometime that year proudly claimed that "We guarantee to break fifty Elvis Presley records in your presence if you buy one of these cars today" (quoted in Choron and Oskam, 1991: 22). What's more, this advertising ploy worked well enough that the dealer in question sold five cars in one day (Martin and Segrave, 1988: 65).

48. For an extended discussion of this phenomenon, see Lawrence Grossberg's *We Gotta Get out of This Place* (1992b).

49. The aforementioned Camaro ad, with its celebration of rock 'n' roll as an unthreatening symbol of what makes America – and Chevrolet – great, is a good example here.

50. For instance, as long ago as 1991 the National Archives in Washington, DC were trafficking in Elvis-meets-Nixon postcards (Linda Simensky, personal communication, 1 January 1992). On a less conventional note, in January 1993 one of the "unofficial" gift shops (i.e., one not affiliated with the Presley estate) located just north of Graceland in Memphis had a T-shirt for sale that showed this picture over the some-what enigmatic caption: "JUST SAY NO!" (Given the otherwise adulatory tone that accompanies Elvis merchandising at these stores, either the vendor or the "author" of the shirt (if not both) seems to have missed the potential irony in placing this particular slogan under the portrait of these two men.) That same year, in honor of Nixon's eightieth birthday, the Richard Nixon Presidential Library and Birthplace sold wristwatches, note cards, posters, coffee mugs, and postcards bearing this image (Pierce, 1994: 329; Ringle, 1993). Most recently, former White House aide Egil "Bud" Krogh has written a book devoted entirely to telling his version of the tale behind this meeting: *The Day Elvis Met Nixon* (1994).

51. As long ago as 1991, this shirt was available at Revolution Books in Cambridge, MA. It's also been spotted as recently as December 1994 at The Alley in Chicago. My thanks to Julian Halliday for first bringing this shirt to my attention, and to Linda A. Detman for her intrepid field work and data collection in locating the Chicago source.

52. For the record, while I think this shirt is probably much funnier with Nixon than it would be without him, I would also maintain that the bulk of the comedic load here rests on Elvis's shoulders. Subtract Elvis from this T-shirt and the end result (i.e., Nixon = Culture) plays as biting political commentary more than as ironic, satirical humor. Remove Nixon, however, and there's still a belly laugh or two here.

53. Or, alternately, the good, the bad, and the ugly?

54. Marcus uses these words specifically to describe, not Elvis, but the equally hard-to-pin-down impact of the cultural formation centered around punk in the 1970s. His writing elsewhere on Elvis, however, suggests that he would be just as comfortable making such a claim for Elvis.

55. For example, while Elvis's appearances on national television in 1956 may have led Tom Smucker's brother to threaten to wear blue jeans to church, the only reason that the connection between these two events is apparent is that Smucker's brother made it so. Without such an explanation, however, one can't reasonably be expected to look at either Elvis's early televised performances or this act of sartorial rebellion and find the cause-and-effect link that exists between them.

56. Marcus's *Lipstick Traces: A Secret History of the Twentieth Century* (1989) is an impressive attempt to explain the cultural significance of the Sex Pistols and 1970s punk rock in

just this way. For a more detailed discussion of this book and its novel approach to cultural history, see my essay, "Making a Better Mystery out of History: Of Plateaus, Roads, and Traces" (Rodman, 1993).

57. Marcus is specifically referring to punk here, but (once again) his words serve as an apt description of Elvis as well.

58. Tony Bennett, Eric Clapton, Bob Dylan, the Eagles, and former Led Zeppelin bandmates Jimmy Page and Robert Plant are all examples of musical stars whose somewhat dimmed careers have recently benefited – at least in the short term – from appearances on this program.

59. Despite the presence of numerous successful female artists (e.g., Madonna, Janet Jackson, the Breeders, Hole, and the like) on MTV's playlist, women have been featured on the show relatively rarely (the most obvious exception here being pop diva Mariah Carey). An examination of the track listings for the two *Unplugged* compilation albums released as of the time of writing (*Uptown MTV "Unplugged,"* 1993; *The Unplugged Collection, Volume One,* 1995) *does* reveal a number of female artists (e.g., Mary J. Blige, Jodeci, k.d. lang, Annie Lennon, and 10,000 Maniacs (fronted by Natalie Merchant)), but these performances are typically not rebroadcast, either in part or in whole, with the same regularity that those by, say, Nirvana or Eric Clapton have been.

60. Artists with successful *Unplugged*-based albums include Arrested Development (1993), Mariah Carey (1992), Clapton (1992), the Eagles (1994), Nirvana (1994), Page and Plant (1994), and Rod Stewart (1993). At the time of writing there are also two collections available of notable, but otherwise unreleased, moments from the show (*Uptown MTV "Unplugged,"* 1993; *The Unplugged Collection, Volume One,* 1995)).

61. The liner notes to *The Unplugged Collection, Volume One* (1995), for instance, offer a detailed account of the show's origins that doesn't mention either Elvis or the "Comeback Special" even in passing.

62. This proto-genre of music television did flourish for a while in the 1970s as the musical bread and butter of prime time variety shows (e.g., *The Captain and Tenille Show, The Donny and Marie Show,* etc.). With the demise of the television variety show, however, this brand of cheesy musical revue (thankfully) died off as well.

63. The original broadcast (available today on videocassette in a somewhat extended form as *Elvis '68 Comeback Special* (1968/1988)) used fragments of this performance throughout the course of the program. A full-length videotape containing just the informal jam session is available as *Elvis: One Night with You* (1968/1988).

64. Technically, the idea for this performance came not from Elvis, but from the show's producer, Steve Binder. Credit for making the performance *work*, however, has to go to Elvis. Without the strength and vitality of Elvis's performance, there would have been no comeback, and this special would probably not be remembered today by any but the most diehard of Elvis fans.

65. While it's not a roadside shrine *per se*, Joni Mabe's Traveling Panoramic Encyclopedia of Everything Elvis, an art exhibit built around a huge collection of Elvis memorabilia, embodies the devotional spirit of the roadside shrines on a somewhat larger scale. The program from a 1991 installation of the Encyclopedia at the Columbia [South Carolina] Museum of Art describes the exhibit as Mabe's "personal vision and interpretation of the Elvis Presley experience a sort of cultural shrine to the King of Rock and Roll." My thanks to Jon Crane for bringing Mabe's work to my attention.

66. See, for example, Samuel Charters's *Elvis Presley Calls His Mother after the Ed Sullivan Show* (1992), Mark Childress's *Tender* (1990), or the various poems about Elvis in David Wojahn's *Mystery Train* (1990: 27, 39, 46, 49, 54, 59–61).

67. An example of a particularly subtle homage can be found in an early scene in *Batman Returns* (1992). For a fleeting moment in the office of bad guy Max Shreck (played by Christopher Walken), one can catch of a glimpse of the previously mentioned photo of Elvis meeting Nixon – only in the movie, Nixon's face has been replaced with that of Shreck, presumably because Walken is a longtime fan of Elvis (Weinraub, 1992: 5).

68. Lynn Spigel's (1990) study of Elvis impersonators offers an insightful explanation of the ways in which impersonators and their audiences consciously attempt to revalidate and redeem Elvis's story through the ritualistic retelling of it in concert performances.

69. Both the Unofficial Elvis Aaron Presley Home Page

 (http://sunsite.unc.edu/elvis/ elvishom.html)

 and the Virtual Voyager Elvis page

 (http://www1.chron.com/fronts/interactive/voyager/elvis/index.html)

 contain links to a wide (and ever-expanding) variety of Elvis-related Internet sites.

70. During the ceremonies surrounding the official release of the Elvis postage stamp in January 1993, I encountered one British fan who angrily shook her umbrella in the air out of a frustrated desire to "cosh" Priscilla over the head with it, while telling anyone who would listen (and even a few people who wouldn't) that Priscilla had no right to show her face at such a sacred occasion.

71. The 1991 K-Tel compilation, *A Tribute to Elvis*, contains a dozen such songs, most of which failed to do well in the pop charts – probably because most of them are so maudlin as to be laughable. Put simply, the hurt in Holsapple's voice at the loss of Elvis is palpable and, most importantly, it sounds real – to the point where it's almost moved me to tears. The only thing that any of the tracks on the K-Tel collection have moved me to, despite their undeniably genuine efforts to come across as sincere expressions of grief, are uncontrollable fits of laughter.

72. For instance, in the midst of working on this project, a professor of English who was certain that studying Elvis was a fruitless intellectual enterprise attempted (without much success) to taunt me by wearing a button (and making sure that I noticed it) proclaiming that "Elvis is dead! Get a life!"

73. See "Elvis 101," 1992; "Elvis Study," 1992; Keller, 1992; "Media Clamor Over . . .," 1992; "Professor Teaches Class . . . ," 1992; Greg Smith, 1992; and Woodin, 1992.

74. It's unlikely, for example, that a course on the cultural significance of Beethoven would have attracted worldwide media attention of the sort that was focused on Nazareth's course.

75. Honorable mention in this category goes to the Reggae Philharmonic Orchestra, for taking "Crawfish," an otherwise unmemorable song from *King Creole* (1958), and turning it into a compellingly funky dance track.

SOURCES

PRINTED MATERIALS

Adler, D. (1993). *The Life and Cuisine of Elvis Presley*. New York: Crown.

Adorno, T.W. (1941). "On Popular Music." Reprinted (1990) in S. Frith and A. Goodwin (eds), *On Record: Rock, Pop, and the Written Word* (pp. 301–14). New York: Pantheon.

Adorno, T.W. (1954). "How to Look at Television," *The Quarterly of Film, Radio, and Television*, 8(3), pp. 213–35.

"Ain't Nothing but a Stamp." (1992). [letters to the editor], *Time* (6 July), p. 10.

"All the King's Fans." (1993). *Harper's* (November), p. 27.

Anders, G. (1992). "Right Now," *Washington Post* (29 July), section C, p. 5.

Anderson, B. (1983). *Imagined Communities: Reflections on the Origin and Spread of Nationalism*. New York: Verso.

Arnold, G. (1992). "Rock of Ages: Berkeley Writer Greil Marcus Talks about What Elvis, Madonna, Nirvana, and Jesus Have in Common," *[Oakland, CA] Express* (21 February), pp. 1ff.

Aufderheide, P. (ed.) (1992). *Beyond P.C.: Toward a Politics of Understanding*. Saint Paul, MN: Graywolf.

Bangs, L. (1977). "Where Were You When Elvis Died?" Reprinted (1987) in *Psychotic Reactions and Carburetor Dung* (pp. 212–16). New York: Alfred A. Knopf.

Bangs, L. (1980). "From Notes for Review of Peter Guralnick's *Lost Highway*." Reprinted (1987) in *Psychotic Reactions and Carburetor Dung* (pp. 322–36). New York: Alfred A. Knopf.

Barker, C. (1994). "Notes on St. Elvis." In P.M. Sammon (ed.), *The King Is Dead: Tales of Elvis Postmortem* (pp. 208–15). New York: Delta.

Bartel, P. (1995). *Everything Elvis*. Dallas: Taylor.

Barth, J. (1991). *Roadside Elvis: The Complete State-by-State Travel Guide for Elvis Presley Fans*. Chicago: Contemporary Books.

Barthes, R. (1957). *Mythologies*. Translation (1972) by A. Lavers. New York: Noonday.

Baty, S.P. (1995). *American Monroe: The Making of a Body Politic*. Berkeley: University of California Press.

Baudrillard, J. (1983). *Simulations*. Translation by P. Foss, P. Patton, and P. Beitchman. New York: Semiotext(e).

Bellah, R., Madsen, R., Sullivan, W.M., Swindler, A., and Tipton, S.M. (1985). *Habits of the Heart: Individualism and Commitment in American Life*. New York: Harper and Row.

Bennetts, L. (1993). "k.d. lang Cuts It Close," *Vanity Fair* (August), pp. 94–9, 142–6.

Berger, Joe. (1995). "With This King . . . I Thee Wed!: Elvis Double to Marry Priscilla Impersonator," *Weekly World News* (28 February), p. 11.

Berger, John. (1972). *Ways of Seeing*. New York: Penguin.

Berman, P. (1992). *Debating P.C.: The Controversy over Political Correctness on College Campuses*. New York: Laurel.

Bernard, J. (1990). "The Fab Four," *Rock and Roll Confidential*, 83, pp. 1–2.

Bérubé, M. (1991). "Public Image Limited: Political Correctness and the Media's Big Lie," *Village Voice* (18 June), pp. 31–7.

Bérubé, M. (1995). "Entertaining Cultural Criticism." Paper presented as part of the Unit for Criticism and Interpretive Theory's Monthly Colloquium Series, University of Illinois, Urbana, April.

"Beware Elvis Presley." (1956). *America* (23 June), pp. 294–5.

Booth, S. (1968). "A Hound Dog, to the Manor Born." Reprinted (1982) in M. Torgoff (ed.), *The Complete Elvis* (pp. 40–69). New York: Delilah.

Booth, S. (1991). *Rythm Oil: A Journey through the Music of the American South*. New York: Pantheon.

Bova, J. (1994). *Don't Ask Forever: My Love Affair with Elvis*. Memphis: Pinnacle.

Bowden, B. (1982). *Performed Literature: Words and Music by Bob Dylan*. Bloomington: Indiana University Press.

Brandon, K. (1993). "6-Figure Families Claim Life Isn't Grand for Them," *Chicago Tribune* (22 February), section 1, pp. 1, 6.

Brewer-Giorgio, G. (1988). *Is Elvis Alive?* New York: Tudor.

Brewer-Giorgio, G. (1990). *The Elvis Files: Was His Death Faked?* New York: Shapolsky.

Brock, V.K. (1979). "Images of Elvis, the South, and America." In J.L. Tharpe (ed.), *Elvis: Images and Fancies* (pp. 87–122). Jackson: University Press of Mississippi.

Bryant, A. (1994). "If Elvis Joins Me, We Both Fly Free?: Airlines Are Getting Downright Quirky in New Schemes to Fill Seats, Boost Revenues," *Charlotte Observer* (30 January), section C, pp. 1, 4.

Butler, B.A. (1992). *Are You Hungry Tonight?: Elvis' Favorite Recipes*. New York: Gramercy.

Cantor, L. (1992). *Wheelin' on Beale: How WDIA-Memphis Became the Nation's First All-Black Radio Station and Created the Sound that Changed America*. New York: Pharos.

Carey, J.W. (1988). "Taking Culture Seriously." In J.W. Carey (ed.), *Media, Myths, and Narratives: Television and the Press* (pp. 8–18). Newbury Park, CA: Sage.

Carey, J.W. (1989). *Communication as Culture: Essays on Media and Society*. Boston: Unwin Hyman.

Carlson, M. (1992). "It's the Little Things . . . ," *Time* (23 November), p. 31.

Carter, P. (1987). *The Road to Botany Bay: An Exploration of Landscape and History*. Chicago: University of Chicago Press.

Chapple, S., and Garofalo, R. (1977). *Rock 'n' Roll Is Here to Pay: The History and Politics of the Music Industry*. Chicago: Nelson-Hall.

Charters, S. (1992). *Elvis Presley Calls His Mother after the Ed Sullivan Show*. Minneapolis: Coffee House.

Childress, M. (1990). *Tender: A Novel*. New York: Harmony.

Choron, S., and Oskam, B. (1991). *Elvis!: The Last Word*. New York: Citadel.

Christgau, R. (1991). "Madonnathinking Madonnabout Madonnamusic," *Village Voice* (28 May), pp. 31, 33.

Clauson-Wicker, S. (1994). "Amazing Graceland," *Mid-Atlantic Country* (April), p. 10.

Clayton, R., and Heard, D. (eds) (1994). *Elvis up Close: In the Words of Those Who Knew Him Best*. Atlanta: Turner.

"Clinton's Inaugural Aims for a Ringing Appeal." (1992). *Chicago Tribune* (19 December), section 1, p. 9.

Cohen, R. (1988). "Return to Sender," *Washington Post Magazine* (9 October), p. 11.

Collins, N.A. (1994). "The Sacred Treasures of Graceland: Excerpts from the Sanctioned Museum Catalogue." In P.M. Sammon (ed.), *The King Is Dead: Tales of Elvis Postmortem* (pp. 197–200). New York: Delta.

Committee to Elect the King. (1992). *Elvis for President*. New York: Crown.

Coupland, D. (1991). *Generation X: Tales for an Accelerated Culture*. New York: St Martin's.

Coupland, D. (1994). *Life after God*. New York: Pocket.

Crane, C.R. (1977). *My Final Tribute: Elvis*. Dallas: Gateway Enterprises.

Creel, G. (1994). "Cashing in on the Elvis Nation." Paper presented to the conference, "Constructing a Dialogue: Current Work on America(s)," Minneapolis, April.

Cronin, P., Isler, S., and Rowland, M. (1992). "Elvis Presley: An Oral Biography," *Musician* (October), pp. 50 60ff.

Cutler, C. (1985). "Phil Ochs and Elvis Presley," *Ré Records Quarterly*, 1(1), pp. 11–16.

Day, A. (1988). *Jokerman: Reading the Lyrics of Bob Dylan*. New York: Basil Blackwell.

DeLillo, D. (1985). *White Noise*. New York: Penguin.

DeNight, B., Fox, S., and Rijff, G. (eds) (1991). *Elvis Album*. New York: Beekman House.

Denton, B. (1991). *Buddy Holly Is Alive and Well on Ganymede*. New York: Avon Books.

Denzin, N.K. (1989). *Interpretive Biography*. Newbury Park, CA: Sage.

DePaoli, G. (ed.) (1994). *Elvis + Marilyn: 2 x Immortal*. New York: Rizzoli.

Dexter, B. (1994). "Elvis Tells Lisa Marie: Divorce Michael!" *Weekly World News* (6 September), pp. 8–9.

Doll, S. (1995). *Elvis: Portrait of the King*. Lincolnwood, IL: Publications International.

Dominick, R. (1990). "Elvis: The Boy Who Would Be King," *Penthouse* (September), pp. 114–18ff.

Donaton, S. (1989). "Elvis' Grandkid Is Cover Queen," *Advertising Age* (10 July), p. 37.

Donnelly, J. (1994). "Elvis and Activism." In H. Rheingold (ed.), *The Millennium Whole Earth Catalog: Access to Tools and Ideas for the Twenty-First Century* (p. 282). New York: HarperCollins.

Dorsch, K. (1992). "Poor Example" [letter to the editor], *Chicago Tribune* (16 March), section 1, p. 14.

Doss, E. (1994). "Saint Elvis: Fans, Faith, and Sacred Objects at Graceland." Paper presented at the annual meeting of the American Studies Association, Nashville, October.

Dundy, E. (1985). *Elvis and Gladys*. New York: Macmillan.

Dyer, R. (1979a). "In Defense of Disco." Reprinted (1990) in S. Frith and A. Goodwin (eds), *On Record: Rock, Pop, and the Written Word* (pp. 410–18). New York: Pantheon.

Dyer, R. (1979b). *Stars*. London: British Film Institute.

Eicher, P. (1993). *The Elvis Sightings*. New York: Avon Books.

Ellis, B.E. (1990). "The Twentysomethings: Adrift in a Pop Landscape," *New York Times* (2 December), section 2, pp. 1, 37.

Ellison, H. (1961). *Rockabilly*. Reprinted (1975) as *Spider Kiss*. New York: Pyramid.

"Elvis Dies!: Kidney Failure Kills the King – at 58!" (1993). *Weekly World News* (15 June), pp. 2–4.

"Elvis Is Everywhere." (1992). *Women's Wear Daily* (4 May), pp. 6–7.

"Elvis 101: The King Lives in College Course." (1992). *Hollywood Reporter* (20 January), p. 22.

"Elvis Presley." (1992). *People* (27 July), pp. 48–9.

"Elvis Study." (1992). *Insight* (17 February), pp. 29–30.

ElvisTown. (1991). Memphis: Towery Publishing.

Farren, M. (1994). *The Hitchhiker's Guide to Elvis.* Burlington, Ont.: Collector's Guide.

Fernández, E. (1991). "P.C. Rider," *Village Voice* (18 June), p. 24.

Flanagan, B. (1987). *Written in My Soul: Conversations with Rock's Great Songwriters.* Chicago: Contemporary Books.

Fontaine, S. (1993). "Woman Cured of Throat Cancer after Licking Elvis Stamp," *Sun* (16 February), p. 5.

Fricke, D. (1990). "Living Colour's Time Is Now," *Rolling Stone* (1 November), pp. 50–1ff.

Frith, S. (1983). "Rock Biography," *Popular Music*, 3, pp. 271–7.

Frith, S. (1987). "Towards an Aesthetic of Popular Music." In R. Leppert and S. McClary (eds), *Music and Society: The Politics of Composition, Performance and Reception* (pp. 133–49). New York: Cambridge University Press.

Frith, S. (1991). "The Good, the Bad, and the Indifferent: Defending Popular Culture from the Populists," *Diacritics*, 21(4), pp. 102–15.

Frith, S., and McRobbie, A. (1978). "Rock and Sexuality." Reprinted (1990) in S. Frith and A. Goodwin (eds), *On Record: Rock, Pop, and the Written Word* (pp. 371–89). New York: Pantheon.

Futrelle, D. (1991). "Reading: The Ineffable Elvis," *Chicago Reader*, section 1, pp. 10, 38–9.

Gans, H. (1974). *Popular Culture and High Culture.* New York: Basic Books.

Garber, M. (1992). *Vested Interests: Cross-Dressing and Cultural Anxiety.* New York: Routledge.

Garratt, S. (1984). "Teenage Dreams." Reprinted (1990) in S. Frith and A. Goodwin (eds), *On Record: Rock, Pop, and the Written Word* (pp. 399–409). New York: Pantheon.

Geertz, C. (1973). *The Interpretation of Cultures.* New York: Basic Books.

Gelfand, C., Blocker-Krantz, L, and Nogueira, R. (1992). *In Search of the King.* New York: Perigee.

George, N. (1988). *The Death of Rhythm and Blues.* New York: E.P. Dutton.

Gless, D.J., and Smith, B.H. (1992). *The Politics of Liberal Education.* Durham, NC: Duke University Press.

Goldman, A. (1981). *Elvis.* New York: Avon Books.

Goldman, A. (1991). *Elvis: The Last 24 Hours.* New York: St Martin's.

Gore, T. (1987). *Raising PG Kids in an X-Rated Society.* Nashville: Abingdon.

Gould, J. (1956). "TV: New Phenomenon. Elvis Presley Rises to Fame as Vocalist Who Is Virtuoso of Hootchy-Kootchy," *New York Times* (6 June), p. 67.

Greenberg, C. (1946). "Avant-Garde and Kitsch." Reprinted (1957) in B. Rosenberg and D.M. White (eds), *Mass Culture: The Popular Arts in America* (pp. 98–107). Glencoe, IL: The Free Press.

Greenwood, E., and Tracy, K. (1990). *The Boy Who Would Be King.* New York: Dutton.

Gregory, N., and Gregory, J. (1980). *When Elvis Died.* New York: Pharos [reprinted edn., 1992].

Grossberg, L. (1984). "Another Boring Day in Paradise: Rock and Roll and the Empowerment of Everyday Life," *Popular Music*, 4, pp. 225–8.

Grossberg, L. (1985). "If Rock and Roll Communicates, Then Why Is It So Noisy?: Pleasure and the Popular," *Popular Music Perspectives*, 2, pp. 451–63.

Grossberg, L. (1986a). "Is There Rock after Punk?" *Critical Studies in Mass Communication*, 3, pp. 50–74.

Grossberg, L. (1986b). "Teaching the Popular." In C. Nelson (ed.), *Theory in the Classroom* (pp. 177–200). Urbana: University of Illinois Press.

Grossberg, L. (1988a). *It's a Sin: Essays on Postmodernism, Politics, and Culture*. Sydney: Power Publications.

Grossberg, L. (1988b). "Rockin' with Reagan, or the Mainstreaming of Postmodernity," *Cultural Critique*, 10, pp. 123–49.

Grossberg, L. (1988c). "Wandering Audiences, Nomadic Critics," *Cultural Studies*, 2, pp. 377–91.

Grossberg, L. (1989a). "The Circulation of Cultural Studies," *Critical Studies in Mass Communication*, 6, pp. 413–21.

Grossberg, L. (1989b). "The Formations of Cultural Studies: An American in Birmingham," *Strategies*, 2, pp. 114–49.

Grossberg, L. (1989c). "MTV: Swinging on the (Postmodern) Star." In I. Angus and S. Jhally (eds), *Cultural Politics in Contemporary America* (pp. 254–68). New York: Routledge.

Grossberg, L. (1992a). "Is There a Fan in the House?: The Affective Sensibility of Fandom." In L.A. Lewis (ed.), *The Adoring Audience: Fan Culture and Popular Media* (pp. 50–65). New York: Routledge.

Grossberg, L. (1992b). *We Gotta Get out of This Place: Popular Conservatism and Postmodern Culture*. New York: Routledge.

Grossberg, L. (1993a). "Cultural Studies and/in New Worlds," *Critical Studies in Mass Communication*, 10, 1–22.

Grossberg, L. (1993b). "Is Anybody Listening? Does Anybody Care?: Musical Formations and Theoretical Fabulations." Paper presented at the conference, "On the Beat: Rock 'n' Rap, Mass Media and Society," Columbia, MO, February.

Grossberg, L. (1995). "Cultural Studies: What's In a Name (One More Time)", *Taboo*, 1, pp. 1–37.

Grossberg, L., Nelson, C., Treichler, P.A., Baughman, L., and Wise, J.M. (eds) (1992). *Cultural Studies*. New York: Routledge.

Guralnick, P. (1979). *Lost Highway: Journeys and Arrivals of American Musicians*. New York: Vintage.

Guralnick, P. (1994). *Last Train to Memphis: The Rise of Elvis Presley*. Boston: Little, Brown.

Guterman, J., and O'Donnell, O. (1991). *The Worst Rock-and-Roll Records of All Time: A Fan's Guide to the Stuff You Love to Hate*. New York: Citadel.

Halberstam, D. (1993). *The Fifties*. New York: Villard.

Hall, E.T. (1976). *Beyond Culture*. New York: Doubleday.

Hall, S. (1981). "Notes on Deconstructing 'The Popular.'" In R. Samuel (ed.), *People's History and Socialist Theory* (pp. 227–40). London: Routledge and Kegan Paul.

Hall, S. (1986). "On Postmodernism and Articulation: An Interview with Stuart Hall," *Journal of Communication Inquiry*, 10(2), pp. 45–60.

Hammontree, P. (1979). "Audience Amplitude: The Cultural Phenomenon of Elvis Presley." In J.L. Tharpe (ed.), *Elvis: Images and Fancies* (pp. 52–60). Jackson: University Press of Mississippi.

Harrington, R. (1991). "So What's Elvis up to Lately?: A Rundown of the Tabloids' Latest Hits at the Hitmakers," *Washington Post*, section C, p. 7.

Harrison, T. (1992). *Elvis People: The Cult of the King*. London: Fount.

Hazen, C., and Freeman, M. (1994). *The Best of Elvis: Recollections of a Great Humanitarian*. Memphis: Pinnacle.

Heileman, J. (1991). "Rouble without a Cause," *Modern Review* (Autumn), pp. 5ff.

Heilman, D. (1992). "Tryin' to Get to You: Greil Marcus Chases the Ghost of Elvis Presley," *Rock & Roll Disc* (March), pp. 9–11ff.

Henderson, W.M. (1984). *Stark Raving Elvis*. New York: Fireside.

"Hillbilly on a Pedestal." (1956). *Newsweek* (14 May), p. 82.

Himowitz, M. (1990). "Earth to Elvis: New Computer Game Lets You Search for 'The King,'" *Ann Arbor News* (6 September), section B, p. 3.

Hinerman, S. (1992). "'I'll Be Here with You': Fans, Fantasy and the Figure of Elvis." In L.A. Lewis (ed.), *The Adoring Audience: Fan Culture and Popular Media* (pp. 107–34). New York: Routledge.

Hirsch, E.D. Jr (1987). *Cultural Literacy: What Every American Needs to Know*. Boston: Houghton Mifflin.

Hirsch, E.D. Jr, Kaliski, J., Pareles, J., Shattuck, R., and Spivak, G. (1989). "Who Needs the Great Works?" *Harper's* (September), pp. 43–52.

Hirsch, E.D. Jr, Kett, J.F., and Trefil, J. (1988). *The Dictionary of Cultural Literacy: What Every American Needs to Know*. Boston: Houghton Mifflin.

Hirsch, E.D. Jr, Kett, J.F., and Trefil, J. (1993). *The Dictionary of Cultural Literacy: What Every American Needs to Know* (2nd rev. edn.). Boston: Houghton Mifflin.

Hirshberg, C., and the editors of *Life*. (1995). *Elvis: A Celebration in Pictures*. New York: Warner.

Hirshey, G. (1985). *Nowhere to Run: The Story of Soul Music*. New York: Penguin.

Holden, S. (1990). "Elvis' Secret Diary," *Weekly World News* (9 October), pp. 23–6.

Holladay, J. (1992). *Where's Elvis?* New York: Checkerboard.

Hopkins, J. (1971). *Elvis: A Biography*. New York: Warner.

Howe, I. (1948). "Notes on Mass Culture." Reprinted (1957) in B. Rosenberg and D.M. White (eds), *Mass Culture: The Popular Arts in America* (pp. 496–503). Glencoe, IL: The Free Press.

Howe, N., and Strauss, B. (1993). *13th Gen: Abort, Retry, Ignore, Fail?* New York: Vintage.

"A Howling Hillbilly Success." (1956). *Life* (30 April), p. 64.

Hughes, R. (1993). *Culture of Complaint: The Fraying of America*. New York: Oxford University Press.

I Am Elvis: A Guide to Elvis Impersonators. (1991). New York: Pocket.

Jacobs, A.J. (1992a). "The Two Kings," *The Nose*, 10, p. 16.

Jacobs, A.J. (1992b). "The Two Kings," *Utne Reader* (July/August), p. 168.

Jacobs, A.J. (1994). *The Two Kings*. New York: Bantam.

Jameson, F. (1984). "Postmodernism, or the Cultural Logic of Late Capitalism," *New Left Review*, 146, pp. 53–92.

Jerome, J. (1992). "A Session with Little Richard," *Life* (1 December), pp. 48–50.

Johns, M. (1992). "Elvis Presley Injured in Motorcycle Crash!" *Weekly World News* (28 July), pp. 4-5.

Jones, L. (1990). "Living Coloured and Proud," *Spin* (October), pp. 49–50ff.

Kanchanawan, N. (1979). "Elvis, Thailand, and I." In J.L. Tharpe (ed.), *Elvis: Images and Fancies* (pp. 162–8). Jackson: University Press of Mississippi.

Kearns, B. (1988). "The Year of the Mutant Elvis," *Spin* (December), p. 72.

Keller, L. (1992). "Elvis May Have Left the Building but He's Back in Classrooms at U. of Iowa," *U.: The National College Newspaper* (Spring), p. 6.

Kelly-Bootle, S. (1992). "Millennial Mall Mythology: *Snow Crash*," *Mondo 2000*, 7, pp. 100–1.

Kendall, W.C. (1979). "And Now, Direct to You from Hillbilly Heaven." In J.L. Tharpe (ed.), *Elvis: Images and Fancies* (pp. 61–4). Jackson: University Press of Mississippi.

"The King & I: Sure, Carville Got the Credit, but Clinton May Really Owe it All to Elvis." (1992/93). *People* (28 December/4 January), pp. 114–15.

"King for a Day." (1992). *People* (14 September), p. 148.

Klonsky, M. (1949). "Along the Midway of Mass Culture." Reprinted (1953) in W. Phillips and P. Rahv (eds), *New Partisan Reader, 1945–1953* (pp. 344–60). New York: Harcourt, Brace and Company.

Kohut, J., and Kohut, J.J. (1994). *Rock Talk: The Great Rock and Roll Quote Book*. Boston: Faber and Faber.

Kreature Comforts. Lowlife Guide to Memphis (or, Memphis on $12.96 a Day). (1992). Memphis: Shangri-La.

Krogh, E. (1994). *The Day Elvis Met Nixon*. Bellevue, WA: Pejama.

Kroker, A., Kroker, M., and Cook, D. (1989). *Panic Encyclopedia*. New York: St Martin's.

Landman, M. (1991). "Fetal Elvis!" *Buzz*, 3, pp. 11–16. [Princeton, WI: Kitchen Sink Comix]

Lapham, L.H. (1992). "Deus ex Machina," *Harper's* (November), pp. 11–13.

Lapides, B. (1992). "Beth Lapides: First Lady-to-be," *In These Times* (16–30 September).

Latham, C., and Sakol, J. (1991). *"E" Is for Elvis: An A-to-Z Illustrated Guide to the King of Rock and Roll*. New York: Plume.

Lee, S. (1990). "Eddie!: An Exclusive Interview with Eddie Murphy by Spike Lee," *Spin* (October), pp. 32–6ff.

Leiss, W., Kline, S., and Jhally, S. (1990, 2nd edn.). *Social Communication in Advertising: Persons, Products and Images of Well-Being* (1st edn. 1985). New York: Routledge.

Levine, L.W. (1988). *Highbrow/Lowbrow: The Emergence of Cultural Hierarchy in America*. Cambridge, MA: Harvard University Press.

Lipsitz, G. (1990). "Comment: What Counts as Culture?" *Chicago Reader* (10 August), section 1, pp. 10–11.

"Long Live the King." (1991). *Sydney [Australia] Morning Herald* (16 August).

Ludwig, H. (1990). "No Place for Elvis," *Archaeology*, 43(6), p. 10.

Ludwig, L. (1994). *The Gospel of Elvis: The Testament and Apocrypha of the Greater Themes of "The King."* Arlington, TX: Summit Publishing.

Lyon, G.W. (1970). "More on the Beatles Textual Problems," *Journal of Popular Culture*, 4, pp. 549–52.

McClary, S. (1991). *Feminine Endings: Music, Gender, and Sexuality*. Minneapolis: University of Minnesota Press.

McClary, S., and Walser, R. (1990). "Start Making Sense!: Musicology Wrestles with Rock." In S. Frith and A. Goodwin (eds), *On Record: Rock, Pop, and the Written Word* (pp. 277–92). New York: Pantheon.

McCoy, C. (1989). "Mississippi Town All Shook up over Voodoo Plot," *Wall Street Journal* (24 February), section A, pp. 1, 4.

McCray, P. (1993). *Elvis Shrugged*. San Diego: Revolutionary Comics.

McDermott, J.F. (1989). "Elvis Presley and the Rieger Award," *Journal of the American Academy of Child and Adolescent Psychiatry*, 28, p. 654.

MacDonald, D. (1953). "A Theory of Mass Culture." Reprinted (1957) in B. Rosenberg and D.M. White (eds), *Mass Culture: The Popular Arts in America* (pp. 59–73). Glencoe, IL: The Free Press.

Madonna (1992). *Sex*. New York: Warner Books.

Malone, B.C. (1985, rev. edn.). *Country Music U.S.A.* (1st edn. 1968). Austin: University of Texas Press.

Manegold, C.S. (1992). "Buffalo Protests Fade into a Footnote on Abortion," *New York Times* (3 May), section 1, p. 20.

Marcus, G. (1981). "Lies about Elvis, Lies about Us: The Myth behind the Truth behind the Legend," *Voice Literary Supplement* (December), pp. 16–17.

Marcus, G. (1985). "The Dead and the Quick," *Artforum*, 23(6), pp. 66–71.

Marcus, G. (1989). *Lipstick Traces: A Secret History of the Twentieth Century*. Cambridge, MA: Harvard University Press.

Marcus, G. (1990a, 3rd rev. edn.). *Mystery Train: Images of America in Rock 'n' Roll Music* (1st edn. 1975). New York: E.P. Dutton.

Marcus, G. (1990b). "Still Dead: Elvis Presley without Music," *Artforum*, 29(1), pp. 117–23.

Marcus, G. (1991). *Dead Elvis: A Chronicle of a Cultural Obsession*. New York: Doubleday.

Marcus, G. (1992a). "The Elvis Strategy," *New York Times* (27 October), section A, p. 15.

Marcus, G. (1992b). [letter to the editor], *Rock & Roll Disc* (May), p. 4.

Marcus, G. (1992c). "Notes on the Life & Death and Incandescent Banality of Rock 'n' Roll," *Esquire* (August), pp. 67–71ff.

Margaronis, M. (1989). "Waiting for the Barbarians: The Ruling Class Defends the Citadel," *Voice Literary Supplement* (January/February), pp. 12–17.

Marsh, D. (1977). "How Great Thou Art." Reprinted (1985) in *Fortunate Son: Criticism and Journalism by America's Best-Known Rock Writer* (pp. 303–6). New York: Random House.

Marsh, D. (1982). *Elvis*. New York: Thunder's Mouth Press (reprinted edn., 1992).

Marsh, D. (1987). *Glory Days: Bruce Springsteen in the 1980s*. New York: Pantheon.

Marsh, D. (1992). "Introduction." In *Elvis* (reprinted edition, pp. vii–xi). New York: Thunder's Mouth.

Marsh, D., and Stein, K. (1981). *The Book of Rock Lists*. New York: Dell.

Marshall, G. (1969). "Taking the Beatles Seriously: Problems of Text," *Journal of Popular Culture*, 3, pp. 28–34.

Martin, L., and Segrave, K. (1988). *Anti-Rock: The Opposition to Rock 'n' Roll*. New York: Da Capo Press (reprinted edn., 1993).

Marx, K. (1852). "The Eighteenth Brumaire of Louis Bonaparte." Excerpted and reprinted (1978) in R.C. Tucker (ed.), *The Marx-Engels Reader* (2nd edn., pp. 594–617). New York: W.W. Norton & Company.

"Media Clamor over Elvis Citings." (1992). *[The University of Iowa] Spectator* (Spring), p. 1.

Mellers, W. (1976). *Twilight of the Gods: The Beatles in Retrospect*. London: Faber.

Mellers, W. (1981). "God, Modality and Meaning in Some Recent Songs of Bob Dylan," *Popular Music*, 1, pp. 143–57.

Melly, G. (1970). *Revolt into Style: The Pop Arts*. New York: Anchor.

Michael, D. (1990). *The Elvis Mandible*. New York: Piranha.

Middleton, R. (1979). "All Shook Up?: Innovation and Continuity in Elvis Presley's Vocal

Style." In J.L. Tharpe (ed.), *Elvis: Images and Fancies* (pp. 151–61). Jackson: University Press of Mississippi.

Morrell, D. (1994). "Presley 45." In P.M. Sammon (ed.), *The King Is Dead: Tales of Elvis Postmortem* (pp. 279–87). New York: Delta.

Musto, M. (1995). "La Dolce Musto," *Village Voice* (10 October), p. 26.

Naipaul, V.S. (1989). *A Turn in the South*. New York: Alfred A. Knopf.

Nash, A. (1995). *Elvis Aaron Presley: Revelations From the Memphis Mafia*. New York: HarperCollins.

Nelkin, D., and Lindee, M.S. (1995). "Elvis' DNA: The Gene as a Cultural Icon," *The Humanist* (May/June), pp. 10–19.

Nicholson, D. (1992). "Please Mr. Postman . . . : If Elvis Deserves a Stamp, So Do America's Black Rockers," *Washington Post* (26 January), section C, p. 5.

Nixon, M. (1992). "Preface." In K. Quain (ed.), *The Elvis Reader: Texts and Sources on the King of Rock 'n' Roll* (pp. xiii–xv). New York: St Martin's.

Norman, P. (1981). *Shout!: The Beatles in Their Generation*. New York: Fireside.

O'Brien, G. (1982). "Anagrams." In M. Torgoff (ed.), *The Complete Elvis* (pp. 10–17). New York: Delilah.

Oermann, R.K., and Cooley, A. (1982). [untitled essay review of 38 books on Elvis Presley], *Journal of Country Music*, 9(2), pp. 120–6.

Olson, M., and Crase, D. (1990). "Presleymania: The Elvis Factor," *Death Studies*, 14, pp. 277–82.

Owen, F. (1990). "Public Service," *Spin* (March), pp. 56–8ff.

Paglia, C. (1990). *Sexual Personae: Art and Decadence from Nefertiti to Emily Dickinson*. New York: Vintage.

Paglia, C. (1991). "What a Drag: Marjorie Garber's *Vested Interests: Cross-Dressing and Cultural Anxiety*." Reprinted (1992) in *Sex, Art, and American Culture: Essays* (pp. 96–100). New York: Vintage.

Pareles, J., and Romanowski, P. (1983). *The "Rolling Stone" Encyclopedia of Rock & Roll*. New York: Rolling Stone Press.

Parker, J. (1993). *Elvis: The Secret Files*. London: Anaya.

Pattison, R. (1987). *The Triumph of Vulgarity: Rock Music in the Mirror of Romanticism*. New York: Oxford University Press.

Peabody, R. and Ebersole, L. (eds) (1994). *Mondo Elvis: A Collection of Stories and Poems about Elvis*. New York: St Martin's.

Pearlman, J. (1986). *Elvis for Beginners*. New York: Writers and Readers.

Phillips, S.C. (1989). "When Words Collide: Reading, Writing, and Revolution," *Voice Literary Supplement* (January/February), p. 30.

Pierce, P.J. (1994). *The Ultimate Elvis: Elvis Presley Day by Day*. New York: Simon & Schuster.

Piraro, D. (1988). *Too Bizarro*. San Francisco: Chronicle.

Poague, L.A. (1974). "Dylan as *Auteur*: Theoretical Notes, and an Analysis of 'Love Minus Zero/No Limit,'" *Journal of Popular Culture*, 8, pp. 53–7.

Poague, L.A. (1979). "Performance Variables: Some Versions of Dylan's 'It Ain't Me, Babe,'" *Journal of Aesthetic Education*, 13(3), pp. 79–97.

Poirier, R. (1967). "Learning from the Beatles," *Partisan Review*, pp. 526–46.

Pond, S. (1990). "The Industry in the Eighties," *Rolling Stone* (15 November), pp. 113–14ff.

Pratt, L.R. (1979). "Elvis, or the Ironies of a Southern Identity." In J.L. Tharpe (ed.), *Elvis: Images and Fancies* (pp. 40–51). Jackson: University Press of Mississippi.

Pratt, L.R. (1992). "Speaking in Tongues: Dead Elvis and the Greil Quest," *Postmodern Culture*, 2(3).

Pratt, M.L. (1990). "Humanities for the Future: Reflections on the Western Culture Debate at Stanford." Reprinted (1992) in D.J. Gless and B.H. Smith (eds), *The Politics of Liberal Education* (pp. 13–31). Durham, NC: Duke University Press.

Pressley, S.A. (1991). "Elvis? She's Alive and Well and Thanks God," *Washington Post* (28 May), section B, pp. 1, 6.

"Professor Teaches Class in King of Rock 'n' Roll." (1992). United Press International wire story, 8 January.

Puterbaugh, P. (1990). "Little Richard," *Rolling Stone* (19 April), pp. 50–2ff.

Quain, K. (ed.) (1992). *The Elvis Reader: Texts and Sources on the King of Rock 'n' Roll*. New York: St Martin's.

Radway, J. (1984). *Reading the Romance: Women, Patriarchy, and Popular Literature*. Chapel Hill: University of North Carolina Press.

Rankin, R. (1990). *Armageddon: The Musical*. New York: Dell.

Reed, B. (1982). "Elvis in Hollywood." In M. Torgoff (ed.), *The Complete Elvis* (pp. 118–25). New York: Delilah.

Reed, L. (1994). "Damaged Goods." In P.M. Sammon (ed.), *The King Is Dead: Tales of Elvis Postmortem* (pp. 24–7). New York: Delta.

Resnick, M. (ed.) (1992). *Alternate Kennedys*. New York: Tor.

Rheingold, H. (1993). *The Virtual Community: Homesteading on the Electronic Frontier*. New York: HarperPerrenial.

Rieff, D. (1993). "Multiculturalism's Silent Partner: It's the Newly Globalized Consumer Economy, Stupid," *Harper's* (August), pp. 62–4ff.

Ringle, K. (1993). "Nixoniana: A Gift of Nostalgia," *Washington Post* (18 December), section F, pp. 1, 8.

Rodman, G.B. (1993). "Making a Better Mystery out of History: Of Plateaus, Roads, and Traces," *Meanjin*, 52(2), pp. 295–312.

Rohn, D.T. (1994). "A Cheap Flight if You Love Him Tender: Airlines Offer Special Deal in Honor of Elvis Presley's Birthday," *Washington Post* (8 January), section D, p. 1.

Romano, C. (1991). "'Dead Elvis' Author Is in Town," *Philadelphia Inquirer* (8 November), section D, pp. 1, 8.

Rosenbaum, R. (1995). "Among the Believers," *New York Times Magazine* (24 September), pp. 50–7ff.

Rosenberg, B. (1957). "Mass Culture in America." In B. Rosenberg and D.M. White (eds), *Mass Culture: The Popular Arts in America* (pp. 3–12). Glencoe, IL: The Free Press.

Rosenberg, B. (1968). "Mass Culture Revisited." Reprinted (1971) in B. Rosenberg and D.M. White (eds), *Mass Culture Revisited* (pp. 3–12). New York: Van Nostrand Reinhold.

Rosenberg, N.V. (1970). "Taking Popular Culture Seriously: The Beatles," *Journal of Popular Culture*, 4, pp. 53–6.

Rosenfeld, M. (1992). "A Little Bit of Graceland at Home: Elvis Lives on at Don and Kim Epperly's Miniature Shrine," *Washington Post* (15 August), section D, pp. 1, 7.

Rovin, J. (1992). *The World According to Elvis: Quotes from the King*. New York: Harper.

Saavedra, M.E. (1991a). "'Elvis Is Alive' Theory Goes to College," *Philadelphia Inquirer* (15 June), section D, pp. 1, 11.

Saavedra, M.E. (1991b). "'The King' Lives?: Elvis Isn't Dead; He's Just Hiding from the Mob," *Lexington Herald-Leader* (15 June), section A, pp. 1, 15.

Sales, R., Senevy, L., and Seth, R. (1992). *In Search of Elvis: A Fact-Filled Seek-and-Find Adventure*. Fort Worth, TX: Summit .

Sammon, P.M. (ed.) (1994). *The King Is Dead: Tales of Elvis Postmortem*. New York: Delta.

Sandow, G. (1987). "Rhythm and Ooze," *Village Voice* (18 August), pp. 71ff.

Sauers, W. (1984). *Elvis Presley: A Complete Reference*. Jefferson, NC: McFarland.

Savan, L. (1992). "Populism and the Show Girl: The *Star*'s Unsold Story," *Village Voice* (11 February), p. 28.

Scherman, R. (1991). *Elvis Is Everywhere*. New York: Clarkson Potter.

Schiller, H.I. (1989). "The Privatization and Transnationalization of Culture." In I. Angus and S. Jhally (eds), *Cultural Politics in Contemporary America* (pp. 317–32). New York: Routledge.

Schmidt, W.E. (1988). "Someplace for the King to Call Home," *New York Times* (12 October).

Schoenstein, R. (1992). "Nothin' but a Hound Dog Idea," *New York Times* (27 January), section A, p. 11.

Schröer, A. (1993). *Private Presley. The Missing Years – Elvis in Germany*. New York: William Morrow and Company.

Seigworth, G. (1993). "The Distance between Me & You: Madonna & Celestial Navigation (or You Can Be My *Lucky Star*)." In C. Schwictenberg (ed.), *The Madonna Connection: Representational Politics, Subcultural Identities, and Cultural Theory* (pp. 291–318). Boulder, CO: Westview.

Shamayyim, M.C. (1995). "Elvis and His Angelic Connection," *Angel Times*, 1(4), pp. 20–25.

Shaw, J. (1991). "The King Is Not Dead," *Sun* (23 July), pp. 6–7.

Shepherd, S. (1991). *Elvis Hornbill: International Business Bird*. New York: Henry Holt.

Shulruff, L.I. (1991). "New Home Products, All Better than the Ones You've Got," *New York Times* (15 August), section B, p. 4.

Shumway, D. (1991). "Rock & Roll as a Cultural Practice," *South Atlantic Quarterly*, 90, pp. 753–69.

Silberman, N.A. (1990). "Elvis: The Myth Lives On," *Archaeology*, 43(4), p. 80.

Sloan, K. and Pierce, C. (eds) (1993). *Elvis Rising: Stories on the King*. New York: Avon.

Slobin, M. (1993). *Subcultural Sounds: Micromusics of the West*. Hanover, NH: Wesleyan University Press.

Smith, Gene. (1994). *Elvis's Man Friday*. Nashville: Light of Day.

Smith, Greg. (1992). "Elvis Lives at UI: Professor to Teach Class on Career, Influence of Presley," *Iowa City Press-Citizen* (15 January).

Smucker, T. (1979). "Precious Lord: New Recordings of the Great Gospel Songs of Thomas A. Dorsey." In G. Marcus (ed.), *Stranded: Rock and Roll for a Desert Island* (pp. 161–70). New York: Alfred A. Knopf.

Spigel, L. (1990). "Communicating with the Dead: Elvis as Medium," *Camera Obscura*, 23, pp. 176–205.

Stanley, D.E. (1994). *The Elvis Encyclopedia*. Santa Monica, CA: General Publishing.

Steele, A. (1990). *Clarke County, Space*. New York: Ace.

Stephenson, N. (1992). *Snow Crash*. New York: Bantam.

Stern, J., and Stern, M. (1987). *Elvis World*. New York: Alfred A. Knopf.

"Sticky Questions in Stamp Land." (1992). *New York Times* (9 February), section 2, p. 22.

Stromberg, P. (1990). "Elvis Alive?: The Ideology of American Consumerism," *Journal of Popular Culture*, 24(3), pp. 11–19.

"Tabloid Journalism 101." (1992). *Harper's* (December), pp. 23ff.

Tannenbaum, R. (1992). "The Man in Black," *Village Voice* (28 July), p. 69.

Tarr, J. (1992). "Them Old Hyannis Blues." In M. Resnick (ed.), *Alternate Kennedys* (pp. 116–27). New York: Tor.

Taubin, A. (1987). "My Elvis," *Village Voice* (11 August), p. 43.

Taylor, R.G. (1987). *Elvis in Art*. New York: St Martin's.

Taylor, W.J. (1995). *Elvis in the Army: The King of Rock 'n' Roll as Seen by an Officer Who Served with Him*. Novato, CA: Presidio.

"Teeners' Hero." (1956). *Time* (14 May), pp. 53–4.

"Text of President's Speech Accepting the Nomination for Another Four Years." (1992). *New York Times* (21 August), section A, pp. 10–11.

Thompson, C.C., and Cole, J.P. (1991). *The Death of Elvis: What Really Happened*. New York: Delacorte.

Trillin, C. (1992). "Character Issue Sticks to Stamps," *The Seattle Post-Intelligencer* (17 March), section A, p. 2.

Ventura, M. (1985). *Shadow Dancing in the U.S.A*. Los Angeles: Jeremy P. Tarcher.

Vermorel, F., and Vermorel, J. (1985). *Starlust: The Secret Life of Fans*. London: Comet.

Vermorel, F., and Vermorel, J. (1992). "A Glimpse of the Fan Factory." In L.A. Lewis (ed.) *The Adoring Audience: Fan Culture and Popular Media* (pp. 191–207). New York: Routledge.

Vikan, G. (1994). "Graceland as *Locus Sanctus*." In G. DePaoli (ed.), *Elvis + Marilyn: 2 x Immortal* (pp. 150–66). New York: Rizzoli.

Waldrop, H. (1982). "Ike at the Mike." Reprinted (1993) in K. Sloan and C. Pierce (eds), *Elvis Rising: Stories on the King* (pp. 126–39). New York: Avon.

Walker, J. (1982). "The Bootleg Elvis." In M. Torgoff (ed.), *The Complete Elvis* (pp. 92–7). New York: Delilah.

Ward, E., Stokes, G., and Tucker, K. (1986). *Rock of Ages: The "Rolling Stone" History of Rock and Roll*. New York: Summit.

Wark, M. (1989). "Elvis: Listen to the Loss," *Art and Text*, 31, pp. 24–8.

Weinraub, B. (1992). "He Looks Hollywood but Talks New York," *New York Times* (24 June), section B, pp. 1, 5.

Wertheimer, A. (1979). *Elvis '56: In the Beginning*. New York: Collier.

West, R., West, S., and Hebler, D. (1977). *Elvis: What Happened?* New York: Ballantine.

Williams, J. (ed.) (1995). *PC Wars: Politics and Theory in the Academy*. New York: Routledge.

Williams, R. (1958a). *Culture and Society 1780–1950*. London: Chatto and Windus.

Williams, R. (1958b). "Culture Is Ordinary." Reprinted (1989) in *Resources of Hope: Culture, Democracy, Socialism* (pp. 3–18). New York: Verso.

Williams, R. (1961). *The Long Revolution: An Analysis of the Democratic, Industrial, and Cultural Changes Transforming Our Society*. New York: Columbia University Press.

Williams, R. (1977). *Marxism and Literature*. New York: Oxford University Press.

Williams, R. (1981). *Culture*. London: Fontana.

Williams, R. (1983, rev. edn.). *Keywords: A Vocabulary of Culture and Society* (1st edn. 1976). New York: Oxford University Press.

Williamson, C. (1989). *Dreamthorp*. New York: Avon.

Williamson, C. (1994). "Double Trouble." In P.M. Sammon (ed.), *The King Is Dead: Tales of Elvis Postmortem* (pp. 54–65). New York: Delta.

Williamson, J. (1978). *Decoding Advertisements: Ideology and Meaning in Advertising*. New York: Marion Boyars.

SOURCES

Wise, S. (1984). "Sexing Elvis." Reprinted (1990) in S. Frith and A. Goodwin (eds), *On Record: Rock, Pop, and the Written Word* (pp. 390–8). New York: Pantheon.

Wojahn, D. (1990). *Mystery Train*. Pittsburgh: University of Pittsburgh Press.

Womack, J. (1993). *Elvissey: A Novel of Elvis Past and Elvis Future*. New York: Tor.

Wombacher, M. (1991). *Elvis Presley Is a Wormfeast!* Peoria, IL: POP Productions.

Wood, J. (1991). "Who Says a White Band Can't Play Rap?: Cultural Consumption, from Elvis Presley to the Young Black Teenagers," *Voice Rock & Roll Quarterly* (March), pp. 10–11.

Woodin, H.S. (1992). "Elvis Cited in U of I Class," *Cedar Rapids Gazette* (23 January), section A, pp. 1, 6.

Worth, F.L., and Tamerius, S.D. (1988). *Elvis: His Life from A to Z*. Chicago: Contemporary Books.

Wyman, B. (1990). "20 Questions: Chuck D," *Playboy* (November), pp. 135–6ff.

Zacharek, S. (1991). "An Interview with Greil Marcus," *Boston Phoenix Literary Section* (November), p. 7.

Zuberi, N.M. (1990). "Rock Music: A Bastard Form," *Michigan Daily* (26 September), p. 8.

SOUND RECORDINGS

Arrested Development. (1993). *Unplugged*. Chrysalis 21994.

The Beach Boys. (1963). "Surfin' U.S.A." Capitol 4932.

The Beach Boys. (1964). "Fun, Fun, Fun." Capitol 5118.

The Beatles. (1965). *Rubber Soul*. Capitol 2442.

The Beatles. (1967). *Sergeant Pepper's Lonely Hearts Club Band*. Capitol 2653.

Chuck Berry. (1984). *The Great Twenty-Eight*. MCA/Chess 92500.

Pat Boone. (1956). "Tutti Frutti." Dot 15443.

Mariah Carey. (1992). *MTV Unplugged EP*. Columbia 52758.

Ray Charles. (1954). "I Got a Woman." Atlantic.

Eric Clapton. (1992). *Unplugged*. Reprise 45024.

Dread Zeppelin. (1990). *Un-Led-Ed*. IRS 13048.

Dread Zeppelin. (1991). *5,000,000*. IRS 13092.

Bob Dylan. (1966). *Blonde on Blonde*. Columbia 841.

The Eagles. (1994). *Hell Freezes Over*. Geffen 24725.

Eurythmics. (1983). "Sweet Dreams (Are Made of This)." *Sweet Dreams (Are Made of This)*. RCA AFL 1-4681.

Bill Haley. (1955). "Rock Around the Clock." Decca 29124.

Jimi Hendrix. (1967). "Fire." *Are You Experienced?* Reprise 6261.

The Isley Brothers. (1975). "Fight the Power (Part 1)." T-Neck 2256.

Jefferson Airplane. (1969). "Volunteers." *Volunteers*. RCA.

The Last Temptation of Elvis. (1990). NME CD 038.

Little Richard. (1956). "Tutti Frutti." Specialty 561.

Living Colour. (1990). "Elvis Is Dead." *Time's Up*. Epic 46202.

Madonna. (1990). "Justify My Love." *The Immaculate Collection*. Sire/Warner Brothers 26440–2

Country Joe McDonald. (1969). "The 'Fish' Cheer/I-Feel-Like-I'm-Fixin'-to-Die Rag." From *Woodstock: Music from the Original Soundtrack and More* [various artists]. Cotillion SD 3-500.

MC5. (1969). "Kick out the Jams." Elektra 45648.

Clyde McPhatter and the Drifters. (1953). "Money Honey." Atlantic 1006.

Mr Bonus. (1986). "Elvis What Happened?" From *Luxury Condos Coming to Your Neighborhood Soon* [various artists]. Coyote 8559.

Nirvana. (1994). *MTV Unplugged in New York*. DGC 24727.

Mojo Nixon and Skid Roper. (1987). "Elvis Is Everywhere." *Bo-Day-Shus*!!! Enigma 73272.

Marie Osmond. (1993). "Karawane." From *Lipstick Traces* [various artists]. Rough Trade R2902.

Jimmy Page and Robert Plant. (1994). *No Quarter: Jimmy Page & Robert Plant Unledded*. Atlantic 82706.

Elvis Presley (1954) "Blue Moon of Kentucky." Sun 209. Re-released (1955) as RCA 47–6380.

Elvis Presley. (1954). "That's All Right (Mama)." Sun 209. Re-released (1955) as RCA 47–6380.

Elvis Presley. (1955). "Mystery Train." Sun 223. Re-released (1955) as RCA 47–6357.

Elvis Presley. (1956). "Don't Be Cruel." RCA 47–6604.

Elvis Presley. (1956). "Heartbreak Hotel." RCA 47–6420.

Elvis Presley. (1956). "Hound Dog." RCA 47–6604.

Elvis Presley (1956). "I Want You, I Need You, I Love You." RCA 47–6540

Elvis Presley. (1957). "Jailhouse Rock." RCA 47–7035.

Elvis Presley. (1960). "Stuck on You." RCA 47–7740.

Elvis Presley. (1961). "Rock-a-Hula Baby." RCA 47–7968.

Elvis Presley. (1962). "Follow that Dream." RCA EPA-4368.

Elvis Presley. (1963). "(There's) No Room to Rhumba in a Sports Car." *Fun in Acapulco*. RCA 2756.

Elvis Presley. (1965). "Do the Clam." RCA 47–8500.

Elvis Presley. (1965). "Puppet on a String." RCA 447–0650.

Elvis Presley. (1968). "If I Can Dream." RCA 47–9670.

Elvis Presley. (1968). "U.S. Male." RCA 47–9465.

Elvis Presley. (1969). "In the Ghetto." RCA 47–9741.

Elvis Presley. (1981). *This Is Elvis – Selections from the Original Motion Picture Soundtrack*. RCA 4031.

Elvis Presley. (1992). *Elvis: The King of Rock 'n' Roll – The Complete 50's Masters*. RCA 07863 66050–2.

Lloyd Price. (1959). "Stagger Lee." ABC-Paramount 9972.

Public Enemy. (1989). "Fight the Power." *Fear of a Black Planet*. Def Jam 45413.

The Residents. (1989). *The King and Eye*. Enigma 73547.

The Sex Pistols. (1976). "Anarchy in the U.K." *Never Mind the Bollocks Here's the Sex Pistols* [released 1977]. Warner Brothers 3147.

The Silhouettes. (1958). "Get a Job." Ember 1029.

Paul Simon. (1986). "Graceland." *Graceland*. Warner Brothers 25447.

Bruce Springsteen. (1980). "The River." *The River*. Columbia 36854.

Bruce Springsteen. (1984). "Born in the U.S.A." *Born in the U.S.A.* Columbia 38653.

Bruce Springsteen. (1984). "No Surrender." *Born in the U.S.A.* Columbia 38653.

Bruce Springsteen. (1985). "Johnny Bye Bye." Columbia 38-04772.

Rod Stewart. (1993). *Unplugged . . . And Seated*. Warner Brothers 45289.

Willie Mae "Big Mama" Thornton. (1953). "Hound Dog." Peacock 1612.

SOURCES

A Tribute to Elvis. (1991). K-Tel 60202.

John Trudell. (1992). "Baby Boom Ché." *AKA Graffiti Man.* Rykodisc 10223.

Big Joe Turner. (1954). "Shake Rattle and Roll." Atlantic.

Big Joe Turner. (1955). "Flip, Flop, and Fly." Atlantic.

The Unplugged Collection, Volume One. (1995). Warner Brothers 45774.

Uptown MTV "Unplugged." (1993). Uptown 10858.

U2. (1988). *Rattle and Hum.* Island 91003.

FILMS, VIDEOS, AND TELEVISION BROADCASTS

Batman. (1989). Produced by Jon Peters and Peter Guber. Directed by Tim Burton. Warner Home Video 12000.

Batman Returns. (1992). Produced by Denise Di Novi and Tim Burton. Directed by Tim Burton. Warner Home Video 15000.

The Big Chill. (1983). Produced by Michael Shamberg. Directed by Lawrence Kasdan. Columbia Tristar Home Video 60112.

Blue Hawaii. (1961). Produced by Hal B. Wallis. Directed by Norman Taurog. Key Video 2001.

Clambake. (1967). Produced by Jules Levy, Arthur Gardner, and Arnold Laven. Directed by Arthur H. Nadel. MGM/UA Home Video 701054.

Do the Right Thing. (1989). Produced and directed by Spike Lee. MCA Home Video 80894.

The Elvis Conspiracy. (1992). Produced by Erik Wilson. Directed by Bill Raymond. Nationally syndicated live television broadcast, 22 January.

Elvis '56. (1987). Produced and directed by Alan Raymond and Susan Raymond. Music Media M470.

The Elvis Files. (1991). Produced by David Griffin. Directed by Bill Raymond. Nationally syndicated live television broadcast, 14 August.

Elvis: One Night with You. (1968/1988). Produced by Steve Binder and Claude Ravier. Directed by Steve Binder. Music Media M467.

Elvis '68 Comeback Special. (1968/1988). Produced and directed by Steve Binder. Music Media M452.

Elvis, The Great Performances, Volume One: Center Stage. (1990). Produced by Jerry Schilling. Directed by Andrew Solt. Buena Vista Home Video 1032.

Harum Scarum. (1965). Produced by Sam Katzman. Directed by Gene Nelson. MGM/UA Home Video 600486.

Jailhouse Rock. (1957). Produced by Pandro S. Berman. Directed by Richard Thorpe. MGM/UA Home Video 500011.

King Creole. (1958). Produced by Hal B. Wallis. Directed by Michael Curtiz. Key Video 2005.

The Man Who Shot Liberty Valance. (1962). Produced by Willis Goldbeck. Directed by John Ford. Paramount Home Video 6114.

Mondo Elvis: The Strange Rites and Rituals of the King's Most Devoted Disciples. (1984). Produced and directed by Tom Corboy [original title: *Rock 'n' Roll Disciples*]. Rhino Home Video 2912.

Mystery Train. (1989). Produced by Jim Stark. Directed by Jim Jarmusch. Orion Home Video 5051.

Paradise, Hawaiian Style. (1966). Produced by Hal B. Wallis. Directed by D. Michael Moore. Key Video 2006.

This Is Elvis. (1981). Produced and directed by Malcolm Leo and Andrew Solt. Warner Home Video 11173.

The Trouble with Girls (And How to Get into It). (1969). Produced by Lester Welch. Directed by Peter Tewksbury. Key Video.

Truth or Dare. (1991). Produced by Tim Clawson and Jay Roewe. Directed by Alek Keshishian. Live Home Video 68976.

INDEX